picturing

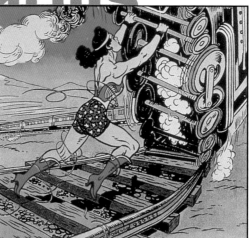

HARRY G. PETERS [FIRST *WONDER WOMAN* ARTIST], *WONDER WOMAN* NO. 26, FEBRUARY 1944.

Picturing the Modern Amazon
New Museum of Contemporary Art
March 30–July 2, 2000
Organized by Laurie Fierstein, Judith Stein, and Joanna Frueh
Picturing the Modern Amazon is made possible by a generous grant from
The Peter Norton Family Foundation.

First published in the United States of America in 2000 by
Rizzoli International Publications, Inc.
300 Park Avenue South
New York, New York 10010
and the New Museum of Contemporary Art
583 Broadway
New York, New York 10012
www.newmuseum.org

Library of Congress Catalog Card Number: 99-75926

ISBN 0-8478-2247-8

Cover and interior design by Hotfoot Studio/
Tanya Ross-Hughes, David Hughes

Printed in Singapore

Front Cover (color image): Andres Serrano, *Lesa Lewis*, 1998.
Color Photograph, 60 × 50".

Frontispiece: Nicole Eisenman, *The Largest Girl I've Ever Painted*, 1986.
Oil on Board, 39 × 35".

the modern amazon

edited by Joanna Frueh, Laurie Fierstein, and Judith Stein

newmuseumbooks

RIZZOLI
NEW YORK

To Al Thomas; and the women who build big muscle

TWO WOMEN WRESTLING
"PLAKAT FÜR EINEN
FRAUEN-RINGKAMPF," 1906.
COLOR POSTER BY GERMAN
LITHOGRAPHER ADOLPH
FRIEDLÄNDER, 37 × 27²/₃".

foreword

When Laurie Fierstein, Joanna Frueh, and Judith Stein first proposed *Picturing the Modern Amazon* to the New Museum of Contemporary Art, an irreverent thought sprang into my head. I saw an image of the ninety-pound weakling from the back-of-comics ads of my childhood, having sand kicked into his eyes by a muscle-bound bully. The bully has his eye on the weakling's beach-blanket beauty, whose heart he wins simply by showing her his superior pecs. (After slinking away, the weakling later returns as an even more powerful, bulked up bodybuilder, thanks to whatever product was being sold, and gets the girl back by socking the bully in the jaw.) In my mind, though, the "90-lb. weakling" was a woman who, once she's turned herself into a powerfully muscled, confident bodybuilder, shoves the bully away and returns to her girlfriend, picking up the engrossing conversation where they'd left off.

I was probably unduly influenced by the *Wonder Woman* comics of that period, but the idea of a woman having enormous physical strength and power was really compelling to me as a child. However, back in the late 1940s it was only wishful thinking, and pretty outrageous thinking at that; the only women who had developed their physiques to that extent were the Strong Women of the circus and fairway, and they were, clearly, freaks.

Is this still true today? Or is the extremely muscular woman a prototype for actualized female strength, control, and power? What is the relationship of feminism to bodily empowerment, and vice versa? What is the female bodybuilder's relationship to mainstream media images of femininity? This timely exhibition, the first to address the history, iconography, and meaning of the Modern Amazon, will offer viewers a fresh view of women bodybuilders, one which provides scholarship, pleasure, and provocation in equal parts. In presenting *Picturing the Modern Amazon*, the Museum continues to explore the myriad relationships between contemporary artistic practice and the fascinating and unpredictable world we live in.

I'm grateful to Laurie Fierstein, Joanna Frueh, and Judith Stein for having initiated and organized the exhibition and catalogue. I am also indebted to the work of authors Irving Lavin, Jan Todd, Steve Wennerstrom,

Leslie Heywood, Al Thomas, Michael Cunningham, Carla Williams, Nathalie Gassel, Maxine Sheets-Johnstone, and Pierre Samuel, for their excellent catalogue contributions, and to bodybuilders Pudgy Stockton, Bev Francis, Lenda Murray, Andrulla Blanchette, and René Toney, for their engaging and insightful interviews.

At Rizzoli, Chris Lyon, Senior Editor, and Laura Kleger offered calm and guiding hands during the production of the catalogue. Hotfoot Studio conceived an innovative design that captures the spirit of the hypermuscular woman.

Once again the New Museum staff has helped make this exhibition a reality through their hard work and dedication. I want to especially acknowledge Anne Barlow, Tom Brumley, Dan Cameron, Anne Ellegood, Melanie Franklin, John Hatfield, Sefa Saglam, and Dennis Szakacs, who have carefully guided the exhibition from its earliest stages.

The exhibition could not have taken place without the dedication of the individuals and foundations that supported it. The Museum is especially grateful to The Peter Norton Family Foundation for supporting this unconventional project and thanks Peter Norton and Susan Cahan, Curator and Director of Arts Programs, for their encouragement.

Last, but most importantly, I extend our thanks to the contributing artists, who have provided works imbued with grace, elegance, precision, and forcefulness—characteristics altogether in keeping with the subject at hand.

Marcia Tucker
Director Emerita

preface

the body
artist

Irving Lavin

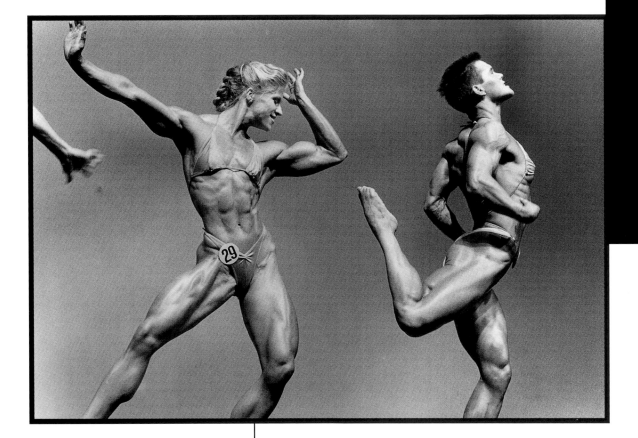

ANJA LANGER (LEFT) AND CHRISTINA FRANKEN (RIGHT), 1986, GERMAN BODYBUILDING CHAMPI-ONSHIPS, MUNICH.

One of the inadvertent compensations for the tribu-lations of parenthood is that we may learn from our off-spring lessons at least as valuable as those we impart to them. Such was the case when one of my daughters, Amelia, became a photographer and conceived an abid-ing interest in bodybuilders. Showing my wife and me some of her work one day she described her subjects as body-sculptures, and my life was transformed. In that instant I realized that I had spent a large part of my professional career as an art historian blindly studying the representation of the human figure in the visual arts (particularly sculpture), without seeing the subjects who

were hidden within and behind the objects of my devotion. Visually speaking, the body is an agglomeration of muscles, each of which has the potential to become a kind of brush- or chisel-stroke, of which the self-artist must become self-conscious, learn to develop, and then work into an overall design. The body may thus become a living work of art, no less thoughtfully conceived and laboriously executed than the painting or sculpture or photograph that portrays it. Behind and within the history of the humanistic tradition in art there lies a prior and inner history of art, that of the artists' models—those largely anonymous and unsung people who preceded and provided the raw material of inspiration. Was the model for the Venus of Willendorf a "bodybuilder"? What were her designs? How did she achieve those extravagant shapes, and what did they mean to her? This last is a crucial point, for every human being comes equipped with a virtually infinite endowment of physical and psychological potentialities, which the individual develops in finite ways to create, willy-nilly or deliberately, a person, a style, and ultimately a message about the meaning of the world as we understand, or fail to understand, it.

Having later witnessed with Amelia a bodybuilding exhibition (*Celebration of the Most Awesome Female Muscle in the World*, organized in 1993 by Laurie Fierstein, who also participated), I further realized that I had an entirely mistaken preconception of the nature of the activity because it is grossly misrepresented in the medium of still photography through which it is best known. Bodybuilding's initiates call it a sport, whereas what I saw was a dramatic action, a performance, and inevitably so, when one thinks about it, because we cannot understand what the body-artist's muscle-strokes have achieved without seeing them in action. The artist/work-of-art is practically never at rest, and the quality of the movement is no less eloquent than the glistening, streamlined forms themselves—balletic is

the only adequate word. And I am convinced that evocations of the body beautiful such as Giambologna's flying figure of Mercury, the messenger of the Gods—familiar to everyone from the flower-telegraphy logo, and distinctly recalled in the volatile forms of Christina Franken and Laura Creavalle illustrated here—cannot be understood apart from contemporary developments of the ballet.

But the term bodybuilding, which we use *faute de mieux*, does have at least one virtue: it suggests the idea of structure, as if the physique were a kind of edifice. In fact, the bodybuilder's body is, I think, a shrine, erected by those who have the imagination and the courage to endure the agony of transforming the inward and outward self into a work of art. They make the supreme sacrifice to the Temple of Beauty, sacrifice of the self.

I have deliberately avoided the term "Amazon" adopted in the title of this book, for reasons that are steeped in irony or paradox. First, because unlike the modern female bodybuilder, the Greco-Roman Amazon, however formidable, never exceeds the classical norms of feminine nobility and pulchritude. Second, because bodybuilding, male as well as female, tends to blur the conventional distinctions between the sexes, diminishing breasts and magnifying thighs among the women, magnifying breasts and diminishing genitalia among the men (the penis being one "muscle" that is not durably enlarged through exercise, so far as I know—as witness the ancient type of the mountainous, musclebound Resting Hercules). Through bodybuilding the sexes tend to merge in a common vision of humanity. The only apt analogy for this ideal, anthropomorphic androgyny are the angels, those other heaven-sent messengers of superhuman beauty and strength, incorporeal embodiments of the dream of human perfectibility.

LAURA CREAVALLE, 1988, IFBB WORLD AMATEUR CHAMPIONSHIPS, SAN JUAN, PUERTO RICO.

BACKGROUND IMAGE: MARGUERITE OF "MARGUERITE AND HANLEY" SHOWN PERFORMING HER FAMOUS ONE-ARM PRESS AND OTHER STRENGTH FEATS WITH HER PARTNER, 1908. TINTED LITHOGRAPH FROM *RINGLING BROTHERS COURIER*, "RINGLING BROS. WORLD'S GREATEST SHOW".

acknowledgments

We are deeply grateful to the New Museum of Contemporary Art and, in particular, to Senior Curator Dan Cameron, for such enthusiastic support of this project, which is as daunting as it is visionary. We also thank the participating artists, essayists, and body-builders for their time, ideas, conversation, and contributions—for their enlightening minds and bodies.

Joanna

Russell Dudley has helped me, intellectually and in the most beautifully prosaic ways, through the ups and downs of working on the Amazon project and being the co-editor most responsible for this book. Russell is my husband, and his abundant critical abilities, good sense, and corporeal knowledge keep my soul-and-mind-inseparable-from-body alert and fluid.

Pudgy Stockton, Bev Francis, Lenda Murray, Andrulla Blanchette, and René Toney, the bodybuilders with whom I conducted interviews, were exceptionally generous with their intelligence, time, and perceptiveness. Often during our conversations I found myself inspired and moved to joy. Sometimes I was haunted afterwards, in the best of ways, by what one of the women said or by how they looked—and I still am. They are transforming me into both a more muscular body and a more muscular thinker.

I worked closely with Melanie Franklin, the Publications Manager at the New Museum. Melanie's calmness, organizational ability, and conversational grace—in person and on e-mail—made the experience a pleasure.

Ludovica Busiri Vici and Christina Hengstmann, New Museum interns who transcribed the lengthy interview tapes, opened up hours of time for me to devote to other editorial responsibilities.

At Rizzoli, Laura Kleger deserves thanks for her sensitive and attentive copyediting.

In the Department of Art at the University of Nevada, Reno, where I teach, three people were of great help: Ann Burton and Andrea Gardella, under-graduate students who assisted with manuscript preparation; and Wendy Ricco, the Department secretary, who graciously taught me new computer skills.

Laurie

My dear, dear friends—you know who you are—with whom I have shared these many years of creating and bringing to fruition Picturing the Modern Amazon, a time during which we forged ideas and muscles and muscular ideas about changing the world, I cherish you all.

In 1993 artist Gustav Rehberger (now deceased) helped seed the idea which became Picturing the Modern Amazon, and in mid-1994 Icelandic art critic and curator Hannes Sigurdsson and I wrote a starting proposal. Their passion and non-conformity, which I profoundly appreciate, accounted for their role in the birth of this project. As its creator, I invited Joanna Frueh and Judith Stein to collaborate. They have been indispensable in bringing the Amazon project to life.

As the co-curator whose primary responsibilities include archival images and comic-book art, I thank: historical consultants for early archival images Jan Todd and David L. Chapman, who enthusiastically shared their knowledge, time, and resources about early day strongwomen; historical consultant for late archival images Steve Wennerstrom, a living encyclope-dia on women's bodybuilding, whose help was well over and above the call; and historical consultants for comic-book images Trina Robbins and Peter Sanderson.

The persons associated with the following institutions, collections, and publications were generous with their time and in making available historical and archival images for this project: Anne-Marie Sauvage, Conservateur, Direction des collections spécialisés, Bibliothèque Nationale de France, Paris; Fred Dahlinger, Director, Circus World Museum, Baraboo, Wisconsin; David L. Chapman, David Chapman Collection; David P. Webster, David Webster Collection, Irvine, Scotland; Frederic Woodbridge Wilson, Curator, and Annette Fern, Research and Reference Librarian, The Harvard Theater Collection, Harvard University, Cambridge, Massachusetts; Steve Gossard, Curator of Circus Collections, Milner Library Special Collections, Illinois State University, Normal, Illinois; Debbie Walk, Curator, John and Mable Ringling Museum of Art, Sarasota, Florida; Larry Heller, Orrin J. Heller Collection, Lawai, Hawaii; Marcia Richards; Jan Todd, Curator, Todd-McLean Physical Culture Collection, University of Texas, Austin; Bill Jentz, Publisher, and Steve Wennerstrom and John Nafpliotis, Editors, Women's Physique World magazine, Hohokus, New Jersey.

Others who assisted with the historical research or images are Ken Harck, Dominique Jando, Joseph D. Roark, Ralph Samuels, Mark Schaeffer, and Andi Schultz.

The images and narratives created by the participating comic-book artists delighted, fascinated, and terrified me. The comics made me laugh, as did the

artists themselves, whose bizarre brilliance is too often misunderstood, underestimated, and oversimplified. Those who helped me find relevant comics and comic-book artists include: Chris Couch, Kitchen Sink Press; Diane Hanson; Larry Heller, LH Art; Bobby Ray, Last Gasp Comics; Arlen Schumer, Dynamic Duo Studio; Leslie Sternbergh; Maggie Thompson, Comic Buyers Guide; and Steve Wennerstrom.

I deeply appreciate the varied help given by curator Lisa Corrin, art historian Marilyn Lavin, artist Barbara Rusin, and project supporters Andreas Eagan, Stephen Harrison, Michael Keene, Colin Knight, Rainer Zinsmeister, and Sully. Thomas A. Weise, Philippe, Ingrid Gherman, and Nicole Conrad respectively translated German, French, and Italian texts and communications. Andy Eggers selflessly supplied me with the computer hardware and software I needed for the project and helped with film research. Wahday Washington at Lats Gym in New York City allowed artists to conduct photo shoots in the gym with bodybuilders.

The depth and imagination of artists and essayists whom I came to know through discussions about this project especially enriched me as we explored new ways of looking at and thinking about female muscularity.

Besides the New Museum administration and staff members already acknowledged, those with whom I worked displayed both a high degree of professionalism and awesome creativity in their work on this project. They were John Hatfield, Anne Barlow, Maureen Sullivan, Meg Blackburn, and Anne Ellegood. Intern Emily Moore provided invaluable research and organizational assistance.

Finally, I embrace my muscular sisters who collaborated in the creation of their picturing, particularly those who posed for artists making works specifically for this project. They include Andrulla Blanchette, Rosemary Cheeseman, Tazzie Colomb, Fran Ferraro, Heather Foster, Valerie Green, Yolanda Hughes, Lesa Lewis, Nancy Lewis, Betty Moore, Marge Murphy, Robin Parker, Midge Shull, and Linda Wood-Hoyte.

Judith

As the co-curator primarily responsible for the section on contemporary art, I wish to send a bouquet of appreciation to every artist—and their dealers—whose works are included in this groundbreaking and provocative exhibition. To Lisa Corrin, who introduced me to Laurie Fierstein after hearing my exhilarated report on weight training, a special rose. I particularly want to acknowledge the many people who facilitated the writing of my essay, including: David Chapman; Joseph Roark; Ann Burroughs and Louise Lewis, California State University at Northridge Art Gallery; Robert A. Haller and the Anthology Film Archive; Stuart Anthony, Exit Art; Colleen Becker, Archivist, Whitney Museum of American Art; David Brigham, Worcester Art Museum; Norma Bartman, who scanned used bookstores on my behalf; Judy Hoffberg, who led me to Dan Talley; Sherman Drexler; Rudy Burkhardt; Vincent Katz; Agustin Perez Rubio; Jan Todd; Gladys Nilsson; Pat Oleszko; Richard Brilliant; Sylvia Sleigh; Matthew Baigell; Anne Monahan; Patricia Likos Ricci; Carrie Rickey; Jonathan Stein; and Rachel Stein.

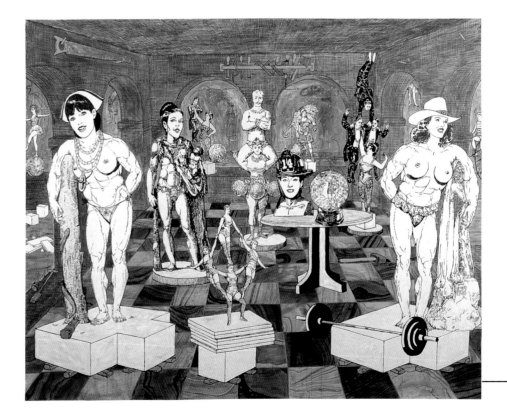

notes on contemporary art images

the contemporary art in this book includes pieces commissioned for the exhibition *Picturing the Modern Amazon* and pre-existing works. Amateur and professional bodybuilders posed for the commissioned works produced by Chicago, Cooling, Cox, Goodman, Leslie, Serrano, Taylor, and Willis. Laurie Fierstein facilitated the initial contact between the artist and the bodybuilders who became the subject matter of these paintings, films, and photographs. While they may function nominally as portraits, these art works exceed both that category and that of figure study, as they are highly inflected with the artist's stylization or fantasy of the body. This inflection also informs a number of pre-existing photo works featuring actual bodybuilders, such as those by Dobbins and the stills from Barney's film *Cremaster 4*.

Several of the pieces clearly reference or appropriate other visual sources: Doogan reinvents the Morton Salt girl (whose commercial image she herself updated in the late 1960s when she worked for a New York design firm); Zucker looks to vintage photographs of strongwomen; Weber collages images from bodybuilding magazines; and Gilje borrows two seductive representations of women, Jean-Auguste-Dominique Ingres's 1845 portrait *Vicomtesse d'Haussonville*, and one of Robert Mapplethorpe's portraits of bodybuilder Lisa Lyon.

Bodybuilding events drove the creation of many of the photographs. Willis shot the Germany-based Nancy Lewis in New York at the 1997 Ms. Olympia competition, in which Lewis participated. Björg's, Salzano's, and Schreiber's images were taken during *Celebration of the Most Awesome Female Muscle in the World* (1993), and Allen, Alper, and Meiselas photographed their subjects during *Evolution F: A Surreal Spectacle of Female Muscle* (1995), two performances organized and produced by Fierstein.

—The Editors

JANE HAMMOND, *THE SOAPSTONE FACTORY (#2)*, 1998–1999. OIL AND MIXED MEDIA ON CANVAS, 74 × 92".

Commissioned Works
Louise Bourgeois
Phyllis Bramson
Judy Chicago
Janet Cooling
Renée Cox
Bailey Doogan
Mary Beth Edelson
Seth Michael Forman
Sidney Goodman
Barbara Hammer
Jane Hammond
Oliver Herring
Chris Hipkiss
Amelia Lavin
Alfred Leslie
Jayne Parker
Andres Serrano
Clarissa Sligh
Jocelyn Taylor
Marnie Weber
Deborah Willis
Barbara Zucker

Pre-Existing Works
Mariette Pathy Allen
Barbara Alper
Matthew Barney
Björg
Bill Dobbins
Nicole Eisenmann
Kathleen Gilje
Annie Leibovitz
Bill Lowenburg
Mary Ellen Mark
Susan Meiselas
Herb Ritts
Alison Saar
James Salzano
Andi Faryl Schreiber
Cindy Sherman
Nancy Spero
Ann Sperry
Sarah Van Ouwerkerk
Anne Walsh

introduction

the modern amazon

Laurie Fierstein

In the summer of 1998 I received an e-mail from a Swiss man who, having seen a reference to *Picturing the Modern Amazon* on a circus website in Switzerland, was curious about the project. Being particularly interested in the concept of the Amazon, he was amenable to sharing his definition: "the modern Amazon is mainly independent and strong (both physically and mentally) rather than aggressive." He was especially enthusiastic and informative about Xena: Warrior Princess, who he believed "may represent the typical amazon (maybe not 'modern')." Then he introduced me to the Xenaverse—where, he said, "the term amazon is frequently used"—which is followed by legions of Xena fans through an enormous international, virtual, marketing network of websites, chat rooms, conventions, clubs, and other commerical domains.[1]

This gentleman's comments engaged me, and I did not challenge his definition, since persistent disagreement has informed the interpretation of amazon identity as well as discussion about the very existence of Amazons in ancient and modern cultures.[2] Nonetheless, I did explain to him that the upcoming exhibition had little to do with women possessing the attributes he described, however admirable those traits may be.

The focus of *Picturing the Modern Amazon* is specific and unambiguous: the representation of women who possess bodies that are conspicuously muscular. We who have worked on this project have come to call such women "hypermuscular", and their prototype is the contemporary female bodybuilder.[3] Hypermuscular women could be defined as those who desire to be very muscular, actively build muscle, and achieve a noticeable muscularity that sets them apart from other women because of the extreme response it generally elicits from people. These criteria do describe professional female bodybuilders, who build muscle and fashion physiques through training and nutrition with the aim of winning bodybuilding contests.

Why, then, have we used the term "hypermuscular woman" rather than "female bodybuilder"? Bill Dobbins—who has devoted himself to following women's bodybuilding contests since their inception—once explained to me that bodybuilding is a term specifically applied to physique competitions and the type of body, or look, sought by competitors within that context.[4] Bodybuilding has offered the only arena in recent history in which muscular women have been able to affirm themselves; while muscle displayed is muscle judged, it is also muscle appreciated. Almost all hypermuscular women have developed and been motivated exclusively within that competitive domain. However, to consider seriously the hypermuscular woman's complexities, implications, and historical evolution, we have had to understand her not only inside the bodybuilding arena but also outside of it. We have had to liberate thoughts, questions, and notions about her from limitations imposed by sex and gender frameworks and stereotypes.

Calling the hypermuscular woman, as represented by the contemporary female bodybuilder, a modern amazon is as much a question as it is a statement, meant to offer and evoke new ways of thinking about this complicated and disturbingly compelling subject. The Amazon project's *raison d'être* is to catalyze this process through visual and discursive exploration.

The female with big, blatant muscles as a paradigm for the concept of the Amazon is distinct not only from our Swiss friend's viewpoint but also from classical images and most other depictions of Amazons in art and literature throughout history. While debate about Amazons has often centered on whether Amazons described in myth actually existed in antiquity or were merely creations of the male psyche, it is not important for my discussion or the Amazon project whether or not these women warriors once walked the earth. The most profound aspects of the discussion of those classical women warriors and their successors examine the prob-

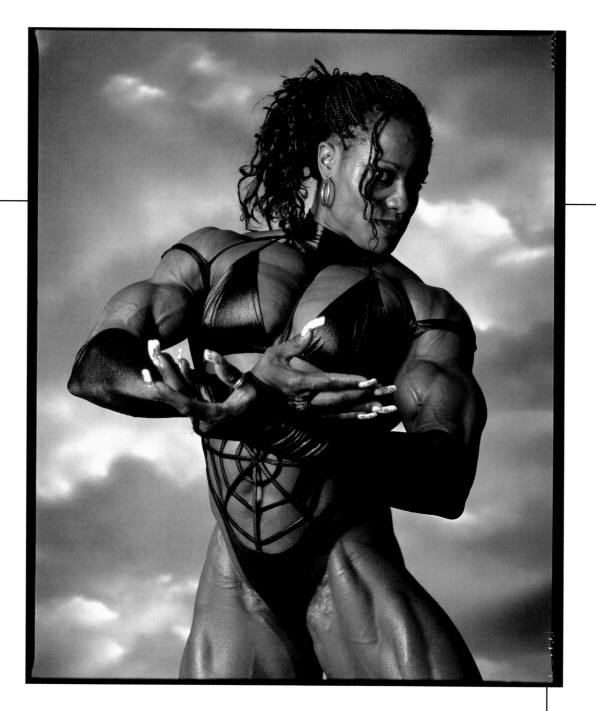

lematic contradictions inherent in conceptions and
depictions of Amazons, which include elements that
inspire both fear and allure, primarily but not exclu-
sively in males.

Historian Abby Wettan Kleinbaum asserts that the
Amazon was "a superlative female that men con-
structed to flatter themselves." In their descriptions
she was "strong, competent, brave, fierce, and lovely—
and desirable, too . . . [and] her strengths and talents
have a supernatural quality" that is not of the body.[5]
An essential aspect of this representation was that the
savagely skilled female opponent with great powers
was ultimately and inevitably conquered. The inherent
allure of this contadictory persona is conquest of her by

the male as "an act of transcendence, a rejection of the ordinary death, of mediocrity—and a reach for immortality."[6] Men's and women's enduring erotic infatuation with the Amazon seems, however, to be far more intrinsic to the human psyche than Kleinbaum's analysis allows. Most Greco-Roman myths about Amazons include some variant of a complex scenario in which a resplendently powerful female creature engages in the seduction of the male hero, which often reaches climax in combat fought with ferocious abandon to exquisite exhaustion.[7] At its very core, the need to vanquish the Amazon, for all the transcendental powers this act engendered within her conqueror, could be the result of the male hero's inability to exist in the presence of such a potent female, symbolic as she was of an inchoate and even more ancient force that was felt but had to be continually erased from the collective human memory. To decimate the Amazon was to eradicate all entombed remembrances of matriarchate.[8]

Only rarely has the representation of Amazons included muscularity as a feature. Any allusion to muscle is usually just that, presented as only peripheral and as vague or conditional.[9] Formidable, visible muscles are a threat that would severely undermine the inevitability of the Amazon's defeat because she would be perceived as already having breached and appropriated, in some measure, the forbidden male domain. Today the prevailing conception of the Amazon in popular culture is usually that of a big (or tall), powerful woman, and when looking at a contemporary hypermuscular woman, the percipient encounters that description in the flesh.[10] While this modern Amazon evokes the same anxieties aroused in ancients by her classical sisters, she is real—a living embodiment of the

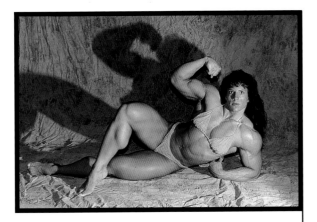

TINA LOCKWOOD, 1994, JAN TANA
CLASSIC, ROANOKE, VIRGINIA.

debated and unnerving Amazon. This may make her even more frightening, for her inescapable presence stirs up socially and historically constituted difficulties about body, gender, sexuality, aesthetics, and power.

How do the modern Amazon's attributes compare with the those found in our Swiss friend's definition and in literary consensus? Despite her larger-than-life image, today's hypermuscular woman has no supernatural powers. She is a mortal whose daily existence resembles everywoman's. She, too, is driven by dreams, passions, pleasures, pain, the desire for affirmation, and the struggle for economic survival. Is she competent, fierce, and brave? In her physique training, unquestionably so. In other aspects of her life, maybe, maybe not. Is the modern Amazon lovely and desirable? That depends upon who is gazing at her.

But upon seeing her, many are excited to lust, which is irrepressible and almost always closeted. Most often, it is heterosexual males who experience this lust, which they rarely admit, and which, if they act upon, they do so in secret encounters. A male's shame for his sexual arousal by a powerfully muscular woman is neither simple nor his alone; for an even more dreadful ignominy is borne by the object of his craving—his "perverse" secret, the modern Amazon herself. Recall the Homeric myth in which Achilles discovered the enchanting beauty of Penthesilea, one of the greatest Amazon warriors, only after he killed her in close combat on the Trojan battlefield. Hellenistic and Roman interpretations of the myth assert that the sex of the Amazon queen was revealed to Achilles upon his removing the armor of his slain opponent, and that this vision of beauty so enraptured him he instantly fell in love with her. The modern Amazon senses this dynamic, immediate response to the sight of her, as she also senses its cruel twist into "perversion" that the ancient story makes clear. Upon seeing Penthesilea's beauty, Achilles wept uncontrollably, and he made love to her bloodied corpse right then and there. As she lay on the ground, Achilles's Greek compatriots ridiculed him for having "filthy and unnatural lust" and cried: "Throw this virago to the dogs as a punishment for exceeding the nature of womankind!" Her body was then dragged by the feet through the dirt and thrown into the Scamander River.[11]

The death and humiliation of Penthesilea were necessary responses to her personification of overwhelming female strength, a central element of the ancient concept of the Amazon. Likewise, our modern Amazon is absolutely physically strong; but thousands of other women are also very physically strong, including weightlifters, some track and field athletes, and many more who are just naturally strong or who perform labor requiring

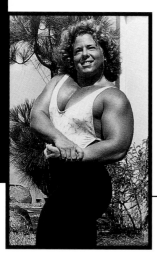

LEFT: JAN HARRELL AS A POWERLIFTER, LATE 1980S.

RIGHT: JAN HARRELL AS A BODYBUILDER, 1991.

women includes the following recognizable and predictable features: she is grotesque, manlike, androgynous, virile, freakish, dumb, narcissistic, obsessive, excessive, unhealthy, pornographic, offensive, and scary; she is a steroid user, a bulldyke, a dominatrix, and an exhibitionist.[14] Although these epithets seem to represent prevailing thinking about a very muscular female, many people see her as dedicated, disciplined,

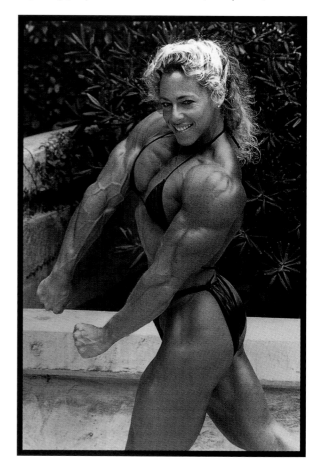

enormous physical prowess. Some of these women are, of course, noticeably muscular; most are not. Their level of discernible muscularity depends, for the most part, on the women's genetics and desires. It is not visible muscle that is the object of their sport or labor, it is performance.[12] Women who exhibit such physical strength and athleticism often face extreme prejudice, and society as well as athletic subcultures still do not fully accept these women alongside their male counterparts. Yet these women are embraced by our culture far more as role models and they reap far greater monetary rewards than do women whose muscles make them *appear* strong and who focus on what their bodies *are* rather than on what their bodies *do*. The less strong and muscular a female athlete appears, the more she is applauded and the greater her chance at national or world fame.

As I write this essay women's weightlifting is about to become an Olympic event for the first time in the history of the games. Summer 2000 is the date. Regarding this, *USA Today* ran "Weightlifting Gets Glamorous," featuring Melanie Kosoff, a genuinely remarkable and gifted weightlifter, probably the best in the United States. That she can thrust overhead as much weight as St. Louis homerun slugger Mark McGwire doesn't explain all the fanfare about her. The author states that "weightlifting hopes she's the long-awaited poster girl," and her coach asserts that if people "see someone like Melanie who is fit, but not a monstrous person, she can change a lot of stereotypes."[13] The implied notion is that a woman can be physically strong and still be a normative woman, but to *appear* strong is to be a monstrosity. The monster stereotype applies to heavily muscled women, be they bulked-up weightlifters or defined bodybuilders. The monster stereotype of hypermuscular

powerful, strong, awesome, beautiful, sensuous, exotic, and erotic, and they consider her an athlete, artist, Atlas, warrior, savior, superhero, living work of art, and, of course, an Amazon.

Regardless of how the hypermuscular woman is perceived, she possesses a body that looks powerful and commands a powerful response; these characteristics unequivocally differentiate the hypermuscular woman from other living women. Because the hypermuscular female body is inescapable and terrifying symbolism and text, the production and maintenance of stereotypes about it and its creator are the only way for people to cope with their own primal recoil at the threat she poses. How better to soothe fear than by reducing the living hypermuscular woman to an abstraction rooted in self-protective clichés?

Could it be that by deliberately creating and flaunting flesh so "excessive," the hypermuscular female

body alarmingly subverts a puritan shame about the body and its sensual pleasures, an entrenched view even as we enter a relatively gender-liberal new millennium? Is "exaggerated" muscle a magnified erotic symbol? An apotheosis of "sin" incarnate—"too much" flesh—that calls up guilt in both women and men? Does extremely developed womanflesh hold special significance for women who have by and large been alienated from their own bodies since the advent of class society, which resulted in their bodies becoming the property of others? And because women's bodies have evolved into a prime determinant of female and feminine identity, could hypermuscularity in women be a reclamation, a powerful remaking of women's identity and sexuality?

These questions likely stimulate a confusing assault of emotion that includes embarrassment, awe, and lust, as well as dread. Big, hard, round, voluptuous muscles that are the body of a woman generate an aesthetic and sexual disequilibrium felt, perceived, and declared to be an attack on normative femininity, including woman as the nurturant origin of life. But paradoxically, big, hard, round, voluptuous muscles that are the body of a woman are also a shadow-casting metaphor for the Great Mother, she who symbolizes Earth and who is the giver of life.

Modern Amazons' bodies are so extravagantly muscular and powerful that passersby who catch a mere glimpse are often riveted in fascination, although shock and indignation may be more frequent responses.

British professional bodybuilder Andrulla Blanchette walks into a small, crowded restaurant on West Tenth Street in New York. Her skintight black leggings with large cut-out holes along the outside reveal bulging thighs. On top she wears only a black bustier with silver adornments. Her enormous, rock-hard arms, shoulders, back, upper chest, and abdominals are bared. Her entry produces a mild disturbance among the diners. Almost immediately, doubletakes turn into stares, whispers behind hands, shifting in seats, and necks straining so eyes can get a look. Verbal ejaculations follow: "My god, she has more muscles than a man!" "She's beautiful!" A remark about steroids, meant to be heard, a moan, a gasp, a thumbs-up, a staccato laugh, several nods of approval. A young woman who has been working behind the counter in a coffee-stained apron, her back arrow-straight, shoulders set, face red, defiantly walks a gauntlet of stares to where Andrulla sits and says, "I just wanted to tell you that I really respect you for what it must have taken to accomplish this"; and she points at the bodybuilder's arm—a vein like an anaconda winds around a granite boulder.

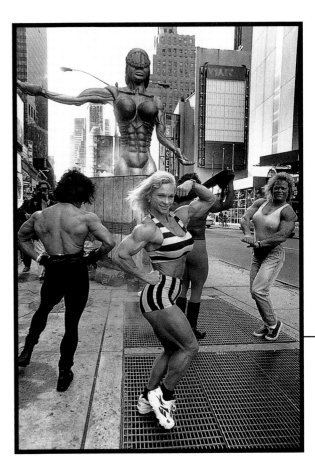

Xena—nor the actor who plays the role, Lucy Lawless—causes no such disturbance among her millions of viewers. Robert Weisbrot, author of *Xena: Warrior Princess; The Official Guide to the Xenaverse*, describes Lawless as follows: "Nearly five feet eleven inches, with intensely bright blue eyes and a lithe physique that could suit either an athlete or a model, Lawless looked every inch the warrior queen."[15] This description of the Amazon, as well as our Swiss friend's, is based on what Kleinbaum calls the "vision originated by men," and it "was not designed to enhance women, but to serve the needs of its male creators."[16] Xena is anything but real. She is an entertainment industry creation of men who allow her just enough heroics to titillate and entertain.[17] That Lawless doesn't look even a smidgen as if she could actually perform any of movie magic's pretend feats provides comfort to producers and audiences alike, all safe within the ramparts of mainstream visual culture. She does not need to be conquered because her Amazonian potencies are so obviously painted-on that she remains altogether acceptable within the design of feminine norms and therefore thoroughly impotent as a fundamental challenge to gender formulas.

The real modern Amazon would never be cast as Xena: Hollywood would simply not permit it. In the rare cases where muscular women are cast in heroic TV or

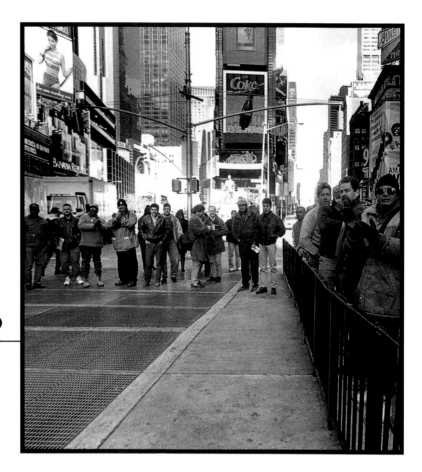

motion picture roles, their death-fate is sealed as surely as it was for the Amazons of Scythia. Philip Green points out in *Cracks in the Pedestal*, his analysis of gender in Hollywood, that even though the two women characters in the movie *Aliens*, Ripley and Vasquez, exert physical, intellectual, and moral power, they differ strikingly from one another: "Whereas Ripley is manifestly a woman in a traditional male role, the sexuality and even gender of the muscular Vasquez are ambiguous." Thus, "the real woman [Ripley] lives. . . . The ambiguous woman must die, for Vasquez is too far gone into 'masculinity' to be recuperated for the sexual order."[18]

Two more essential elements drive the *Aliens* gender scenario: Ripley, played by Sigourney Weaver, leads as the commander, while Vasquez, played by Jeanette Goldstein, is "proletarian muscle"; and Vasquez, the Latina character—the non-white—is permitted to be too much—an Amazonian body.[19] Green is not surprised that "in a society divided by boundaries of class, gender, and race, the death warrant [for such a character] is overdetermined."[20] Within the entertainment industry's framework, lithe Xena survives whereas visibly muscular Vasquez is another casualty in the immemorial war against the Amazons, in which, Kleinbaum asserts, "the opponents are mythical, but the battles are nonetheless real."[21]

Just as the ancients alleviated their anxiety by repeatedly depicting defeated Amazons being expelled from masculine territory, current anxieties push back the modern Amazon into the wasteland of the troubled psyche because she has already made real incursions into masculine territory. Consequently, only with great difficulty is the very notion of an ultramuscular woman assimilated into popular consciousness, for she presents a clear and present danger not only to what a woman is and ought to be, but also to the constitution of male-ness. While she challenges male prerogatives, doesn't she, paradoxically, really want to be a man? Why else would she want to "look like a man"? Even feminists have frequently written off the hypermuscular woman as irrelevant or even detrimental to women's empower-ment because they have read her as a mimicker of men: isn't a muscular woman literally and figuratively devel-oping male characteristics in order to adapt better to patriarchal culture? Contemporary thinkers have only begun to investigate and uncover the deepest motiva-tions for female muscle-building, so answers to the above questions are minimal and not in much agreement. However, it is certain that the hypermuscular woman is a woman—who wants and has big muscles and who identifies herself as female and sees herself squarely within the parameters of feminine identity. As such, she

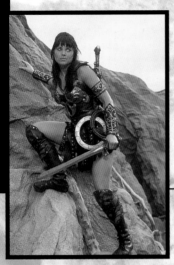

LUCY LAWLESS AS XENA: WARRIOR PRINCESS.

very muscular human being is, in fact, excessive either behaviorally or aesthetically is debatable.

[4] Even while that look—in bodybuilding parlance, "what the judges want"—is in constant flux and often hotly debated, a general aesthetic, popular in contests, exists based on muscle size, overall shape of physique, and definition dependent upon low body fat. This aesthetic tends to include small joints, wasp waist, small hips, and V-taper from waist to shoulders. Degree of muscle size and leanness as well as conventionally feminine facial appearance have been debated for women competitors.

[5] Kleinbaum, *War Against the Amazons*, 1.

[6] Ibid., 3.

[7] See Tammy Jo Eckhart, *Amazons: Erotic Explorations of Ancient Myths* (New York: Masquerade Books, 1997).

[8] J. J. Bachofen, *Myth, Religion, and Mother Right* (Princeton, N. J.: Princeton University Press, 1992), 100–109, sees the amazonian as an extreme form of matriarchy and as the principal adversary of the rise of Dionysian religion, which "demanded the recognition of the glorious superiority of the male-phallic nature." Bachofen asserts that "Amazonism was a universal phenomenon . . . found from Central Asia to the Occident, from the Scythian north to West Africa."

[9] See Pierre Samuel's "Amazons in Fiction: A Bibliography" in this book.

[10] In the winter of 1998–99 I anonymously posted the following questions, without context, in a popular current events chat room: 1) What are amazons? 2) What does an amazon look like? I received twenty-eight responses from nineteen states and nine countries. The four most popular answers to question one were: 1) People who live in the rainforest, 2) Tribes of man-hating women who lived long ago and killed their male babies, 3) Tall women warriors who fought the Greeks with swords and spears, and 4) Women who lived on an island without men. To question two, the response was pretty universal: a big (or tall), powerful woman.

represents a unique gender phenomenon that exemplifies paleontologist Stephen Jay Gould's comment: "any biological potential that can, through training, be developed to the point of blurring conventional gender distinctions is of great importance in the taxonomy of our culture."[22]

Feminist and queer activism and theory have led to a liberation of gender identities, which are beginning to be accepted as fluid and multidimensional rather than fixed and dualistic. As a result, the intricate intertwining and inseparability of aesthetic ideology and the sexual order are coming under fresh consideration. So, while one can say that by becoming hypermuscular the female bodybuilder assumes conventional male characteristics, one can also say that the hypermuscular woman is creating an aesthetic and sexual image that defines, in generous terms, a new kind of woman whose reality and potential reveals and explores the expansiveness of gender categories and identities. The Amazon project will help in the evolution of a new comprehension of women who want and have muscles like Hercules.

ABOVE: CHRISTA BAUCH, 1993.

BACKGROUND IMAGE: BATTLE OF GREEKS AND AMAZONS, FRAGMENT OF FRIEZE FROM THE MAUSOLEUM AT HALICARNASSUS, C. 350 BC.

[11] Robert Graves, *The Greek Myths, Complete Edition* (London: Penguin Books, 1992) 674, 681–82 nn.1,3, cites numerous accounts of the story. Some tell that Penthesilea drove Achilles from the field on several occasions, even that she killed him and the god Zeus restored him to life. Josine Blok, *The Early Amazon* (Leiden and New York: E. J. Brill, 1994), discusses at length the confrontation between Achilles and Penthesilea.

[12] The difference between a hypermuscular bodybuilder and a weightlifter or powerlifter is that the bodybuilder uses weights to mold her body's aesthetic appearance while the weightlifter (lifts: clean-and-jerk, snatch) or powerlifter (lifts: bench press, squat, deadlift) uses her body as a lever or series of levers to move weights. For other athletes as well, application of skill to a task involving movement is central, and that application may include strength.

[13] Sharon Raboin, "Weightlifting Gets Glamorous," *USA Today*, September 3, 1998, Bonus Section, 8–9. Raboin describes Kosoff as a "5-foot, 126 pounder with a face you could find in the pages of *Vogue*."

[14] Many people assume that hypermuscular women are lesbians. If we begin with the

Notes:

[1] *Xena: Warrior Princess* is a syndicated TV series produced by Renaissance Pictures for Universal/MCA. Starring New Zealander Lucy Lawless as Xena, the show debuted September 4, 1995, in the United States.

[2] See Abby Wettan Kleinbaum, *The War Against the Amazons* (New York: McGraw Hill, 1983), for the presentation and analysis of historical and mythological definitions and evidence of amazons.

[3] The term "hypermuscular" works because it conveys a great degree of noticeable muscularity. It is problematic, however, because hyper defines things, actions, and conditions in terms of excessiveness; and whether a

broadly accepted definition of a lesbian as a woman who is sexually and emotionally drawn to other women, what has muscle to do with that? The percentage of hypermuscular women who are lesbians is probably about the same as the percentage of lesbians in the rest of the population. Because many people consider both lesbians and muscular women to be manly or desirous of being men, it is easy to see how people conclude that muscular women are lesbians. But neither lesbians nor hypermusclar women want to be men. If that were so, they would be transsexuals. Fear of this stereotype, hypermuscular woman as lesbian, lives within bodybuilding circles along with the stereotype of male bodybuilders as homoerotic symbols. These stereotypes account for a good deal of homophobia and lesbophobia within that milieu.

Anabolic steroids are generally synthetic derivatives of the male hormone testosterone, though a few are derivates of the female hormones estrogen and progesterone. Steroids are taken by bodybuilders or athletes to increase strength, stamina, and muscle size. In this respect steroids work primarily in the muscle cells by increasing protein synthesis, creatine phosphate synthesis, and glycogen and fluid storage. Although it is widely assumed that many bodybuilders, both women and men, and many athletes, both professional and amateur, use anabolic steroids, comprehensive clinical and scientific studies of anabolic steroids have never been conducted because they are illegal and considered controlled substances. Most knowledge is therefore experiential or anecdotal. The generally accepted and strident identification of bodybuilders as steroid users is curious. The objections to steroid use include medical, ethical, moral, legal, and gender issues. With regard to female bodybuilders or other women athletes, the issue of gender becomes preeminent, since anabolic steroids are mostly a male hormone derivative. Often I have heard the objection to muscularity in women stated in terms of steroid use. We should pause to wonder, however, why muscular and physically strong women who made their public appearances prior to the discovery of steroids (toward the end of World War II) were considered freaks and monstrosities by many of their contemporaries.

VIVIANA VIOLANTE, 1998.

15 Robert Weisbrot, *Xena: Warrior Princess; The Official Guide to the Xenaverse* (New York: Main Street Books, 1998), 7.

16 Kleinbaum, *War Against the Amazons*, 3.

17 The men are producer Rob Tapert, co-producers John Schuliann (head writer) and David Eick, and Universal Studio's Dan Filie and Ned Nalle.

18 Philip Green, *Cracks in the Pedestal: Ideology and Gender in Hollywood* (Amherst: University of Massachusetts Press, 1998), 61–62. Green further explains Ripley's and Vasquez's gender differences in the two following excerpts:

When Ripley, after spending almost the entire movie in body-concealing fatigues, finally strips for action, the camera's gaze, and that of every male in the audience, is on her bosom: until this moment it has been present only by its absence. Vasquez, conversely, is in a real sense always stripped; although she is much more buxom than Ripley, up to the moment of her death the camera's gaze is always centered on her uncovered biceps, as well as on the immense weapon she cradles in her arms.

When we first meet Vasquez doing chin-ups, a male marine sarcastically asks her, "Hey Vasquez, have you ever been mistaken for a man?" To general laughter from almost every woman in the audience, Vasquez replies,"No, have you?" but the joke is double-edged. It only makes sense (that is, it is only funny) because of the assumption . . . that masculinity is naturally defined by muscular physique and physical prowess. Because of this expectation about the "natural" and, correlatively, the "unnatural," we know that the unmanned male will die before Vasquez, but we also know that she has just signed her own death warrant. She will die heroically, saving a lesser male from a hideous living death, but die she will. Even in the best of causes, this is one transgression that Hollywood always punishes.

19 Green, *Cracks in the Pedestal*, 63.

20 Ibid., 63.

21 Kleinbaum, *War Against the Amazons*, 3.

22 Stephen Jay Gould, letter to author, 19 November 1994.

object
lessons

Judith Stein

Watching my first Ms. Olympia contest in 1997 alongside Laurie Fierstein, Al Thomas, and Michael Cunningham, I began sorting through art history to find a framework to understand bodybuilding on its own, aesthetic terms. I watched the women's tanned and oiled bodies in awe, marveling at their dramatically volumetric arms which resembled braided challah breads. Like some of the Body Artists I knew in the art world who merged the creator with the created, these performing contestants had labored diligently to construct their bodies as objects of aesthetic contemplation. But were bodybuilders works of art? Were they artists?

It was this gala evening that spurred my interest in identifying the overlaps between art and physical culture, especially in the political- and performance-oriented art environments of the 1970s and 1980s.[1] I found that feminism had inflected both bodybuilding and the visual arts in similar ways. I discovered little known precedents to Picturing the Modern Amazon, *in which museums had made room for physique displays. The following essay presents these fascinating findings and traces a lineage for the recent artworks included in the* Amazon *exhibition.*

During the 1960s and 1970s, many avant-garde art works prominently featured performing bodies. Performance Artists, who were not necessarily trained as actors or dancers, used their own bodies as their medium, gleefully scrambling distinctions between art

and life, subject and object, and artist and model.[2] One of the earliest examples was the British artistic team of Gilbert and George, who in 1969 began exhibiting themselves as Living Sculpture. This new body-conscious genre attracted many feminists, who used it to focus attention on the ways society demeaned females as sex objects. For example, Hannah Wilke posed nude to mimic a controversial Duchamp sculpture in her cleverly titled photographic diptych *I Object . . .,* (1977–78). Martha Rosler displayed herself being stripped and measured in a 1973 performance that she documented on video and released in 1977 as *Vital Statistics of a Citizen, Simply Obtained.*

In Rosler's piece, taking a woman's measure depersonalizes and humiliates her; in Wilke's, voyeurism is derided. Yet there are those for whom scrutiny is not a negative experience. Physique contestants, for example, accept visual evaluation as part of the competitive process. But be they art world Performance Artists or bodybuilders, women and men who place themselves on exhibit are liable to be seen as exhibitionists. Body artists circumvented this with a transformative, art world ploy—voilà, they were objects. Perhaps for similar reasons, bodybuilders also position themselves as the embodiment of art. When contextualized as art objects, both bodybuilders and artists are able to shape and influence the viewer's gaze. However, there is one major difference: one pumps iron, the other, irony.

Photographer Dan Talley wittily skewed the overlapping vocabularies of art and bodybuilding in *A Biceptual Artist,* a postcard created in 1978. It showed sculptor Gail Whately flexing her sizable biceps, while flaunting such "bisexual" attributes as hairy armpits and no bra. Chicagoan Gladys Nilsson spoofed woman's performative body display in *Pumping Iron,* a 1980 watercolor showing a gal in an evening gown theatrically raising a small clothes iron. Nilsson's 1976 watercolor *A Artyst is*

WALTER K. GUTMAN, *ANOTHER RETURN OF THE GODDESS,* 1983. DYE-TRANSFER COLOR PHOTOGRAPH (MOUNTED ON BOARD), 60^{15}/$_{16}$ × 26^{1}/$_{8}$". PICTURING CLAUDIA WILBOURN.

a *Woik of Aart* pictured a woman proudly brandishing a paintbrush while sashaying down the street behind a picture frame. Its content and spirit resemble the contemporary sentiments expressed by Performance Artist Pat Oleszko, who turned Descartes on his head by declaring "I am therefore I art."

Extending this notion one step further, the artist and environmental activist Phyllis Yampolsky posited that anyone could be art. On May 22, 1978, she commandeered SoHo's OK Harris and Susan Caldwell galleries to stage the benefit performance *In the Event of Living Sculpture . . . Who Is Not a Work of Art?* Fifty artists and art-world luminaries participated, exhibiting themselves or another person as an art object. They ranged from a sultry Hannah Wilke, who panhandled in support of impoverished artists, to Duane Hanson, who confounded visitors by posing a real woman to imitate his celebrated, lifelike fabrications.[3]

Eleanor Antin's droll *Carving: A Traditional Sculpture* (1972) is the classic feminist exploration of the conceit that women possess special status as art objects. While shedding poundage during a strict diet regime, Antin photographed herself daily from four vantage points. Her tongue-in-cheek accompanying statement declared: "The work was done in the traditional Greek mode: 'The Greek sculptor worked at his block from all four sides and carved away one thin layer after another. . . .' When the image was finally refined to the point of aesthetic satisfaction the work was completed." She concluded her text by paraphrasing "our great predecessor" Michelangelo, who wrote: "not even the greatest sculptor can make anything that isn't already inside the marble."[4]

The Renaissance sculptor's words resonate in the context of bodybuilding. For example, it is commonplace wisdom in weight training that hard work and discipline can develop only what genetics have provided; not every bodybuilder can look like Kim Chizevsky, for example. As it happens, Michelangelo's sculptural concepts were invoked in relation to bodybuilding just four years after Antin created her subtractive "sculpture" *Carving*. Art historian Colin Eisler observed that Michelangelo's idea "of bringing form out of the 'blob,'" was "somewhat analogous to the process of self-realization through bodybuilding . . . , in which exercise brings out the fresh manifestations of the divine original within."[5]

Eisler made his comments in February 1976 at New York's Whitney Museum of American Art in an unprecedented public program entitled *Articulate Muscle: The Male Body in Art.* Occasioned by the publication of author Charles Gaines's and photographer George Butler's book *Pumping Iron*, the program included a symposium, film screening, and demonstration by bodybuilding champions Arnold Schwarzenegger, Frank Zane, and Ed Corey. A capacity crowd crammed into the Whitney's fourth floor to watch them pose on a spotlit turntable. But first, critic Vicki Goldberg moderated a series of scholarly presentations by Eisler, Matthew Baigell, Richard Brilliant, and Mason Cooley.[6] Brilliant, who spoke on "The Body as Gesture," recalls that the audience "could hardly wait until we were done to put on exhibitions of their own, in the flesh."[7]

Just for that occasion, the gallery walls were installed with Butler's photos of bodybuilders.[8] By all accounts, the thrill of the evening came with the live demonstration. Corey, Zane, and Schwarzenegger held the audience spellbound as the turntable made a full

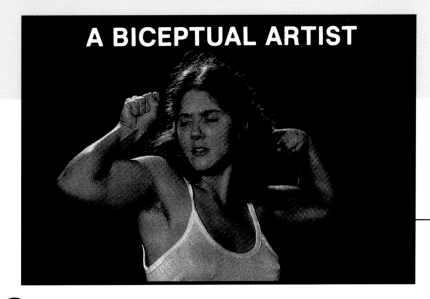

DAN TALLEY, *BICEPTUAL ARTIST*, 1978. POSTCARD, 3¹/₂ × 5¹/₂". PICTURING GAIL WHATLEY.

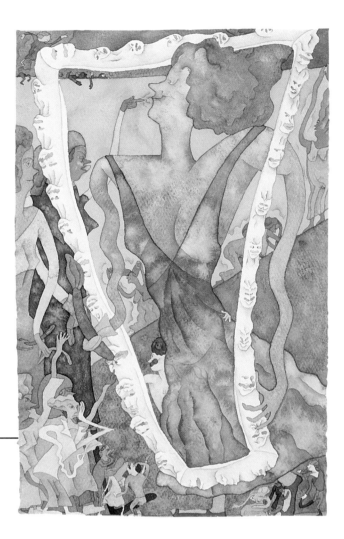

revolution for each of their poses. Serving as a guide for the art world denizens who never had seen a bodybuilder up close, narrator Charles Gaines commented that: "physique posing is a kinetic form of art. . . . Posing is the presentation; the physique is the object being presented."

In the question and answer period that followed, the three performers were asked about the connections between art and bodybuilding. Zane reflected that: "[My body] is like a piece of sculpture because like a sculptor works at a statue with different tools . . . I do the same thing . . . but my apparatus is different. I use barbells, dumbbells, and pulleys. . . . I feel like an artist [and] my body is a work of art." To which Professor Eisler responded: ". . . if you are a work of art, you had the disadvantage of having a bad art teacher because, to me, your poses are the personification of nineteenth-century camp." Boos and catcalls ensued. Goldberg hastily concluded the program and the academics breathed a sigh of relief.[9]

The Whitney event had showcased only the male body. Public awareness of female bodybuilding was nascent in 1976. But one year later, the United States Women's Physique Association sponsored its first contest. It was only a matter of time before a museum or gallery would organize an educational program like the Whitney's that would include women. On October 4, 1982, the art gallery of California State University at Northridge hosted a dual-gendered posing session in conjunction with an exhibition of photographs of bodybuilders.[10] Unlike the New York audiences, this California crowd dismayed the participants with their reserved behavior.[11] Undaunted, four years later gallery director Louise Lewis sponsored a second bodybuilding event that was more oriented to Performance Art. It was no surprise that the event was spearheaded by Lisa Lyon.

Immortalized by photographer Robert Mapplethorpe, Lisa Lyon is the one name that the general public still proffers when asked to cite a woman bodybuilder. Although the first women's competition occurred two

years earlier, it is the "World Women's Bodybuilding Championship," organized by Lyon in 1979, that the public regards as ground zero. Lyon, who had unerring marketing instincts, named it a "world" event even though all of the participants came from California. She garnered for the event the sponsorship of a Los Angeles TV station and of Gold's Gym where she trained, as had Schwarzenegger before her. Calling upon her considerable choreographic skills, Lyon had crafted a dazzling routine for the competition. According to some reports, most of the other contestants ran through standard gym routines and some hadn't realized until the last minute that they were expected to pose to music.[12] Lyon won first place.

"[Women] are not trained to think about our potential . . . , we are trained to think about our limitations. . . . Our energies transcend anything most people can imagine," Lyon quoted herself as saying on her resume of the mid-80s. At UCLA in the first half of the 70s, an energetic Lyon had majored in Ethnic Arts and Anthropology, and minored in Art and French. She studied kendo, a Japanese martial art, ballet, flamenco, and jazz dance, as well as piano, guitar, voice, and percussion. In addition, she took classes in acting and in 1977 did graduate work at UCLA in Critical Studies, Political Sociology, and Cinema. She supported herself as a film studio story analyst. As described by novelist Bruce Chatwin, in his introductory text to Robert Mapplethorpe's 1983 book of photographs *Lady: Lisa Lyon*, the stunningly attractive Lyon considered "bodybuilding as ritual, and her concept of this ritual as Art."[13]

Lyon conceived of herself primarily as a "Performance Artist" and secondarily as the "First World Women's Bodybuilding Champion."[14] Chatwin recounted that she had enraged the new crop of women bodybuilders by declining to defend her title at the Second World Championship, considering herself not so much an athlete as a 'performance artist'—a sculptor whose raw material was her own body. Since this material was, in the long run, ephemeral, she was on the lookout for the right photographer to document it. 'A mirror,' she says, 'is not an objective witness.'"[15] By 1986, Lyon had collaborated with well known photographers such as Mapplethorpe, Helmut Newton, and Joel-Peter Witkin, as well as the British sculptor Barry Flannigan. When their artworks depicting Lisa were shown at notable venues, so too was the art of Lisa Lyon.

At California State University at Northridge on the evening of November 7, 1986, the crowds started lining up hours before the scheduled opening at the Art Gallery. They couldn't wait to see *Icons of the Divine: The Human Form as Art*, a performance art event created and directed by Lyon.[16] When finally admitted to the gallery, the patient audience pooled around raised platforms to gaze up at three male and three female bodybuilders posing as works of sculpture. Lit dramatically, fancifully costumed and made-up, the otherwise motionless models changed position every five minutes. Live electronic music underscored the impression of transformative magic afoot.

The title *Icons of the Divine* revealed Lyon's earnest interest in the spiritual dimension of bodybuilding. In an excerpt of her poetry quoted on the postcard invitation, she expressed a concept of inner beauty that harkened back to Michelangelo: "The most perfect grace consists not in external ornamentation but in allowing the original material to stand forth." All of the participants shared Lyon's intention to present "the human form as art." For example, Darla Miller suggested: "I try to sculpt my body like a statue, creating the perfect curves and contours . . . a beautiful body that beams . . . to reflect a perfect physical being . . . in the image of God."[17] Lyon dominated the second half of the program with a videotape of her 1984 Tokyo performance *Contemporary Alchemy, Evolution Ritual*.[18] She had worn only body paint and a G-string to perform a dramatically choreographed series of poses. "Respect this female power," she intoned on the tape, in a sexy voice-over of her own poetry.

Although Lisa Lyon was the most renowned proponent of artful bodybuilding in the early '80s, Claudia Wilbourn also merits recognition. In the 1979 "World Championship" she had come in second behind Lyon. An articulate, first-generation feminist with a BFA in studio art, Wilbourn liked the feeling of physical power that bodybuilding gave her: "When you are a little person, ninety pounds and female, people always treat you like a doll. A childlike figure, not to be taken seriously."[19] She was attracted by the challenge of penetrating what she termed the "male bastion" of bodybuilding: "They saw that I drove myself as hard as they did. Harder. . . . They could not deny me. I forced them to change their minds." For Wilbourn, bodybuilding "was not just a sport. It was a personal expression. By creating an ideal from my body, molding and remolding each detail, until it satisfied my inner vision, I was defining an aesthetic. It was a form of artistic statement."

Sometime in 1980, she met Walter K. Gutman, a seventy-seven-year-old filmmaker and patron of the arts. Eccentric and charming, Gutman had a longstanding attraction to powerfully muscular women. "I became an artist in order to try to meet strong women," he guilelessly revealed in 1983, in reference to taking up painting in the 1950s.[20] A securities analyst dubbed "a Proust in Wall Street," Gutman had been actively involved with the New York avant-garde for decades.[21]

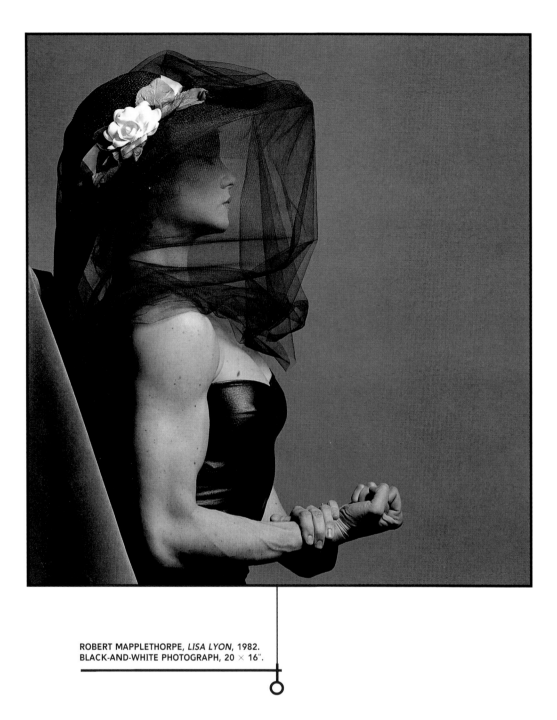

**ROBERT MAPPLETHORPE, *LISA LYON*, 1982.
BLACK-AND-WHITE PHOTOGRAPH, 20 × 16".**

Citing his friend's "Dionysian passion for feminine bodies," sculptor George Segal has described how Gutman would bring muscular circus performers to his studio, who would pose for his sculpture while Gutman photographed the process.[22] Gutman's 1981 photographic portfolio *Inspirations of Strong Women* included documentation of a 1960s session with Suzanne Perry, a celebrated acrobat with Ringling Brothers Barnum & Bailey Circus, and a co-founder of Big Apple Circus.[23]

"Bodybuilding broadens the spectrum of the feminine by adding strength," Gutman said on the soundtrack of his unconventional 1981 film *Clothed in Muscle: A Dance of the Body*. A collaborative venture between Gutman and Wilbourn, *Clothed in Muscle* granted viewers permission to scrutinize her unclothed body.[24] As the camera reverentially detailed her musculature, the voice-over expressed the former art school model's interest in doing bodybuilding competitions without

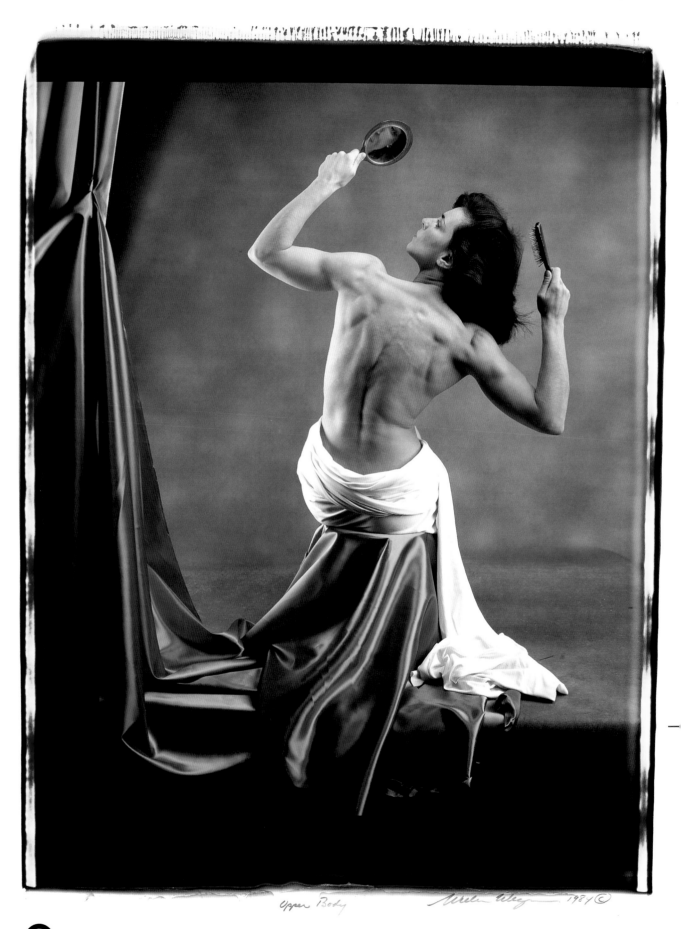

Upper Body 1984 ©

bathing suits. The filmmaker muses in the voice-over: "I thought to myself: She's not nude. She's clothed in muscle." In a statement he made subsequent to the filming, Gutman said, "Claudia is a sculptor and . . . felt, as I did, that the effect of body building, when filmed nude . . . makes it look in frequent sections like antique Greek sculpture . . . a dance of the body."

The idea that "in bodybuilding, muscles function in much the same way as clothing" was also articulated by feminist film critic Annette Kuhn in her insightful analysis of Charles Gaines's 1984 film *Pumping Iron II: The Women*.[25] This influential movie covered the 1984 Ms. Olympia championship, held at Caesar's Palace, Las Vegas. Gaines closely followed three of the competitors: Rachel McLish, Carla Dunlap, and the Australian Bev Francis, a former champion powerlifter. Viewers of the film could eavesdrop on the jurors, the women, and their trainers as they disputed the contentious issue of "appropriate" muscularity for women—discussions prompted by Francis's singular build. No woman with

such developed muscles had ever before entered the competition. Deemed "too masculine" by the judges, she placed last, the top prize going to Dunlap. Yet the lithe and sinewy look epitomized by Lisa Lyon and Claudia Wilbourn was soon to be out of style. Muscle, like clothing, has cycles of fashion, and taste was changing.[26]

While Gutman's *Clothed in Muscle* played at art movie houses, documentaries such as *Pumping Iron II* and the contemporary *Women of Iron* brought the image of the hypermuscular woman to a wider audience.[27] Before the '80s, hypermuscular women rarely appear in the movies. For example, six years after the admirable and unabashedly muscular Rosie the Riveter exhorted women to do their part for the War effort, George Cukor's 1949 film *Adam's Rib* presented a physically powerful model whom few were expected to emulate.[28] In this delightful Hepburn and Tracy vehicle, the heavily corseted Hope Emerson played Olympia La Pere, a carnival understander who could support the weight of five men. To demonstrate her skills, the Samsonian

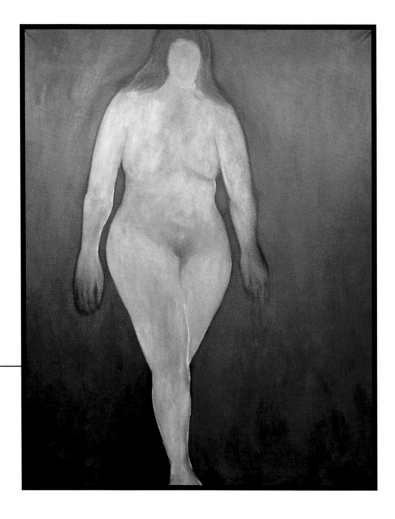

LEFT: WILLIAM WEGMAN, *UPPER BODY*, 1984. POLACOLOR II POLAROID PRINT, 24 × 20". PICTURING EVE DARCY.

RIGHT: SHERMAN DREXLER, *GERTRUDE EDERLE*, 1963. OIL ON CANVAS, 60 × 50".

La Pere hoisted an irate Tracy into the air. By 1989, director Blake Edwards would cast the hypermuscular Raye Hollitt as a babe of an aerobics instructor who strips before bedding John Ritter, a dissolute writer, in *Skin Deep*.

Among the rare examples are Sherman Drexler, who in 1963 painted an Amazonian swimmer in *Gertrude Ederle*,[30] and his wife, the writer and painter Rosalyn Drexler, who showed a wrestler glorying in her success in the 1965 painting *The Winner*.[31] In the 1970s, painter and photographer Rudy Burkhardt made a series of collages based on his photos of the model Takwa, flexing her biceps.

Many more artists became aware of hypermuscular women in the first half of the '80s, thanks in part to Lisa Lyon's visibility and to the documentaries that familiarized the larger American population with the world of women bodybuilders.[32] Howard Kanovitz's *Red Figure Posedown* 1983; is one of a series based on images he discovered in magazines. Kanovitz found that physique contestants presented "a new kind of figure. These gals had a quality that reminded me of Greek sculpture, or even Michelangelo's works in the Medici Chapel."[33] Gustav Rehberger underscored the attributes of his muscular models in the drawings he made while teaching at the Art Students League. The photographer William Wegman, better known for his images of beguiling Weimeraners, did a series of Polaroids of his muscular friend Eve Darcy in 1984. In her colossal-scaled *Rainbow Caverns* (1987), Ida Applebroog featured a dark-skinned bodybuilder as a trope of female empowerment.

By the mid-80s, the idea that the human body is a malleable sculptural material had become common currency.[34] It had jumped the confines of both the art world and the bodybuilding community to land in the domain of popular culture. Today every gym and health club offers classes in body sculpting.[35] Anyone with willpower can become a body artist. If they diet, they do subtractive sculpture, if they weight train, it's additive. Does this represent the democratization of the art world, or perhaps the logical extension of Marcel Duchamp's belief that any found object can be art if placed in an artful setting? Like the roués and just plain folks who celebrate in the final scene of *Pecker*, filmmaker John Waters's 1998 send-up of contemporary art, we may be toasting the end of irony.

Notes:

[1] The connections linking the worlds of art and of physical culture predate the present era. Sports historian Jan Todd has shown that the reintroduction of Greek and Roman sculpture during the Neoclassical period stimulated an interest in exercise that helped Europeans attain the ideal of ancient beauty. Jan Todd, "The Classical Ideal and Its Impact on The Search for Suitable Exercise: 1774–1830," *Iron Game History* 2, no. 4 (November 1992): 6–16. See, for example, Sir John Sinclair's 1806 comment that Greek sculpture should be viewed as "living examples of the perfection which the human form is capable of attaining," quoted in Todd, "Classical Ideal," 7.

According to Greek legend, Pygmalion, a king of Cyprus, once fabricated an ideal female figure that was brought to life for him by Aphrodite. While early-nineteenth-century Europeans such as Sinclair regarded classical statuary as reverse Pygmalions that reflected the physiognomies of actual models, there were those at the close of the century who reversed the relationship of art and life back to a legendary realm. The founder of bodybuilding, Eugene Sandow, conceived of himself

HOWARD KANOVITZ, *RED FIGURE POSEDOWN*, 1983. RED PIGMENT AND CHARCOAL ON PAPER, 16 × 20½".

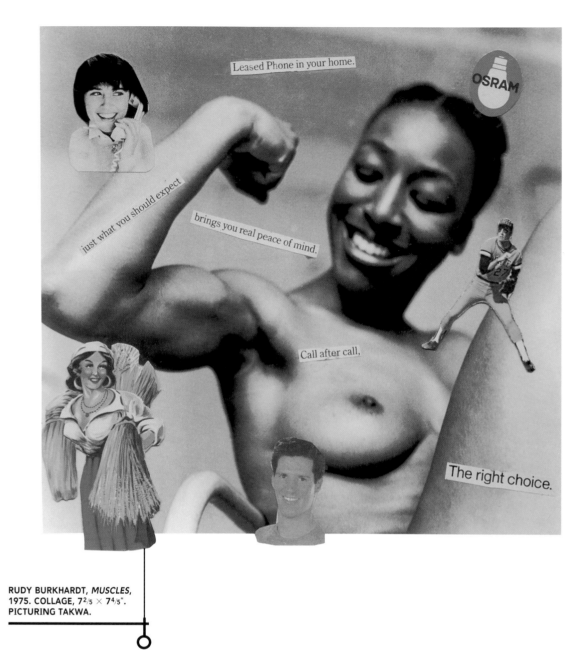

RUDY BURKHARDT, *MUSCLES*, 1975. COLLAGE, 7²/₅ × 7⁴/₅". PICTURING TAKWA.

as a living version of Greek sculpture. When he posed, he covered his body with white powder to better resemble carved marble. Modeling himself on ancient art, he in turn modeled for sculptors and photographers. In 1903, promoter and muscleman Bernarr Macfadden sponsored the world's first physique contest in New York's Madison Square Garden. Among those he picked as judges were prominent painters and sculptors, who were schooled in classical sculpture and therefore were expert in evaluating the ideals of symmetry, proportion and clarity of human musculature as defined by the ancients.

[2] See for example, Max Kozloff, "Pygmalion Reversed," *Artforum* 14, no. 3 (November 1975): 30–37; Peter Frank, "Auto-art; Self-indulgent? And how!," *Art News* 75, no. 7 (September 1976): 43–48.

[3] Sponsored by Doris Freedman, the performance was a benefit for the Public Art Fund of New York. The fifty participants included the well known Louise Bourgeois, Tom Wesselmann, and Mark di Suvero, as well as non-artists such as former Museum of Modern Art director John Hightower, and former

Metropolitan Museum director Thomas Hoving, who came as each other's sculpture, equipped with megaphones and canvas director's chairs. The "living works of art" posed as the viewers thronged around them. Dealer Robert Graham contributed the seventy-eight-year-old painter Alice Neel, wearing a lamé dress, bonnet, and gilded orthopedic shoes. He called his work *Alice Neel in the Eighteenth Century*. Neel sat on a studded chair and chatted with viewers, proclaiming she was a "speaking statue." Sherman Drexler contributed two interrelated "works": a gridded painting, in which each segment depicted a female figure in motion poses; and actress Lucinda Ziesing in a body stocking, who stood near the canvas, assuming in turn each painted position. According to Yampolsky, Larry Rivers had intended to exhibit a Bowery bum as his work of art, but was dissuaded by the sponsors; Phyllis Yampolsky, conversation with author, 15 March 1999. I am indebted to Sherman Drexler, who brought this event to my attention. See Gerald Marzorati, "Everyone and Every Walk a Work of Art," *The SoHo Weekly News*, 25 May 1978; "Art Brought to Life with Living Sculpture," *New York Post*, 23 May 1978, 25; Malcolm N. Carter, "Arts Alive," *Associated Press*, 23 May 1978.

4 From the exhibition *Endurance*, curated by Jeanette Ingberman and Papo Colo, that was organized and presented by Exit Art, New York, from March 4–April 22, 1995; exhibition texts from forthcoming book *Endurance Art: The Information*, edited by Mary Anne Staniszewski with contributions from Papo Colo, RoseLee Goldberg, Jeanette Ingberman, and Kathy O'Dell, with research by Melissa Rachleff.

5 Colin Eisler, quoted in Al Antuck, "Bodybuilding in the Whitney Museum," *Muscle Magazine International* 2, no. 2 (August 1976): 66. Eisler's talk was titled "Metaphors of Art: Narcissus, Virtue, and Exercise." All other text quotations of comments made on this evening are found in Antuck's article. Sports historian Joe Roark kindly provided me with this source.

6 Vicki Goldberg was chosen because she had recently written what the Whitney Museum's press release identified as the first mass media article on the subject of bodybuilding; see Vicki Goldberg, "Body Building," *New York Times Magazine* (30 November 1975): 45–54.

7 Richard Brilliant, letter to author, 31 July 1998. Painter Sylvia Sleigh, noted for her depictions of male nudes, related that she had been slated to speak on the topic "Misapprehension on the Painting of Man (Beauty and Homosexuality)." She struggled through the throng to reach the sidelined podium with her husband, the critic Lawrence Alloway, with her favorite model Paul Rosano in tow. But when she learned that the spotlight on the central posing platform would not be extinguished during the slide presentations, she declined to participate. She decided that the clamorous assembly was not in the mood for intellectual engagement. Sleigh recalls that although artist Scott Burton had been cited in the Whitney's press release as a panel participant, he was not present that evening. Telephone conversation with author, 28 December 1998.

8 Butler and a crew filmed the evening's events for his forthcoming documentary, and excerpts of earlier footage were included in the Whitney program. His documentary film *Pumping Iron* was completed in 1977 but did not contain any footage of the event.

9 Matthew Baigell, for one, felt menaced by the crowd. In his estimation, the panel's presentations had not been well-received by the audience, who was more accustomed to watching bodybuilding displays than to listening to scholarly disputations about them; Baigell, conversation with author, 17 February 1999.

10 The photographs were by William Heimanson, and the live muscle display was performed by Eileen Carda, Dennis Fields, and Audrey and Shurray Perryman.

11 Gallery director Louise Lewis recalls that the athletes wrongly assumed that the lack of spontaneous vocal appreciation and the withholding of applause until the conclusion of the presentation had signaled not politeness but disapproval; Lewis, interview by John Hunt, in *Icons of the Divine*, 1987, videocassette. *Icons of the Divine* documented a 1986 performance of the same name by Lisa Lyon at the California State University at Northridge Art Gallery.

12 Nik Cohn, *Women of Iron: The World of Female Bodybuilders* (Wideview Books, 1981), 153.

IDA APPLEBROOG, *RAINBOW CAVERNS*, 1987. OIL ON CANVAS, 86 × 132".

13 Bruce Chatwin in Robert Mapplethorpe, *Lady: Lisa Lyon* (New York: St. Martin's Press, 1983), 12.

14 These are the terms she used on her résumé in 1986. A narrative section read in part: "Collaborating with a conceptual artist she developed her initial posing routine into a museum piece. She could dead lift 265 pounds but marked her greatest achievement as the impact of this form of body sculpture. . . ."

15 Chatwin, *Lisa Lyon*, 11.

16 *Icons of the Divine* was one of three programs in a performance art series on the theme of the body entitled "Non-Static." It included Lyon's piece; Noreen Barnes's, Bryan Hornbeck's, and Karen Kearns's "The Salvia Milkshake"; and Ilene Segalove and Steve Proffitt's humorous radio broadcast "Bodyparts."

The names of twelve bodybuilders, called Performance Artists, were listed on the program for *Icons of the Divine*: Katie Anawalt Arnoldi, Michael Buonanno, Laura Creavalle, Suzanne de Cayette, Edmund Druilhet, Charles Glass, Cindy Lee, J. J. Marsh, Darla Miller, Shawn Ray, Suzanne Tigert, and Rick Valente.

17 Both quotations were contained in the unpaginated, photocopied program flyer that was given to *Icons of the Divine* attendees.

18 Presented in spring 1984 at the Laforet Museum Harajuku, the Japanese event was one component of a four-part performance series, *Next Wave of American Women*, featuring respectively, Lisa Lyon, Laurie Anderson, Cindy Sherman, and Molissa Fenley. Japanese colleagues have told me that Lyon's performance was "the" event of the season, and was much talked about.

19 This and subsequent quotes of Claudia Wilbourn are found in Cohn, *Women of Iron*, 149–53.

20 Walter Gutman, "Interview with Walter Gutman," interview by Robert A. Haller, *Field of Vision* 12 (summer 1983): 8.

See also Haller's other interview with Gutman, "Walter Gutman on Photography," *Field of Vision* 13 (spring 1985): 17–18.

21 See John Brooks, "Profiles: A Proust in Wall Street [Walter Gutman]," *The New Yorker* (20 June 1959): 41–64. Gutman was a man of wide interests and talents—a former art critic for *The Nation* magazine, he had also published a book on painter Raphael Soyer (*Raphael Soyer, Paintings and Drawings* [New York: Shorewood Publishing Co., 1960]). His large circle of friends included Jack Kerouac, Allen Ginsberg, Alfred Leslie, Robert Frank, Alice Neel, Charlotte Moorman, George Segal, Lucinda Childs, and Bob Thompson. Neel painted him in 1965 wearing a suit and topcoat and holding his hat in his hand.

As a benefactor of the arts. he funded Carolee Schnee-mann's 1964 Judson Church performance, *Meat Joy* [Letters: Carolee Schneemann on Walter Gutman", *Field of Vision* 13 (spring 1985): 31], and Red Grooms's and Mimi Gross's 1962 film *Shoot the Moon* [Mimi Gross, conversation with author, 7 April 1999]. When his firm G-String Enterprises bankrolled Frank and Leslie's 1959 classic film of the beat generation, *Pull My Daisy*, his partners included Jack Dreyfus, then of the Dreyfus Fund; see Priscilla S. Meyer, "The Naked Truth,"

Forbes (16 January 1984): 113. For a time, Gutman served as an unconventional father figure for critic Jill Johnston; see her *Mother Bound: Autobiography in Search of a Father* (New York: Alfred A. Knopf, 1983), 117–120.

22 George Segal, "Introduction," in Walter Gutman, *Inspirations of Strong Women*, (New York: Anthology Film Archives, 1981), unpaginated. This photographic portfolio of thirteen color dye-transfer prints was published in 1981 to help raise funds for Anthology Film Archives. About half of the photographs in the portfolio were made between 1966–71 and the rest between 1979–81.

A selection of Gutman's dye-transfer prints entitled *The Beauty of Strong Women* were shown at Richard Bellamy's Oil and Steel Gallery in New York, in 1984, to benefit the Trisha Brown Dance Company. Gutman's photographs are today in the permanent collections of the Center for Creative Photography, Tucson, Arizona; the Yale University Art Gallery, New Haven, Connecticut; and the International Center of Photography, New York, New York.

23 Gutman revered Suzanne Perry, whom he had met at a party when she had come up to him to say, "I hear you like

GUSTAV REHBERGER, *WOMAN*, 1987.
SANGUINE PASTEL, 35 × 23".

PHYLLIS BRAMSON, *BEING BOTH OBJECT AND SUBJECT*, 1998. OIL ON CANVAS AND MIXED MEDIA, 70½ × 50".

muscles. I have muscles." It was Gutman's staunch enthusiasm for her that propelled him into filmmaking in 1968 when he was in his sixties. After Gutman introduced the acrobat to his friend, filmmaker George Kuchar, the younger artist promptly included Perry in a movie. But Gutman was greatly disappointed when he saw how Kuchar had presented her. As Gutman recounted to Robert Haller, "It was insulting to my goddess. So I decided that I would have to make a film glorifying a strong woman; no one else seemed to want to do it. So I bought a Super 8. And I made that film from slides I had taken at George Segal's; it was called *The Adoration of Suzie.*" Gutman, "Interview," 11. Although Gutman would later claim, "I just didn't know what the hell I was doing," several critics have found his quirky and personal films worthy of serious attention. For example, Shirley Clarke has likened his ingenuity to that of the self-taught painter Henri Rousseau, and Lenny Lipton described him as an "American Don Quixote." These quotes and Gutman quotations in the text are found on the website of Arthouse Inc., the distributor for Gutman's *Clothed in Muscle*, at http://arthouseinc.com/clothed.html.

24 Like the proverbial foot fetishist who became a shoe salesman, Gutman directed his private obsession with muscular women into socially accepted channels, creating some remarkable films in the process. Not only did *Clothed in Muscle* depict Wilbourn posing nude, but it also contained a section of vintage photos of nineteenth century strong women, as well as sexually provocative images of mixed gender wrestling. The film also included images of other muscular women such as Karyn Bastiasen and Mary Lou Harmel. In an earlier film, *The Erotic Signal*, shot in Mildred Burke's studio in 1978, Gutman included segments on a woman weightlifter and a nude aerialist. For Gutman's process as a filmmaker, see Walter Gutman, "The Accident as a Creative Force," *Visions* (May/June 1983): 6–7.

25 Annette Kuhn, "The Body and Cinema: Some Problems for Feminism," *Grafts: Feminist Cultural Criticism*, ed. Susan Sheridan (London and New York: Verso, 1988), 17. See especially her proposal that muscles are like drag for female bodybuilders: "like clothing, women's assumption of muscles implies a transgression of the proper boundaries of sexual difference." For a recent discussion of bodybuilding as "glamorous camouflage" in the realm of gay male theater, see John Rechy, "Muscles and Mascara: On Bodybuilding as an Art," *Art Issues*, no. 53 (summer 1998): 15–19.

26 According to Laurie Fierstein, which whom the author exchanged e-mail in January 1999, no woman with Bev Francis's 1984 body type has ever won the Ms. Olympia contest.

Francis chose to scale down her physique in order to win a World Championship bodybuilding competition a few years later. (See the interview with Francis in this book.) Although Cory Everson, who reigned as Ms. Olympia from 1985 to 1990, was more heavily muscled than her predecessors, Fierstein believes that a breakthrough regarding the issue of muscularity came when the very muscular Lenda Murray won the contest in 1990. However, Fierstein observes, in subsequent shows Murray's physique seemed somewhat less muscular and "hard." In 1991 a smaller Murray won the Ms. Olympia victory over Francis, when the latter was the most muscular she had ever been.

While taste variations in judging muscle have persisted throughout the last two decades of women's bodybuilding, it seems to Fierstein that between 1988 and 1990 there was a general trend toward the more muscular women winning both professional and amateur bodybuilding competitions. By 1991, seasoned observers noted a shifting away from such dense muscularity.

This trend came out in bold relief at the Ms. International contest in Columbus, Ohio in March 1992 where the most lightly muscled competitor, Anja Schriener, triumphed over the most muscular Paula Bircumshaw. In response, the audience vocalized its protest and even pelted the judging panel with objects. Since then, while the judging in the contests has been erratic, the public face of bodybuilding has moved away from muscular females altogether in favor of the fitness competitors. For coverage of this development see Marion Roach, "Female Bodybuilders Discover Curves," *New York Times*, 10 November 1998, p. F9.

27 In addition to Kuhn, "Body and Cinema," see Chris Holmlund, ". . . Visible Difference and Flex Appeal: The Body, Sex, Sexuality and Race in the 'Pumping Iron' Films," *Cinema Journal* 28, no. 4 (summer 1989): 38–51. A cinema scholar from the Department of Romance and Asian Literature at the University of Tennessee, Holmlund also wrote about *Pumping Iron II* in the 1980s.

28 Ruth Gordon and Garson Kanin wrote the screenplay.

29 European artists such as Lachaise, Léger, Maillol, and Picasso, and Americans Chaim Gross and Reginald Marsh, had depicted monumental, muscled, and statuesque women, but their work falls outside of the scope of this essay.

30 This expressionist rendering of the first woman to swim across the English Channel, who also set a new time record, is based on a 1926 photograph of the American emerging from her historic Channel swim. See Van Deren Coke, *The Painter and the Photograph: From Delacroix to Warhol* (Albuquerque, NM: University of New Mexico Press, 1972), 124–25. Dubbed "the master of the hefty nude" by critic Tom Hess in *New York* magazine in 1977, Drexler had long focused on images of substantial women; see for example his gouache on paper *Eve* (1960) in the collection of the Hirshhorn Museum and Sculpture Garden.

31 Rosalyn Drexler, who is married to the painter Sherman Drexler, once wrestled professionally as Rosa Carlo, "The Mexican Spitfire"; see Rosalyn Drexler, "A Woman's Place Is on the Mat," *Esquire* (February 1966): 79–81, 120–24, 126–27. Set in sports arena, *The Winner* combines images of a referee and a wrestler.

32 For example, *Pumping Iron II* introduced the bodybuilders Carla Dunlap and Bev Francis to the artist and movie critic Carrie Rickey, whose 1985 catalogue essay, "Mapping Autogeography," accompanied the exhibition *Nude, Naked, Stripped* at the Hayden Gallery of MIT's List Visual Arts Center. She observed that their "deliberately built bodies" suggest both the power of physical strength and the mental will power to achieve it. Carrie Rickey, "Mapping Autogeography: Six

Rules for Navigating the Body Politic," *Nude, Naked, Stripped* (Cambridge, Mass: The MIT Press, 1985), 5.

33 Howard Kanovitz, letter to author, 12 November 1998. Painter Howard Kanovitz, a former studio assistant of Franz Kline's who came to the fore in the '70s as a photo-realist, was awakened to women's potential for hypermuscularity by a woman friend. He liked the rhythmic abstract pattern of their rippling muscles. Some of these paintings and charcoal and conté crayon drawings resemble illustrations on a Greek vase. See a review of his work, Amei Wallach, "Stylish Musclewomen," *Newsday*, 24 June 1983.

34 See for example, Rickey, "Mapping Autogeography," 5, who noted this evolution in body consciousness in 1985.

35 The term "bodysculpture" first gained popularity in the 1970s. (See for example, Valerie and Ralph Carnes, *Bodysculpture: Weight Training for Women* [New York: St. Martin's Press, 1978]). But the ideas were current long before this. David Chapman has kindly called to my attention the periodical *Body-Molding*, published irregularly starting in April 1925, which was devoted to promoting the Checkley system of posture and body control. Bodysculpting also connotes cosmetic surgery.

ALISON SAAR, *SLEDGE HAMMER MAMA*, 1996. WOOD, NAILS, RUSTED TIN, AND HAMMER HEAD, 32 × 6 × 8".

the real nude

Joanna Frueh

I.

a human being cannot be a nude. This statement is true according to the formulation devised by art historians in which the naked body is ordinary—flawed and vulnerable—and the nude is clothed in ideal beauty. Naked is real, all too human, and the nude, an abstraction, transcends human imperfection. Within this definition, the nude, like other aesthetic objects and images, has no utility. Its value, embedded in the visual, is moving viewers to contemplative states. One cannot smell or touch the nude, for it is ethereal and ultimately disembodied grace, impossible to achieve with the earthly and recalcitrant matter that is the body. The nude's aloofness is, in some way, repugnant. It is a fascist form, an exemplar of absolute purity, so supremely clean that it does not admit to orifices and emissions. Because the nude, a vision in human form, has not been corporeal, it betrays human beings' aesthetic potential.

II.

a bodybuilder in her late twenties, who aspires to professional status, told me that seeing professional bodybuilder Nicole Bass in a televised competition inspired her to begin bodybuilding. "She was so pretty," said the woman, who had recently moved to New York from England. She also revealed that her mother hates her daughter's built body; an African-American bodybuilder in her early thirties had told me a similar story: these daughters' muscle repulses their mothers. A gym owner calls one of his female bodybuilder clients, whom I know, an "abomination," whereas her aesthetic capacity, like that of hypermuscular women in general, attracts and comforts me. Big female muscle is a relief to me, a splurge of beauty suggesting that aesthetic amplitude for women is a possibility, that shapeliness need not be only ballet-dancer delicate, sexpot voluptuous, or fit-ness firm. Big female muscle *is* useful: it is gender generous, enabling not only a contemplation of western civilization's gender constrictions but also literally building a way out of them; it expands and affirms women's aesthetic potential; it is a model of female power that is flesh and sweat.

The real nude is both fine and applied art. Fine art theory designates the former non-utilitarian and the latter useful, but this binary distinction is simplistic. The bodybuilder develops strength, which is practical, while also developing shape, which is supposedly purposeless. However, the combination of these processes and their outcomes belongs within what scholar Mara Miller calls "a continuum between the poles of two kinds of purposes: the obvious, well-known and well-defined, often physical purposes on the one hand . . . , and on the other hand, those purposes at the other extreme which are so abstract, so vague, so difficult to get ahold of that they can only be recognized ex post facto." The bodybuilder attains her obvious goal, strength development, along with a number of more subtle results listed by Miller: "discernment of new bases for relation with others or for the identification of the self" and "recognizing human dignity." Between the vague and the obvious is "a wide variety of semi-articulate purposes," which might include challenging gender normalization and asserting both dominance and allure. All in all, the real nude is a vehicle for "developing self-consciousness and for extending boundaries of consciousness," and that designates her as art.[1] The hypermuscular woman is the real nude. She is a beautiful body that lives, a fresh vision of human form.

DEBORAH WILLIS, *UNTITLED, BODYBUILDER #14*, 1997. C-PRINT, 20 × 24". PICTURING NANCY LEWIS.

III.

fashion magazines for women regularly assert that women want lean, toned bodies, not bulk. In the June 1998 issue of *Elle* I read that "Hollywood trainer Valerie Waters guarantees blockbuster results for her lemming-like following of celebrity clients, who range from Lauren Holly to Cindy Crawford," by following their "standing order," which is: "I want to lose a little weight and tone my hips and bum and legs and arms, but not get bulky."[2] Underlying the taste for slender firmness is fear of unseemly size and shape, of looking and, by visual implication, of being unfeminine. Massive, severely defined muscle reads as masculine, and fashion magazines not only arbitrate but also police gender. The

aesthetics of femininity, embodied in the female nude, declares bulk to be literally and figuratively bad form. The fat woman, full of bulk, who carries on the good fight in the battle of the bulge, the fight to lose weight, has, as in every righteous war, the gods on her side. The divinities of fitness—those "celebrity clients" who perpetuate in films and photographs the non-corporeality of the female nude—urge the unseemly fat woman on to a victorious loss.

The hypermuscular woman carries bulk, but she is on the wrong side of sacrosanct authority because she will not change—lose—her errant femininity. Who can trust a woman who has forcefully deformed herself by

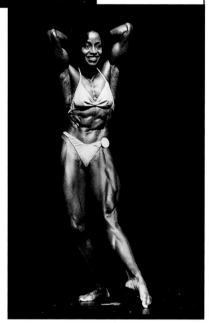

deliberately gaining bulk and *giving* herself volume, who has arranged her mass with such disregard for the female nude and the fantasies of femininity that it maintains? What woman would deliberately make herself into a monster? Surely her mind is as monstrous as her flesh, for mind and body, in all of us, are one, and the real nude is conceiving herself as much mentally as physically when she trains and diets, undergoes breast implant surgery, or ingests anabolic, androgenic, and metabolic agents as well as a multiplicity of less controversial supplements.[3]

Women who build big muscle—naturally or with the help of drugs—encounter a complex of misunderstanding, hostility, and critique. Male-owned bodybuilding magazines ignore extremely muscular women. Feminist scholars such as Susan Bordo and Leslie Heywood examine the problematic reality of women who seem to emulate the male body and its cultural meanings. Bordo analyzes "our cultural association of curvaceousness with incompetence," and warns: "To reshape one's body into a male body is not to put on male power and privilege. To feel autonomous and free while harnessing body and soul to an obsessive body-practice is to serve, not transform, a social order that limits female possibilities."[4] Applying a fundamental idea of Christine Battersby in *Gender and Genius*, we can further complicate the issue of women looking like men, by whatever means. Battersby asserts that the celebrated male artist has been both like a woman but not a woman. He has seri-

ously appropriated femininity by being sensitive, intuitive, responsive, and emotional, which are qualities supposedly natural to women.[5] But the female bodybuilder who is brilliant in muscle, like the female artist who is brilliant in visual creativity, must not encroach seriously on masculine territory. The hypermuscular woman should not display physical power or big muscles; she should not appear to be stronger than men like to think they are. While brilliant men can alter or play with their gender—in a sense, be geniuses with gender—women cannot.

IV.

hercules lifted the giant Antaeus off the ground. The real nude can hoist the living flesh of men.

V.

Probably no one would compare a female bodybuilder's body to an apple, strawberry, peach, or flower. These are objects that art historian Kenneth Clark associates with (the female nude in his classic 1956 examination of the body in high art, *The Nude: A Study in Ideal Form*. Ripe, petite, and handleable delights that can be pushed or bitten into; penetrable and enjoyable delicacy characterizes the traditional female nude. In her largest, most Rubenesque manifestation, she may be succulently robust, but she is never hard. Roundness, softness, and sometimes fat typify the

female nude, which, "more than any other subject," asserts art historian Lynda Nead, "connotes 'Art,'" and "is an icon of Western culture, a symbol of civilization and accomplishment."[6] Soft, receptively ample flesh maintains western civilization's yoking of beauty and femininity, which is a problematic link between the female nude and actual female bodies. The latter must conform to the female nude if a woman wishes to be appreciated as attractive. Scholar Roberta Seid considers this phenomenon: "Bombarded by verbal and visual commercial images of the nude, women have been seduced into believing that they should—and could, with enough effort—have one of those perfect bodies.

They expect the image reflected in their mirrors to look like the nude."[7] The media updates the art historical nude into today's model of perfection. Both the new and the old nude connote woman's unflawedness and perfect femininity. Perfect—meaning unflawed. Perfect—meaning perfectly feminine.

In contrast, the real nude is imperfect. A tan obscures blemishes and spider veins; she has stretchmarks; she removes "masculine" body hair; she bloats when she has her period. But she is radiant and monumental, like a goddess or god, which is considered the ancestral female nude within Western art practice. The real nude, whose flesh is ample and hard, does not fulfill Western

MARY BETH EDELSON, *BODY OF EVIDENCE*, 1998. TRANSFER ON CHIFFON FABRIC, 16 × 10". PICTURING ROSIE HERNANDEZ, BASED ON A PHOTOGRAPH BY STEVE WENNERSTROM.

civilization's requirements for the appearance of the female body. The hypermuscular woman does more than depart from the respected art of high femininity, which societal ideals demand that women practice. She breaks with (the limits imposed by) civilization; and, generally, civilization's practitioners, whether academic experts or everyman and everywoman, cannot see the muscular woman's highly refined body as a sophisticated aesthetic accomplishment. For if we dwell comfortably in the homey habits of gender, we receive the bodybuilder's aesthetic self-creation as a slap. From our insistence on formulaic femininity—and its historical and current manifestationsin the female nude—we slap back. If you damage cultural conventions, if you are a rude and unwieldy icon, culture, in the words and actions of individuals, will often punish you.

VI.

"**a**re you a man? You look like a man." "You're disgusting. Why do you want to look like that?" "Will you whip us?" These questions were addressed to female bodybuilders in public locations in New York City in the mid-1990s. The hypermuscular woman unintentionally provokes humiliating and leering taunts because her nudity, which people perceive underneath her street clothes, materializes a strenuous and revolutionary idea: women are not submissive bodies, signifying interiority, receptivity, and passiveness, in Jean-Paul Sartre's succinct phrase, being "in the form of a hole."[8] "Hole-ness"—penetrability and emptiness—is both a culturally dominant conception and a bodily archetype of females, and it informs perceptions of male and female corporeal form. The female bodybuilder, like other women, has a vagina and a uterus; she has an "empty" anatomy that operates synecdochically, so the female is read as a hole. Philosopher Maxine Sheets-Johnstone acutely and thoroughly analyzes this female bodily archetype in her study of female/male power relations *The Roots of*

Power: Animate Form and Gendered Bodies. Her analysis also demystifies the parallel synecdoche for men, which is the penis. Whereas being in the form of a hole is lacking, weak, and "'year-round' receptive," being in the form of an erect penis is powerful and controlling. The phallus's exteriority "complements" the vagina's interiority. The corporeal archetypes that Sheets-Johnstone examines have produced archetypal power relations of female submissiveness and male dominance. The male's mythic(al) organ is simultaneously elegant and ridiculous, "blown up out of proportion" from its actual size and humanness into a sexually vigorous to rampaging tool that dominates not only men's behavior but also cultural attitudes and imagination about women's as well as men's sexuality, psychology, and potenial.[9]

These gendered archetypes of female interiority and male exteriority operate in the gym as in culture at large. "A male bodybuilder's body ideally has no interior," asserts scholar and bodybuilder Marcia Ian. "It is to contain no space, but be solid, lean meat. . . . Muscle. . . connotes exteriority, the exteriority of the phallus," which is an inflated vision of solid, lean meat.[10] Ian observes that within the bodybuilding world serious female muscle is unloved. There, she understands, "the subjection of woman is effected by enforcing the equivalence of femaleness (a set of physical characteristics) with femininity (a set of 'qualities' such as weakness, passivity, receptivity);" hypermuscular women, unlike their male counterparts, "are not offered [by promoters] as estimable idealizable potential role models."[11] Sheets-Johnstone encourages the reader to think seriously and caringly about real bodies in the light of the corporeal archetypes she analyzes, and suggests that the latter need to be "culturally reworked."[12] The hypermuscular female is such a reworking, which is a primary reason why people attack the real nude. Bluntly put, she's just a cunt, so why doesn't she look receptive, penetrable? All her big hardness reads as phallic. A female in priapic condition displays a synecdochical quandary.

LEFT: MONICA BOZICEVICH, 1990.

RIGHT: KAY BAXTER, 1984.

VII.

aphrodite/Amazon: bulging with the brilliance of muscle, with the radiance beloved by the Greeks in the divinities that they created. The divine body is brighter than any mortal can bear to look upon. No human can compete with it. Yet the real nude fashions a body that, more than most mortal bodies, shines: with joy in its aesthetic plenitude, or, in competition, with the oil that emphasizes muscularity.

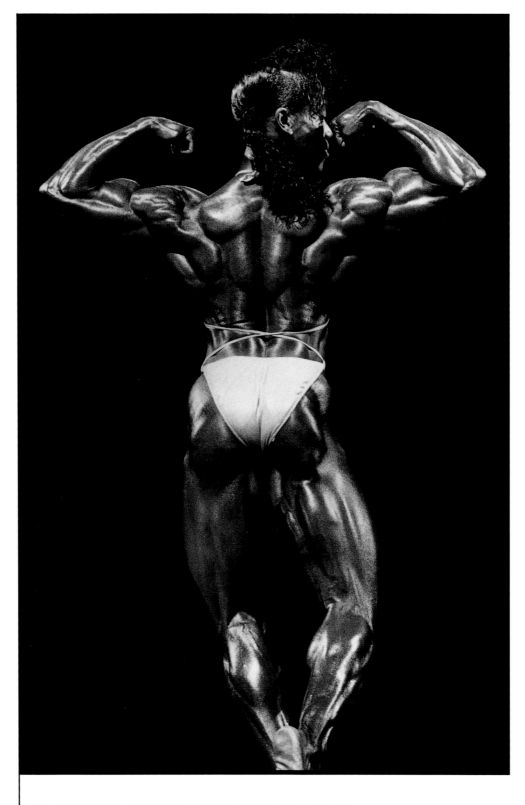

LEFT: JUDY CHICAGO, *MAQUETTE FOR MODERN AMAZON*, 1999. LAMINATED GLASS, WITH GLASS CHROMATIC EROSION BY VICKI LEON, 30 × 20 × 30". PICTURING ROBIN PARKER AND JOHN CARL.

RIGHT: LENDA MURRAY, 1990, MS. OLYMPIA CONTEST, NEW YORK.

TOP: MATTHEW BARNEY, *CREMASTER 4: FAIRIE FIELD*, 1994.
FOUR C-PRINTS, SELF-LUBRICATING PLASTIC FRAMES: THREE SMALL IMAGES,
17$^{1}/_{2}$ × 12$^{3}/_{4}$ × 1$^{1}/_{2}$" EACH; ONE LARGE IMAGE, 27$^{1}/_{2}$ × 33$^{1}/_{4}$ × 1$^{1}/_{2}$".

BOTTOM: YVONNE MCCOY'S CALVES, 1991.

VIII.

the priapic female nude is a descendant of both Aphrodite and the ancient Greek male nude. Praxiteles's *Aphrodite of Knidos*, executed probably between 360 and 330 B.C., became the model for iconic female beauty. This sculpture has been lost, but it represented the goddess as young, fair-skinned, probably blonde, and without developed or defined muscle. Marilyn Monroe descends from Aphrodite, as do other ultrafeminine icons of beauty.[14] The Greek Aphrodite is the female bodybuilder's conceptual rather than physical ancestor. Her muscle signfies the god-

Aphrodite/Amazon's muscle suggests a heavier than average body, reminiscent of the "concentrated mass of being" that scholar Jean-Pierre Vernant attributes to the bodies of Greek divinities,[13] who, while being monumentally heavy, like a bronze or marble sculpture, leap without touching the earth and fly across it as they run. Aphrodite/Amazon may also comport herself with weightless grace.

dess's sovereign self. As art historian Christine Mitchell Havelock makes clear in her study *The Aphrodite of Knidos and Her Successors: A Historical Review of the Female Nude in Greek Art*, Aphrodite's self-sovereignty is heroic—noble, eloquent, and powerfully independent. Perhaps she heroicizes being in the form of a hole, and surely females' fullness of being is as substantial as males'. The hypermuscular female's form resembles

Apollo and Hercules. Today's male fashion model, with his implied athleticism and washboard abs, descends from Apollo and his sculptural kin, male warrior nudes. Athlete and hero; a body that connotes strength, activity, and energy; a tectonic structure in which muscle and sinew are supremely defined: this, the male nude designed by the Greeks, has been assigned positive values by both art historians and bodybuilders. "Male bodybuilders are supposed to emulate or concretize mythical models such as Zeus, Hercules,. . . or Apollon," asserts Marcia Ian. Yet, the female bodybuilder, who develops a kind of *cuirasse esthètique*—the schematic, standard male torso musculature devised by the sculptor Polykleitos in the fifth century B.C.—and otherwise fashions herself as the heroic male nude, is perceived as bewildering and grotesque.[15] Exhibiting internal structure rather than interiority, building and displaying the potent body architecture praised by art historians rather than the Knidos's sensuous softness, the female conveys an instrumental and phallic power that are the territory of the male nude and the prerogative of men in Western culture. The phallic archetype, which has come to connote fullness of being by virtue of males having an organ that fills itself up,[16] is a smokescreen, hiding the fact that both females and males can be geniuses with gender, can rework the status of their bodies and beings. The female bodybuilder need not undertake such physical transformations in order to reposition privilege or celebrate women being the muscular rivals of men. Rather, this corporeal reshaping allows us to appreciate the real nude—who may be hypermuscular, dark-skinned, midlife, or different from both the Greeks's Aphrodite and Apollo in other ways—for her self-realization in the form of monster/beauty.[17]

IX.

the real nude has been categorized as a freak. Harvey L. Boswell, author of the 1966 a pamphlet *Strange People*, cites turn-of-the-century professional strong woman Vulcana among his twenty-four specimens of human freaks, all of whom are pictured in photographs. (Vulcana was born Kate Roberts in 1883.[18]) Her face is beautiful, in a conventionally feminine way, and she flexes a bicep of lavishly dense muscle. Her shoulder and forearm are equally opulent. I see a gorgeous human being, so I ruminate over Boswell's explanations: a freak is "a person markedly abnormal either mentally or physically," and "a person can either be born a freak or become one later in life."[19] According to Boswell, genetics, endocrine dysfunction, and even self-mutilation can play a part in this state of being or process of becoming.

Hypermuscular women share some processes of development with Boswell's freaks. Bodybuilders cite genetics as a basis for someone's (in)ability to build superior muscle. Vulcana, like Ms. Olympia winners Lenda Murray and Kim Chizevsky, demonstrates hereditary capacity for hypermuscularity. Endocrine glands produce hormones. By implication of Boswell's theory of endocrine dysfunction, supremely muscled women's estrogen is out of whack. In actuality, testosterone levels vary in women as they do in men. Any self-mutilation by hypermuscular women is mental, as they have cut themselves off from people's idea of normal femininity. With difficulty I can see that Vulcana, and today's muscular women, are as ugly to some viewers as her pamphlet companions. All are embodiments of eccentric growth.[20]

X.

although to many the real nude is at best a foreign beauty, she exhibits principles of form that are panculturally appealing. While different cultures manifest different standards of beauty, the principles themselves are bases of beauty and pleasurable experience. Scholar Wilfried Van Damme discusses the following pancultural principles of attractiveness in his *Beauty in Context: Towards an Anthropological Approach to Aesthetics*: skill, symmetry and balance, clarity, smoothness and brightness, youthfulness, novelty, and fineness.[21] Skill is necessary for bodybuilding and the real nude excels at developing muscle. She strives for muscle symmetry and balance, and her body is a study in clarity. She distinctly defines her volumes and contours through training and dieting, and, in competition, highlights her muscle by oiling her skin and flexing. Tanning light skin evens skin tone, so that the skin itself appears to be

VULCANA, STRONG-WOMAN AND PHYSIQUE PERFORMER FROM THE UNITED KINGDOM, C. 1910, COVER OF *LA SANTÉ PAR LES SPORTS*, PARIS, 8 APRIL 1914.

fetish to others. Comics artists often exaggerate the hypermuscular woman's shapes in order to heighten erotic effect; not only are R. Crumb's or Alain Célerier's amazons gargantuanly muscled, they also display breasts the size of their quads, tiny waists that serve to emphasize the massiveness of shoulders, arms, and legs, and bosoms that feel (naturally) soft or (muscularly) hard. As in Michelangelo's male nudes, the head, hands, and feet of a Célerier sex queen are disproportionately small. These are not the parts that have become engorged with the artist's lust.

Hypermuscular women, in the comics and in reality, often appear both primitive and futuristic, atavistic and prophetic. Philosopher Alphonso Lingis suggests that bodybuilders' bodies seem "halted before the age of the self-domestication of the hunter-gatherers."[24] His poeticizing aligns with bodybuilders' self-conception of being natural and animal—which are frequently used tropes in bodybuilding magazines—and with literary critic Marianna Torgovnick's explanation of the trope of the primitive in modernism. Western culture conceives of the primitive as extremely different, existing at the lowest cultural level in relation to the highest, the Western; the primitive is at once desirable and despised. Torgovnick defines primitives as "our untamed selves, our id forces—libidinous, irrational, violent, dangerous. Primitives are mystics, in tune with nature, part of its harmonies. Primitives are free."[25] We want to control and domesticate them while simultaneously wanting them to overpower us and our inhibited, rational way of being. We want to be them. We exoticize the hypermuscular woman, who is more primitive even than her male counterpart—within the trope of primitivism, women, children, and animals are more primitive than men—while allowing her to fascinate us, if only through repulsion. Primitive bodies are exotic in the extreme, as are futuristic bodies such as the warrior represented in Futurist Umberto Boccioni's 1914 sculpture *Unique Forms of Continuity in Space*. Bronze and gleaming like the gods, the bodily abstraction in *Unique Forms* is a holy terror. Compact and bulging like a bodybuilder, mean, quick, armored, finned, full of force and forward movement, this science-fiction animal/robot body, like comics' hypermuscular superheroines, is a corporeal dynamo. Regardless of the hypermuscular woman's service to fantasies—for sexual pleasure with

KAY BAXTER, 1984.

smooth—uniformly colored and flawless. Oiling gives the effect of allover luminosity—the Greeks' *charis*, a grace that Jean-Pierre Vernant calls a "joyful luster, the resplendence of a divine body."[22] According to Van Damme, smoothness and brightness suggest youthfulness and health, "healthy skin [that] better reflects the light," physical prime of life, and energy and vitality.[23] In magazine articles and interviews, proponents of bodybuilding culture tout the healthfulness of bodybuilding.

The real nude's novelty is obvious in her extremity, which causes her to function as freak to some and erotic

her perhaps overpowering muscle, including a muscular cunt—she is an artistic innovator who redesigns the female nude. (Fiction in which amazons are subjects often focuses on their extreme, enticing, and terrifying sexual powers and prowess, including muscular cunts.)

Van Damme acknowledges that novelty, the "human need to display 'exploratory behaviour,'" can exceed a "saturation point" of pleasure, thus decreasing it.[26] Despite evidence of the real nude's fineness, the precision and detail created from her consummate craftsmanship, she so exceeds western beauty ideals of female form that for many she does not embody the elegance and grace that also characterize the principle of fineness.

XI.

"What determines a freak in one society does not always determine one in another," Boswell pragmatically asserts.[27] Aficionados of female hypermuscularity find the real nude sexually attractive. What others experience as curiosity, grotesqueness, and terror, the aficionado experiences as fantastically exciting, superlative, and rare beauty. The real nude provokes terror and pleasure, as did the sublime in eighteenth-century art theory. Writers on aesthetics such as Edmund Burke and Immanuel Kant associated the sublime with masculine characteristics and the beautiful with feminine traits. For Kant, the beautiful produces a "restful," contemplative experience, whereas the sublime produces disturbance, and is an "outrage on the imagination." Besides mixing an experience of terror and pleasure,

KATHLEEN GILJE,
COMTESSE D'HAUSSONVILLE,
RESTORED, **1996. OIL ON**
LINEN, 52½ × 36⅛".

the real nude is also akin to Kant's sublime in that it "provokes [a] representation of limitlessness."[28] The real nude is representative of bodies that are yet to be built into being, and implies form beyond preconceived (feminine) form.[29]

"Laura, you're looking sexier than ever," was a compliment offered to Laura Creavalle at the 1996 Ms. Olympia competition, in which she placed fourth and was competing for the ninth year in a row at age thirty-seven.[30] Legendary poser Diana Dennis has created artistic performances—more complex and narrative than standard bodybuilding posing, and even her own competition posing—that, into her forties, project female sexual potency, desire, and satisfaction, as well as stereotypically feminine sexuality. Self-presentation as a sexual stereotype is common for the real nude and is exemplified by all but one of the twenty-seven body-builders photographed by Bill Dobbins for his *The Women: Photographs of the Top Female Bodybuilders.* (Bev Francis, who does not wear a bikini and whose

pose recalls Pierre-Auguste Rodin's *Thinker*, is the exception. Although Francis did dye her hair blonde during her bodybuilding career, she did not exude the pin-up aura of many female bodybuilders.) Countering an image of the big, hard female body as manly and bellicose, as brute force, many female bodybuilders feminize themselves: by dying their hair blonde, they employ a sign of vulnerability and innocence; by painting their fingernails and curling, ornamenting, or upsweeping their hair, they utilize decorative grooming; by undergoing breast implant surgery, they emphasize a fetishized part of female bodies; and by wearing corsets or other lingerie for photo shoots, they court conventional sexual fantasy. The use of feminine gender markers isn't all bad, but the necessity to prove woman-liness may take a toll on self-realization and self-love. With or without exaggerated feminine signs, the real nude is highly sensual: these exaggerations are not essential elements of her *charis*, which weds dignity, sensuality, and the "stature, breadth, presence, . . .

SIDNEY GOODMAN, *THREE AMAZONS*, 1998–1999. OIL ON CANVAS, 99 × 81". PICTURING A COMPOSITE OF MARGE MURPHY AND MIDGE SHULL.

strength of arm, freshness of complexion, and a relaxation, suppleness and agility of the limbs" that Vernant describes as the Greek ideal embodied by human beings.[31] The real nude, whether tall or short, stands straight; she is broad, poised, imposing, strong enough to wrestle men, youthful looking, and when posing with the distinctiveness and elegance of Diana Dennis or Natalia Murnikoviene, eloquently lithe. This comprises a corporeal rhetoric that stimulates desire in an onlooker, perhaps through kinesthesia.[32]

XII.

I have a kinesthetic response to the real nude. In her presence I am invigorated, my posture improves, I feel my strength and flexibility, my capacity for many powers, my allure. This, I think, is why she moves me to tears.

Notes:

[1] See Mara Miller, *The Garden as an Art* (Albany: State University of New York Press, 1993), 85–91.

[2] J.S., "America's Best Bodies," *Elle* (June 1998): 156.

[3] Hypermuscular women's use of drugs raises moral, ethical, legal, medical, and aesthetic issues that remain virtually undiscussed by scholars or in the bodybuilding and popular press.

[4] Susan Bordo, *Unbearable Weight: Feminism, Western Culture, and the Body* (Berkeley, Los Angeles, London: University of California Press, 1993), 179. For further discussion of this subject, see "The Body and the Reproduction of Femininity," in *Unbearable Weight*, 178–79; and "Masculinity Vanishing," in Leslie Heywood, *Bodymakers: A Cultural Anatomy of Women's Body Building* (New Brunswick, N.J., and London: Rutgers University Press, 1998).

[5] Christine Battersby, *Gender and Genius: Towards a Feminist Aesthetics* (Bloomington and Indianapolis: Indiana University Press, 1989).

[6] Lynda Nead, *The Female Nude: Art, Obscenity and Sexuality* (London and New York: Routledge), 1.

[7] Roberta Seid, "Too 'Close to the Bone': The Historical Context for Women's Obsession with Slenderness," in Patricia Fallon, Melanie A. Katzman, and Susan C. Wooley, eds., *Feminist Perspectives on Eating Disorders* (New York: The Guilford Press, 1994), 10.

[8] Jean-Paul Sartre, quoted in Maxine Sheets-Johnstone, *The Roots of Power: Animate Form and Gendered Bodies* (Chicago and La Salle, Ill.: Open Court, 1994), 9.

[9] Sheets-Johnstone, *Roots of Power*, 11, 125.

[10] Marcia Ian, "When Is a Body Not a Body? When It's a Building," in Joel Sanders, ed., *Stud: Architectures of Masculinity* (New York: Princeton Architectural Press, 1996), 191, 197.

[11] Ian, "When Is a Body Not a Body," 198–99.

[12] Sheets-Johnstone, *Roots of Power*, 330.

[13] Jean-Pierre Vernant, "Dim Body, Dazzling Body," trans. Anne M. Wilson, in Michel Feher with Ramona Naddaff and Nadia Tazi, eds., *Fragments for a History of the Human Body: Part One* (New York: Zone, 1989), 36.

[14] I both critique and adore blonde beauties in "Blonde Bunny Goddess," in my forthcoming *Monster/Beauty: Building the Body of Love* (Berkeley, Los Angeles, London: University of California Press, 2000).

[15] Ian, "When is a Body Not a Body," 193.

[16] Sheets-Johnstone, *Roots of Power*, 183

[17] I develop at length the ideas in this paragraph in *Monster/Beauty*.

[18] According to French strength historian Edmond Desbonnet, her father was an Irish minister. Others say her parentage was Welsh.

[19] Harvey L. Boswell, *Strange People* (Wilson, N.C.: Harvey L. Boswell, 1966), unpaginated.

[20] The title of a Louise Bourgeois drawing from 1996, "Eccentric Growth," set me thinking about a particular kind of reaction that many people have to extremely muscled women.

[21] Wilfried Van Damme, *Beauty in Context: Towards an Anthropological Approach to Aesthetics* (Leiden, New York, Cologne: E. J. Brill, 1996). Van Damme devotes chapter three to a discussion of these characteristics.

[22] Vernant, "Dim Body," 28.

[23] Van Damme, *Beauty in Context*, 87.

[24] Alphonso Lingis, *Foreign Bodies* (New York and London: Routlege, 1994), 42.

[25] Marianna Torgovnick, *Gone Primitive: Savage Intellects, Modern Lives* (Chicago and London: The University of Chicago Press, 1990), 8.

[26] Van Damme, *Beauty in Context*, 65.

[27] Boswell, *Strange People*, unpaginated.

[28] Immanuel Kant, *Critique of Aesthetic Judgement*, trans. J. C. Meredith (Oxford: Clarendon Press, 1911), 90–91, 107.

[29] Nead, *Female Nude*, 25–33, draws on the sublime in eighteenth-century art writing in order to frame a response to her questions: "So what possibilities are there for the construction of a progressive aesthetic around the notion of form beyond the procedures and protocols of western high art? Does the sublime suggest new ways of representing the female body and female subjectivities from a feminist position?" Although Nead, 8–10, is critical of female bodybuilding in ways that parallel and complement Bordo's and Heywood's critiques, it seems to me that the hypermuscular woman, in her sublimeness, has implications about shaping the female body beyond its normative limits, and *is* developing a progressive aesthetic.

[30] Steve Wennerstrom, "The End of an Era," *Flex* (March–April 1996): 78, notes, "Entering a 10th Olympia [in 1997], Creavalle will become the contest's queen of longevity, and that in itself is an accomplishment of special merit, considering that a bodybuilder's entire competitive career seldom lasts 10 years."

[31] Vernant, "Dim Body," 28.

[32] Never having seen a live or videotaped performance by Murnikoviene, I have relied upon Steve Wennerstrom's description. He writes that she "delivers a physique brimming with elegance and a genuine sense of style all too frequently absent at the advanced level" of the Ms. Olympia competition. Wennerstrom, "End of an Era," 76.

bring on the

the

ama

zons

an evolutionary history

Jan Todd

MARY ELLEN MARK, *SHAVANAAS BEGUM WITH
HER THREE-YEAR-OLD DAUGHTER, PARVEEN.
GREAT GEMINI CIRCUS, PERINTALMANNA, INDIA,
1989. TONED GELATIN SILVER PRINT, 16 × 20".*

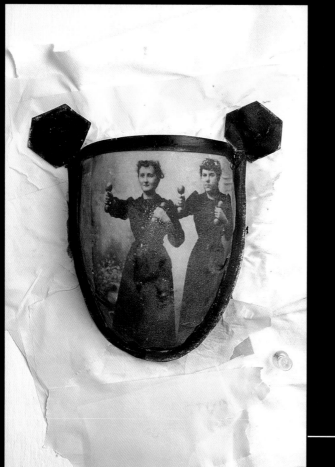

The debate over women and muscularity is hardly new. One hundred and twenty-six years ago, Prentice Mumford argued in *Lippincott's Monthly Magazine* that forces at work in the late nineteenth century would create a new breed of woman, and that the "idea of woman as the weaker sex will become old-fashioned and finally obsolete."[1] Although historians have paid little attention to Mumford's prophetic words since he wrote them in 1873, dozens of women and men have continued to believe, and to demonstrate by their life choices, that women have as much right to strength and muscularity as men do; convention be damned.

Scholars now recognize that both the circus and the various forms of variety theater that proliferated throughout Europe and the United States in the late nineteenth century were influential transmitters of ideals and images.[2] The semiotician Paul Bouissaic

argues that the acts and traditions of the circus were really "a set of rules for cultural transformations." A circus performance, he wrote, "manipulates a cultural system to such an extent that it leaves the audience contemplating a demonstration of humanity freed from the constraints of the culture within which the perform-ance takes place."[3] Bouissaic's theory helps to explain the large number of women who, at the very height of the supposedly restrained and genteel Victorian era, trained for strength, donned tights, and advertised themselves as professional strongwomen.

Although Sansona and several other strongwomen worked in Europe in the eighteenth century, it was not until the circus had evolved from an equestrian show to a multi-ring extravaganza that a sizeable num-ber of women began to understand that they could make good livings by exhibiting their strength and their

MONS. D'ATALIE,
THE MAN WITH THE IRON JAW, AND
MLL'E ANGELA,
THE FEMALE SAMPSON,

ABOVE: MLLE ANGELA D'ATALIE, THE FEMALE SAMPSON, AND M. D'ATALIE, LITHOGRAPH FROM 1873 *BARNUM ADVANCE COURIER.*

BELOW: UNIDENTIFIED STRONGWOMAN DRESSING BACKSTAGE IN CIRCUS TENT (THOUGHT TO BE MADAME YUCCA), 1902.

BACKGROUND IMAGE: UNIDENTIFIED STRONGWOMAN LIFTING ANCHOR AND WEIGHTS WITH HAIR AND TEETH, C. 1780–1810, LITHOGRAPH.

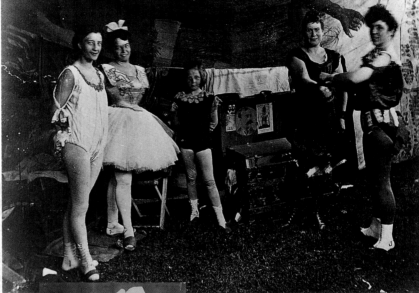

Luise-Leers.
Trapezphänomen

muscular bodies. Although acts varied and most women did more than one type of strength feat, there were three main types of strength performers in the circuses and vaudeville halls of the late nineteenth and early twentieth centuries. The first type, of course, was the true strongwoman whose act consisted of breaking chains, juggling cannonballs, lifting barbells, fellow performers, and animals, and performing other feats requiring real strength. The second type was the "resistance artist" who demonstrated her strength by resisting weights held by her teeth (called iron-jaw acts) or held by her hair, or placed on her body. The third type of strength performer was the acrobat/ handbalancer. In this third category fall the many women who worked as "understanders" in acrobatic troupes, as well as aerial artists such as Luisita Leers, the phenomenal German acrobat who flexed her biceps with pride in the Ringling Brothers' 1930 *Advance Courier*.[4]

Space doesn't permit a full listing of the more than one hundred women who have now been identified as professional strongwomen of one sort or another over the past 180 years.[5] However, there were three superstars among these performers, all of whom used just one name: Athleta, Minerva, and Sandwina. Athleta was born in Anvers, Belgium, in 1868. Like many of the

ABOVE: LUISITA LEERS, C. 1928–1930, AN EARLY IMAGE OF THE GERMAN-BORN AERIAL STRONGWOMAN. SIGNED SEPIA POSTCARD, 5½ × 3½".

RIGHT: "UNE FEMME ATHLÈTE EN 1783," LITHOGRAPH DEPICTING AN EIGHTEENTH-CENTURY WOMAN PERFORMING FEATS OF STRENGTH.

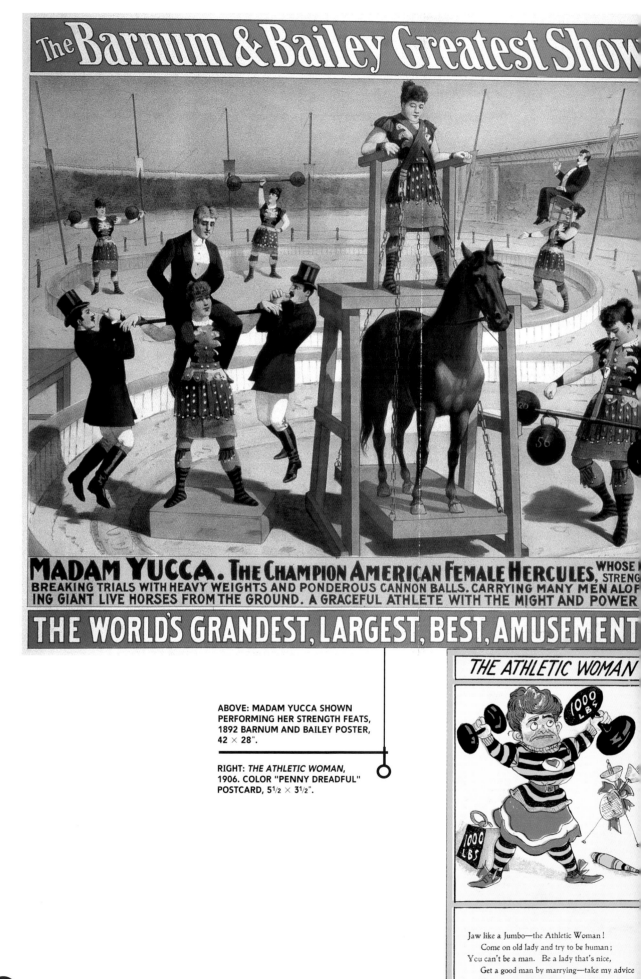

The Barnum & Bailey Greatest Show

COPYRIGHT 1906 BY ARTHUR LIVINGSTON, N.Y. 1137

MADAM YUCCA. THE CHAMPION AMERICAN FEMALE HERCULES, WHOSE STRENG
BREAKING TRIALS WITH HEAVY WEIGHTS AND PONDEROUS CANNON BALLS. CARRYING MANY MEN ALOF
ING GIANT LIVE HORSES FROM THE GROUND. A GRACEFUL ATHLETE WITH THE MIGHT AND POWER

THE WORLD'S GRANDEST, LARGEST, BEST, AMUSEMENT

ABOVE: MADAM YUCCA SHOWN
PERFORMING HER STRENGTH FEATS,
1892 BARNUM AND BAILEY POSTER,
42 × 28".

RIGHT: *THE ATHLETIC WOMAN*,
1906. COLOR "PENNY DREADFUL"
POSTCARD, 5¹/₂ × 3¹/₂".

THE ATHLETIC WOMAN

Jaw like a Jumbo—the Athletic Woman !
 Come on old lady and try to be human ;
You can't be a man. Be a lady that's nice,
 Get a good man by marrying—take my advice

COPYRIGHT 1906 BY ARTHUR LIVINGSTON. N.Y. 1137

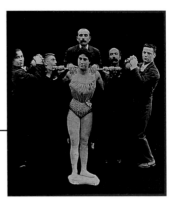

strongwomen active in this era, Athleta came from a circus family and from an early age had participated in tumbling, rope climbing, and other strengthening activities. Her first solo performance was at the glamorous Eden Alhambra Theater in Brussels. French strength historian Edmund Desbonnet reported, "No one had ever seen a woman perform such feats of strength."[6]

Athleta understood, as did most of the successful strongmen and strongwomen, that audiences needed to see real things lifted and moved, not just iron weights. And so she demonstrated her strength by lifting people, horses and barrels; by bending horseshoes and spikes; and by wrestling other women professionals. A regular part of her strength act was to waltz while supporting three men on her shoulders. Athleta was rarely able to participate in standard weightlifting events because of her heavy touring schedule, but in front of reliable witnesses she lifted 204 pounds over her head.[7]

The second factor that catapulted Athleta to stardom, however, was her appearance. The *fin de siècle* era relished full-figured, vigorous models of womanhood, and Athleta was considered a great beauty. Her measurements in 1908, three years after her retirement from the stage, were: bust, 48 inches; waist, 35.4 inches; and upper arm, 16.7 inches.

Although Athleta appeared in the United States, she did not have nearly the impact on America that another strongwoman, the German immigrant Josephine Wohlford, had. In 1890, after an illustration of Mlle Victorine, the "luscious and robust strongest woman in the world," appeared in the widely read tabloid *National Police Gazette*,[8] Josie Wohlford was quoted in the *Police Gazette* as saying: "I hereby challenge her to arrange a match to lift heavy-weights and catch cannonballs from 10 pounds to 20 pounds for $500 to $1000 a side and the female heavy-weightlifting championship of the world. The $100 my backer, Mr. C. P. Blatt, has posted with Richard K. Fox, shows that I mean business."[9]

Taking the stage name Minerva, Wohlford soon defeated Victorine and was presented by Richard K. Fox with a championship belt made of silver and gold and engraved with the words "The *Police Gazette* champi-

onship belt, representing the female heavyweight lifting championship of the world."[10] During most of her active years as a performer, Minerva weighed around 230 pounds at a height of 5'8".[11] Although some of her bulk came from her training, Minerva also told one reporter: "Eating is about the principal part of my existence, and I always have the best I can possibly procure. For breakfast I generally have beef, cooked rare, oatmeal, French-fry potatoes, sliced tomatoes with onions and two cups of coffee. At dinner I have French soup, plenty of vegetables, squabs and game. When supper comes, I am always ready for it, and I then have soup, porterhouse steak, three fried eggs, two different kinds of salads and tea. For every meal I have a bottle of the best wine I can procure."[12]

Minerva may have been the strongest of all the early performers. Contemporary reports credit her with a "700 pound lift from the floor with two hands and a one hand press over her head with 100 pounds." In her act, she also broke horseshoes, caught cannonballs, and did harness lifting.[13] Minerva's most famous feat of strength was a hip and harness lift performed in front

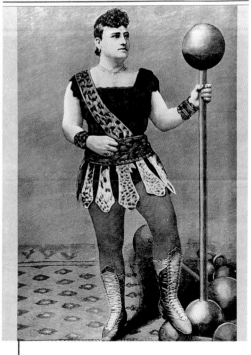

MINERVA, 1893, LITHOGRAPH FROM *POLICE GAZETTE*, JULY 1916. TINTED LITHO, 13 1/2 × 10 3/4".

of hundreds of witnesses at the Bijou Theater in Hoboken, New Jersey, in 1895. This feat, in which she lifted eighteen men and a platform for a total weight of approximately three thousand pounds, has never been approached by any other woman. For many years, the *Guinness Book of Records* listed it as the greatest feat of strength ever performed by a woman.[14]

Two decades later Katie Brumbach Heyman, who toured professionally as Sandwina, became an even greater sensation than Minerva had been in the 1890s.[15] Unlike the massively built Minerva, the taller Sandwina's two hundred pounds were more gracefully proportioned. Kate Carew, a reporter for a New York newspaper, described her as the "most bewilderingly beautiful woman I have ever seen. She is as majestic as the Sphinx, as pretty as a valentine and as wholesome as a great big slice of bread and butter."[16] William Ingliss was equally rhapsodic in a 1911 article for *Harper's Weekly*, noting that Sandwina had "as pretty a face, as sweet a smile and as fine a head of silky brown curls as a man could ask to see . . . but she had the muscles of Thor. Those shoulders! And the arms on her—a pair of thick, white graceful, rippling pythons! A condition not a theory confronts us. The New Woman is not threatening; she is here. She is modestly billed as Katie Sandwina, Europe's Queen of Strength, Beauty and Dexterity. She'll be Queen of America too. . . ."[17]

Sandwina may not have become the "Queen of America," but she was a remarkably successful entertainer. Like Athleta, Katie Brumbach was born with sawdust in her blood. Her mother, Joanna, and her father, Phillipe, were strength athletes, and all sixteen Brumbach children performed in the family-run circus. Katie began performing at age two and was taking on all comers in wrestling while still a teenager. She married handbalancer Max Heyman, a gifted acrobat who was considerably smaller than his wife. Together, they created an act in which Sandwina demonstrated her strength by lifting Max overhead and doing the manual of arms with him as if he were a rifle. The show proved to be a success and in 1909 they moved to the United States to work for Keith's Orpheum Vaudeville circuit, the most prestigious circuit in the business. The next year, Sandwina became the center ring attraction for the Ringling Circus. For the next three decades, she often earned fifteen hundred dollars a week.

Although the Depression of the 1930s closed many vaudeville houses and circuses, two women emerged who substantially changed the course of weight training for women. The first was Ivy Russell, born in 1907 in Surrey, England. The second was a young Californian, Abbye Eville Stockton, born ten years later. Although exceptionally strong, these two women became more

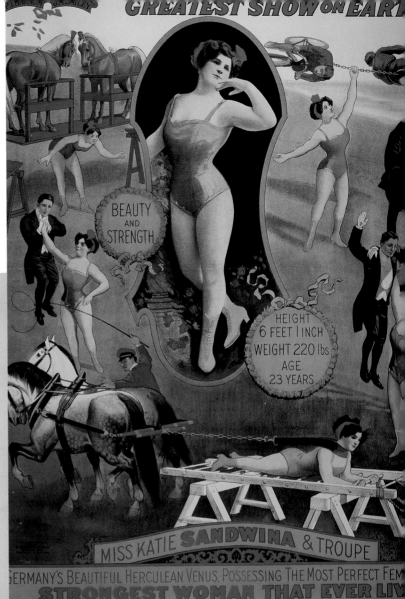

GREATEST SHOW ON EARTH

BEAUTY AND STRENGTH

HEIGHT 6 FEET 1 INCH
WEIGHT 220 lbs
AGE 23 YEARS

MISS KATIE SANDWINA & TROUPE

GERMANY'S BEAUTIFUL HERCULEAN VENUS, POSSESSING THE MOST PERFECT FEM
STRONGEST WOMAN THAT EVER LIV

RIGHT: KATIE SANDWINA, 1912 BARNUM & BAILEY POSTER, 42 × 28".

BELOW: CHARLES J. HOWARD, *YOU NEED MIND CULTURE MORE THAN PHYSICAL EXERCISE*, "PENNY DREADFUL" RESPONDS TO THE RISING WOMEN'S PHYSICAL CULTURE MOVEMENT, C. 1900. COLOR ON NEWSPRINT, 10 × 7".

YOU NEED MIND CULTURE MORE THAN PHYSICAL EXERCISE

You have taken to Athletics, and to that we can't object,
But there's another matter which you ought not to neglect
I mean the weak condition of your feeble little mind;
Some exercise to strengthen it you really ought to find.

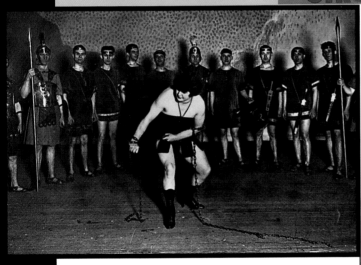

ABOVE: STRONGWOMAN KATIE SANDWINA BREAKS CHAINS IN CIRCUS PERFORMANCE, C. 1923. PHOTOGRAPH, 7 × 9½".

RIGHT: JAPANESE STRONGWOMEN AND FEMALE WRESTLERS, "A CONGRESS OF 50 OF JAPAN'S FAMOUS STRONG MEN AND WOMEN GLADIATORS," 1913 BARNUM & BAILEY POSTER (DETAIL), 28 × 42".

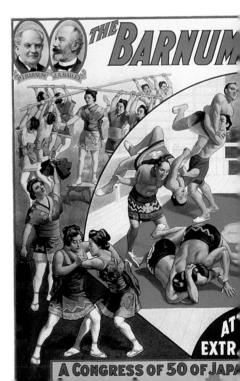

THE BARNUM

P.T.BARNUM J.A.BAILEY

AT
EXTR

A CONGRESS OF 50 OF JAPA

THE THREE HUGONY SISTERS (AKA THE LAVACCI SISTERS), ACROBATS FROM ITALY AT THE RINGLING BROTHERS BARNUM & BAILEY CIRCUS IN BARABOO, WISCONSIN, AUGUST 3, 1933. BLACK-AND-WHITE PHOTOGRAPH, 2³/₄ × 1⁷/₈".

Abbye Eville was born 11 August 1917 and moved to Santa Monica in 1924. Called Pudgy as a small child by her father, the name stuck. During her senior year in high school, Pudgy began seeing UCLA student Les Stockton. Their favorite date was to go down to the beach and practice gymnastics. They soon had so much company that the city of Santa Monica erected an outdoor platform and "Muscle Beach" was born.

As the weekend exhibitions at Muscle Beach grew in popularity, so did Pudgy's fame. She appeared in mainstream publications such as *Life*, *Pic*, and *Laff*, and in two newsreels of that era—*Whatta Build* and *Muscle Town USA*. By the end of the 1940s, Pudgy's figure had appeared on forty-two magazine covers from around the world.

In 1944, Bob Hoffman asked her to become a regular contributor to *Strength & Health*. Her column was called "Barbelles" and it ran for nearly a decade. Although Pudgy's place in the history of women's bodybuilding is secure simply on the merits of her lifting career, her *Strength & Health* columns were extremely important. Writing in what was then the most influential fitness magazine in the world, Stockton featured the other women who trained with her at Muscle Beach as she trumpeted the benefits of barbell training. By publicizing women such as Relna Brewer McRae, Evalynne

famous for their physiques than they were for their strength feats. Russell, whose body was remarkably muscular, shocked many who saw her. Stockton's body, while lithe, was also voluptuous, and she became a role model for other women who turned to weight training over the next several decades.

Ivy Russell began training at age fourteen to cure her tuberculosis. She not only got well, she got exceptionally strong. Over the next twenty years, she gave numerous exhibitions in the British Isles, making best lifts of 193 pounds in the clean and jerk and 410¹/₂ pounds in the deadlift.[18] She also successfully lobbied the British Amateur Weightlifting Association to admit women as full members and to sanction contests for women.

Although some weightlifting enthusiasts were simply interested in Russell's strength, what captivated the media and, in turn, the public was her body and her athleticism. Russell carried almost no fat on her 125-pound frame and displayed muscularity rivaling many modern bodybuilders. No one knew quite what to make of her. She didn't look like the turn-of-the century strongwomen, yet she also didn't look like the girl next door. She presented a new archetype for womanhood—yet one that would not be embraced for many years. However, her rare combination of strength and muscularity made her quite famous. In 1934, at the height of her career, she was featured on the cover of the *National Police Gazette*.[19]

On the other side of the Atlantic, Abbye "Pudgy" Stockton's glowing skin, shining hair, miraculous curves, and amazing strength graced the golden sands of Santa Monica in the late 1930s.[20] Competent, feminine, strong, and sexy, Stockton caused one bodybuilding writer to observe in 1997: "There hasn't been anybody since her who has dominated the field so completely and there won't be anybody who ever will again. There are so many luminaries today that none can dominate the bodybuilding firmament as Abbye once did."[21]

Smith, and Edith Roeder, Stockton demonstrated that weights would enhance a woman's figure and athletic ability. Although Pudgy held only one bodybuilding title during her career—Miss Physical Culture Venus in 1948—her influence on women's weight training has endured. Lisa Lyon, whom some would argue was the first modern woman bodybuilder, was so inspired by pictures of Pudgy that she joined Stockton's gym in the late seventies. With Pudgy's help, Lyon won the first professional bodybuilding contest for women and helped usher in the modern era of women's bodybuilding.[22]

There are others, of course, who contributed to the evolution of the modern Amazon. At the turn of the century, magazine publisher Bernarr Macfadden urged women to use weights to improve themselves physically in both *Physical Culture* and its sister publication, *Women's Physical Development*. Macfadden further promoted the relationship between women and weights through his sponsorship of several physical culture extravaganzas that included women's physique contests. The 1905 show, held in Madison Square Garden, attracted over fifteen thousand spectators and was covered by most of the New York newspapers.[23] In the mid-20s, *Strength*, then the most influential weightlifting magazine in the United States, began actively promoting the idea of women and strength. For instance, a 1923 editorial by Carl Easton Williams urged readers to "idealize and glorify strength. . . . We want them to be saturated with this notion of strength as being the basis of a scheme of living."[24]

Another major figure in the debate over women and muscles was Robert (Bob) Hoffman of York, Pennsylvania, who began publishing *Strength & Health* magazine in 1932. *Strength & Health* was more than simply the

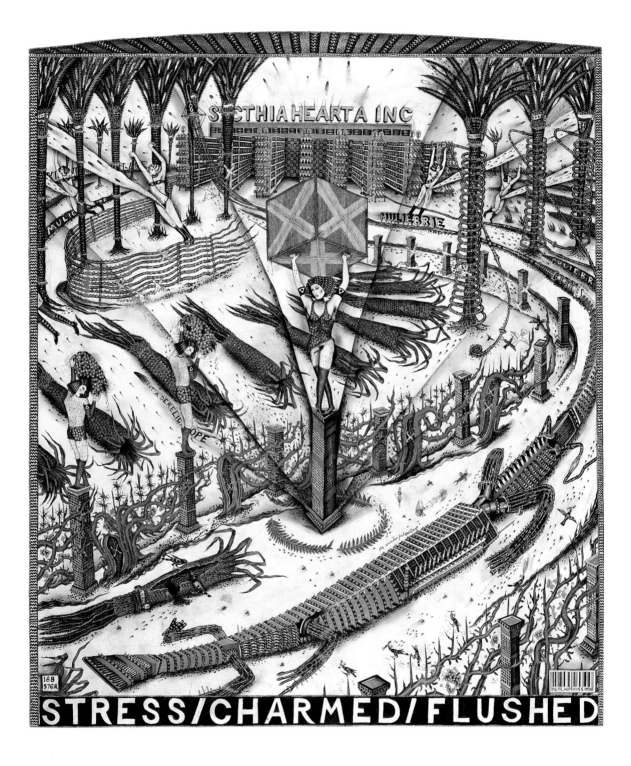

ABOVE: CHRIS HIPKISS, *STRESS/CHARMED/FLUSHED*,
JULY–OCTOBER 1998. DRAWING WITH PENCIL, INK,
PAINT (LUMINOUS), 31¹/₅ × 27¹/₃".

RIGHT: F. APPEL, MISS LALA AND KAIRA
PERFORMING VARIOUS AERIAL STRENGTH
FEATS, 1890. POSTER, 22 × 16¹/₂".

MISS LALA AND KAIRA LE BLANC, EUROPEAN STRENGTH, AERIAL, AND ACROBATIC PERFORMERS, C. 1878–1887.

[5] Among the most notable of the early performers was Angela D'Atalie, "the female Sampson [sic]." D'Atalie toured with her husband, a famous iron-jaw artist, and two adopted sons. Barnum's promotional literature for the 1873 season described her as "not only the strongest and most thoroughly developed physically, but is likewise modest and retiring, and without doubt, the most beautifully formed woman in the profession." *Barnum's Advance Courier for 1873*, (P.T. Barnum, 1873), 11. Another early pioneer was Mademoiselle Lavely, who toured with the King, Burk & Co. Circus in 1883 as "The Strongest Woman in the World." Lavely offered a thousand dollars to any woman who could match her feats of strength. These included "lifting with her teeth huge barrels filled with water weighing 300 and 480 pounds." *King, Burk & Co.'s Great Allied Shows, Museum, Trained Animal Exposition and Congress of Sensational Features Advance Courier* (King, Burk & Co., 1883).

Alma Hayes, born in Montreal in 1852, assumed the name Millie De Grandville for her career as "the lady with the jaws of iron." De Grandville worked in both the circus and variety theater, and specialized in holding a cannon in her teeth while it was fired. William L. Slout, *Olympians of the Sawdust Circle: A Biographical Dictionary of the Nineteenth Century American Circus* (William L. Slout, 1998), 71. Cannons also were featured in the acts of Mademoiselle Doublier, who toured Europe in the 1880s and 1890s with her pro-wrestler husband and of Madame Ali Bracco, "the Cannon Woman of the 1870s," who was described by French strength historian Edmund Desbonnet as a woman with "superb musculature" and "very real strength." Edmund Desbonnet, *The Kings of Strength* (Paris: Librairie Berger-Levrault/Librairie Athlétique, 1911); trans. David Chapman (unpublished manuscript, 1998), 209.

One of the few women of color in the profession was Lala, also known as "Miss Olga the Mulatto Strongwoman." Olga was born to a white mother and black father in 1858 and began performing as a circus artist at the age of nine, using the name Lala. She was an all-around artist, and worked at various times as a wire-walker, handbalancer, trapeze artist, and strongwoman. Desbonnet saw her act in 1887 and reported that she held an "enormous" cannon by her teeth, which was then fired. She also "hung by her knees from a trapeze while holding rings in her hands; she then took a man weighing 70 kilos who hung from the rings and brought her hands to the level of her thigh several times, thus doing a sort of two-handed press with 70 kilos." Desbonnet reports that he "was jealous of her biceps." How large were her arms? Desbonnet claimed that he measured their circumference as 38.5 centimeters (15 1/8 inches), "all muscle and of an incomparable

voice of the competitive weightlifting community. It was an innovator in its advocacy of new ideas and methods for training, and from its very first issue Hoffman argued that women, no less than men, should see to the perfection of their bodies, and that weight training would help women become better athletes in their chosen sport.[25]

Finally, there was Dr. Al Thomas, professor in the Department of English at Kutztown University, and life-long weight training devotee, who in a series of groundbreaking articles for *Iron Man* magazine in the 1970s raised the dialogue to a new level. Thomas wasn't interested in simply arguing for exercise. He wanted women to fully realize their potential for strength and muscular development. Thomas' articles helped pave the way for the first women's powerlifting meet, held in 1977, and the first official women's bodybuilding show, held in 1978. Without him to encourage, and to applaud the post-Title IX influx of women to the gymnasiums, we would not be where we are today.[26]

Notes:

The author would like to thank Mr. David Chapman for permission to use his translation of Edmund Desbonnet's The Kings of Strength.

[1] Prentice Mumford, "The Coming Woman," *Lippincott's Monthly Magazine* 9 (January 1872): 107.

[2] See, for instance, Paul Bouissaic, *Circus and Culture* (Bloomington: Indiana University Press, 1976).

[3] Bouissaic, *Circus and Culture*, 8.

[4] *Ringling Brothers Barnum & Bailey Advance Courier for 1930* (Ringling Brothers, 1930), 6.

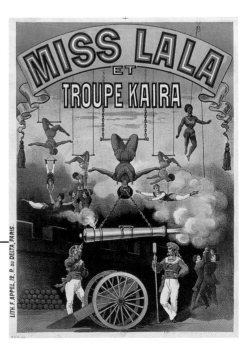

shape." Performing with Olga in 1887 was Theophilia Szterker, an all-around circus performer who used the stage name Miss Kaira. According to Desbonnet, Kaira was "an equally superb woman," who did a remarkable tumbling act. Desbonnet, *Kings of Strength*, 219–20.

 Another important early strength artist was Mary Uller, who performed at various times as both Madam Yucca and Madam Santel. According to the magician Harry Houdini, who toured with Yucca and her husband, circus owner John T. Welsh, Yucca was authentically strong, specializing in lifting horses and elephants. She was described in an 1899 promotional advertisement as "handsome of form and feature, with nothing in her appearance to suggest her almost superhuman strength. . . . Dumb-bells weighing 150 pounds and anvils weighing 500 pounds, she manipulates like paper pellets." *The Great Adam Forepaugh and Sells Brothers Consolidated Shows Courier for 1898* (Adam Forepaugh and Sells Brothers Consolidated, 1898). See also: James W. Shettel, "They Bought a Circus," *The White Tops*, n.d., pp. 5–7, Strongwoman Clipping File #2, The Todd-McLean Physical Culture Collection, The University of Texas at Austin.

[6] Desbonnet, *Kings of Strength*, 235.

[7] Ibid., 235. Desbonnet described these as lifts done in "three stages," meaning that she lifted the weights first onto a belt at her waist, then to her shoulders, and finally jerked them overhead. This type of lift was called a Continental and Jerk and was the standard method of overhead lifting in that era.

[8] Mlle Victorine, *National Police Gazette*, 25 January 1890, 7, 13.

[9] Josie Wohlford, letter to the editor, *National Police Gazette*, 13 March 1891, 10. A copy of the letter is also included in Gene Smith and Jayne Barry Smith, eds., *The Police Gazette* (New York: Simon and Schuster, 1972), 134–135. Although it is mentioned in several later *Police Gazettes* that Minerva defeated Victorine, no contest report appears in any of the *Police Gazettes* that survive from these years.

[10] The belt was presented to Minerva on 19 December 1893. Fox gave a similar belt to boxer John L. Sullivan.

[11] "Minerva: Strongest Woman," *Police Gazette*, April 1874, 16. C.P. Blatt's measurements are included in: "A Strongman from Pittsburgh," *New York Times*, 21 March 1891, 8. He is described as being 5'9 1/2" tall "in his stockings" and weighing 205 without "a superfluous ounce of adipose tissue." He measured 43 1/2" around the chest and 17 1/2" around the biceps. Interestingly, this article makes no mention of Minerva even though, according to most reports, they married in 1888.

[12] "Minerva Interviewed," *San Antonio Daily Light*, 15 August 1892.

[13] Shelland, "Recalling Minerva," *Police Gazette*, 28 December 1931, 3.

[14] "Weightlifting," *Guinness Book of Records* (New York: Sterling Publishing, 1978).

[15] Biographical information on Sandwina is available in David P. Willoughby, "The Muscular Strength of Women as Compared with Men . . . with Special Reference to the Feats of Katie Sandwina," *Skill* (December 1967): 4–5; Robert J. Devenney, "Stars of the Big Top—Katie Sandwina," *Muscle Power* (July 1947): 16; "Grandma Strong Lady of the Circus," *Hit* (December 1949): 26–27; and Max Heyman, "I Married the World's Strongest Woman," *American Weekly* (5 July 1953): 10–13.

[16] Kate Carew, "At the Circus," n.d., unpaginated, Sandwina Clipping file, The Todd-McLean Physical Culture Collection, The University of Texas at Austin.

[17] William Ingliss, "Here's the Circus," *Harper's Weekly* (April 1911).

[18] The deadlift is performed by pulling a barbell from the floor to the front of the thighs. For information on Russell's lifting records, see David P. Willoughby, *The Super Athletes*, (New York: A. S. Barnes, 1972), 575–76.

ABOVE: CHARMION IN FEATHERED HAT, C. 1903–1906. BLACK-AND-WHITE PHOTOGRAPH FROM GLASS PLATE NEGATIVE, 10 × 8".

RIGHT: JEANNE GILLOT, AKA ANNET LEUTH, FRENCH STRONGWOMAN APPEARING WITH STRONGMEN IN SIDE-SHOW ACT, C. 1900. BLACK-AND-WHITE POSTCARD, 3 1/4 × 5 1/4".

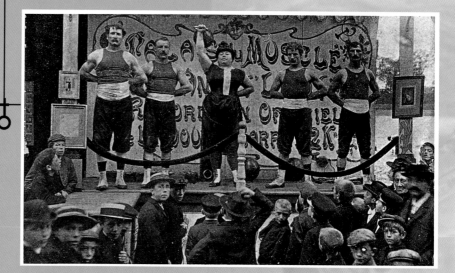

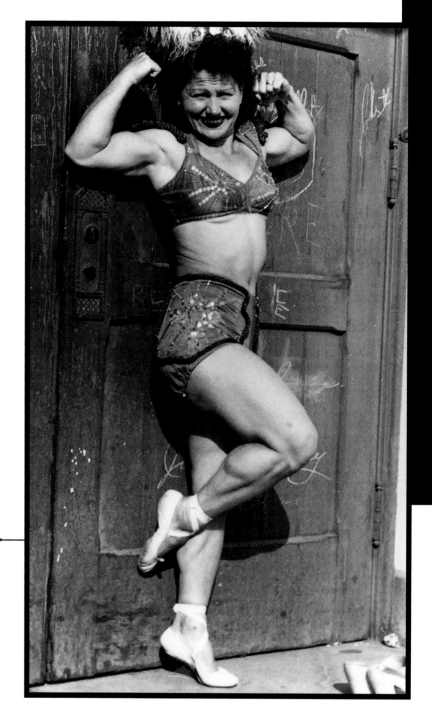

[19] *Pearson's Weekly*, 9 October 1937, cited in Al Thomas, *The Female Physique Athlete: A History to Date*, (Abs-Solutely Publishing Co., 1983): 90. Russell appeared on the cover of the 1 September 1934 issue of the *National Police Gazette*.

[20] Stockton's bosom played a major role in her appeal. The public's fascination with the bosom as a symbol of femininity has influenced much of the history of women's weight training and bodybuilding. Fears that women would injure their breasts in vigorous sports such as basketball and field hockey gave way in weightlifting to a fear that women would lose their breasts by becoming too muscular. Even modern women's bodybuilding, which glorifies leanness, has been caught up in the bosom debate. Those top women who possess the muscularity and definition necessary for bodybuilding competition generally no longer possess the necessary fat levels to also have "acceptably" large breasts. This has led many modern bodybuilders to surgically augment their breasts with silicone implants, a procedure many consider unethical, or at least ironic.

[21] Al Thomas, "Out of the Past . . . A Fond Remembrance of Abbye 'Pudgy' Stockton," *Body and Power* 2 (March 1981): 12.

[22] Lisa Lyon, interview with Pudgy Stockton, Santa Monica, California, 28 October 1991. Lyon won the first NPC World Pro Championships in 1979.

[23] For further information on Macfadden and his early physique competitions, see Jan Todd, "Bernarr Macfadden: Reformer of Feminine Form," *Journal of Sport History* 14 (spring 1987).

[24] Carl Easton Williams, "Strength Has a New Meaning," *Strength* (December 1923): 53.

[25] Bob Hoffman, "How to Improve at Your Chosen Sport," *Strength & Health* 1 (December 1932): 6–8.

[26] Thomas's first women's article for *Iron Man* appeared in July 1973. His last appeared in 1985.

women's body-

building

a contemporary history

Steve Wennerstrom

MARNIE WEBER, *THE COMPETITION*, 1998.
PHOTOMONTAGE, 24 × 36".

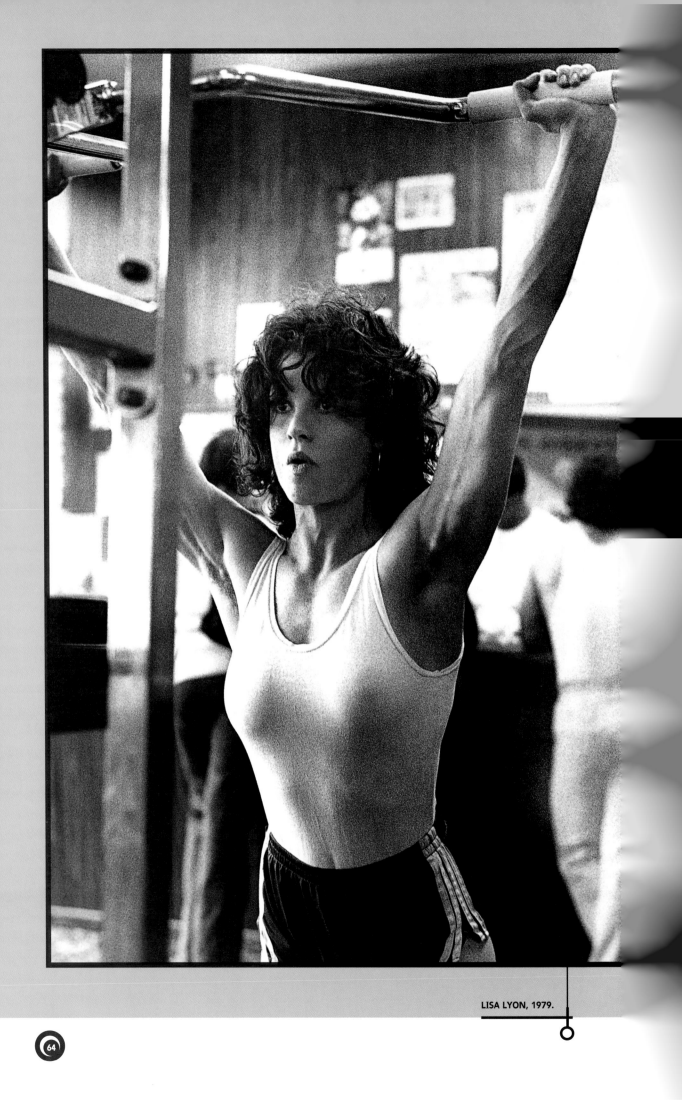

LISA LYON, 1979.

misunderstanding muscle

a cursory look through the history of humankind reveals that the muscular woman was often maligned, misunderstood, or even ignored completely. Qualities such as strength, power, and muscularity were all considered male traits not to be pursued by the female of the species. Archaic as such a view may sound today, this belief was firmly entrenched in most societies and cultures. Within the past two hundred years, women possessing supreme levels of strength and muscularity found their way for lack of any real opportunities, to either circuses or vaudeville acts to demonstrate their unique abilities.

Over the past twenty years or so, many muscular females have gravitated toward bodybuilding competitions, which, from their beginnings for women in the late 1970s, have been fraught with controversy about how women's muscle should be judged. Throughout this brief history, competitors have dealt with a constant barrage of judging inconsistencies interwoven with the negativity society imposes on women with extreme degrees of muscularity. For muscular women, who are great in not only muscle but also courage, misunderstanding is a fact of life; perhaps even more impressive than the very physiques they proudly display is the remarkable psychological strength that bodybuilders must possess in order to undergo such direct personal scrutiny by others.

created the USWPA (United States Women's Physique Association)—an organization complete with its own journal, *Sartorius*—and he had begun staging contests open to all women. In November 1977, Gina LaSpina won McGhee's United States Women's Championship, establishing ground zero for the sport.

By October 1978, Doris Barrilleaux, a competitor in one of McGhee's events, founded her own organization, The Superior Physique Association, in Florida. Barrilleaux also produced a newsletter for her organization and for the next several years became actively involved in the administration of the fledgling sport. Over time, she became known as The First Lady of Women's Bodybuilding, in honor of her contributions as chairwoman of the AFWB (American Federation of Women Bodybuilders) and later as chairwoman of the Women's Committee of the IFBB (International Federation of Body Builders).

Aside from McGhee's annual contests, 1979 saw two major events that dramatically propelled the sport forward. On June 16 at the Embassy Auditorium in Los Angeles, Lisa Lyon won what was billed as the first Women's World Bodybuilding Championship. Although the event featured only twelve women, all from the California area, the charismatic Lyon brought widespread interest and immeasurable media coverage to bodybuilding through magazine, newspaper, and television

a concise history of competition

the 1970s brought winds of change for women. In concert with the burgeoning feminist movement and the enactment of Title IX in women's sports, women gained a new level of opportunity within the United States. A newfound interest in women's athleticism ignited on a global scale. Millions watched the gymnastic artistry of Olga Korbut and Nadia Comeneci in the Olympic games, while tennis players Billie Jean King and Bobby Riggs kept viewers glued to their television sets to watch the now infamous "Battle of the Sexes." The combined effect of such events created a perfect moment for the birth of the sport of women's bodybuilding.

Enter Henry McGhee, a weight training director at the Canton, Ohio YMCA. As early as 1976, McGhee had toyed with the idea of a contest for women judged closely to the standards set by men's bodybuilding competitions. McGhee, following these standards, stressed that muscle shape, size, and definition should be strongly considered in selecting a champion. It was clear that McGhee wanted his event to differ completely from traditional beauty pageants. By 1977 McGhee had

GINA LASPINA, 1977.

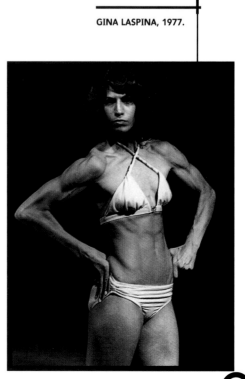

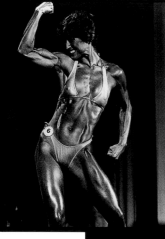

next few years.[2] 1980 would also become known as The Year of Firsts. An American Championship was staged in Santa Monica on September 5, with Floridian Laura Combes edging out Californian Claudia Wilbourn by one point in a field of thirty-seven women. Months earlier, on April 8, the U.S. Championship took place in Atlantic City and was won by Rachel McLish. This was followed by the inaugural Ms. Olympia on August 30 in Philadelphia, that was also won by McLish. Offering $10,000 in prize money, half of which went to McLish, the Ms. Olympia was considered to be bodybuilding's most prestigious women's event, and the 1980 competition made McLish an instant star in the sport. The following year the Ms. Olympia prize money more than doubled—to $25,000—and over the next fifteen years that sum steadily increased to the 1995 high of $115,000. Currently the total Ms. Olympia prize money stands at $100,000.

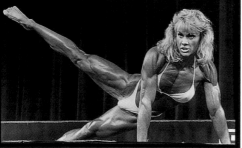

Women's bodybuilding gained wide notice in the early 1980s when the IFBB instituted events such as the first Pro World Championship in Atlantic City, which was won by Lynn Conkwright. Also important were the first IFBB European Championships, held in London on May 30, 1981, which divided contestants into two weight classes. Additional international interest was generated in 1983 when the Wembley Conference Centre in London hosted the first IFBB World Amateur Championships on October 1 with thirty-seven women from twenty-two countries participating, and when the IFBB Asian Championship took place July 2–3 in Singapore. In December 1983 George Butler filmed *Pumping Iron II: The Women* during the Caesar's World Cup contest at Caesar's Palace in Las Vegas. The film featured—and made bodybuilding stars of—McLish,

interviews in the United States and abroad. Two months later, on August 18, Patsy Chapman won the Best in the World contest held in Philadelphia. This was the first event for women where prize money was offered to the top placers. Chapman won $2,500 of the $5,000 total.[1]

By 1980, the women's competitions were experiencing unprecedented growth and popularity. Numerous men's organizations, such as the AAU (Amateur Athletic Union), WABBA (World Amateur Body Building Association), NABBA (National Amateur Body Building Association), WBBG (World Body Building Guild), and the IFBB, all established women's division competitions within the

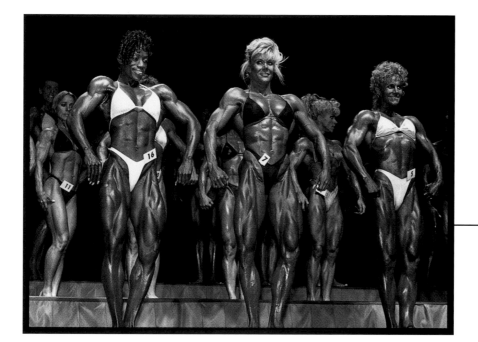

ANNE WALSH, *UNTITLED (NPC CHAMPIONS VI)*
(DETAIL), 1994. C-PRINT, 14 × 14".

female muscle and the media

the rapid growth and interest in women's body-building during the late 1970s provided television, newspapers, and magazines with a novelty that fed the media's voracious appetite for the unique.

Women's competitions quickly found their way into the pages of the longstanding men's bodybuilding journals. Increased contest reporting, a reflection of increased public interest in the sport, also spawned profiles of the better competitors. With the frequency of competitions at a feverish pitch, top performer's names became more and more familiar to those who followed women's bodybuilding.

Apart from the predictable coverage that body-building magazines gave the budding sport, high-profile publications such as *Sports Illustrated* and *Playboy* ran major features related to women's bodybuilding as early as 1980. The pioneering female bodybuilders' cultural presence gained momentum throughout the '80s as the mainstream press, including *People*, *US*, *Time*, and countless regional interest magazines, profiled the female physique phenomenon. *Sports Illustrated*'s awkwardly titled article, "Here She Is, Miss, Well, What?"

Bev Francis, Lori Bowen, and Carla Dunlap. In winning this event, Dunlap garnered the most titles won in one year by a female bodybuilder to date by taking first place in the 1983 Pro World, Ms. Olympia, and Caesar's World Cup competitions. This triple victory netted Dunlap $42,000 in prize money.

During the 1984 competitive season, Cory Everson emerged as the sport's newest star. She won the NPC (National Physique Committee) National Championships in New Orleans, and two months later she added the Ms. Olympia crown to her accomplishments, unseating Carla Dunlap. Everson acheived unprecedented fame in women's bodybuilding, reigning as Ms. Olympia—she won six successive titles—until she retired as an unde-feated professional in 1989. In 1990 Lenda Murray, a former professional cheerleader from Southfield, Michi-gan, was crowned Ms. Olympia. Murray equalled Ever-son's six successive victories before being dethroned by midwesterner Kim Chizevsky in 1996. At the time of this essay's writing, Chizevsky has dominated the Ms. Olympia contest for three years with an unparalleled level of muscular development.

from the 17 March 1980 issue, is a prime example of the lack of knowledge of the sport demonstrated by many of these magazines.

In April 1982, *Body & Power* magazine became the first national periodical to cover women's bodybuilding exclusively. Edited by myself, the bimonthly set the stage for future magazines of this genre, but lasted for only seven issues before ceasing publication in May 1983. In 1984, however, four new magazines—*Strength Training for Beauty* (January), *Body Talk* (spring), and *Sleek Physique* and *Women's Physique World* (fall)—launched premier issues. For most of these magazines the road to financial stability was challenging, and to date, only *Women's Physique World*, also edited by myself, is still on the newsstands. Although two more nationally distributed women's bodybuilding magazines did surface—*Muscle and Beauty* in February 1985, and *Female Bodybuilding* in December 1986—neither lasted to the present day; no other women's bodybuilding publications have been launched for national newsstand distribution since 1986.

Coverage of women's bodybuilding by newspapers was sporadic and primarily limited to local competitors who had distinguished themselves at the upper levels of the sport. These athletes were usually highlighted in Lifestyle or Viewpoint rather than Sports sections, whose editors had long been reluctant to recognize bodybuilding as a legitimate sport. Nevertheless, newspapers in the '80s and '90s did periodically feature profiles of women and their desire to achieve muscular development.

Television was quick to jump on the female bodybuilding bandwagon. Virtually every talk show, both regional and national, paraded before their cameras a seemingly endless lineup of muscular women to tell of their experiences with exceptional physique development and to offer training tips. Audience responses ranged from appreciative to dumbfounded and even revolted. Shows such as *Real*

People, *The New You Asked for It*, *PM Magazine*, and *Leave It to Women* vied with talk show icons Merv Griffin, Mike Douglas, and Phil Donahue to feature women bodybuilders. In 1982, the ground swell in national interest in women's bodybuilding peaked with a March 4 segment on the ABC News show *20/20* titled "The New Body Beautiful?" Current talk show hosts such as Sally Jessie Raphael, Geraldo Rivera, and Montel Williams, among many others, have continued to bring women's bodybuilding to millions of television viewers through their theme-show format.

But the most notable coverage that television offered early women's bodybuilding came by way of network giant NBC's *Sportsworld* and then cable upstart HBO. Both would provide detailed contest coverage, with NBC first airing the 1980 U.S. Championships from Atlantic City, hosted by Mike Adamle and Lisa Lyon. The following year NBC returned with comparable coverage of the inaugural IFBB Pro World Championship, also from Atlantic City. HBO debuted its own women's bodybuilding coverage with the 1981 American Championships, at Caesar's Palace in Las Vegas. For NBC the female bodybuilding events provided an eye-catching addition to the boxing and automobile racing segments that frequently bracketed the bikini-clad bodybuilding competitors. Network executives kept the women's

FIRST U.S. WOMEN'S BODYBUILDING CHAMPIONSHIP, 1980, ATLANTIC CITY, NEW JERSEY. PICTURING NBC SPORTS COMMENTATOR MIKE ADAMLE WITH CONTESTANTS (LEFT TO RIGHT) KAY BAXTER, LYNN CONKRIGHT, CAROL PIBEAM, LAURA COMBES, CARLA KAY YORK, STELLA MARTINEZ, PAM BROOKS.

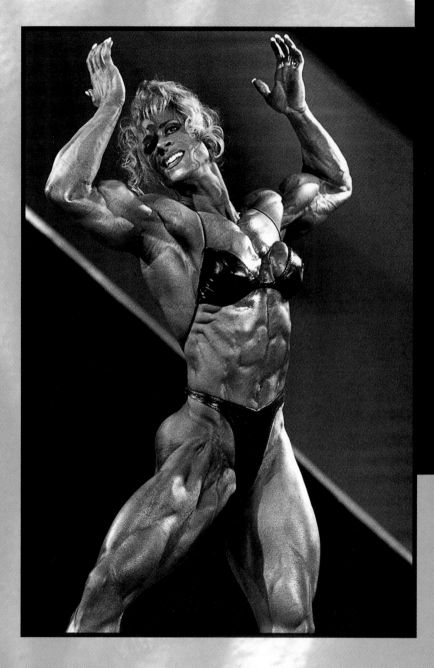

competitions on their program schedules for the remainder of the '80s, always combining them with other sports that traditionally cultivate a male viewership. Today ESPN and the FOX Network run coverage of bodybuilding and have recently placed a somewhat stronger emphasis on the more recently developed fitness competitions, which have a broader appeal to audiences less familiar with the more muscular bodybuilding competitors.

Women's bodybuilding drew its first true international media focus with the April 1985 release of George Butler's and Charles Gaines's feature-length film *Pumping Iron II: The Women*, which introduced audiences to a growing subculture that had never been dealt with in a cinematic format. Women's bodybuilding benefited greatly from the worldwide exposure gained

through the film. Eliciting a gamut of opinions on its quality from the public, *Pumping Iron II* received generally positive critiques from film critics. Both the sport's officials as well as its cognoscenti would later agree that the movie's release date coincided with the apex of mainstream interest in the sport.

the rush to judgment

from female bodybuilding's earliest days, judging has been charged with controversy and inconsistency. Because every organization has drawn up its own set of rules and guidelines, there is a wide range of differing opinions, not to mention interpretation of these rules and guidelines. One element of universal dispute is the question of how much muscle is to be judged acceptable.

Bev Francis's entry in the 1983 Caesar's World Cup was encouraged by the producers of *Pumping Iron II* in order to offer a dramatic—much more muscular—contrast to the physiques of Bowen, Dunlap, and McLish, and the film documents Francis's "extreme" muscle as a source of judging contention. Considering the almost complete absence of positive reinforcement for the muscular woman through history, the how-much-muscle issue seems to have been destined to hover like a dark cloud over women's bodybuilding.

As early as 1983, when the sport was just developing, IFBB president Ben Weider issued the following directive to the organization: "The shape the judges should look for is a feminine one, and excessive bulk and masculinity should be marked down. Deportment, skin tone, and general appearance will then become more important, and competitors realizing this, we hope, will stop striving for excessive muscularity, etc. This is the message you should put across to the competitors and judges. Feminine shape will then once again become a desirable asset to a woman body-builder."[3] This directive caused even greater confusion as judges struggled to define what "excessive" meant in a sport that required competitors to achieve a level of muscular development far above what the average individual considers normal.

Beyond the growing complexities of judging philosophies, another issue arose from the imperfect judging system: how would the purity of the sport survive vis-à-vis the external influence of commercial interests? Wasn't it common knowledge that promoters needed hardcore muscle to fill the seats at a contest? And wasn't it equally understandable that magazine publishers and media were in search of a look considered more appealing than the hardcore one, a look that would attract a broader, mainstream audience? Could the two factions compromise?

A statement by *Pumping Iron II* co-filmmaker Charles Gaines suggests that the economic survival of women's bodybuilding as a sport depended on its beauty pageant element and its avoidance of gender issues. In the November 1983 issue of *Psychology Today*, he asserted:

> Women's bodybuilding is now almost totally represented by slim, athletic, graceful, pretty women on whom muscles do not show until they are flexed—women, it is hoped by those with a commercial interest in the sport, with whom American women will want to identify and with whom American men would choose to dally.

Ironically, it is precisely this survival strategy that the doomsayers of the sport say is killing it. The sport, they say, consists now of a boring series of beauty contests among women with the taut, slightly desiccated bodies of female gymnasts. . . . [H]ow much interest would there be in a series of 100-yard dashes in which all the runners had agreed to never finish in less than 10 seconds?

. . . If female bodybuilding is to flourish, it will have to address . . . the . . . question of what the sport and art of women's bodybuilding are all about. . . . Are they about the unhindered development and competition of female muscle? . . .

In that . . . possibility . . . there is the mysterious potential for growth, both physical and symbolic; . . . and there is opportunity, perhaps the only one, for women's bodybuilding to finally find its archetype.[4]

Indeed, there exists a strong relation between the female body's societal and cultural significance and women's bodybuilding and muscular females. But sadly, a full acceptance or understanding of these very special individuals may not be fully realized for years to come. That will be the stuff for future historians to sort out.

Notes:

[1] Promoted by George Snyder, with Arnold Schwarzenegger as master of ceremonies, the contest became the forerunner to the Ms. Olympia, an event that Snyder inaugurated a year later. On the heels of the Best in the World contest, Mr. Olympia Frank Zane promoted a professional women's event in Santa Monica on June 28, 1980. Of the $6000 total prize money, winner Stacey Bentley earned $2000.

[2] From 1981 through the present, IFBB-sanctioned events have been staged in the United States and internationally, and all serve as opportunities for winners to qualify for the more prestigious Ms. Olympia. In 1986, co-promoters Jim Lorimer and Arnold Schwarzenegger created the IFBB Ms. International, which offered ten thousand dollars in prize money. This sum has since quintupled, and the very popular and highly regarded

Ms. International has been contested annually since 1988. Along with this contest, the Ms. Olympia and the Jan Tana Classic (inaugurated in 1991) are currently designated as professional within the IFBB. Other organizations have generally been unsuccessful in consistently staging a professional contest or series of contests that compare favorably with IFBB events.

[3] Weider's directive reflects a common fear of female "extremity." His "etc." suggests a kind of hysteria, as if something even worse and less feminine than women's "extreme muscularity" looms on the horizon of female bodybuilding. *Eds.*

[4] Charles Gaines, "Iron Sisters," *Psychology Today* 17, no. 11 (November 1983): 64–68.

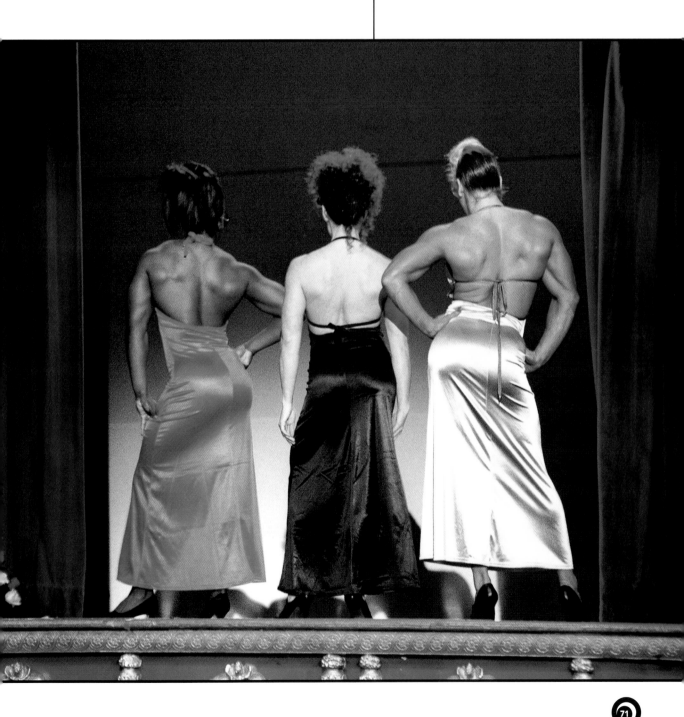

SUSAN MEISELAS, *EVOLUTION F—PICTURING HEATHER FOSTER, KIMBERLY ROBERTS, AND NIKKI FULLER*, 1995. COLOR PHOTOGRAPH.

ghettos of obscurity:

individual sovereignty and the struggle for recognition in female bodybuilding

Leslie Heywood

to men a man is but a mind. Who cares what face he carries or what he wears? But woman's body *is* the woman.

—Ambrose Bierce

Because you make so little impression you see. You get born and you try this . . . and you are born at the same time with a lot of other people, all mixed up with them, like trying to, having to move your arms and legs with strings only the same strings are hitched to all the other arms and legs and . . . the strings are all in one another's way like five or six people all trying to make a rug on the same loom only each one wants to weave his own pattern into the rug; and it can't matter, you know that, or the Ones that set up the loom would have arranged things a little better, and yet it must matter because you keep on trying or having to keep on trying and then all of a sudden it's all over and all you have left is a block of stone with scratches on it provided there was someone to remember to have the marble scratched and set up or had time to, and it rains on it and the sun shines on it and after awhile they don't even remember the name and what the scratches were trying to tell, and it doesn't matter.

—William Faulkner, *Absalom, Absalom!*

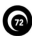

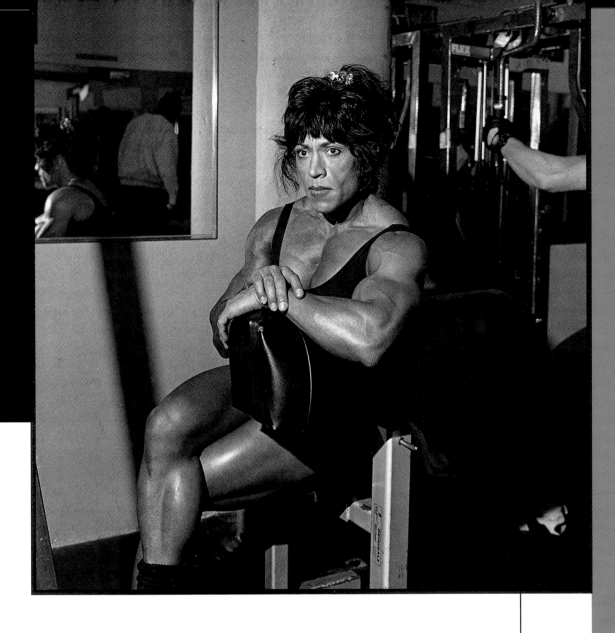

BILL LOWENBURG, *ROBIN PARKER,
NEW YORK CITY*, 1996. BLACK-AND-
WHITE PHOTOGRAPH, 11 × 11".

gle has always been influenced by cultural ideas about gender. These problems and their inflections go a long way in explaining some of the conflicts behind and potentialities of the practice of bodybuilding for women.

Writing of Mexican culture in "The Sons of La Malinche," Octavio Paz performs a lyrical taxonomy of the Spanish words *chingar* and *chingada* that focuses the struggle for recognition: "The verb *chingar*—malign and agile and playful, like a caged animal—creates many expressions that turn our world into a jungle . . . the only thing of value is manliness, personal strength, a capacity for imposing oneself on others. . . . the *Chingada* is no one; she disappears into nothingness; she is Nothingness. And yet she is the cruel incarnation of the feminine condition."[1] Such words are magic, and bring ways of life into being: "This is the model we have from my mother, nurturing/waiting on my father and brother

and again, flesh against substances harder than flesh. In the contention for individual recognition, definitions of and problems with the masculine and the feminine in American culture are no less marked than in the interplay between *chingar* and *chingada*, the masculine and the feminine, that Paz describes. Gender roles in America, as elsewhere in Western culture, have been influenced by what sociologist Morag Macsween calls the "irreconcilability of individuality and femininity, the way individuality, despite its surface presentation as a gender-neutral category, is culturally associated with the masculine."[3]

Identity and recognition as an individual, as many psychologists and social historians have pointed out, is often dependent upon an escape from and repudiation of those traits culturally marked as feminine. This was a standard premise of some strains of second-wave femi-

nism, which argued for the revaluation of those characteristics and for a space for women's development as individuals. The activity of women's bodybuilding was made possible by this argument, and developed as a practice only after these arguments had gained some cultural currency. Both bodybuilding practice and feminist argument were significant disruptions of traditional ideas about women, for in the Western tradition generally, and that tradition's particular manifestation in philosophy, the "feminine" as a space or set of traits was marked as something which inhibited the development of full self-consciousness and individual being. To G. W. F. Hegel, for instance, the feminine, and the family associated with it, marked the antithesis of individuality: "it is only as a citizen that he is actual and substantial . . . the individual, so far as he is not a citizen and belongs to the Family, is only an unreal impotent shadow."[4] Just as the domain of the bodybuilder was initially the domain of the masculine and physical presence, the domain of the feminine as the domain of the impotent shadow is similar to the figuration of the feminine as nothingness by Paz. It is the space of non-being, the antithesis of individuality. The female bodybuilder is an erasure of such non-spaces, an eruption from nothingness into being.

The negative configuration of the feminine has popular as well as literary and philosophical manifestations. Rock critics Simon Reynolds and Joy Press trace this pattern in America through the beat culture of the late 1950s and early 1960s, showing that "the familiar dialectic between male adventurism and female conformism, male wildness and female domestication [in Jack Kerouac's *On the Road*], foreshadows Timothy Leary's discourse of heroic odyssey into the acid maelstrom. Leary espoused LSD as a way of de-familiarizing the world: beneath this project lurked his desire . . . to escape the family."[5] The daily world of the familiar is feminine, and is decidedly non-heroic. It is the world of self-effacement and must be escaped for the achievement of self. For Reynolds and Press, this figuration of the masculine as independence and original, significant achievement and the feminine as that which limits independence and achievement, persists throughout the history of the popular music they study. Feminist literary critics have located the same pattern in the canonical literature up through the twentieth century, where the artist was male and women and domestic life provided the necessary support that simultaneously served as a distraction from their more important, valued work—their art.

BILL LOWENBURG, *ROBIN PARKER, NEW YORK CITY*, 1996. BLACK-AND-WHITE PHOTOGRAPH, 11 × 11".

Literature? Philosophy? Popular music? So what's any of this got to do with those hot babes with monstrous biceps, lats, and pecs? In the trajectory I am tracing here, we may seem a long way from bodybuilding, but really we are at its back door, approaching its very heart, a couple of heartbeats, a few logical steps away. Breathe in for a minute, deep into your chest. Feel the space of your ribs expand. Start thinking about what blood in the muscles does. Start thinking about how this feeling—expanded space—anchors you into the world. Think about how iron weights that pump the blood might turn someone who has traditionally been defined as nothingness—the one who props up others and supports *their* achievements—into living flesh. How the historical trajectories might be undone, weight by pulsing weight, bicep by bicep, face by flushed face.

Previous to the time when a large number of women participated in organized sports or were "working out," historical assumptions about the masculine and feminine had a corollary influence on how we thought about male and female bodies. In the words of an 1872 Supreme Court legal brief, "the natural and proper timidity and delicacy which belongs to the female sex evidently unfits it for many of the occupations of civil life."[6] These sentiments are echoed even now. Each time a girl hears the old putdown "you throw like a girl," these words hollow her out and

reduce her because they assume she is laughable, not as good as, something less.[7] Because of the dialectic between these assumptions and actual bodies, female athletes (of whom bodybuilders are perhaps the most visible and in-your-face in terms of overturning traditional assumptions) join in the "masculine" struggle for recognition as individuals in an explicit, undeniable way.

Traditionally, like the assertive, valued, and bounded individuality of the masculine, the male body was represented as large, strong, invulnerable, whole, and existing for itself, a synechdoche for strength and power in the social world, regardless of the physical condition those actual bodies may have been in. Like the passive, devalued nothingness of the feminine, the (usually white) female body was seen as small and soft, penetrable and weak, and had a place only in the domestic arena, either as caretaker or as a reproductive machine. *Chingadas*, women reduced to their bodies, brute flesh. Reduced to physical appearance as beauty. Brute flesh that takes up little space, little enough to mirror their lack of power and individual place. Visible invisibilities: "a woman should be seen and not heard," beauty which indicates her position as something less than a fully developed individual existing for her own purposes and her own terms.

These bodily configurations are a paradox, because as the Bierce epigraph shows, a man's body was figured simultaneously as powerful and as inconsequential to his being. It is the mind that has substance: "to men a man is but a mind. Who cares what face he carries or what he wears?" The body, like the feminine, is deval-

ued: "But woman's body *is* the woman."[8] According to the tradition, a woman's very being is her body, her physical appearance. Yet that body/appearance is also coded for lack of structural integrity: it is malleable, vulnerable, soft. *Chingada*, flesh that marks a being of nothingness. Can you see her there, skin blue behind the glass, her blood beating in a silence so wide that it swallows all of space? Do you see him on the other side, skin red with blood and fully flushed, biceps standing at attention, his `inconsequential' body coded to signal the same sharpness attributed to his mind? Hard, clean lines. Power. Being. *Chingar*, the power to move in the world. Stand out.

In some ways this model of gender seems dated today. Presence is no longer the prerogative of the masculine. Who has presence? Who among us has power to act on the world? Who has blood they can slow down long enough to feel? In a hyped-up, speeding mass-culture of images that has recently commodified the male body to the same extent as the female, "who cares what face he carries or what he wears" seems an anachronism of a much earlier period in time. Just think Lucky Vanous, the Diet Coke man, and *Details* magazine—today everyone, not just women, seems to long for a sense of power, a way to feel alive, and, like the position of the traditional feminine, said to give women a sexual power that is actually empty, images are assumed to confer power. Guys have to have the right Hilfigers and sets of pecs, the right set of washboard abs to stand out of those Calvin Klein briefs. The hunger for visibility, the hunger for the kind of meaningful life that powers late-twentieth-century culture, has reached a fever pitch. Images promise that meaning and status. Fierce desires for individuality and purpose are manipulated and played by the lifestyles we're sold, the hyperreal. Bled of meaning, our lives have become the images, the only "self" we possess. Individual significance erased at every turn, the contemporary sense of being in America, masculine or feminine, might be summed up not by "I think therefore I am," but rather by "I have an audience, therefore I am." No audience, and you have no blood and guts—no meaning, no form. No audience, and you are only empty whistling space. Is it coincidence that at this period in American history so many people are spending so much time in the gym, trying to fill in the sense of self that's been erased?

David Wild makes note of this desperation for visibility in an article on MTV's *The Real World* in *Rolling Stone*. He writes that "one senses *The Real World* speaks to an entire generation of viewers that can hardly wait to get a camera crew on its ass. An application in *The Real Real World* book led to 10,000 new

BILL LOWENBURG, *CHRISTA BAUCH, NEW YORK CITY*, 1996. BLACK-AND-WHITE PHOTOGRAPH, 11 × 11". ♀

NANCY SPERO, MIRROR IMAGE, 1994. HANDPRINTING AND PRINTED COLLAGE ON PAPER, 19¹/₂ × 24".

young bodies anxious to sign on for house duty. One imagines packs of twentysomethings lying in wait for a quick way out of the ghetto of obscurity."[9] While Wild's description can be interpreted as yet another older writer's jab at the superficiality of persons belonging to "Generation X" (or Y), it also points to a sense of being that many in contemporary culture experience as real: the sense that one is confined to a "ghetto of obscurity," invisible, meaningless, unless one has an audience to rescue them. The attention of that audience—and only that attention—confers a momentary sense of identity upon the one who is brought out of the realm of shadows through being seen.

The more we become impotent shadows, the more we desire the actuality of presence, fictitiously metaphysical though we may know that presence to be. It is a bitter historical irony that women have been offered a shot at presence—that is, existence as individuals in and for themselves—in the age of the hyperreal, where

the very notion of presence is assiduously erased. The accelerated hyperreal of images that rules us makes the desire for individual presence all the more formidable, as if we feel that presence slipping away in our every effort to feel our existences twisting and shouting through the breeze. As Susan Bordo writes in *Twilight Zones*: "Freedom. Choice. Autonomy. Self. Agency. These are powerful words in our culture, fighting words. But they are also words that are increasingly empty in many people's experience. Are we invoking the rhetoric with such desperation precisely because the felt reality is slipping away, running through our fingers?"[10]

There is a double irony at work here, because throughout the mass media, the female athlete is being newly constructed as a graphic symbol for "freedom, choice, autonomy, self, and agency," as many people feel those very things slipping away. She is figured in advertising as one of the few sites where women's individual quest for distinction is uniquely fulfilled, and

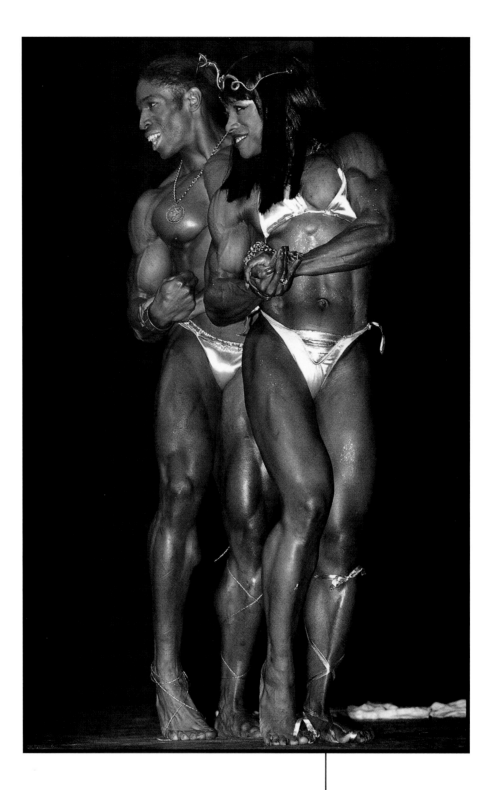

ABOVE: BJÖRG, *UNTITLED*, 1993. BLACK-AND-WHITE
PHOTOGRAPH, 20 × 16". PICTURING LINDA WOOD-HOYTE
WITH RON COLEMAN.

RIGHT: MARIETTE PATHY ALLEN, *NIKKI'S BACK AT
EVOLUTION F*, 1995. SELENIUM-TONED GELATIN SILVER
PRINT, 10 × 8". PICTURING NIKKI FULLER.

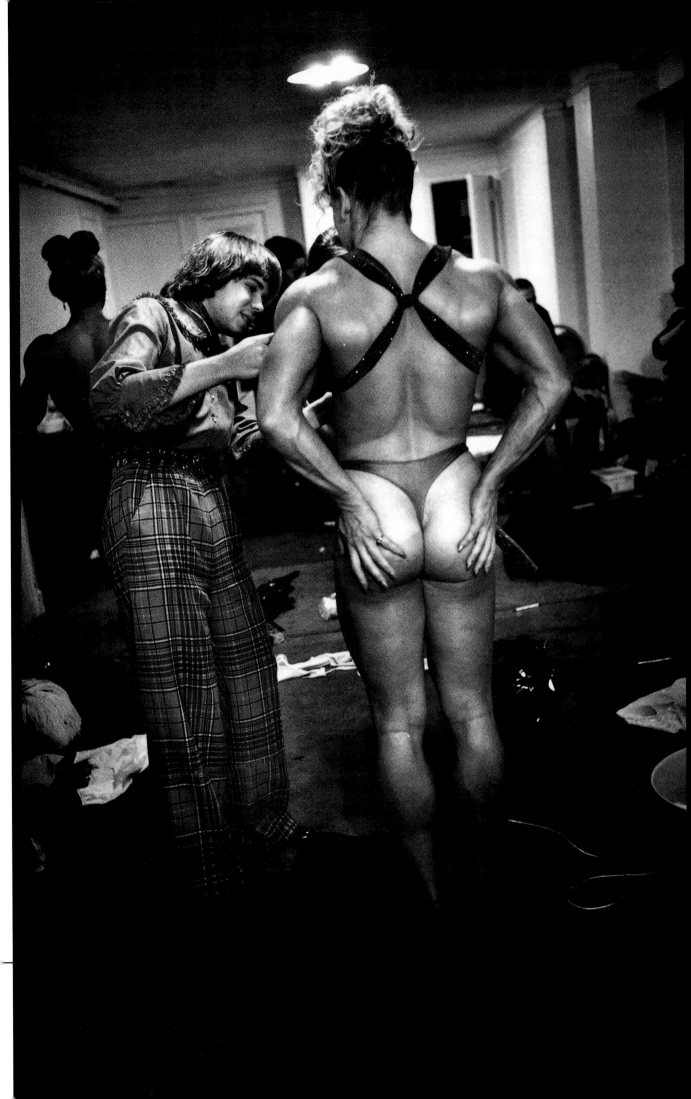

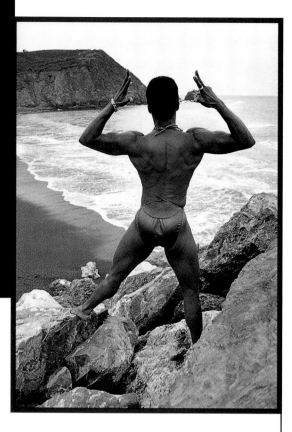

FAITH SLOAN.

major part of the cultural image repertoire. The "women we love who also kick ass," as media icon Gabrielle Reece has been described, are selling really well.[11] This is a very recent development, one that women's bodybuilding has been instrumental in facilitating. The female bodybuilder, her visibility, her pumped-up presence in the world, is one of the things responsible for the development of women as individuals with significant, filled-out flesh, for the chance to make a running jump out of nothingness. Or perhaps just a really clean lift.

Female bodybuilders possess a different form of visibility than the traditional, invisible visibility of "women should be seen and not heard." Following on the heels of Title IX, the first women bodybuilders came into the public eye in the late 1970s, when cultural occurrences such as the women's liberation movement, affirmative action legislation, and the development of women's sports generated wider public interest in and acceptance of strong, athletic women. But the female bodybuilder is more than an image. Knock, knock, her heart pulses. She feels her blood beat in her temples, breath deep down into her chest. She steps out from behind the glass of non-being. Sounds: the rushing of cars, cold birds. Her hands reach blindly for the weights, and she waits for the pump of her blood like a drug. In a culture that once canceled female being with assignations of nothingness, a generic nothingness comes to inhabit the heart of being just as she begins to have access to it. Erased, traced in, then brushed away. Fueled by a double erasure, the weight of history that denigrated the feminine and the current weightlessness of the hyperreal, the female bodybuilder feels her heart and fights that erasure with every rep. She tortures, soothes, her lungs. She erupts into the surfaces of being in the most graphic ways.

Bodybuilding is the manifestation of the will to be visible. Though her body is still her substance, its tangible sign, the coding of that substance has changed. Instead of the paradox of a substance that is insubstantial, a physical visibility that is coded as social invisibility or lack of intrinsic worth ("she's a body, not a brain"), the female bodybuilder's body signals the presence of a controlling mind: "a love of being able to control the outcome of one's efforts . . . formed the foundation of Faith's involvement in bodybuilding," writes Faith Sloan, webmistress and bodybuilder, at the beginning of her bodybuilding Web page.[12] Impotent shadows don't desire, or create anything, but female bodybuilders do. The muscular female body, mind and muscle, fuel and flesh. A mark against history, insubstantiality, meaninglessness. An irrefutable indication of presence, sustained work, and the desperate desire for meaning and significance as an individual that fuels it.

sports participation and bodily development is sold as the arena in which women have the most freedom and control. This is an ironic development for a culture that has long denigrated the female athlete (and bodybuilders more than other athletes) as "unnatural" and "too masculine," and has seen "freedom, choice, autonomy, self, agency" as solely the prerogative of men. So now she too can have it, right? Presence is at hand. Just lace up your Nike Airs. After all, Nike *is* the ancient Greek goddess of victory. So get your butt into the gym. Or out there on the track. Or hit the mountain, Mt. Everest preferably. Or break out those snowboards, girls. What are you waiting for? In the hyperreal, we can all achieve physical prowess, and we are *chingadas* no more. But what we forget is that the model of the female athlete is presented as attainable by all women as a panacea to "nothingness," even though in reality it is not attainable by all. The hyperreal makes a promise of being it can't fulfill.

While female athletes first developed as a significant demographic in America and came to prominence after the passage of Title IX, the Education Act of 1972, which mandated equal funding and facilities for women's sports in American high schools and colleges receiving federal funds, it wasn't until the 1996 Olympics that they gained widespread acceptance. Now the tough sports babe with integrity flesh is a

Though their innovative influence would show up more fully later, the first women's bodybuilding shows seemed based on the *chingada* model. In 1977, Ohio YMCA director Henry McGhee established the United States Women's Physique Association (USWPA) and sponsored the first bodybuilding contest for women. Gina LaSpina won the show, but her long-limbed, soft-stomached, stringily-muscled physique would hardly be recognized as a bodybuilder's today. Other promoters followed McGhee's lead, and contests became more frequent. George Snyder's "The Best in the World," staged in 1979, was modeled on beauty pageants, and required the women to pose in high heels. Snyder marketed the event as a "beauty contest for women in good shape,"

and in keeping with cultural ideas about feminine diminutiveness, muscle poses were prohibited so that the competitors would not appear too "intimidating" or "unfeminine."[13]

Carla Dunlap Kaan, who was to become the first Ms. Olympia, staged a resistance by kicking off her heels, and simultaneously striking a front double-biceps pose—the pose most widely recognizable as a body-builder's. Other competitors followed. No *chingadas* these, women's bodybuilding began with women taking matters into their own hands and kicking off their stilettos. It was a statement of self-empowerment that graphically disavowed the centuries-old association between women, femininity, and weakness, asserting

SETH MICHAEL FORMAN, *WOMAN HANDLING A SNAKE*, 1998. OIL ON LINEN, 24 × 25".

their right to compete as real athletes in a real sport. To put themselves on display as integrity, as individuals capable of achievement, not just a role. Not just flesh.

Lisa Lyon, who was the first female bodybuilder to receive wide public recognition, won the first Women's World Bodybuilding Championship in 1979 in Los Angeles. She made television, magazine, and newspaper appearances worldwide, and served as the model of the first photography series devoted to a female bodybuilder, Robert Mapplethorpe's *Lady: Lisa Lyon.* Lyon's body was characteristic of the first wave of women's bodybuilding: aesthetically balanced, and muscular in a smooth way. She communicated not so much a transgression of femininity but a development of it. Lyon, and others like her such as the popular Rachel McLish, built a body that was in alignment with the body ideals of the early 1980s, a body that was athletic and toned. Lyon's body was the size and style of some of today's fitness competitors, clearly worked on but minimally developed, lacking the density and sheer bulk female bodybuilders would develop ten years later. Unlike Lyon and her peers, these later bodybuilders literally reconfigured definitions of the feminine and female power.

Larger bodybuilders of the first wave, such as Laura Combes, Kay Baxter, Lori Bowen, and especially Bev Francis, paved the way for the body that would become widely accepted by the end of the '80s. This body had comparatively so much more muscle mass, vascularity, and striations that it made typical first wave bodies look tiny; Francis was the first to build this kind of body, roughly eight years before its time. Francis, a powerlifter, switched to bodybuilding in the early '80s and constructed a body with so much muscle mass and so little bodyfat that from the neck down it appeared gender indeterminate. Her body was the focus of the controversy over femininity that raged in *Pumping Iron II: The Women* and remains a crucial question in the sport to this day. In the movie, Francis's body was positioned as the counterpoint to McLish's beauty-queen good looks, perceived by many as an example of the threat women's bodybuilding can pose to traditional notions of femininity. While Francis finished a humiliating eighth in that contest although she was clearly the most muscular, her body set a standard of possibility for women that would reach ascendancy in the 1990s, when the densely muscled Lenda Murray was crowned Ms. Olympia. The early '90s marked female bodybuilding's second wave, an unprecedented period in development of the female form in which really big women were the norm. Since 1994 there has been an uneasy acceptance of a few huge women such as Ms. Olympia Kim Chizevsky, but it is the much smaller fitness competitors (whose bodies resemble the earlier model of

Lyon and McLish) who garner the most public visibility today.

If we encourage the right for women to develop themselves as individuals rather than packaging themselves to conform with an old standard based on diminishment, this should not be the case. There was and is a lot at stake in women's bodybuilding. More than any other image, more than any other embodied experience, the muscular female body stands as an irrefutable sign of and substantiality in a culture that has traditionally configured the nonmuscular, feminine body as insubstantial. She weaves her own pattern in the loom all right, and the other elbows and arms stay out of her way. Whether she is conscious of it or not, the female bodybuilder carries the ghost of the traditional feminine, *chingada*, with her into the gym. She is haunted by it, and it hollows her out. But it is also what drives her. Each repetition she performs, each curl for her biceps, each press for her chest is a strike against those shrieking ghosts—*a woman is feminine*, *a woman is weak*. These repetitions are marks against nothingness, inscriptions on the tomb. Each heavy weight she hoists is concrete evidence that she is substantial, that she has her own being, that she is there. Marking the face of being, marking time.

Perhaps more than any other sport, female bodybuilding represents the visual and tactile deconstruction of the traditional feminine, its nothingness, its status as impotent shadow. The muscular female body is a physical, irrefutable presence that disavows all the old ideas about female weakness and inferiority. It stands as an individual achievement, a tangible, lived refutation of ingrained cultural assumptions of feminine insubstantiality that, in concrete social situations, still affect who is valued and who isn't, and whose voice carries more weight.

Female bodybuilding is about sovereignty, establishing a place in the universe. Its obsessiveness, based in control and repetition, is also an expression of the fear that one may simply fade away or disappear into the peripheral darkness outside of civic life. It is about the violent struggle for "recognition" as Alexander Kojeve, in his reading of Hegel, describes it: "He must make himself recognized by the other, he must leave in himself the certainty of being recognized by another . . . He must overcome [his adversary] 'dialectically.' That is, he must leave him life and consciousness, and destroy his autonomy."[14]

Traditionally, in the dialectic of the feminine and the masculine there was no struggle, because life, consciousness, and autonomy, were fought for only between men. Women, as impotent shadows, weren't even in the fight. Women were rigorously socialized not to assert

ABOVE: JOCELYN TAYLOR, *ARMIDE 2000*, 1999. STILL FROM SINGLE CHANNEL VIDEO WORK. PICTURING ROSEMARY CHEESEMAN.

OPPOSITE, BACKGROUND IMAGE: LOIS BOSHER, ONE OF THE EARLY MODERN-ERA BODYBUILDERS, C. 1960S. BLACK-AND-WHITE COPY OF PHOTOGRAPH, 6 × 10".

themselves, and self-assertion was always punished. The cultural "taboo against female self-assertion" as Alice Echols calls it in her introduction to *Daring to be Bad*, operated precisely to deny women this struggle for being.[15] Throughout Western philosophy and its manifestations in lived, daily culture, there runs the fear of a Copernican revolution that would lead to a self-erasing decentering. Power and prestige in this world is measured by one's gravitational pull, the strength of one's struggle to distinguish oneself and exist.

The assumption of individual sovereignty, the idea that women were free and separate individuals in control of their own destinies, lay behind the crucial concepts of reproductive freedom and equal opportunity. The language of sovereignty, so critical to the second-wave women's movement in the U.S., has dropped out of the cultural lexicon, a rhetoric of absolute justice and individual rights replaced by the much weaker rhetoric of choice. But now there is a body to match the power of the earlier words. Strikingly, nonverbally, with her liv-

ing, breathing, powerfully shaped flesh, the female bodybuilder gives us this vocabulary once again. Irrefutably there in what Joanna Frueh calls the female bodybuilder's "monster/beauty" is an enactment of sovereignty and self-determination in the flesh.[16]

Female bodybuilding is about the impossible quest for recognition, centrality, and all it entails, the quest to be seen as a worthy adversary in the struggle for being. But in postmodern culture there is also the awareness that the fight itself may be meaningless, so the female bodybuilder's quest is also about the fear that when the fight is over, despite winning, she might still be only a dusty satellite circling a distant, dead star. The idea is to become luminous, visible, enormous, a presence that shines through being seen, an irrefutable mark that clutches being by the throat and wrestles it down so she can stand clear and free.

Unique in our history, at this particular cultural moment female self-assertion is tolerated, or at least not punished as much as it has been in the past.

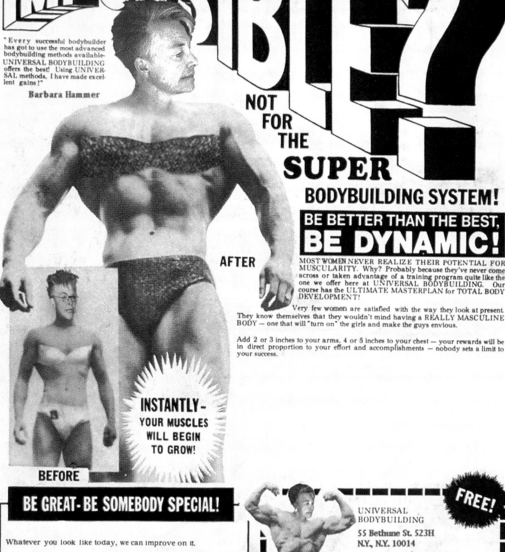

The gauge of this is the cultural attitude toward the female bodybuilder, who is still the most visible mark against female diminution, or woman as less-than. Not as good, not as much. If she asserts herself, if she steps out of that less-than place as female bodybuilders have most certainly stepped, she becomes too-much. Often, through cultural ridicule, these women have paid for this assertion. When you hear someone say that a female bodybuilder is "unfeminine," "too big," or that women "shouldn't look like that," these statements carry within them cultural traditions that wipe out women as individuals, persons accepted and valued beyond their traditional roles.

Such statements are marks against female viability, our very being. But there is a widespread cultural acceptance of the female athlete generally, which signals that we might at last be truly stepping out of the shadows for the first time. Freedom? Autonomy? Choice? Keep your eye on the female bodybuilding scene, for if the sport passes away into fitness, those words will mock us, and we will be faceless, bloodless and bodiless once again. Beautiful, empty terrors. *Chingadas*. Ciphers. Holes. Let's not go back there. Keep your eyes open and your ears to the ground, and keep your biceps pumped.

Notes:

[1] Octavio Paz, "The Sons of La Malinche," in *The Labyrinth of Solitude* (New York: Grove Press, 1985) 79, 86.

[2] Cherrie Moraga, "Preface," in Cherrie Moraga and Gloria Anzaldua, eds., *This Bridge Called My Back: Writings By Radical Women of Color* (New York: Kitchen Table: Women of Color Press, 1983), xvi.

[3] In *Anorexic Bodies*, Macsween writes, "In our equal opportunities culture a non-gendered subjectivity is—formally at least—'available' for women, who are simultaneously non-gendered subjects and feminine objects. The superficial gender-neutrality of individuality masks its fundamentally masculine character. . . . Reconciling the hidden incompatibility between individuality and femininity is the central task of growing up female in contemporary Western culture." Morag Macsween, *Anorexic Bodies* (London: Routledge, 1993), 3.

[4] G. W. F. Hegel, *The Phenomenology of Spirit*, trans. A. V. Miller (Oxford: Oxford University Press, 1977), 270.

[5] Simon Reynolds and Joy Press, *The Sex Revolts: Gender, Rebellion, and Rock 'n' Roll* (Cambridge, Mass.: Harvard University Press, 1995), 11.

[6] *Bradwell v. Illinois*, 83 U.S. (16 Wall) 130 (1872), 140–42; quoted in Robin Morgan, ed., *Sisterhood is Powerful: An Anthology of Writings from the Women's Liberation Movement* (New York: Random House, 1970), 163.

[7] This is now further echoed, ironically, in the Nike Web site for girls, which was first called "Play Like a Girl," and then "Girls in the Game," and serves as a forum for young female athletes to speak to each other about their sports experiences (http://www.nike.com/girls/).

[8] The Bierce citation appears in Morgan, *Sisterhood is Powerful*, 36.

[9] David Wild, "Television Reality Bites Back," *Rolling Stone* 742 (5 September 1996): 71.

[10] Susan Bordo, *Twilight Zones: The Hidden Life of Cultural Images From Plato to O. J.* (Berkeley: University of California Press, 1997), 57.

[11] Karen Karbo and Gabrielle Reece, *Big Girl in the Middle* (New York: Crown, 1997), 175.

[12] The address for Faith Sloan's web page is http://www.frsa.com/bbpage.html.

[13] See Bill Dobbins's introduction to *The Women* (New York: Artisan Press, 1994), 26.

[14] Alexander Kojeve, *Introduction to the Reading of Hegel: Lectures on the* Phenomenology of Spirit (New York: Basic Books, 1969), 15.

[15] Alice Echols, *Daring to Be Bad: Radical Feminism in America 1967–1975* (Minneapolis: University of Minnesota Press, 1989), 17. On male bodybuilding as a demonstration of the precarious nature of being, see Leslie Heywood, "Masculinity Vanishing: Bodybuilding and Contemporary Culture," in Pamela Moore, ed., *Building Bodies* (New Brunswick: Rutgers University Press, 1997), 165–83.

[16] See Joanna Frueh, "Monster/Beauty: Midlife Bodybuilding as Aesthetic Discipline," in Kathleen Woodward, ed., *Figuring Age: Women, Bodies, Generations* (Bloomington: Indiana University Press, 1998).

toward a new
aesthetics
of body
for the
mod-
ern
woman

selected writings of Al Thomas

BARBARA ALPER, *MUSCLES AND CURLS*,
1995. BLACK-AND-WHITE PHOTOGRAPH,
20 × 16". PICTURING JUDY MILLER.

al Thomas is unique in our time. He has contributed more than any other individual to an understanding of female muscle through both his discourse and his life's endeavors. Thomas's writings are rhapsodic and devotional—personally invested theory that demonstrates a scholar's breadth and specificity of knowledge. Voluptuous and densely fleshy, like the subject it addresses, his work is revelatory and complexly textured in its probing of the meaning of female muscle, for he delves into the recesses and arcane regions of human experience. Literary critic Maxwell Geismar's statement about Thomas Wolfe, published in 1946, readily applies to Al Thomas: "both in his build and in his inclinations there is little of the synoptical in this writer."[1] In attempting to convey the essence of Thomas's writings on the subject of the muscular woman, the editors of this book were faced with the dilemma confronting Geismar as editor of Wolfe's work—the difficulty of selecting from an author's richly expansive writings. Chronologically arranged and spanning three decades, these edited selections stand as only an introduction to Thomas's capacious and mostly unpublished work.

—Laurie Fierstein

"some notes toward an aesthetics of body for the modern woman," 1968[2]

even the painfully frustrating sexual role to which [woman] has been conditioned by centuries of manipulation by shaman and priest (inglorious decline from the reign of magna mater, big-breasted and stout of thigh), even this is merely symptomatic of a larger disorder. Woman's malaise, the anger which has sparked the present revolution, grows out of her unawareness not only about what her body is, but about what body is. Body, itself. This is not just an affirmation of the need to reestablish a sense of the "feel" of the body. . . . It is more than this. Woman can have a deeply experiential sense of the "feel" of her body and still fail to authenticate herself existentially, and still remain submissive to the cultural patterns and definitions which were part of the dehumanization implicit in the roles according to which she saw herself.

ABOVE: LAURA BINETTI, 1997.

RIGHT: TWIGGY WITH ADEL ROOTSTEIN MANNEQUINS, 1967.

In the sense that it is used here, "body" is the means by which idea or concept is made "beautiful in flesh to walk."[3] If the purpose of these notes were the establishment of an apocalyptic-religious mode of viewing "body," rather than the creation of an aesthetics, one would be inclined to refer to the later writings of Norman Brown.[4] Indeed, such a reference is relevant since, in establishing an aesthetics, one is called upon to examine a percipient's movement from symbol or trope or metaphor to truth, from *figura* to *veritas*. . . . As a step toward the delineation of an aesthetics of body, the Brownian rejection of mere conceptual (Apollonian or sublimation) consciousness in favor of experiential (Dionysian or bodily) consciousness is also helpful. In his view the ultimate "thing to be realized is the reincarnation. The last mystery to be unveiled is the union of humanity and divinity in the body." The final and saving victory is that won over the literal, the concept, thing-denying abstraction. . . .

On the other hand, a sense of the spiritual is not communicated discursively; it is released in the percipient as feeling by the tension or disequilibrium set up in him by the field of force created by the thing, the body. Unlike the word which does not contain meaning, the thing, by virtue of a sensory relationship the percipient immediately establishes with it, does in a sense "contain" the feeling released in him. . . .

For woman to "know" herself, to discern with the living flesh of her hand the mysteries of the living flesh that is she, she must be a breaker of the little gods of the hearthside who have exacted her womanliness as the price of their propitiation. Her meatness is she, and there is no definition of her—however highflown its accounting of soul, *anima*, breath, spirit—that can properly fail to grapple with the aesthetic-religious problem that consciousness terminates in flesh. The little gods of the hearthside are literalists, abstractionists, idolizing and idolized by words. Woman strong in the flesh is death to abstractions, the canards of mystiques feminine, aesthetic, or "religious." "Incarnation is iconoclasm. Literalism is idolatry." Woman strong in the flesh has wakened *to* body, not *from* body. Fulfillment, in both the religious and aesthetic senses, is not in idea, but in carnal thingness, in body.

. . . Dionysus [is] the apotheosis of fleshly emancipation and symbolical consciousness, which, like the snowflake, needs its speck of thingness, its body or

symbol, to crystallize around. . . . The worship of Dionysus is in freedom, the fearless realization of the bodily sense, the concomitant of integrity or wholeness. . . .

At this low point in her decline from the matriarchate, the body of woman is a counter, an abstraction, like paper currency, without value in itself, useful only in trade. . . . Her complaint should be of de-objectification. In the times beyond recall and proof, except for the proof implicit in man's archetypal fear of wholeness in woman, the sun was female, the woman her earthly vicar. A drop of silver sperm, the moon: the male. And then, as now, the vicar participated in the attributes of deity. The earth mother was, at once, her Sun Mother's creator and creature. (The narcissism of man's creating a god in his own image.) Woman: steady, strong, the source of light and heat, the giver of life. Man: a consort, capricious, a satellite, reflecting her heat, feeling vigor only in her presence. Earth mother, *magna mater*, ultimate thing, ultimate object: maternity, fecundity, passion, fire given flesh. Each to be experienced immediately in the flesh, not qualities drawn away from it, inconceivable as abstractions. Each without existence except as flesh, except *in* flesh.

. . . Her objectness was the focus in the realm of shadows for all the essences without which life would be sterility. . . .

All of this is not merely semantic cavil of the polemicists' misuse of the term "objectification." Before freedom can be won, it is necessary that woman realize the nature of her enslavement, and in a larger sense than any other, it has resulted from the immemorial process of abstraction to which she has been subjected. As a result of this, she has come to be ever less a concrete particular and progressively a manipulatable abstraction winnowed off from the intractable thing. . . .

Twiggy is the idea of female with all its localizing concreteness winnowed away.[5] Part of the shock, when it was one of recognition, resided in the sense that the English girl exuded so much sunniness and freshness, but nonetheless failed to crystallize out from the male's solution of consciousness of that unmistakable experience: woman. One's response to her was like that to a pleasant idea. It is not strange that adjectives, such as "coltish," "whimsical," "ingenuous," "girlish," came abundantly. They always do concerning ideas. Ideas are far easier to communicate than feelings, and our response to them is more tranquil. . . .

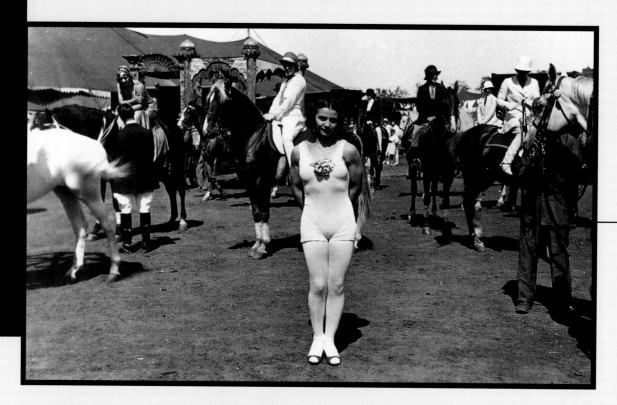

. . . One's sense, with Twiggy, of being "vaguely disturbed" and dissatisfied comes from the awareness of his being cheated, which is inevitable when abstractions, however pleasant, are substituted for the mystery of body and its call to the carnalizing of knowledge, to a knowledge not of deduction but immediate perception, of bodily senses. . . .

The abstractionist spoke in the person of sergeant of police, freeloading at the circus, when nudging a sidekick and grinning, he eyed the lithe aerialist striding by: "Christ, what a pile of muscle, looks like a man." Fertile ground for the ironist. But reason for despair to all who looked with pleasure upon the sinuous articulation of flesh, bone, and muscle which was female body—and without which all the network of intellectual, emotional, and spiritual energies would be as nothing, the shadow of a nothing . . . the policeman was unable to find a response appropriate to the particular in all its intractable contingency and hence, abstracted away from the thing-in-itself an aspect of it,

muscularity, classifying this as he had been "taught" under the larger generic heading, "man."

. . . To respond to incarnate woman—as opposed to specific qualities abstracted from her total field of force—one has to sense the whole by an immediate perception of the bodily senses, not by falling back upon comfortable (but killing) expedients of generalization, categorization, or deduction. To help their followers achieve an authentic sense of value, the advocates of freedom for the modern woman must establish an aesthetic of body on this sort of insight. But they must be sensitive, also, to psychological imperatives acting upon themselves as well as upon men. These forces have made the prototype of the fragmented female inevitable in a male-dominated society. This prototype is so "comfortable" indeed that most women will not choose to exchange it, even for that of the whole, incarnate woman.

. . . The perceptive have never needed scientific study to unearth the source of these psychological imperatives and the ends they served in the male ego. The study, however, has been made, the statistics compiled for all to read, if they have but the eyes to see. Masters and Johnson in *Human Sexual Response* have broadcast to the world the best kept secret of all time: the sexual superiority of women.[6] The source of self-contempt, worry, recrimination, anguish: in print, at last, to a chorus of relieved sighs. Perhaps now that coitus has been relieved of the built-in . . . corollary, that Laurentian phallicism which is just another aspect of Puritanism—perhaps now the return to whole woman, woman in all her flesh, is possible. The findings con-

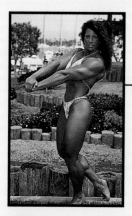

TINA LOCKWOOD, 1994. ♀

cerning woman's greater capacity to experience sexual pleasure and her longer sexual life are true, of course, only for women who are free of male- and custom-decreed roles of passivity based upon a conditioned sense of physical inadequacy. The study is liberating only for women who are free of the sense that their value depends upon their assimilability into a conceptual pattern masterminded by men. Perhaps when men realize that the inferiority of their orgasm to woman's is not a sign of personal inadequacy, but their sex's, the need to reduce woman to an abstraction will gradually disappear.

LEFT: AERIALIST LUISITA LEERS POSES ON THE GROUNDS OF RINGLING BROTHERS. BARNUM & BAILEY CIRCUS IN CHICAGO'S GRANT PARK, AUGUST 1933. BLACK-AND-WHITE PHOTOGRAPH, 2½ × 2".

BELOW: LOUISE BOURGEOIS, *ST. SEBASTIENNE*, 1998. INK ON PAPER MOUNTED ON CANVAS, 73½ × 63".

The symbolizing faculty being what it is, women's body and flesh and muscle have always been been feared as objective correlatives for a sexual potential vaguely apprehended by the adult male—and pre-saged by the body—as an implicit threat to him as an individual, rather than as a member of a sex. The power-for-evil of an unbreathed secret. Hence, the need to divest woman of her flesh. The need to see her as only a role-bearer is just another abstractionist ploy, saving man from a confrontation with the incomprehensible, the inapprehensible woman with all her baffling variety and particularity hard upon her bones. Twiggy is a threat to no man. She evokes at most a curious smile, nothing of the sense of being

thrust back upon his phyletic resources that man experiences in the presence of body, the ever-changing, changeless wonder of it. . . .

. . . Both freedom and self-realization depend upon the modern woman's sense of her reality. Hers is the body made, not received—and surely not received as merely one abstraction among many comprising the ground rules of a male-conceived femaleness.

"introduction: some notes toward an appreciation of the female mesomorph; societal and cultural responses to her body type and this book's role in the vindication of her and her new aesthetics of muscular femininity," 1983[7]

muscles are admired in all God's creatures but one, the human female. It has not, however, always been thus. In time beyond memory, *magna mater* bestrode the hearthside, marketplace, and training field. A mighty fortress: mother, chieftain, champion. She embodied the power, both spiritual and muscular, of the female principle until, whittled-away down through the epochs, it was turned into the powerless "feminine" principle. . . . If, since those sane and simple times, admiration for woman's muscle and socio-political autonomy has unraveled into contempt, there are at long last signs of a change in the wind. . . .

[This study] is about the female mesomorph.[8] It is a paean to her mesomorphy. It is a beckoning of the muscular woman out of her "safe" closet, an invitation to join the human race. Strong words, but an overstatement only to those who have never experienced, or loved somebody who has experienced, the dehumanization visited upon the "girl with Mr. America muscles."

Among other concerns, this [study] provides some notes toward an *apologia* (defense) for the muscular woman in a world where there is absolutely no professional literature dealing with the problems attendant upon a girl's discovery of the inevitable burdens of mesomorphy in a culture whose aesthetics of physique comes from the "ladies' magazines." In our era, the epithet "muscular" is applied to women as a value judgement expressing contempt, rather than as a neutral term which either is or is not appropriate, given the body type of the referent.

This [study] provides an alternative to the dehumanization suffered by the female mesomorph from earliest childhood because of the taunting of friends, to whose jibes she is, and will always remain, fair game. Such cruelty she comes to see as her just due. By the time she reaches woman's estate, she may never have experienced any other consistent response to her, her body, and consequently her very being. Unless a creature of

unshakable self-esteem, she is ready to be hacked to size on a Procrustean bed, predictably enough the size and shape of her ectomorphic sisters. . . .[9]

This book is for the muscular girl and woman athlete who, settling back with a book on weight training for women, is stabbed with an expression of contempt for her body type, which is all the more painful for its implicitness and unlikely source: "Women are capable of performing maximal resistance exercises and achieving considerable levels of strength with little or no overt evidence of muscular hypertrophy" (muscular development of a high order). Such assurances are anything but assuring to the young mesomorph. And they speak multitudes about the real world's feeling about womanly muscle, not to mention the real feeling of physical educators: (1) that hypertrophy can always be avoided and (2) that "overt evidence" of muscular development should be avoided by "real" women.

One of the purposes of this [study] is to provide such women with a sense of both the inevitability and the desirability of muscle for mesomorphs and the superior pleasure available to such women because of their unique beauty. Many women can achieve high levels of strength and athleticism with little evidence of hypertrophy. Many men can, too. Some women, and men also, cannot. About one women in three is a mesomorph, and exercise goes to her muscles. If this seems an exaggerated estimate, the reason has much to do with this somatotype's wide range. Another reason is that muscular females, despite a positive prognosis for success in most sports, represent a disproportionately high percentage of sport dropouts. These naturals discover early in their careers that their muscles are soon growing, if not bulging, however "daintily" they may exercise. Since membership in their clique (not to mention their sex) is threatened by overt muscularity—the causative agents for their "despised" condition (sports and exercise) are sacrificed. The loss to sport is significant. The loss in human terms is hardly less than tragic. It is this hatred for the emblem of her very being, her body (a self-contempt to which she is conditioned from birth), that turns the muscular girl away from sport. The lesson comes early to her that a society is willing and eager to reward the slip-of-a-girl who performs athletic feats beyond those expected of a slip-of-a-girl, but has only contempt for the strong-limbed mesomorph whose performance can never outstrip the expectations aroused by her magnificent muscle. . . .

One of the purposes of this book is to redress the grievances of women who, though deeply committed to strength and muscle, used to find most of the strength publications closed-off to them, but not closed to "lithesome cuties" who postured prettily with weighted

wands in a manner sufficiently unthreatening to allay the fears of the balding dodderers in the strength establishment. No threat to anybody resided in such caricatures of womanhood—except of course to the long-suffering mesomorph. This book is for all the long-ignored women who have paid the freight in the game of muscle building, only to find themselves humiliated by seeing even the serious publications throw open their doors to the atrophied beauty queens and then slam those doors in their faces as women with "too much muscle," as women with whom "most of our 'lady' readers couldn't or wouldn't want to identify" (as one editor put it).

This book is a first spring day, looking forward to what promises to be a long hot summer of attention paid to these magnificent women of strength. It is the opening of closet doors, the payoff to long months and years of heisting barbells in cellars, bedrooms, garages, and, too often, unwelcoming men's gyms. It is the coming of age of an exciting new sport and also of an athlete of beauty who is destined to redefine the criteria of both womanly beauty and womanhood.

"the symbolism of body: muscle as metaphor," 1983[10]

Prefatory Note: Not long ago I was taken to task by an anthropology professor, fresh from an article I had written on the body as metaphor: "I liked your piece," he wrote, "but isn't it a bit theoretical for a phenomenon which is commonplace enough, the woman with prominent musculature? I remember examples aplenty from my youth—and fondly, too, I assure you." My response was, and is here, that "theoretical" or not, any serious treatment of the female mesomorph has to start with just such a consideration, and none ever has. If the only concern were with what the female mesomorph "is," there would be no problem. All the best fabricators of the female form, from the Greeks through Michelangelo to Maillol, have been intoxicated by the female mesomorph.[11] What other sort of physique could have ignited their creative fires?

Can one imagine Jaclyn Smith or Marilyn Monroe as models for the Nike of Samothrace?[12]

That which has caused the muscular woman to become a pariah, however, is not what she "is," but what she "means," what she is the metaphor *of* or *for*. Because this mystery has never been broached, much less solved, the female mesomorph remains the only slave still remaining to be liberated by the women's movement, which has not yet even begun to train its big guns at the institutions and frames of mind which have dehumanized the woman of muscle. Women athletes have been discussed to death. Mesomorph women as mesomorph women—never. Women's muscle-as-muscle remains an embarrassment, even to the liberationists it appears. . . .

The downright anger generated by the phenomenon of women's bodybuilding is a gut reflex that bespeaks much about the painful dislocation of old truths concerning "proper" female roles and, ultimately, about who's on top (metaphorically or literally). In addition to being something that moves mountains and curls barbells, the body is a metaphor that moves. It is symbolic. As a new bodily ideal insinuates itself into our culture's sensibility, so does a sense of body's "meaning," along with an awareness of the forces responsible for our culture's manipulation of women through the entrenched metaphors of femaleness.

The subject of womanly muscle has been historically consigned to whispers or locker-room jokes. Not so here. . . . The intent . . . is to de-mythify the forces that have celebrated atrophy . . . as our culture's touchstone of womanly beauty, souring in the process our primitive pleasure in Diana's full-muscled body (and all that it sings of the untrammeled spirit).

"the stony heart and the heart of flesh: some notes toward a resolution," 1997[13]

the female mesomorph—and the ideal she embodies—seems defeated here at the beginning of 1997. . . .[14] This fallen goddess faces a decision. She can choose from a huge cast the "correct role model" for herself, or she can . . . transform herself into a "role model for her culture and her time." If she chooses the

ANN SPERRY, *JEWELRY FOR AMAZONS.*
ARMLET, 1998, STEEL AND GLASS,
5 × 12 × 7½".

HEATHER FOSTER, 1997.

latter alternative, she'll have to face with Amazonian fortitude the hard truth that the meaning of Grand-Flesh—the body-as-symbol—is a deeply interior and immanent meaning: one that is emblemed at the far end of the dark journey into herself, into her sex's and her race's self. . . .

Understanding the body is not achieved by the mediation of the conceptual faculties. The body is best understood by those who apprehend, if not always comprehend it as the working-out in man of the phyletic . . . One's understanding of the body, then, is rooted at levels of our unconscious as deep as the terrain mediated by archetype and symbol (and by the body as symbol). It is rooted in that part of our human continent which is the domain of sexual process and procreation, the part which resonates not to ideas, but to the particular and the concrete: the sacrum (so appropriately named by the ancients who knew that the sexual process is precisely that, sacred). Strangely, perversely perhaps, the mediation process that occurs in the sacrum, the realm of sexuality with its resonance to the body and to the concrete, is still suspect to the abstractionist, still not acceptable in the drawing room. . . .

Like a painting, like a sculpture, the human body provides an audience with an insight into the very private and personal mythology of its possessor/creator. This mythology is embodied *in* and *by* (given meat *in*

and *by*) the human body. If the ultimately developed female body provides a deep insight into a dramatically structured and hence complexly satisfying personal mythology, it is because such flesh is the product of great cultivation and much poetic "making": a deeper and more symbolic probing of our condition than that of the game-playing Fitnessist's less dramatically structured, less complexly satisfying, and less "poetically made" flesh and muscle. . . .[15]

More than a Fitnessist's often beautiful leaping-about on a platform—more than any other bodily endeavor—the cultivation of profound accessions of strength and muscle is an interior process. If the fitness competitor is locked into the abstract rules of Fitnessism, the ultimately developed physiquewomen (locked in to her corpuscular interior self) is pure artist, as profoundly opposite her fitness sister as the artist always is from the abstractionist. The inspiration, and also the stuff, of the physiquewoman's creation is that of all art: body. In what sense "body"? Body as the opposite of idea; body as the opposite of the abstract geometries of leaping-about on a fitness competition platform: but (ironically if not perversely) body, also, as the only means of release in its "audience" of the deep feeling that is triggered whenever body—and especially ultimately developed female body—moves into, and through, its audience's "force field of consciousness."

Spirit: the source of the currently Fallen physique-woman's resurrective power, the source of all human renewal and heroic revitalization. . . .

The deep memory is what informs us when, alone (always alone, adrift-on-our-own, as in no other game), we dive into the sea (of our Being); and rising to the surface, we embark, without a coach, upon our ponderous swim. Alone. . . .

Hunkered-down in her holy middle, the deep-diving physiquewoman, the body-as-symbol, discovers, not as a theory but as nonverbal, immediate, sensory, transforming experience: a "unified field." There in her sacrum (where thought has become living cells), she experiences an inner reality as complex and diverse as its twin, the "reality" of the outer world. . . .

One comes to the realization that symbol-consciousness, Spirit-consciousness heals. The ancient notion that "body is spirit" is a "natural" one to folks who have never even heard of Nietzsche or Emerson or Norman Brown or any of their disciples. . . .

In symbol consciousness, the reality principle (the appearance and power principle) gives over to the suzerainty of thought: external reality gives over to internal reality; psychoanalysis gives over to the realm where thoughts are all-powerful. The strongwoman believes with a "child"-like power in her new interior reality, in her new symbol-consciousness: she hunkers herself down in her "sacred middle," restores her divided and broken old self in Spirit, and then proceeds to the next thing to be done in "delicious anticipation," in "confidently knowing anticipation" of unprecedented Powers.

INTERNATIONAL FITNESS CHAMPION DEBBIE KRUCK, 1992.

untitled essay, 1998

embarking upon the new millennium, we discover in a recent essay by Sam Keen, "Awakening the Spirit in Everyday Life," that "our interconnectedness with the cosmos is programmed into our genes" and, just as critically, that the new ecological-spiritual myth is premised upon our reunification with Nature and upon our burgeoning awareness of the power implicit in a culture-crystallizing (and -symbolizing) image of a sexual embodiment informed more by inclusion—either sex imaged *in* and *as* the other—than by the old and killing exclusion—either sex imaged *apart from* and *other than* the other.[16]

We foresee and have, in a sense, already embarked upon an epoch whose chief moral determinants are premised upon a monistic (non-dualistic) hierarchy of manifestations: a unity which is implicit in the symbol-generative discovery of the high in the low (the seeming "low"); a religious-aesthetic dynamic in which Spirit celebrates, and is celebrated in, species-unifying and species-informing incarnation, the (w)holiness of thingness; and a sense of the new epoch as a continuing exegesis whose primary text centers on the androgyne (the feminine as masculine, the masculine as feminine)—the unification of the heretofore fragmented individual, and in this re-memberment the discovery of the individual's ancient, immitigable, and not-yet-divisioned (w)holiness.

Leaving behind the myths of Patriarchy and their apotheosis of progress and unlimited growth, we settle in upon a new millennium whose informing and heroic myth is not the old one of the high- and low-born, but a heroic myth of unity and oneness, its constitutive metaphors will be substanced of toe-stubbing natural symbols that express in the blood-laden language of body the contraction of the dying millennium and the expansiveness of the new one: the natural symbols that distinguish the abstractionist and masculine *fin de siècle* (premised upon ego and conceptualism and doingness) from the body-resonant and feminine New Age (premised upon Spirit and experience and being). The completion of this movement from Patriarchy to a New Order based upon *unity* awaits the exactly correct, consciousness-clarifying symbology.

The movement beyond Patriarchy awaits the symbolizing and centering vision that focuses far beyond Patriarchy, *not* upon a soft-minded redemption of some sort, envisaged (in a false either-or dichotomy) as Patriarchy's opposite, but upon a fusion that focuses on health, upon a culture that's healed and re-membered, upon a social contract that's truly just. If not to Matriarchy, wise and empowered woman looks forward to a time and a culture in which men and women, either sex *in* and *as* the other symbolically, honor and trust and

empower their feminine and feminine-masculine aspects. Such honor(ing) and trust(ing) and (em)power(ing) will permit men and women to love each other, freeing them from the distrust and disdain which, in the old Patriarchal order, had killed off their ability to love themselves as themselves; as well as having killed off in the men any capacity to relate to their *own* feminine aspect, much less to the women in their lives. The New Epoch awaits the symbol-vision of an embodied feminine principle, in whose confrontation a desacralized environment and its culture are restored.

Unlike her Fitnessist sister, who is committed to the "world of the father" and to the culture of containment, our avatar (of the Eternal Feminine Archetype asleep in our unconscious) will not, cannot, cower in denial of this new era, whose tentative shapings and redefinitions of power are joined with—annealed into—femininity's—and feminism's—phylum-organizing and -informing powers.

The beautiful Fitnessist's figure as metaphor is pursued and seized as yet another means of self-liberation

in late-twentieth-century capitalism, but, upon closer study, betrays itself to be the very opposite: the cruelest illusion of a choice (or a behavior) that truly liberates.

Unlike her Fitnessist sister, our Avatar of the Eternal Feminine doesn't give over, as her beautiful sister has, to *virtual* size and *virtual* form, but rather celebrates a manifestly real and even heroic feminine size and form, stretching and opening up femininity's contraction at the end of the old century: glorying in her physique-reminder to the new culture about the body-architecture of (a godlike-) goddessness, the ancient conservatism of (godlike-) goddess-body's traditional unity.

In today's iconography, the profoundest bodying-forth of this monumental (androgyne-) female Unity is the ultimacy of late-twentieth-century bodybuilding flesh. How strange that this woman-body, seen by many in 1998 as a freakish perversion, is the body that (on its own unyielding terms) swims into our consciousness, not as something arbitrary, added on as an afterthought, but as the metaphor—the emblossoming epiphany, the phyletic artifact— perfectly responsive to the New Woman of a New Age. Monumental, bodybuilding, female flesh provides the structure, the "architecture of soul," the ultimate jumping off point for a formalist understanding of imponderble Amazon womanness, which echoes so resoundingly Archibald MacLeish's reminder to us in "Ars Poetica" that the ultimate-enfleshing, like any other "poem," "should not [merely] mean, but be."

SARAH VAN OUWERKERK, *MOTHER AND DAUGHTER*, 1995. BLACK-AND-WHITE SILVER PRINT, 20 × 16". PICTURING JENNIFER GREENBAUM AND SHANA.

This, then, is the body accused of having pushed the sensibility and aesthetics and *order* of our time to the very edge of chaos, but which, instead of destroying order, or fleeing its demands like the Fitnessist, plays out the ordering role, the role that inevitably devolves to woman. It seems inevitable that the body-as-symbol and its tenant, keyed to the power implicit in their noble metaphor-form, will turn their culture back from the brink. And (far from remaining at odds with their disinheriting sisters or *even* the hierarchical establishment)

they will rise to and transcend these challenges, as only such a body (as symbol) and its heroic tenant can.

The impact upon an observer of such an heroic body—as a text to be experienced formalistically in a formalist-critical mode—is inevitably a function of expression, not of communication, per se. What the observer "gets" from such a body—that which is released in him as feeling ("meaning")—is wrung, almost literally, from body-elements that resonate "poetically" as things (as things always resonate "poetically") in his nervous system, NOT as ideas in his brain, NOT as ideas "communicated" by some directing mind behind or outside the body—but by the body as body, by the body in all its species-unifying and species-informing incarnation and thingness, by the androgyne-body and its celebration of unity and of the discovery of the individual's ancient, immitigable, and not-yet-divisioned (w)holiness.

Notes:

[1] Maxwell Geismar, ed., *The Portable Thomas Wolfe* (New York: The Viking Press, 1946), 1.

[2] From Al Thomas, "Some Notes Toward an Aesthetics of Body for the Modern Woman," *Compass* (1972): 3–10. The essay was written in 1968.

[3] Often in Thomas's writings quotation marks appear not only around words and phrases that are meant to be questioned, but also around phrases such as "beautiful in flesh to walk" that are quotes from the literature and poetry that he taught over a thirty-six-year career as a professor. Occasionally Thomas cites the sources of such quotes in the text, but he has not provided endnotes with publication data or page references. Circumstances during the preparation of this book made it impossible for Thomas to provide the editors with complete sources. In order to preserve Thomas's style and content, we have chosen to leave uncited literary quotes in the text as they appear in both his published and unpublished work. In the few cases where Thomas cites an author and publication, we give publication data in a note. *Eds.*

[4] Thomas is referring to Norman O. Brown's *Love's Body* (New York: Vintage Books, 1966). *Eds.*

[5] Twiggy was a British model noted for her extreme tenuity, who in the mid-1960s became the archetype and icon of an anorexic look prevalent in high fashion today. *Eds.*

[6] William H. Masters and Virginia E. Johnson, *Human Sexual Response* (Boston: Little, Brown & Company, 1966). Eds.

[7] Al Thomas, "Introduction: Some Notes Toward an Appreciation of the Female Mesomorph; Societal and Cultural Responses to Her Body Type and This Book's Role in the Vindication of Her and Her New Aesthetics of Muscular Femininity," in Al Thomas, et. al., *The Female Physique Athlete: A History to Date; 1977–1983* (Abs-Solutely/The Women's Physique Publication/Bill Jentz, 1983), 9–12.

[8] Mesomorph: the physique characterized by predominance of the structures developed from the mesodermal layer of the embryo: bone, muscle, connective tissue; hence, the muscular body build. (Though not impressed by the validity of Dr. Sheldon's somatotyping as a psycho-physiological measuring and classificatory technique, I am employing his terms here since they are generally familiar and useful to a discussion of this new, anti-traditional aesthetic of physique.)

Dr. Sheldon is Dr. William Herbert Sheldon. *Eds.*

[9] Ectomorph: The physique characterized by predominance of the structures developed form the ectodermal layer of the embryo: skin, nerves, sense organs, and brain; hence, the slender body build, with insignificant muscular development.

[10] Thomas, "The Symbolism of Body: Muscle as Metaphor," in Thomas, et. al., *The Female Physique Athlete*, 17.

[11] Michelangelo used male models as a basis for his mesomorphic female figures. *Eds.*

[12] Jaclyn Smith was one of the three female stars of the 1970s television series *Charlie's Angels*. All three looked like ectomorphs. *Eds.*

[13] Al Thomas, "The Stony Heart and the Heart of Flesh: Some Notes Toward a Resolution" (unpublished manuscript, 1997), 212–43.

[14] Thomas is referring to developments that presage the declining position of women's bodybuilding inside of competitive bodybuilding and the culture/industry surrounding it. The controversy over women building muscle has plagued women's bodybuilding since its beginnings (see Steve Wennerstrom's essay in this book), and this controversy reached an apex in the early 1990s. During that period, in response to the growing muscularity of female bodybuilders, women's "fitness" competitions were created. (See note 15.) Such competitions were firmly entrenched by 1997. Fitness competition favoritism appeared dramatically in contest promotions and popular bodybuilding magazines. The latter discontinued cover photographs of female bodybuilders and sharply curtailed both articles featuring women bodybuilders and contest coverage photos of them. This was accompanied by a host of articles and columns criticizing or assailing women's bodybuilding for having gone "too far." Women bodybuilders and their images were also dropped entirely from the tiny portion they occupied in sales promotion in the health and fitness industry for supplements, beverages, exercise equipment and gear, gyms, activewear, and footwear. Thomas's statement that the "female mesomorph . . . seems defeated" also reflects his disappointment, twenty years after the beginning of women's bodybuilding, in the lack of response to the muscular woman in popular or high culture.

[15] Fitnessist refers to fitness contest competitors, who look like lightly muscled beauty pageant women and who, as contestants, perform aerobic/acrobatic routines and sometimes strength-endurance feats. The fitness contest—figure contest in some European events—was organized in the early 1990s as an alternative to female bodybuilding competitions. *Eds.*

[16] Sam Keen, "Awakening the Spirit in Everyday Life," *Science of Mind* (March 1996): 39–49.

dream girl

Michael Cunningham

When I was a boy I developed—or I might say was host to—a female alter ego. She was about my age and size, but unlike me she lived a life of adventure and intrigue. She was strong and clever; she feared no one. When I rode in the back of my parents' car at night she often clung to the top, brave and determined, buffeted by wind, squinting into the headlights of oncoming cars and trucks as she searched for her kidnapped sidekick. When I ate lunch in the grade school cafeteria with my only friend, a jovial boy who already, in the third grade, looked remarkably like Ed McMahon, she crept silent as a Mohican under the tables, searching for the crystal she needed to defeat the aliens from whose spaceship she had just escaped.

I told stories about her, silently, to myself, starting around age eight and continuing until I was just shy of puberty. At the age of eight I was, essentially, a cross between a young pharoah and a male Emma Bovary. I lay on my bed for hours, staring out the window, while my parents wondered with increasing impatience why I didn't play outside anymore. Was I sick, or what?

Often I stood before the mirror in my bedroom with a towel piled on my head, imagining myself as a figure of mystery, passionately desired by others in a complex, inchoate way that had something to do with Helen of Troy and something to do with an Aztec prince. I went often to my bedroom window as if it were a balcony; as if someone ardent and supplicant might be waiting below, hoping merely for a glimpse of me.

Meanwhile, out in the streets, my girl-hero (her name that year was Judy, I believe) roared through the neighborhood, pursued by CIA agents who needed the atomic detonating device she'd defiantly swallowed, and were prepared to slice her open to get it. She wore high black boots then; she had a rocket sled that emitted two thin blue jets of flame and hovered a foot above the suburban ground.

If I could scarcely throw a softball out of the back yard, she was strong enough to hurl a rock straight up into a cyclops' eye and then tie vines around his legs to trip him as he stumbled, groping blindly. If I found myself muddled and ashamed, paralyzed, when the older boy from across the street threw lit matches at me or imitated my walk, she relentlessly tracked down criminals, and saw that they paid for their crimes.

I kept changing the girl's name and circumstances. She was, variously, an orphan who survived on her own by pluck and ingenuity, the neglected child of a husband-and-wife detective team, and the daughter of a widowed, globe-trotting scientist. Her hairstyles and outfits kept changing too. Her taste in clothes ran to leather and fur, always flatteringly cut, but her names were consistently plain, unpretentious, and optimistic. Names like Judy, Annie, and Nancy just seemed right for her.

Whatever her name and circumstances, though, she was always essentially the same girl. She was a magnetic, incorrigible figure whose head was never turned by the adoration of those drawn to her ferocious, utterly natural beauty. She was constantly in danger at the hands of thieves, kidnappers, aliens, monsters, and other villains, and although she nearly lost her life hundreds of times she always won out in the end.

As I got older—as I turned nine and then ten— Judy/Annie/Nancy grew more sophisticated and refined. She bought a house (she *acquired* a house, somewhat mysteriously, since she always got what she needed but had no way of earning money), and started having a social life. After solving a crime or eluding a psychopath she'd take a long hot bath in her enormous tub, put on a silk dress and spike heels, and go out on the town. She had a series of escorts, all vaguely based on Tony Franciosa or Gene Barry, whose job it was to look awestruck and adoring as she descended stairs, to sit across from her in a series of cavernous, glittering restaurants and night clubs, to have their hearts broken, and then to disappear. Judy/Annie/Nancy didn't put out; the question never came up. She simply got ready, went out for dinner and dancing, and then it was the next morning.

From the time I learned to read I was drawn to adventurous female characters. I particularly admired Nancy Drew (and borrowed her name for a while). I

loved Meg in *A Wrinkle in Time*, Mary in *The Secret Garden* and, a little later, Jane Eyre and Elizabeth Bennett. Movies and television offered far less in the way of role models. I adored Lucy Ricardo, but did not take her seriously. I was infatuated with Samantha of *Bewitched*, but couldn't fully respect her. Why, I wondered, did she agree so readily to keep her powers of witchcraft secret? Was she really that eager to pass as an ordinary wife?

My own girl character owed a certain debt to heroines like Nancy Drew and Jane Eyre but was, as far as I can tell, fundamentally my invention, created out of a hunger none of the available stories quite satisfied. My girl was girlish—she was beautiful—but also immensely powerful and highly unorthodox, and she did not need

anyone to bail her out. She wasn't nearly as well behaved as Nancy Drew; she wouldn't have wasted five minutes on Nancy's dull, stalwart boyfriend Ned. Although she'd have considered Mr. Rochester an interesting challenge she'd never have married him, as Jane Eyre did. She'd have solved the mystery of the woman in the attic, risked her own life saving Rochester from the fire, warned him to be more truthful and less proud in the future, and gone on to other adventures.

The culture has made some progress since I was a fantasy-prone boy in the early '60s, and I can only imagine what I might have made of a figure like Xena: Warrior Princess, if she'd existed when I was a kid. I'd have loved her, of course, but I suspect my imaginary heroine would not have closely resembled even someone as unassailably potent as Xena. My fetish figure—my Amazon—was strong but not particularly butch. My private goddess was tender, emotionally vulnerable; her heroism stemmed not so much from the fact that she was impervious, like Xena, to most of the softer emotions but rather from her determination to act bravely anyway, even as she suffered from them. My female warrior was compelled to remain solitary, so as to better fight evil in its myriad forms. A man would, inevitably, have overestimated his powers, repeatedly gotten into trouble, required rescue, and then been depressed about it. A man would only have slowed her down.

I have not required the companionship of my female alter ego in decades. Or rather, I have not required her companionship in fantasy form. Around the time I turned thirteen I started imagining other sorts of adventures. Judy/Annie/Nancy faded away, along with the other artifacts of my dreamy, difficult childhood.

Now, more than thirty years later, I feel as if she's come back, in the form of the Modern Amazon. I'm happy and a little surprised to see her, after all this time. We've both changed a great deal, and we're both still startlingly the same. When I last pictured Judy/Annie/Nancy, over three decades ago, I saw her as sinewy and strong but not muscular—I couldn't have imagined a muscular woman then. If asked, I'd proba-

bly have said it was not biologically possible. Superman had muscles as well as super powers; Supergirl merely had super powers. Even Wonder Woman, who was important enough to rate her own comic book, was a traditional femme fatale, with pert breasts, a tapered waist, and smooth, uneventful arms.

I'm certain, though, that if my invisible female companion had aged alongside me—if I'd kept her narrative going another three decades—she'd have evolved into a Modern Amazon. She'd ripple and bulge. She'd have deltoids big as cantaloupes, and voluptuously segmented abs. Her arms would be bigger than my thighs; her thighs would be such natural wonders it would be easy to imagine tiny families pulling up before them in Winnebagos, and gazing up at them through binoculars.

I'm sure, too, that she'd wear her muscles defiantly in front of all the people who would inevitably treat her as a freak. She wouldn't pay much attention to the assorted taunts and critiques. The notion that immensely strong women are somehow grotesque would simply amuse her. She'd have more pressing business on her mind. She'd live, as she's always lived, along the more dangerous edges of the world.

That, after all, was the point of her. She wasn't regular. She wasn't a "normal" girl but she wasn't a girl posing as a boy, either. She wasn't even a tomboy. She was herself. She was potent and tenacious; she was butch and femme; she felt deeply and fought hard. She was heroic and, like many heroes, lived a solitary, defiant life. Like many heroes, she could hardly have cared less about satisfying the dictates of conventional taste.

I picture her, right now, riding on top of my parents' car, which was one of my favorite adventures for her when I was a little boy. She is not, of course, supposed to be up there at all, but she's on a mission, and she won't be stopped. She crouches in the wind, alert along every fiber of her body. I sit below, in the warm silence of the back seat, thinking of her as she laughs softly to herself from the sheer pleasure of the risk, and looks fearlessly ahead, into the glare of the headlights and the dark world beyond.

PM BUTLER, *BLONDE AVENGER* NO. 1 (DETAIL), MARCH 1993.

hardcore:

the radical self-portraiture of black female bodybuilders

Carla Williams

I.

"*Yo, Yo, Yo—go girl!" "Hey, over here—We here for you, girl!" "You look good! REAL GOOD!" This is family and neighborhood pride at stake on the stage tonight. Sisters, mothers, boyfriends, husbands, cousins, and friends from the outer boroughs, Jersey, Philly, the deep South, and everywhere else have assembled in Manhattan on a cool, late November day to watch loved ones walk barefoot and nearly naked onto a wooden stage where they will display their physically perfected bodies to be judged by a panel of mostly white men. They will flex, pose, and strut back and forth as the crowd cheers them on. Throughout the evening each will perform a personal choreographed routine designed to demonstrate their physical prowess in action. The audience watches them march single-file in groups of three, four, and five across the stage while an off-stage announcer booms their names over a loudspeaker, extolling their pulchritudinous virtues, whipping up the crowd.*

The easy comparison, of course, is to the auction block, although only one third of the bodies on stage tonight are black. Bodybuilding is a "sport of plastic form,"[1] judged entirely subjectively, aesthetically. There is no tape to burst through, no millisecond record to shatter. Even though this display is both celebratory and voluntary, for the black women on some level the stakes are the same as those placed on the bodies of the African women, our ancestors, who survived the Middle Passage[2] only to be corralled and sold to the highest bidder upon their arrival. We have all been taught: *Whenever you so much as step outside your house, you are representing the race.*

Black females have historically not been in the posi-

tion to control the creation and dissemination of their images in the popular consciousness. The black female image has generally been polarized into stereotypes of the oversexed Jezebel and the asexual, castrating mammy,[3] with only biology, not self-determination as a contributing factor. In certain arenas, however, black females have established a strong voice with regard to bodily matters: For example, from the early blues music of Gertrude "Ma" Rainey and Bessie Smith in the 1920s to the contemporary rap music of Queen Latifah, Salt-N-Pepa, and Lil' Kim, black women speak a definitive, very public position vis-à-vis the expression of their bodies. Similarly, the accomplishments of black female bodybuilders[4] are redefining both their personal and black women's collective image in relation to a legacy of images that preceded them in history and in popular culture. Perhaps more than any other sport, bodybuilding is a triumph of control, both mental and physical. New York bodybuilder and national titleholder Linda Wood-Hoyte offered an example: "Bodybuilding is almost scientific. I love that it is an exact sport. Your body can change from the time you're backstage to when you're onstage doing your posing—it's that precise. I've seen it happen; people who just lose their definition on stage because they're nervous and they start retaining water."[5]

RENÉE COX, *PICTURING HEATHER FOSTER*, 1998. COLOR PHOTOGRAPH, 60 × 40".

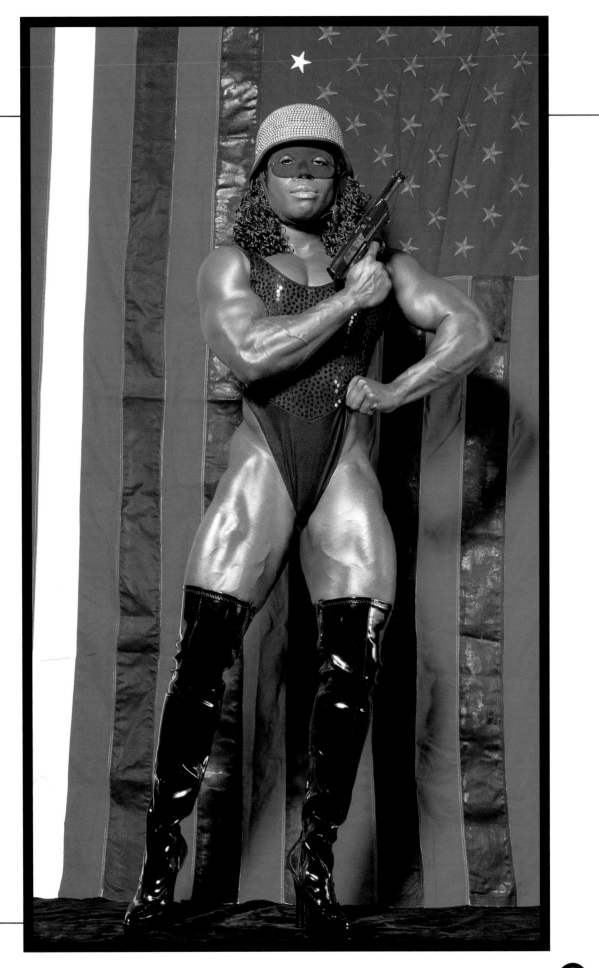

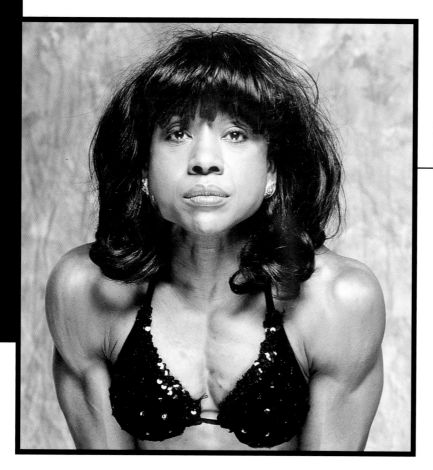

The success of black women in bodybuilding positions the sport as a decisive and positive means of expression through the sculptural creation of the body as a vehicle for self-definition. The complexities of defining such heightened displays of strength, femininity, and womanhood are further compounded within the boundaries of a matriarchal culture in which black men's lack of power is deemed the fault of strong, "castrating" black women. Through the act of self-presentation black women have begun to challenge and reinvent what it means to be black and female within a culture that values neither. Through their extreme manifestation of control over their own bodies, black female bodybuilders represent in physical strength the power that eludes black women in general in society.

II.

*t*he Beacon Theatre is a garishly decorated landmark on the Upper West Side in Manhattan. Each member of a largely working-class crowd has paid nearly two hundred dollars for both the afternoon pre-judging contest and the evening finals of the "Wimbledon" of women's bodybuilding,[6] the Ms. Olympia competition, which is to take place in the Beacon.[7]

It doesn't.

Well, not exactly it doesn't. It takes place in an adjoining hall at the Beacon, a smaller, decidedly less glamorous venue than the main hall. For the crème de la crème of the women's international bodybuilding world, it seems like a comedown, a consolation prize. Having been to the Beacon before I am dismayed by the lesser location. (I read later that the show lost money or at best barely broke even; it is now rumored to have perhaps signaled the demise of professional women's bodybuilding as a spectator sport,[8] even though it has always been, at best, "a cult sport."[9]) But no one is counting the unsold seats as the hall begins to fill, and it becomes quickly apparent that tonight's audience isn't put off by the surroundings. They are here to cheer their own on to victory. It's another world, mom, my friend's son whispers incredulously to her as we enter the hall.

Class is an important factor in these competitions, a circumstance that during the next few hours Lenda, Yolanda, Laura, Vickie, Nancy,[10] and their fans will simultaneously celebrate and transcend. Because of its primarily working-class audience, bodybuilding carries the stigma of low culture.[11] Black women, whose histori-

cal bodies are the very symbol of labor, are inherently representative of the working class whether or not they themselves are among it. Of the eighteen participants, all five black women will finish in the top ten, although this year none will place first. To paraphrase Alice Walker and Audre Lorde, we in the audience are here cheering for ourselves, the black girls who were not meant to survive. Win, place, or show, for the black women who will take the stage tonight, their mere existence is yet another litany for our survival.

III.

Black women's bodies are more naturally inclined to be muscular. If I had to think quickly of an icon of black female physical strength and beauty I would instantly think of actress Pam Grier, "kickin' ass and takin' names"[12] while dominating the blaxploitation genre films of the 1970s. Resurrected in the starring role in 1997's Jackie Brown, Grier played the middle-aged, weary-yet-triumphant heroine in director Quentin Tarantino's homage to her earlier, inner-city morality tales including Coffy and Foxy Brown. Much has been made in recent press about the fact that there was neither a precedent nor a white female equivalent to the image Grier created in film. "A gun-toting community savior who posed for Players magazine, Grier was something folks had never seen before,"[13] one interviewer wrote. For three decades she has represented the conflation of sex and strength, though not necessarily muscularity, in the proudly black female, body, so much so that she no longer needs to exhibit her strength to embody it.

On Halloween night 1978, around the same time that Grier was at her pinnacle in Hollywood and at the box office,[14] singer and performance artist Grace Jones took the stage at Roseland Ballroom in New York City, wearing a cropped t-shirt and the "protective cup and handwraps"[15] of a boxer, an androgynous man-woman literally throwing punches at the crowd and growling out sexually ambiguous lyrics against a throbbing disco beat. Several years later she became the first black woman action star in mainstream films, as villains in the 1984 Arnold Schwarzenegger vehicle Conan the Destroyer and in the 1985 James Bond film A View To A Kill. Like Grier, Jones was not particularly muscular, but she was "exotic": tall, very dark, unfeminine, and menacing. It was almost as if her radical blackness alone, her blue-black skin, both represented the strength which she was said to possess and explained all the curious rest. Given that, all she had to do was kick a leg up, snarl, and we were convinced. Although she often collaborated with other artists, Grace was a

self-styled "freak,"[16] and the difference of her physicality was exploited to both scare and seduce audiences into paying submission.

Sometimes, however, the association of black women with an indefinable physical superiority is not as overt as in the cases of Grier and Jones. In an episode titled "Destiny" in the second season of the extremely popular syndicated television show Xena: Warrior Princess, the titular heroine Xena, played by actress Lucy Lawless, is injured in a battle and has flashbacks to her incipient warriordom. She is queen of a band of bawdy pirates who have just taken Julius Caesar into captivity. Aboard their ship a stowaway is discovered: upon being unearthed, the heavily cloaked stowaway unleashes a feral fury as he fiercely battles every man aboard the ship, reducing each to a helpless pile of quivering flesh. Xena watches captivated as the whirling dervish of self-defense makes mincemeat of the men and is finally subdued and brought before her.

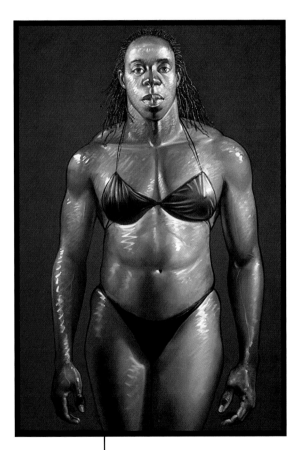

ALFRED LESLIE, BETTY MOORE, 1998. OIL ON CANVAS, 7 × 5'.

The hood is pulled back to reveal that the stowaway is no man at all, but rather a Gaelic-speaking, black Egyptian, female escaped slave named M'Lila. The wild, untameable black female is a stereotype that evokes jungle fantasies of the wantonly permissive, if not downright sexually aggressive, "animalistic" African woman. The subject's lack of voice, as with M'Lila who does not speak the same language as her captors, is emphasized as a means of preventing the black female from literally "having a voice" in her representation and denying the black woman control.

In exchange for sparing her life, Xena demands that M'Lila, played by actress Ebonie Smith, teach Xena her secret "powers," in particular the nerve pinch. The two women form a relationship, and M'Lila is killed protecting Xena. Thus is born the "evil" Xena, whose subsequent career of wreaking havoc on the bad guys, we now learn, is an extended revenge sequence for the death of her friend and instructor.[17] Moreover, through this episode the body of the black female both symbolically and literally becomes the genesis of Xena's superior power, and thus untamable, superior strength is equated with the black female body. Furthermore, the black female does not merely go away, to resurface in another episode; she ceases to exist in order for Xena to assume her superior position of strength, as if their two bodies can not co-exist. By inference, the strong black female body is a threatening one that must be either brought down or made invisible.

IV.

*Y*ou can't fool me—that's a man. Everyone is always so sure. They've never seen a woman who looked like that before so they won't believe that one can naturally exist. Having been told frequently as an athletic child that she "looked like a man," New York-based body-builder and physical therapist Heather Foster suggests that she was a likely candidate to exploit a physicality so readily associated with males. On the other hand, when Lesa Lewis, the 1997 National Physique Committee (NPC) USA Champion, was posed the question: *If you could change something in the sport what would it be?* her answer was: "Don't let the women get too manly,"[18] a sentiment echoed by Wood-Hoyte.[19] Although some women nevertheless choose to exploit their perceived androgyny,[20] it is a primary concern for

DEBORAH WILLIS, *NANCY LEWIS*, 1997. 3 C-PRINTS, EACH 20 × 24".

many of the women involved in the sport, because if the questioning begins with gender, it inevitably segues to sexuality.

On our way to the local Iron Maiden qualifier at a Shriner's Hall in Culver City my partner is asking me questions about the research, speculating on what we're about to experience. I bet there'll be serious family there, *she muses. I explain that I don't think so—unlike softball, basketball, and golf, I don't think this is a sport that's particularly popular with lesbians. She's doubtful; after all, if a woman chooses to look "mannish" then she's a "dyke," right? In truth, the lesbians who are involved in the sport are frequently ostracized for embodying the stereotype that the straight women are trying hard to undo by donning the exaggerated signifiers of femininity so many wear. Done hair, woven for length and then piled high so that their back muscles will show. Long, sculpted and painted fingernails accentuating the tips of perfectly formed hands like bold exclamation points of femininity. Stiletto pumps highlighting calf muscles that look powerful enough to crush those spindly heels into dust. This is the hyperfeminine costume of the average female bodybuilder in competition and in photographs. Pair this grooming with a body that looks more traditionally like a man's than a woman's, and it produces a gender and sexuality confusion among the general public that the majority of female bodybuilders work hard to subvert. Joe Weider and Ben Weider (the Weider Corporation), who publish most of the best-known fitness magazines and who founded the International Federation of Bodybuilding (IFBB) and the NPC, "heavily promote the value of heterosexuality for the bodybuilding community."*[21] *When asked about her sexuality, an otherwise refined and contained contestant quickly and firmly declares:* I'm strictly dickly. *To each her own.*

Observers cannot understand why a woman would choose to look this way, to look more muscular than a man while still expecting to be desired by one. In 1993, Angela Bassett played singer Tina Turner in the movie biography *What's Love Got To Do With It?*; in order to achieve Turner's remarkable on-stage stamina, Bassett pumped iron and consequently developed a highly muscular form including "an exquisite pair of biceps."[22] The period clothes and wigs enhanced the incongruity of her radical female body to a point where she looked like she was playing Turner in drag, creating a distraction from the narrative and nearly eclipsing the focus of the film. In a 1991–92 controlled study involving ten of the approximately twenty-five competing female bodybuilders in the world (including three self-described African-American women), all "mentioned that being

homosexual was the most frequent stereotype attributed to her and was the one that caused her the most emotional pain."[23]

To compound the association, black female sexuality has always been aligned with lesbianism. As psychiatrist and cultural theorist Sander Gilman has noted, beginning in the nineteenth century the physical development of black female genitalia was related to that of the lesbian because of the so-called "excesses" of sexuality attributed to both.[24] Of the terms most associated with "butch," or masculine-looking lesbian women, "bull-dyker," "bull-dagger," "bull-dyke" and simply "dyke" were originated in African-American communities to refer to lesbians or bisexual women.[25] In the early decades of the twentieth century, the theme of lesbianism and the terms associated with it often made their way into the lyrics of blues songs, particularly those performed by women, such as Bessie Smith's *Prove It on Me Blues* and Lucille Bogan's *B.D. [Bull Dyke] Woman's Blues*.[26] It follows from precedent, then, that the hypermuscular black female body, as a locus of supposed masculine identity in that it connotes radical lesbianism, becomes an easy, if not logical target of frequent assumption and innuendo.

V.

*f*rom *my seat in the audience I am consumed by the sickly sweet chemical smell of the tanning lotions that the white athletes use to darken their skin. Dark skin is thought to be more aesthetically pleasing, to show off the muscles better. After Lisa Lyon put the sport of female bodybuilding on the map in 1979 by winning the first World Women's Bodybuilding Championship in Los Angeles, she called bodybuilding "a sport meant for black men" and described buying liquid graphite in bulk from a lock and key shop in order to "highlight her muscles" for competitions.[27] In fact, "skin tone" is one of the evaluative factors in competitions.[28] So many of the women are dark-skinned, I also start to wonder, irrationally, if "the darker the berry, the stronger the juice" is somehow true. In some instances because of the tanning products, I cannot tell who is white and who is black without looking at the hair. The hair, even though much of it is store-bought, is almost always the ethnicity giveaway. And in bodybuilding, there is almost always a lot of hair.*

It is striking that like Jones and Bassett, most of the top female bodybuilders are dark-skinned. In the traditional pecking order in the United States, lighter-skinned blacks have long been favored over darker-skinned blacks because of their closer physical proximity to an

ideal of whiteness. It is a divisive prejudice that is deeply ingrained in the collective black American consciousness and is perhaps most insidiously imposed by blacks against one another, although it is certainly prevalent in the dominant culture as well. Undoubtedly, the triumphs of performers like Jones and Academy Award nominee Bassett, and those of these women athletes, are subverting and healing some very old wounds in the collective body regarding skin color.

"Bodybuilders are perhaps the most unprejudiced people I know," Wood-Hoyte remarked. "They're really more interested in judging you on your achievements." According to veteran sports writer and photographer Reg Bradford, the judging in the major competitions has been, for the most part, color-blind.[29] The same is not true, however, of the media coverage of the sport. On the one hand, I want to revel in the purported color blindness of the competitions, yet I cannot help but wonder why darker-skinned, six-time Ms. Olympia Lenda Murray has never been featured by herself on a cover of the top bodybuilding magazines.[30]

VI.

Black women are more naturally inclined to be muscular, one of the black Olympia contestants remarked to me. I remember sports commentator and oddsmaker Jimmy "the Greek" Snyder catching hell for some similar comments years ago[31] and while I contemplate the thin line between a compliment and a racist remark, I nod in polite agreement, for the moment wondering if there might not be something to that statement after all. Studies have supposedly shown that black men have higher levels of testosterone than any other ethnic group, so it stands to reason that black women would have a genetic advantage as well.[32] Reg Bradford notes that black bodybuilders in the Americas and the Caribbean are better developed than blacks elsewhere. He also posits the theory that the experience of slavery, the survival of the Middle Passage and the practice of breeding healthy bodies that could endure the heavy labor demanded of slaves, have given blacks a superior genetic strain that produces "the elite of the elite of the physical body."[33]

Although she had never trained for the sport, Carla Dunlap Kaan, the first black woman to win the Ms. Olympia contest (in 1983, the year before Vanessa Williams made media history by becoming the first black woman crowned Miss America), placed fifth in a field of forty-five entrants in her first competition.[34] Yolanda Hughes, Ms. International 1997, who also placed third in the 1997 Ms. Olympia competition, began competing in 1982, placing in the top five in

every local and national competition she entered.[35] After three months of training, Murray entered her first competition, the 1985 Michigan Championship, and finished fourth in the heavyweight class.[36] Laura Creavalle, a Guyanese-Canadian bodybuilder, saw her first women's competition in Jamaica around 1982 and decided to become a competitive bodybuilder; six months later, she won her first competition. Like these and many of the other black female competitors, Heather Foster also entered her first competition on a lark, with no specific training (although she was a competitive athlete in other sports), and won.

"You are an artist creating a sculpture," says Foster. "You put on muscle like clay. You never get it right—there's always something you want to improve or erase. I never think my body is perfect, even though I put in 110% effort for a competition."[37] The issue of perfection is a contentious one. Many bodybuilders agree with Foster.[38] There are consequences for achieving the "perfect" bodybuilder's form. "I normally don't want attention. Usually, I'm trying to avoid attention," says Nancy Lewis.[39] Hughes says that she works hard to perfect her body, yet rarely goes about uncovered in public in order not to invite unwanted attention.[40] Prior to her first competition at City College in New York City, "I hadn't even worn a two-piece bathing suit," Foster recalled modestly.

This paradox is true among female bodybuilders of every race: the development of extraordinarily muscular bodies invites a lot of unsolicited responses and opinions directed at the women. As Bradford notes, "they are constantly on display."[41] In a discussion of black female subjectivity, artist Lorraine O'Grady has observed that black women in general are not inclined to show their bodies publicly.[42] The remarkably negative press in black communities over singer Toni Braxton's nude appearance on the April 1997 cover of *Vibe* magazine proves that the display of the black female body is still a collectively unresolved issue. Viewers were shocked and outraged; public nudity is a "white thing," and not something a successful and self-respecting black woman would indulge in.[43] Black female bodybuilders both subvert and are subject to this persistent myth in the black community through the very public—and very bare—display of their bodies.

If it is true that black women are more naturally inclined to be muscular, are they, then, more naturally inclined to win these contests or to represent physical strength in the media? While white participants and observers feel that black women are beginning to dominate bodybuilding just as black men do, none of the black women I speak with have that perception. Moreover, how does strength relate to power? In a sport that

ANDI FARYL SCHREIBER, *KARLA NELSEN AND MILLIE CARTER BACKSTAGE AT "A CELEBRATION OF THE MOST AWESOME FEMALE MUSCLE IN THE WORLD,"* NYC, 1993. BLACK-AND-WHITE PHOTOGRAPH, 16 × 20".

does not promise financial reward, in which the primary way to earn a living at it, I am told, is through selling one's image as an erotic fetish in activities like private wrestling sessions, I ponder the meaning of success, of "making it."

Eleven years after her victory as Ms. Olympia, as a member of Team Danskin, Dunlap Kaan was featured in a two-page advertisement for Danskin exercise products that ran in women's fashion magazines in April 1994. On the first page, centered against a white background, was a small, faded, family snapshot of Dunlap as a child standing in a comfortable, middle-class living room in a leotard and tights, striking the pose of a ballerina. The ad copy read: *She picked up her toys. She picked up her cat. She picked up her clothes.* Turning the page, the reader saw a full-color, full-page image of Dunlap Kaan standing triumphant and glorious, holding her husband over her head. The caption read: *Now she picks up her husband.* I had never before seen a strong, muscular, black female body being celebrated in a mainstream beauty magazine, and I was thrilled and proud, clipping and saving that advertisement for years.

Yet when Dunlap Kaan hoisted her white husband over her head, was she symbolically reinforcing the notion of the castrating black female who is "too much"

for the black male, here literally absent from the picture? In fact, several of the top black female bodybuilders have white partners. When I described the advertisement's images to a black female colleague, the stereotype of the domineering black woman is immediately what came to mind for her, the personal transformed into the political. On the popular *Amos 'n' Andy* radio and television shows in the 1950s, through the character of Sapphire Stevens, the wife of George "Kingfish" Stevens, black women were depicted "as over-bearing, whip-cracking, *'Never trust a Black man'* females who had to constantly hound their men to get up out of bed and 'get a job.'"[44] I saw this same tired image again as the perpetually fussing mother in the 1998 made-for-television biography of envelope-pushing basketball player Dennis Rodman. It is a persistent image attached to the black female in a society that denigrates their strength and denies them their often justifiable rage and anger by attributing their difficulty to gender and color. *The blacker the berry, the sweeter the juice, but when they get that black they ain't no use.*[45]

The difficulty with developing healthy relationships with partners of any race is compounded for these women, who, because of their extremely muscular bodies, narrow the playing field of potential partners

who are willing to be physically matched by or in some cases subordinate to their women. Another real hazard is the fetishist who will enjoy her body in private but deny her in public. "Black and white men both like the look of black muscle but are less inclined to publicly admit their attraction to the black women in the sport," confides one of the women who experienced such a closeted relationship. Ultimately, was Dunlap Kaan's black body a successful commodity, that is, did it sell the Danskin products? Did it also successfully sell a positive image of black female strength, femininity, and beauty?

Engaging the question of representing femininity and strength, artist Cynthia Wiggins, herself once a fledgling bodybuilder, created the 1994 installation titled *Difference and Pathology*.[46] In it she included three photographs: on the left was a foot wearing a high-heeled pump stepping up on a stool, which ironically references the pedestal of posing and competition. Cut off just above the flexing calf muscle, the photo-

graph united the glamorous and the mundane, the elegant shoe and the functional metal stepladder; text to the left of it read: "she doesn't use her feminine strength." At the center of the installation was a close-up of a woman's full mouth and torso wearing a lacy red bra. On the right was a hand wearing a weightlifting glove outstretched over a weight that sits on the floor in front of it: was it dropped, or does she reach for it? The incongruity of the lingerie and the glove posited the question of femininity in the sport and whether or not the two can coexist. Of her own attraction to body-building, Wiggins explained that "it was just something I did, I think partly because as a girl I wasn't supposed to." Having weight-trained on and off since high school, Wiggins returned to the gym to create *Difference and Pathology*. In part referencing the politics of interracial relationships and how that dynamic informs the image of a physically strong woman, she "even tweaked the color in the central image because I didn't want my race to be a determining factor in how the piece was read."[47]

CYNTHIA WIGGINS, *DIFFERENCE AND PATHOLOGY,* INSTALLATION VIEW (*SHE DOESN'T USE HER FEMININE STRENGTH*). 1994.

Bill Dobbins' 1994 photography book *The Women* features twenty-seven female bodybuilders and fitness competitors, including four black women, among them the then-reigning Ms. Olympia Lenda Murray. Images of Murray dominate the book with a total of fourteen; there are four photographs of Hughes; four of bodybuilder and "American Gladiator" Sha-Ri Pendleton;[48] and four of Creavalle, a ten-time Ms. Olympia competitor. Creavalle is an extremely confident and outspoken competitor who has encountered more than a little resistance during her fifteen years in the sport due to her frank and forthright personality.[49] She described photo sessions with Dobbins as intimidating; in true, coaxing-photographer fashion, Dobbins would tell her she didn't "look sexy enough"[50] in order to obtain a desired pose from her.

Interspersed throughout the book, the images of Creavalle form a compelling narrative about identity and race in the world of bodybuilding and beyond. In the first image she is seen from behind seated on the bench of a weight machine, wearing a black, thong bathing suit, and bending over to the left to pick up a three-pound Weider barbell as the left strap of her suit slips provocatively off of her shoulder. She wears a curly blond wig, which stands out in bold relief against her glistening, red-brown skin. Her face is completely obscured. The next image is a two-page spread of her lying unclothed on a sofa that is the color of her skin, her arms gripping its back and arm and her calves flexed and erect. Her face is turned from the camera, although a sliver of her profile is just visible beyond a straight, auburn-colored wig styled into a flip.

The next image shows Creavalle in the auburn wig seated on a wooden bench, turning toward the camera in a three-quarter pose, her hands constrained in a wooden vise reminiscent of prisoners' stocks. Half of her face is visible, turned seductively toward the camera as if in coy compliance with her restraints. While the flexed strength of her body is meant to suggest that she cannot be captured or confined by such an antiquated device, the reality connotes a bondage that she enjoys and participates in for the pleasure of the viewer, a willingness to tame herself, or be tamed, in order to seduce. That her clearly superior strength does not allow her to break free of the constraint within the frame is a racially charged metaphor for black women's actual lack of power, even when they are among the most physically powerful women in the world.

The final image of Creavalle is the only one that does not take up a full page and the only one in black-and-white. It shows Creavalle seated in profile on a marbleized pedestal, her face once again obscured by a cascade of blond curls and her hands clasped against

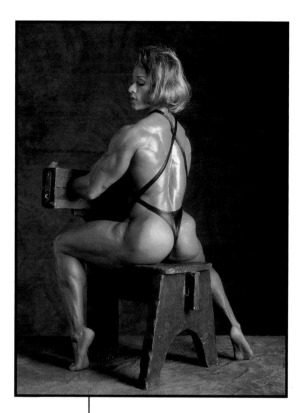

BILL DOBBINS, *LAURA CREAVALLE*, 1993. C-PRINT, 16 × 20".

her forehead in a pose reminiscent of Auguste Rodin's 1880 sculpture *The Thinker*. The implication is that Creavalle is here only playing the role of a thinking person; the smaller size of the image and the lack of color in the photograph suggests that this pose does not reflect her strongest attributes, thus visually reinforcing the widely held notion that bodybuilders are not intellectuals. Furthermore, the exaggerated wigs, so incongruous on the black body, function as a comment on the necessity of adhering to the standard of blond-haired beauty that is prevalent in the sport. Altogether, the photographs are highly sexualized representations of the businesswoman Creavalle, who is one of only two female bodybuilders (and the only black woman) under contract with the Weider Corporation (Creavalle writes a cooking column for *Muscle and Fitness* magazine) and who runs fitness camps in Maine and Florida. Wood-Hoyte also refutes the dumb jock image daily: she is a top level professional in a Fortune 500 company, readily acknowledging that her executive career is an anomaly within the sport.

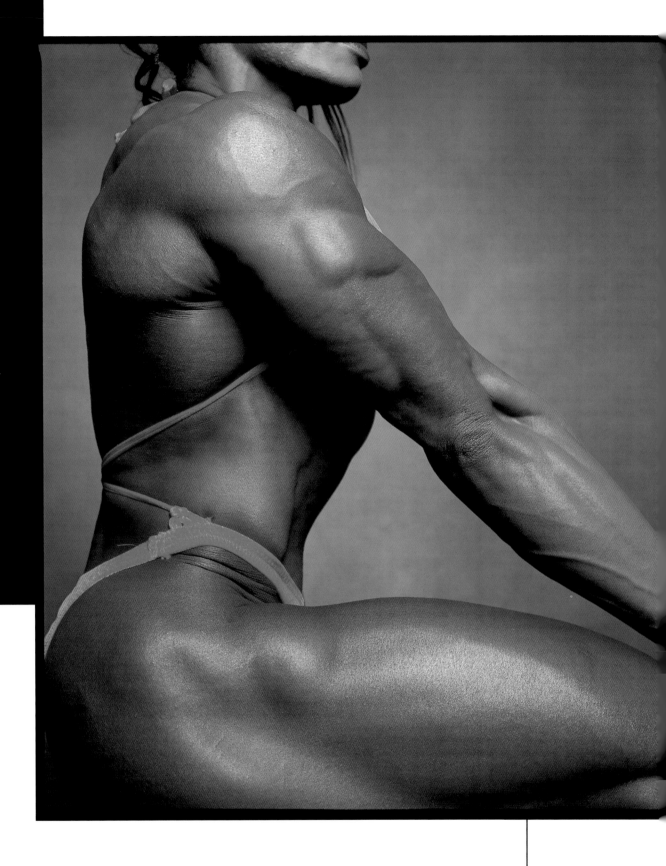

ANDRES SERRANO, *LESA LEWIS*, 1998.
COLOR PHOTOGRAPH, 60 × 50".

VIII.

We experience our bodies in incongruous ways. The privacy of our sensations, the personal awareness derived from physical acts, the joys and pleasures aroused through intimate contact with other bodies teach us profound lessons about our personal identity and self-sufficiency. We experience our own body in ways that are unavailable to the inspection of others. Our pain or ecstasy is our own and known only second-hand to those with whom we share its secrets. But our bodies also are in the world. The incongruity between personal lessons of self-sufficiency and public ones of insufficiency is transferred to the tension between domination and civilization in the civic realm. There we attempt to shape an arena that can protect us from our own weaknesses and those of others but also can accommodate our desire to turn toward those others and be open to experiencing them as the Other.[51]

In the world of female bodybuilding, I am the Other because I am a spectator, not a participant in an arena of women who sculpt their bodies into specimens of desire and beauty, power and pride. Every one of the black women that I spoke with cited a sense of personal challenge and achievement as the reason they became involved and the reason they continue to build their bodies. It has proven to be a realm where black women can excel based on their own merits and over which they exert the ultimate control of their bodies: strong, sexual, and otherwise.

In the world outside of bodybuilding, I am one of them, a black woman, opening a window onto their experiences and aspirations that will inform and instruct the way all strong black women can be understood beyond the stage and in spite of their bodies. Wood-Hoyte concludes: "Bodybuilding is a magnificent sport. I accept it with all its faults."[52] Although successful competitors like Creavalle see the sport as a dying one, in which the champions are getting physically bigger while general interest in and acceptance of the sport for women is waning, she still competed in the 1998 Ms. Olympia contest in Prague, Czechoslovakia. With the recognition of its limitations, theirs is a crucial presence in the representation of black women, their participation in the sport essential.

"I'm no Amazon—I hope not,"[53] states Creavalle emphatically, refusing to align her personal image with the mythical fantasy of male-bashing female domination that is connoted by that word. I would prefer to call her and all of the others simply strong black women, or exceptional athletes, and allow their accomplishments and talent—rather than, say, photographs by a white male photographer—to define their images.

Yet there is an undeniable history of the image of black women that informs the interpretation of these modern standard-bearers and sets them apart from the other women in the sport. Artists like Wiggins, who has an acute understanding of both that legacy and the practical reality of the sport, attempt to reconcile the two and forge a new consciousness that gives agency and responsibility to the subjects. Whether the sport survives, metamorphoses, or fades away, the body of the black female bodybuilder is now part of the discourse, and that image will continue to inform the collective understanding every time a black woman takes the stage.

Notes:

[1] Bill Dobbins, *The Women* (New York: Artisan, 1994), 11.

[2] The phrase "Middle Passage" refers to the transport of Africans to the Americas via slave ships across the Atlantic Ocean.

[3] K. Sue Jewell, *From Mammy to Miss America and Beyond: Cultural Images and the Shaping of U.S. Social Policy* (London: Routledge, 1993), 36–37.

[4] All of the women interviewed for this article identify themselves as being of African descent.

[5] Linda Wood-Hoyte, interview with author, February 1998.

[6] From Carla Dunlap Kaan biography, http://www.tiac.net/users/flexcom/, cited on 12 January 1998.

[7] This Ms. Olympia contest was held 22 November 1997.

[8] Ron Avidan, "Gossip, News & Opinions," at http://www.getbig.com/gossip.htm, cited on 5 February 1998.

[9] Reg Bradford, conversation with author, February 1998.

[10] Lenda Murray, Yolanda Hughes, Laura Creavalle, Vicky Gates-Lewis, and Nancy Lewis were the black competitors in the 1997 Ms. Olympia contest. Although many people assume competitor Andrulla Blanchette to be black, she does not identify herself as such.

[11] Laurie Schulze, "On the Muscle," in Pamela L. Moore, ed., *Building Bodies* (New Jersey: Rutgers University Press, 1997), 18.

[12] From "Coffy Baby," lyrics by Roselle Wearen, music by Roy Ayers, performed by Denise Bridgewater, 1973.

[13] Scott Poulson-Bryant, "The Illest Na Na," *Vibe* 6, no. 1 (February 1998): 80.

[14] Unlike many early black stars, particularly female, the sex-and-violence image she created and sold did result in power for Grier, who retained a percentage of future profits. Poulson-Bryant, "Illest Na Na," 80.

[15] See Miriam Kershaw, "Postcolonialism and Androgyny: The Performance Art of Grace Jones," *Art Journal* 56, no. 4 (winter 1997): 19–25 for a discussion of Jones's performance art; and Jean Paul Goude, *Jungle Fever* (New York: Xavier Moreau, 1981), 102–15, for an alternate discussion of and images from this performance piece.

[16] "Freak" is a term frequently leveled at female bodybuilders. See Schulze, "On the Muscle," 18.

[17] As a public act, female bodybuilding is "seen as a 'resistance to' and 'refusal of' social control," an extreme of the stereotype of the uncontrollable female. Ibid., 18.

[18] Lesa Lewis, http://www.geocities.com/HotSprings/6118/lewis.htm, cited on 30 January 1998.

[19] Linda Wood-Hoyte, interview with author, February 1998.

20 Florida-based bodybuilder Gillian Hodge, who no longer competes, was for a while, I am told, cross-dressing as Dennis Rodman. She also shaved her head at one point, in defiance of the established (competitive) female bodybuilder standard of hyper-feminine hair.

21 Alan M. Klein, "Pumping Irony: Crisis and Contradiction in Bodybuilding," *Sociology of Sport Journal* 3, no. 2 (1986): 112–33, as cited in Leslee A. Fisher, "'Building One's Self Up': Bodybuilding and the Construction of Identity among Professional Female Bodybuilders," in Moore, *Building Bodies*, 155.

22 Dobbins, *Women*, 8.

23 Fisher, "Bodybuilding and the Construction of Identity," 156.

24 Sander Gilman, *Difference and Pathology: Stereotypes of Sexuality, Race and Madness* (Ithaca and London: Cornell University Press, 1985), 89.

25 Paul Oliver, *Blues Fell This Morning: Meaning in the Blues* (Cambridge and New York: Cambridge University Press, 1994), 100; and Steven Watson, *The Harlem Renaissance: Hub of African-American Culture, 1920–1930*, Circles of the Twentieth Century Series, no. 1 (1996), 135.

26 No white female performer, except perhaps Marlene Dietrich, was so explicit—or celebratory—about her lesbian identity.

27 Lisa Lyon, as quoted in Bruce Chatwin, "An Eye and Some Body," in Robert Mapplethorpe, *Lady: Lisa Lyon* (New York: St. Martin's Press, 1983), 16.

28 Dobbins, *Women*, 26.

29 Linda Wood-Hoyte and Reg Bradford, interviews with author, February 1998. Not every competitor felt that the competitions were color-blind. One believed that judges try to discourage the black women by giving them unjustified lower rankings.

30 The closest Lenda Murray came to making a cover of a widely circulated magazine was Weider's *Muscle and Fitness* in 1997, but a white fitness athlete was superimposed alongside her image. Murray was on the cover of *Women's Physique World* (which has a smaller circulation) in 1992 and has been on numerous covers with other bodybuilders. Yolanda Hughes was on a cover of *Women's Physique World* in 1997. My thanks to Reg Bradford for calling this to my attention.

31 In a 1988 interview with WRC-TV in Washington Jimmy Snyder was quoted as saying that during the Civil War, "the slave owner would breed his big black with his big woman so that he would have a big black kid. That's where it all started." The station was seeking comment in connection with Martin Luther King's birthday, asking about the progress blacks have made in society. Snyder also said if blacks "take over coaching jobs like everybody wants them to, there's not to be anything left for the white people." Later, Snyder said a black athlete was better than a white one because "he's been bred to be that way because of his thigh size and big size." Information from Snyder's obituary at http://espnet.sportszone.com/editors/nfl/news/0421greek.html, cited on 5 February 1998.

32 This question and all claims to support this notion are part of an ongoing debate among scholars, scientists, and other interested parties.

33 Reg Bradford, conversation with author, February 1998. Bradford's comments are very similar to Snyder's, although Bradford does not use the inflammatory, derogatory language that got Snyder fired. Bradford is African-American.

34 Biography of Carla Dunlap Kaan on her web page: http://www.tiac.net/users/flexcom/, cited on 14 November 1997.

35 Yolanda Hughes, conversation with author, December 1997, and http://www.goyo.com/profile.html, cited on 20 December 1997.

36 See http://www.frsa.com/pixfemuscle/lenda.html, cited on 20 December 1997.

37 Heather Foster, conversation with author, February 1998.

38 Fisher, "Bodybuilding and the Construction of Identity," 153–55.

39 Nancy Lewis, http://www.geocities.com/HotSprings/6118/lewis.htm, cited on 14 January 1998.

40 Yolanda Hughes, conversation with author, December 1997.

41 Reg Bradford, conversation with author, February 1998.

42 Lorraine O'Grady, "Olympia's Maid: Reclaiming Black Female Subjectivity," in Joanna Frueh, Cassandra L. Langer, and Arlene Raven, eds., *New Feminist Criticism: Art, Identity, Action* (New York: Icon Editions, 1994), 152–70.

43 See Karen Grigsby Bates, "Let's Not Indulge Society's 'Chocolate' Fantasies Media: Black women posing nude feed an image of the wanton hussy that so many others have worked to disavow," *Los Angeles Times*, 9 September 1997, Home Edition, B7; Donna Britt, "Beauty-parlor Sense Shuns Temptations," *Dallas Morning News*, 18 June 1997, Home Final Edition, 8C; and Michel Marriott, "Black Erotica Defies Cultural Tradition," *Cleveland Plain Dealer*, 15 June 1997, Arts & Living Section, 2J.

44 Byron L. Crudup, "Bring Back Amos 'n' Andy, Please?" http://www.users.fast.net/~blc/amos1.htm, cited on 5 February 1998.

45 With numerous variations, this is a traditional saying in the African American community; it derives from the lyrics of blues songs, but I think from several different sources, including *Take a Whiff on Me*, with the lyric "The blacker the berry, the sweeter the juice/Takes a brown-skin woman for my particular use. . ." cited on 4 August 1999 at http://www.datacomm.de/~virus/lyr/whiff1.htm.

46 The title is derived from Gilman's *Difference and Pathology* cited above.

47 All Cynthia Wiggins quotes from a conversation with the author, June 1998.

48 Pendleton was Gladiator "Blaze" on the television program.

49 It is believed that such outspokenness has cost Creavalle the title of Ms. Olympia.

50 Laura Creavalle, conversation with author, July 1998. It is significant to note that Creavalle does not use the Dobbins photographs for publicity, nor does she profit directly from them. They are his work with her functioning as the model only.

51 Gerard Hauser, guest editor, "The Body as Source and Site of Argument," from a call for papers, *Argumentation & Advocacy* journal, sent as an e-mail, 13 November 1997

52 Linda Wood-Hoyte, interview with author, February, 1998. Wood-Hoyte cites her inability to be in any way spontaneous in her social life as the biggest down side to bodybuilding. "My friends are pearls, jewels. I have to plan very carefully to spend any time with them."

53 Laura Creavalle, conversation with author, July 1998.

my muscles, myself:

selected autobiographical writings

Nathalie Gassel

"muscles as a form of megalomania"[1]

i started with a few pull-ups. In this movement, my hands grip the bar above and I lift my body to it. I do ten reps slowly, in a euphoria particular to muscles engorging and expressing their capacity for strength and mass. Mirrors run down the whole wall. You never lose sight of your body. You watch it swell, tighten. The skin, muscles, and veins transform. After come machine pull-ups, in which you use a cabled system to pull weights towards yourself, the machine set to the maximum you can handle in relation to the number of reps you will do. You feel encased from the inside, tightened by a rush of blood that makes your limbs heavy, goes through them, distorting, shortening their movement. Five, ten minutes later, the blood disperses and the muscles are harder to the look and touch, taut, less fluid, metallic to the eye. Those who touch them are moved. They lose their control, sink into lust, are enthralled by sculptures of thinking flesh, reflecting their reflections, striving in many ways to discover or rediscover the arousal of bodies, compression, suffocation, the strength of an embrace.

"why these female muscles?"[2]

most often, in fact, appearance is judged, and one is categorized according to visual and sociological criteria. We must therefore choose a meaningful appearance, one that does not betray our personality, that translates our desires, and helps to represent what we wish to be. . . .

How do we come to consider strength important and posit appearance as a decision? Only through eroticism, through the flesh's strength, the origin of motivation.

I am not looking for a worker's body, meant for carrying heavy loads. I am not looking for a slave's body. I am looking for a body that is free of these kinds of external constraints. An aristocratic body and an esthetic and erotic body. A seductive, powerful body. Not a power to carry out tasks, to serve, but a potential power that brings me back to myself, a power visible through its attributes. A power for hand-to-hand fights, a private power. It is personal, not functional, it is a seduction, a presence.

NATHALIE GASSEL AT AGE 6 OR 7, C. 1971.

A weak body often comes with smartness, with a strong presence of the mind, with spiritual choices, with a freedom toward others, their beliefs, their pragmatisms, an intimacy with anxiety, death, a fever that makes one particularly sensitive to the disembodied world of the soul and spirit, lofty feelings. By building the body, we are cultivating more mundane sensations, but we are also exhibiting a solid, embodied, all-encompassing will to dominate, which will not be limited to the sole richness of mind. We want a more absolute self-assertion, a religion of the self, an existence in front of others, one that is tangible, unavoidable, visible with that visibility that leaps to the eye, a will to dominate, glued to the skin, expressed by the shape of the body in a uniquely erotic way.

"muscle and eroticism"[3]

With a dumbbell in each hand, I flex my arms, alternating, so that my balls of muscles burst out, harder, more congested. My blood rises. My strength asserts its power. My fingers tighten around the cold metal of the weight. My muscles become rigid, never losing the oily fluidity which I want to feel gushing into my muscles. I strain to lift once more. More swelling, capacity, bulk. My skin tightens. My power bursts. An orgy of sensations. I am in ecstasy. Radiance, a mass of fleshy, strong muscle tissue. Ha! One more, one more, in front of those looking at me with their gluey eyes, wanting to feel me. So let them touch this hard body, so let them touch it and understand my muscle's determination to turn into steel. I know what they want. They tell me of their desire to be under my influence, to be enslaved by me. I pay homage to this desire: I like to have my congested body against a yielding body longing for unconditional surrender, to assert the sovereignty of my desire by moves that are delightful for my body, to use my strength to compress and my power to enthrall and enjoy. To mix flesh so that energy is born in the convulsion. At the end, no, at the beginning of the way, I need power. Its necessity, its willfulness, its joy. To carry out the aggressive act, to cause the strongest urges within me, within us, to sing. To seek above, below in life, in death, in love, the depths of the war chant, the first chant—it was for me anyway. As a child, I only liked martial music—the kind that would lead to battle by inflaming unknown internal bubbling forces, by raising some kind of hope for escape and independence in a world where the body surrenders itself to its guts and its flesh, to its nourishment and its battles, propelled into the blood of enemies. And here is the body dazzled by its materiality, plunged into the depths of its sticky and organic joy and elated by its strength, the gushing of its blood, to its fixity of purpose, its full power. I remember: the pride of being intrepid, the ideal of becoming indifferent to hard knocks, the many battles intended to establish a glorious Me, open to all tumult. The energy of combat, of blind flesh, of flesh which is only flesh, without transcendence, with nothing beyond itself. Immersed, living, gathered in all its atoms, in its visceral explosion, its bold joy. This must occur in itself: this impulse toward the body of another, this journey, this fall. The return of the material to the object, charged with the sense of the warmth of skin, and the welcome of caresses, of sweet kisses and of the extraordinary turmoil in the midst of the night, the complete opacity between you and other, other and you. In war, slashed corpses offer the same hypnotic passion. But back to muscles, to that capacity to dominate and enslave a body for my pleasure and yours, to that seizure, that consumption of another's flesh, willing, sacrificed on the altar of my thirst. In such an outburst of energy, like a volcano, I celebrate the opening of my passions to the world. My muscle has been built to assert its power and presence: its movement indicates my life's fundamental principles which are to be, to do, to show. I love therefore to display myself lifting iron bars with a well-performing body rebuilt by training, and I love to make love to a body with this same exaltation and instinctive joy coming from my partner's acknowledgment and welcome of my great might.

"how i turned into an enthralled muscle woman"[4]

the hardness of her muscles, their brute strength, this is what I wanted to attain, the only body I wished to have. And for the first time, before my very eyes, a woman personified this body. The kind that I had then was unacceptable to me. Her body was mine, actualized, come into being. Now I only had to bring it about in me. My body should contain and be defined by the swelling of my muscles, filled with blood. A difficult task that would require years of work and persistence: one must constantly revive, awaken, get the blood going again, fight against the incessant threat of seeing muscles shrink. My body would have access to power and through it, to all the glorious struggles—to freedom and to happiness. I was going to take pleasure in my strength and the looks cast upon me. My naked muscles would become a martial sight. To make love or war, through the same impulse, required that I bare my body, show it. It became an illustration, seductive and esthetic, entitled to exhibit boisterous and brutal energy.

He ascends the staircase two steps at a time. I start later and overtake him. I do it by instinct. I dart a challenging, straight, intense look at him. That's how I like him, how I want him; because of his inability to beat me and, even more, because I made him upset by the discovery of this inability, perverted and lost in it. This is what I understood when I saw that muscular female body for the first time: what my sensual pleasure could be, what my happiness could be, what an enjoyable, burning explosion could be born within. As a result, others would feel either pathologically, obsessively attracted, or foolishly repulsed. And like a mirror, these hard-muscled women must have stirred in me the same feelings of fascinated attraction. I dreamed they had daring spirits. Their skin, their figures were hypnotizing.

To yield or concede, this is precisely what I refused to be compelled to do by any external force. I wanted as much as possible from a life in which I decide and get pleasure. As much as possible from my voluptuous strength and from these muscles which give to bodily contact the feeling of pleasure.

I gently caress his slender body and then, when he asks for it, I become brutal. His delicacy is striking and beautiful beneath my hands. His body lays belly down, and I lay on top without any fighting; a motionless test of strength—where our bulks come face to face with their differences in thickness, in muscle tone, in power— suffices to make my body, concretely, in its own flesh, the guiding element of our encounter. Our minds are impregnated with these differences. He is consenting. If my body were not the stronger, I could not be pleased. I could not get any carnal pleasure.

Facing this man who is smaller than I (barely) twice as thin, I am carried away with pleasure. I embrace, I squeeze his body. My desire is stimulated by a spring, the might of which throws him down. He succumbs to this muscular seduction. This body, my body, becomes luminous, since it experiences joy. Then it wanders to test other ones and to exhibit again the swelling of its muscles, their thickness, their hardness, their stone and flesh aspect, their life. I love my muscles and women's muscles in their excessiveness. I would lick those of a very big woman with steely eyes. I would take in my hand what is left of her breasts, would entirely unveil her body, certainly, I would kiss every bit of it from head to toe. I would be overwhelmed with pleasure. Electrified. I would be subjugated by a desire for flesh, and beyond, a desire for the spirit that this flesh reflects, seduced by the rugged strength, and also by a flamboyant and cerebral soul and by veins and tissues swollen with blood. I could certainly probe this body with my hands and with my own body. I could drive my flesh against hers with velvety blows. Test and follow its exact shape, I could slide my skin against her skin, feel its quivering density, its solidity and its resistance to my own body. Our opaque bodies do not penetrate one another, but merge into a single picture, rub each other with their weight, their heavy volume, learning to know each other inch by inch for their mutual pleasure.

I would watch her putting on her clothes again, slipping on a pair of jean shorts, her very broad shoulders crossed with veins, her legs spitting out their curves, her biceps seething into the empty space, her chest armored with strong muscles like a female gladiator, her calves bulging towards a larger space, and all of it done with playfulness and provocation. A smile crosses her lips. She is conspicuously proud to have this bodily asset of a simultaneously flashy and aphrodisiac power, a harmonious hugeness of muscles posing in absolutely sexual provocativeness.

Notes:

Translated by Pierre Samuel, Bourg-la-Reine, France; Molly Stevens, New York, New York; Joanna Frueh, Reno, Nevada.

[1] Nathalie Gassel, "Muscles as a Form of Megalomania," *Athéna 2* (February 1996): 35.

[2] Nathalie Gassel, "Why These Female Muscles?" *Athéna 2* (October–December 1996): 4.

[3] Nathalie Gassel, "Muscle and Eroticism," *Athéna 2* (winter 1997): 4–5.

[4] Nathalie Gassel, "How I turned Into an Entralled Muscle Woman," *Athéna 2* (spring–summer 1997): 6, 8–9.

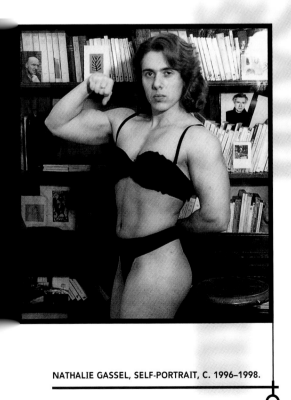

NATHALIE GASSEL, SELF-PORTRAIT, C. 1996–1998.

female muscu-larity and the comics

Maxine Sheets-Johnstone

JOHN BYRNES, *WONDER WOMAN* NO. 106,
FEBRUARY 1996.

I. amazons, art, and archetypes

Many of them are loud, tough, and menacing. They snarl, scowl, and sneer—like Battleaxe (from *The Thing*); Jaguar (from *The Jaguar*); Bitchy Bitch (by Roberta Gregory); Nixa (from *Visual Assault Comics*); unnamed female character from Alberto Ponticelli's *Emancipation*; and Samantha (from *Starman*). And almost all of them have grapefruit-style breasts, often of more than operatic proportions—like Gaby (from *Girl Crazy*); Francesca (from *Fang*), Mareva (from *Mareva*); Jackie (from *All Growth*); Karate Girl (from *Karate Girl Tengu Wars*); Satanika (from *Satanika*), and Sorney and Dark Francis (from *Atomic Age Amazons*), the latter character having gigantic, militarized ones that shoot bullets. In mainstream comics especially (but not exclusively), which feature characters such as Wonder Woman (from *Wonder Woman*), She-Hulk (from *Fantastic Four*), and Pagan (from *Batman*), they have Scarlett O'Hara waists, all natural, of course, no Southern-belle lacings needed. And they commonly have a Samson-like mane that is wild, but in the manner of a *coiffure soignée* even in the most turmoiled and violent of times.

The first thing of notice from the viewpoint of artistic portrayal is how these modern female powerhouses differ radically from those original Amazons of Greek antiquity, whose mythical forms first decorated vases in the second quarter of the sixth century B.C. That some of the painted warrior figures on the vases are female is apparent only in those instances when they are graphically or inscriptively marked as female,[1] for the figures themselves are dressed and equipped in regular soldierly fashion, that is, in the manner that any male warrior is dressed and equipped; they too wear helmets and carry spears, for instance. In the painted Heraclean Amazonomachies (Amazon battles), the Amazons are commonly taken to be defending Themiskyra, their own city, from Greek invaders[2]; in other painted Amazonomachies, they are taken to be on the offensive, but according to Dietrich von Bothmer, foremost Amazon art historian, it remains uncertain whether or not they are invading Attica in connection with the Trojan war.[3]

Von Bothmer's meticulous and thorough study of all the vase paintings is informative and relevant. His concern is to give detailed and precise descriptions of the painted figures in terms of who they are, what they are wearing, and how they are posed; his concern is not to give descriptive accounts of their physical presence as such—descriptions that would give us a bodily sense of them as people. Careful sifting through his extensive and fastidious descriptions, however, allows us glimpses here and there of their physical presence, and these glimpses provide us with a firm basis for fleshing out a fuller sense of the painted Amazons. In a rare instance, for example, von Bothmer comments that "The figures are stocky and muscular and there is nothing mincing about the style."[4] He thus implicitly suggests that, however consistently defeated they are in their battles,[5] these Amazons have corporeal powers on par with those of male warriors, a suggestion that coincides with the similarity of their dress and equipment to male dress and equipment. If we examine and reflect further upon his exacting descriptions of the bodily postures of the Amazons, however, we find that the first-noted superficial likenesses between male and female warriors are not reliable indicators of their respective corporeal powers. In particular, we begin to discover how corporeal powers have been rendered artistically by the various painters or specified from the viewpoint of the spectator, and how our various visual perceptions of corporeal power come about—how, for example, when we see depictions of the Amazonomachies, we know immediately in each instance who

KEEP YER HANDS WHERE I CAN SEE 'EM, YA BASTICHES!

SIMON BISLEY, *LOBO'S BACK* **NO. 2, JUNE 1992.**

among the figures has the upper hand. In turn, we begin to unravel the *intercorporeal spatial dynamics* that are at the heart of artistic renditions and perceptions of power. Descriptive remarks von Bothmer makes readily demonstrate the dynamics for us.

"Unless the distribution of types among the preserved Amazonomachies is utterly fortuitous and wholly unrepresentative," von Bothmer writes, "it can be assumed that . . . the retreating Amazon . . . was the favourite [depicted pose] among the variants employed on neck-amphorae."[6] Earlier he has noted that there are six variants in compositions featuring Heracles and three or more Amazons which he describes in terms of different facings and bodily attitudes.[7] Later, describing Andromache (the Amazon counterpart of Herakles) quite specifically, he says that "[she] appears in all the known variants of her flight and collapse," and that "the best loved remains the back-view, running right with knees buckling, the head turned left . . . followed closely by another in back-view, breaking down facing Herakles, without running away."[8]

The variants along with the "best loved" position are spatially portentous pictorial forms that graphically articulate intercorporeal power relations. They do so by specifying certain intercorporeal spatial relationships: higher than/lower than (thus larger than/smaller than); in front of/behind; facing directly/facing backward toward; facing right/facing left.[9] These spatial relationships and the intercorporeal powers they articulate have a long history, and one traceable not only along human lines, but also more broadly along primate ones. Given their evolutionary lineage, the spatial relationships are properly identified as corporeal archetypes. Two observations on the common primate practice of *presenting* readily demonstrate the archetypal nature of these relationships. At the same time, by exemplifying the spatial dynamics of intercorporeal powers in living terms, they demonstrate the conjunction between intercorporeal spatial dynamics in everyday life and intercorporeal spatial dynamics in Amazonomachy vase paintings.

ROBERTA GREGORY, *BITCHY BITCH*, 1998. INK ON PAPER, 14 × 11".

The meanings "submission" and "vulnerability" . . . are a built-in [element] of primate bodily life. Why? Because primates generally have face-on, front-end defense systems and aggressive displays. In *presenting*, they face their hind-ends to a conspecific. They thus place themselves in an inferior position insofar as they cannot easily see the presented-to animal nor monitor its behavior, nor can they easily defend themselves in such a position. In addition, in presenting they frequently lower themselves toward the ground, thus giving the presented-to animal an advantage with respect to the all-pervasive biological value, *size*.[10]

Presenting, which is usually a gesture of submission is often accompanied by nervous, even fearful, behavior on the part of the presenting animal.[11]

Primate corporeal archetypes—being larger than/smaller than, being higher than/lower than, being in front of/being behind, and so on—are the stuff of intercorporeal power relations.[12] They undergird human understandings of power—just as they undergird baboon, chimpanzee, and other primate understandings of power. Diverse cultural expressions of power in human societies derive from these evolutionary archetypes. So also do cultural depictions of power; they too have their roots in what is in the first place evolutionarily given. By identifying what is there in our primate history—what is evolutionarily given—and by tracing out the various ways in which cultures modify and transform corporeal archetypes of power, one can make explicit a corporeal semantics and come to an appreciation of how cultures rework what is essentially panhuman, and even pan-animate; that is, one can come to an appreciation of how cultures exaggerate, distort, elaborate, or suppress archetypal forms of power and thereby practice particular kinds of intercorporeal power relations.

We can apply this archetypal thematic history directly to the present task. Consider briefly von Bothmer's descriptions once again. However two-dimensional his printed words and however two-dimensional the actual vase paintings that they describe, we immediately recognize dynamically, in three-dimensional corporeal terms, what is going on. We understand the backward turn of a head, a back-view posture, a buckling of knees, and so on. We understand power on the basis of our bodies. Our bodies are the source of our intercorporeal understandings of power. However much and to whatever degree they are culturally reworked, corporeal archetypes remain the generative source of our experiences of power and of any artistic renditions of power.

II. sizing up the ABCs: archetypes, breasts, and the comics

So what are we to make of twentieth-century comic-book females? What are their archetypal patternings and roots? They seem to have not only the right stuff—the muscular stuff of which warriors are made—but *mutatis mutandis*, the right stuff in the right place. Or do they? What about those breasts (and in most if not all instances those extraordinarily generous bottoms to match)? Are they integral to the stuff of which twentieth-century Amazons are made—in notable contrast to the stuff of which original Amazons were made, Amazons who in the vase paintings give indication of no such parts, and who in their mythology are said to have excised their left breast in order both to draw their bows and to fight more effectively? Or are their twentieth-century male creators unwittingly superposing, in psychologically projective ways, male values and preoccupations onto females?[13] Or are their male creators, in visionary ways, intentionally portraying androgyny at its finest, doing nothing other than giving us the best possible mix of two sexes? Or are they doing neither, but rather showing us quintessential female, female pure and simple if only we viewers would throw off our cultural blinders (and perhaps moral laces) and see it?

It is temptingly easy in a number of instances to choose among the possibilities and to tell what we think male comic artists are doing—or what they think they are doing—but such specifics are not the point. The point is what, if anything, do mega-breasts have to do with Amazons? More sharply put, what does *mamma*-mania (Latin *mamma* = breast) have to do with female muscularity, especially when, in more instances than one would expect if the sizable huskiness were merely an occasional anomaly, muscularity to whatever degree

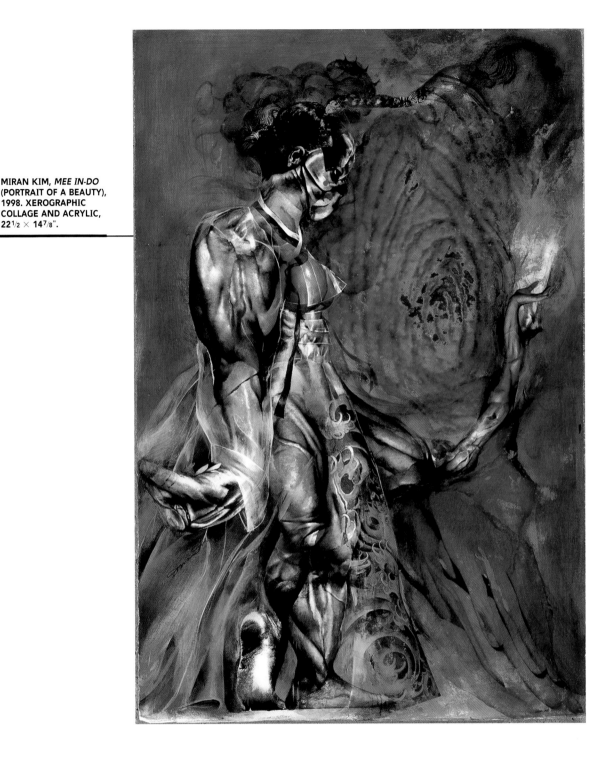

would hardly suffice: physiological license is needed to make support of those ballooned, always-perfectly-stationed-never-out-of-place parts credible, and biological license is needed to make the survival of their owners credible. If those oversized appendages really are integral to the stuff of which twentieth-century Amazons are made, then the question we should ask is how the male artists who draw them have redefined Amazon from its original artistic and mythological instantiation such that the Amazons we see (assuming we grant they *are* Amazons) are a picture of twentieth-century times rather than early Greek ones.[14] In view of our archetypal thematic and the larger-than-life nature of our subject, our best strategy is to single out *size* as an archetypal paradigm of intercorporeal power, specifying both its archetypal evolutionary meaning and its elaboration in today's American culture, to the end that we come to an appreciation of how super-female muscularity and super-breast-laden females, as portrayed in comic books, are related and what they augur, signal, or symbolize in the way of female power.[15]

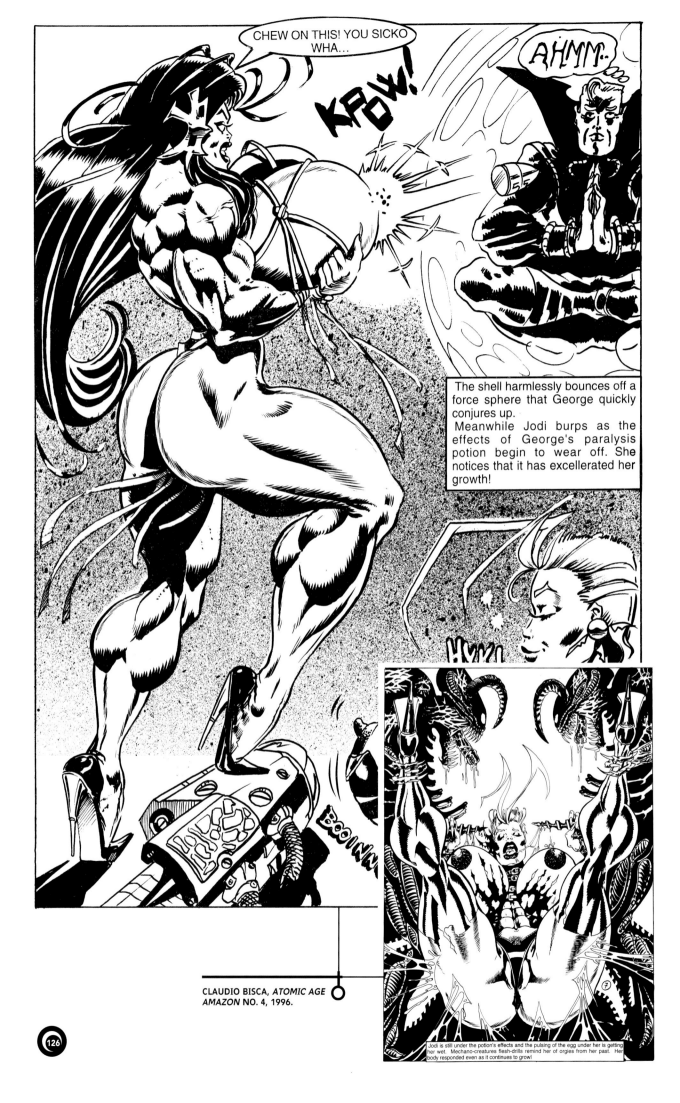

CLAUDIO BISCA, *ATOMIC AGE AMAZON* NO. 4, 1996.

III. inflation and its cultural elaborations

Inflation of the whole body or of a part of the body is a common occurrence in animate life. Evolutionary studies of nonhuman animals show that inflation can function as an aggressive display or a deterrent to aggression, or as a sexual signal. Darwin calls attention to its significance in his writings on both natural and sexual selection. By making themselves larger than they actually are, many animals are able to ward off predators—for example, the common European toad, which inflates its body and stands on tip-toe when it meets a snake—or to attract a mate—for example, the male sea-elephant, whose nose, being potentially both a weapon for fighting other males and a display for attracting females, "is greatly elongated during the breeding-season, and can then be erected."[16] As the examples suggest, the semantic significance and value of *size* are pivotal in the agonistic and sexual social relations of many vertebrate species, humans included. Moreover humans are by no means unaware of the potential advantage—agonistic or sexual—of their given biological size and of the possibility of creating the illusion of being larger in whole or in part than they actually are. Fashions document this fact in our culture. So also do the social problems of growing children, adolescents, and even adults, who harken after the message of power that inflation of the whole body or of certain body parts secures. It bears emphasizing that the power message is not limited to overall body size (height or breadth, or both), but quite specifically includes—traditionally for males only—muscular development, and just as specifically a high-figured measurement of certain sexual body parts; body parts that, when displayed (particularly in the evolutionary sense of being potent semantic markers for others), are a powerful signal of sexual power—and in addition, for males, a powerful signal of possible aggressive and violent power in the service of sex. Having *more* in the way of muscles—again, traditionally for males only—and of breasts and penises is in twentieth-century American society definitely better than having less.

How is it better? With respect to breasts and penises, the bigger you are in these parts, the more you are aroused and the stronger and more insatiable your sexual desire for, and sexual powers over, others. So the popular though not by any means always-subtle-or-implicit message goes. Having a large penis or breasts means having powerful sexual desires, powerful sexual urges—and of course powerful orgasms, all of these powerful experiences being ever so much more powerful than what smaller specimens of humanity enjoy. It is hardly surprising, then, that in present-day *more* American society, what is not achieved through nature

MARK BODE, *MAMMORIES FROM THE OTHER GROUND. . .* , 1998. ACRYLIC ON BOARD, 19 × 11".

has been made achievable by American medical practice—at least for those wealthy enough to cover the costs of in-the-flesh (rather than merely fashionable) inflations.[17] *More* in the way of male muscles coincides in exacting ways with the first of the two evolutionary values of size specified above; it is an unequivocal signal of sheer power, power that a so endowed male may use offensively or as a deterrent. More muscle is not in and of itself a marker of sexual power. Whether it is perceived as such depends on the eyes of the beholder and/or on its felt significance to the individual himself. Its power as a sexual signal is thus not a ready-made *but a cultural (or sub-cultural) elaboration* of that potent evolutionary marker, *size*.[18] That sexual power may be and is culturally elaborated on the basis of size, and in particular on the basis of hypermuscularity, is straightaway documented in a negative way by Amazon vase paintings mentioned earlier: while Amazons in these particular paintings are "muscular,"[19] there is no indication whatsoever that their muscularity has sexual overtones or sexual significance.[20]

In sum, there is nothing inherently sexual about larger-than-everyday-life muscles. The connection is

purely cultural. But the cultural connection may itself be profitably understood in further ways from the viewpoint of evolutionary biology and the principles of sexual selection.

When we view cultivated super-male-muscularity in twentieth-century America in terms of sexual selection,[21] that is, as a male ploy to gain female attention in the manner of the male sea-elephant inflating its nose as described above, a different but essentially complementary perspective emerges on the archetypal value of *size* and its present-day cultural elaboration. To show this complementarity, let us suppose that a particular instance of cultivated super-male-muscularity *does* function as a sexual marker, that it *is* perceived as such on the basis of the archetypal marker *size*. But let us suppose too that the perception is explained further according to the principles of sexual selection theory and not only as the cultural elaboration of an evolutionary archetype. So explained, the actual sexual success or lack of success of the hypermuscular male turns on female choice. There is in consequence no question of forced sex—no threat of aggressive and violent sexual abuse—in virtue of the sheer might of the male's mighty muscles. Sexual selection means that the female chooses either to mate or not to mate with the mighty-muscled male.

Biologist William Eberhard has written extensively on the subject of female choice and sexual selection, showing how, with reference to highly varied male sex organs in a wide variety of species, females will "favor any male that [is] better able to meet the females' criteria (by squeezing her harder, touching her over a wider area, rubbing her more often, and so on) even though his genitalia [are] no better at delivering sperm than those of other males." He proposes that "male genitalia function as 'internal courtship' devices."[22] Taking

Eberhard's extensive studies into account in the present context, we might readily and with good reason say that when super-muscularity functions as a sexual signal, it functions as an external courtship device; it promises more ardent squeezes, touchings over a wider area, and so on, all on the basis of what super muscle size augurs and promises. All the same, whether *Big Sex!*-by-dint-of-*Big Muscles!* is realized depends upon female choice. In other words, however much sexuality is culturally elaborated as a dimension of *Big Muscles!*, and however much the latter are perceived as promising *more*, there is no guarantee that *Big Sex!* will take place. Hence, though size and power clearly go together, and incrementally so, when *Big Sex!* is funneled into the equation, it is not necessarily successful: the female may just say "No!"

Yet highly muscled animals—be they human, orangutan, baboon, sheep, elk, or whatever—are indisputably creatures of power. They are recognized as such. In the comics, this same archetypal rule applies. Whether male or female, *size* is of inherent value with respect to intercorporeal power relations. From this perspective, the difference between super-muscled comic book males and females appears on the surface to be just that: superficial. They compete, war, fight, and so on, on an equal footing in the comics. One might think, then, that just as super-male-muscularity may spell *Big Sex!*, so too may super-female-muscularity. But female-muscularity as graphically drawn by male comic-book artists spells *Big Sex!* along quite different lines. These hyper-muscled females obviously have cultivated, developed muscles—Quadra Blu (from *Max Rep in the Age of the Astrotitans*) is a prime example; Wonder Woman's muscles, for example, are no match for Quadra Blu's. The point is significant because the further one moves from mainstream comics, in which female muscularity is at times recognized if not celebrated apart from sex, the further one ordinarily moves away from a celebration of female muscularity and ultimately toward a degradation of females.[23] In fact, the further one moves away from mainstream comics, the further away one moves from any concerns with the original comic thematic of social justice or social anything other than sex; and concomitantly, the closer one typically moves toward an ego-centricomics and to drawings of females that, along with their super-muscled bodies, sport mega-sized breasts that no amount of weightlifting and bench-

BRAD PARKER, *GAY COMIX* NO. 12, SPRING/SUMMER 1988.

GILBERT HERNANDEZ, "UNA," *GIRL CRAZY* NO. 3, JULY 1996.

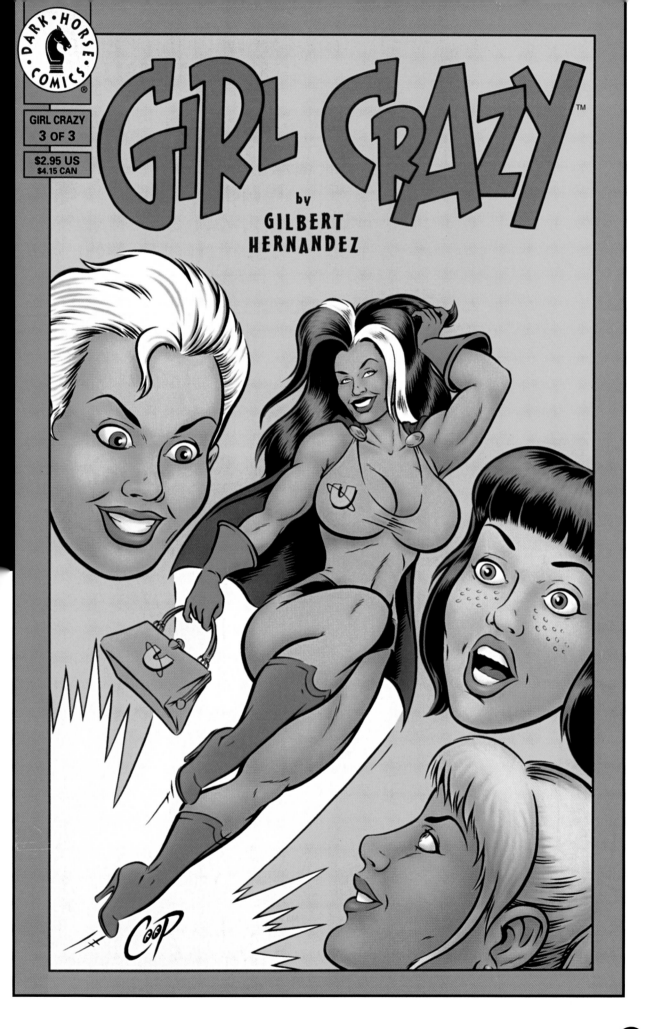

ALBERTO PONTICELLI, *EMANCIPATION*,
1998. INK ON PAPER, 14 × 20".

pressings could produce. Indeed, along with physiologi-
cal and biological license, anatomical license is needed
to tether the abundance of all this mammary flesh to
something other than the appetitive fantasies of its cre-
ators. Breasts, after all, consist not of muscular tissue
but of gland tissue, fibrous tissue, and fatty tissue. More-
over, we rightfully presume that the breasts of these
super-muscled females are all-natural, no additives. The
connection of female sexuality with female hypermuscu-
arity that is evident in the comics is thus not a cultural
elaboration of a super-developed musculature as it is
for males.[24] It is a more complex phenomenon. We can
begin to unravel its structure by asking what the rela-
tionship is between muscularity and sexual power, as
that muscularity *is displayed by females*? As we will
see, the answer has less to do with muscularity than
with *mamma*-mania, a basically cultural phenomenon
that is elaborated by way of larger-than-life external
courtship devices, devices that appear to be consis-
tently present not so much for the benefit of the male
characters in the comics, but for the benefit of the
preponderantly male readers of the comics; or at the
very least, as much for the benefit of the latter as for

IV. hyper-female-muscularity and hyper-female-breasts

hyper-female-muscularity in the comics is eclipsed
by hyper-female-breasts. In effect, the site of power has
changed: from muscles to mammaries. In turn, the fun-
damental erotics of female power, in contrast to male
power, commonly lies elsewhere than in muscles. The
implicit command addressed to the reader is not "Feel
my muscles!" but "Feel my breasts!" When we turn our
attention to this command, we make a sizable discovery.
Breasts are hard and powerful. They are pictorially
depicted as such by the male artists. We might even
affirm that they are powerful because they are hard,
power being eroticized by being presented as corpore-
ally hard. In present-day American culture, hard is in,
soft is out, so there is nothing other to do with these
mammas (properly, *mammae*) but to make them hard.
This means that however rounded the form of super-
sized mammaries, that rounded form is not realized by
squishy material like glandular, fibrous, or fatty tissue.
It is realized or appears to be realized by "projective
tissue," that is, by psychological transference. Inflated
breasts are by this means permanently inflated. They

know no ups and downs, no flaccidities, no danglings; you can count on them to be there fully and everlastingly. Hard mega-breasts are a semantic marker not of muscularly patterned power but of phallically patterned power. They are a blown-up fairy tale—a phallic fiction—of never-diminished sexual powers and never-ending sexual satisfactions. There is no fleshly sensuality in these fairy tales. Everything is hard and big: female breasts don't hang any more than penises do. In this respect, they are a decidedly cultivated cultural archetype, and one, we might note, that is becoming more and more popular and common in these tag-end years of the twentieth century.[25]

Female muscularity in the comics becomes a pretext for breasts, i.e., for sex. Story lines support this claim. They are preoccupied with sex. They feature sex change operations (*Lobo's Back,* no. 3; *Grim Jack,* no. 41), mutant sexual developments (*All Growth,* no. 1), paparazzi taking pictures of sunbathing females (*Fantastic Four,* no. 275), and so on. They feature just the kind of stories the popular media features when they want to sell something—bad, in the double sense of dying to make money and of using what Monty Python long ago christened "the naughty parts" to sell it, i.e., using sexual exposure. But female muscularity is or may be by itself erotic quite apart from breasts.[26] Where it is so purportedly featured in the comics, it not uncommonly verges on violence—the pornography of violence and the violence of pornography—which preempts eroticism and makes a comical response—seeing the humor of it all—a demented one. *All Amazon,* no. 6 forthrightly makes the point in its cover banner: "For slightly demented adults only"; so does *Horny Biker Slut* in its cover exhortation "Judge not . . . or judge, what do I care?" In the comics generally, we find violence galore, some of it transient and offhand, as when someone gratuitously breaks someone else's neck (*Subgirlz*). It is not the least surprising, then, that where comics consist of a headless female that is manually and genitally mined for her sex and of buxomed and great-fannied nannies that are mined for theirs (both in *Hup*), violence has become a Sadeian pleasure and way of life. Reflecting upon the acceptance of this violence, one might find it surprising that such comics are not regarded as hard-core pornography, all the more so given that research findings conclusively show that viewing pornography increases tolerance for violence in both men and women.[27]

In sum, with few exceptions (e.g., Joan Hilty's *OH* comics, Marx and Vosburg's *Sisterhood of Steel* comics), the overall impression one gains from the comics regardless of sexual orientation of the comic book figures or of their creators is that female muscularity is saturated with sex—having it, wanting it, wishing

it, talking it, thinking it, planning it—to the point that female muscularity is virtually nowhere in sight. As for the ascendant and reigning sexuality presented, it is of a phallicomic kind in which a sensuous aesthetics of flesh is likewise nowhere in evidence. It has been preempted by an always hot, urgent, orgasmic sex that wants immediate gratification. In such circumstances, the sweet density of flesh that is not one-dimensional, but both hard and soft, is co-opted by a quick, now, subculture of cravings that degrade rather than celebrate what is complexly female; a potentially powerful sensuality is consistently swamped by powerful sex. These displacements are evident the moment one begins digging below the surface and elucidating those historical, archetypal roots that wind their way around the subject of female muscularity and are found in one cultural way or another to strangle the very female power that female muscularity is supposed to celebrate.

Notes:

[1] Graphic markings include breasts drawn as small circles, earrings, and long hair; inscriptive markings identify by name—Andromache, Glauke, and Iphito, for example.

[2] The Amazons' home city is identified in only one vase painting composed by an artist named the Castellani Painter. See Dietrich von Bothmer, *Amazons in Greek Art* (Oxford: The Clarendon Press, 1957), 10, 14.

[3] Von Bothmer, *Amazons in Greek Art*, 72.

[4] Ibid., 14.

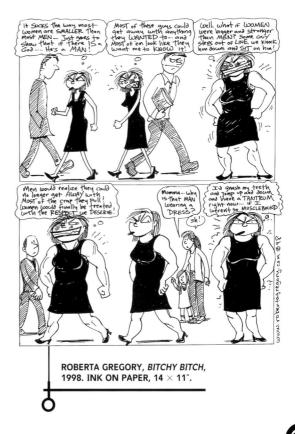

ROBERTA GREGORY, *BITCHY BITCH,* 1998. INK ON PAPER, 14 × 11".

5 Of one painting, von Bothmer writes, "The Amazons have not yet turned to flee," a memorable comment that pithily expresses the always expected and foregone fate of the Amazons. Ibid., 25.

6 Ibid., 62.

7 The six variants are: 1) "the Amazon behind Herakles is a hoplite [an armored foot soldier] and faces right"; 2) "the Amazon (hoplite) runs off to left"; 3) "the Amazon (hoplite) runs off to left looking round"; 4) "the Amazon behind Herakles is an archer [Amazons are typically archers] and runs off to left"; 5) "the same, but looking round"; 6) "the archer collapses facing right." Von Bothmer notes that "Andromache assumes any one of the[se] positions which were developed during the second quarter of the sixth century" and that "[h]er companion to the right is usually shown in the defending attitude." Ibid., 53. Earlier, he has stated that "Andromache,. . . as we may continue to call the principal opponent of Herakles, strikes the attitudes which were developed in the second quarter of the sixth century and shortly thereafter. She either breaks down facing Herakles [16 paintings] . . . , once averting her head . . . , or breaks down in her flight and looks around [17 paintings]." Ibid., 45.

8 Ibid., 63.

LEFT: FRANK MILLER AND DAVE GIBBONS, *MARTHA WASHINGTON GOES TO WAR* NO. 5, NOVEMBER 1994.

BELOW: JOAN HILTY, PAGE FROM *IMMOLA AND THE LUNA LEGION: TESTING 3-5-0-0*, NOVEMBER 1993.

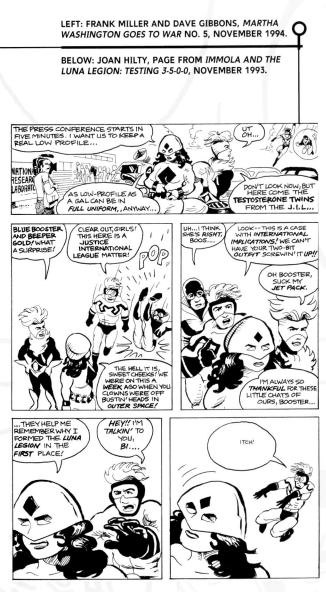

9 Herakles is most usually pictured facing right and Andromache most usually retreating to the right. The power of a left-to-right directional line is implicitly indicated. The battle lines in these vase paintings are from these perspective clearly drawn: what is on the right or what moves rightward around the vase from the viewpoint of the observer is the ruling figure. See von Bothmer, *Amazons in Greek Art*, 21–22 and 24, for further specifications:

> To the left of Herakles a companion (Telamon?), with a big plastic snake on his shield, worsts an Amazon in a position similar to that of the queen, whereas behind Andromache a Greek is defeated by an Amazon whose shield is emblazoned with nine white balls. This is the first time that the victorious Amazon appears to the *right* of Herakles and Andromache.
>
> The group in the centre is a trio: an Amazon is seen from behind, squatting on her heels, and faces an attacker from the right who pounces on her with raised spear. A striding Greek on the left attacks from behind. The directions of the principal Amazon and that of the most active Greek are significant.

Likening the scene to scenes of Achilles and Memnon, von Bothmer goes on immediately to specify that "Achilles always faces left [i.e., views from a right vantage point].

10 Maxine Sheets-Johnstone, *The Roots of Power: Animate Form and Gendered Bodies* (Chicago: Open Court Publishing, 1994), 73.

11 K.R.L. Hall and Irven DeVore, "Baboon Social Behavior," in Phyllis Dolhinow, ed., *Primate Patterns* (New York: Holt, Rinehart and Winston, 1972), 125-80, 174.

12 See Sheets-Johnstone, *Roots of Power*, for examples and further delineations.

13 The question is reminiscent of Kleinbaum's remark: "Neither in the Greek nor the Roman classical culture did the Amazon image serve to glorify women. It was used by male authors, artists, and political leaders to enhance their own perception of themselves as historically significant." Abby Wettan Kleinbaum, *The War Against the Amazons* (New York: New Press/McGraw Book Co., 1983), 219–20. Kleinbaum's initial and longer commentary also warrants citation: "The Amazon is a dream that men created, an image of a superlative female that men constructed to flatter themselves. Although men never invoked the Amazon to praise women, they described her as strong, competent, brave, fierce, and lovely—and desirable too. Like her modern-day incarnation, Wonder Woman, her strengths and talents have a supernatural quality. She is therefore a suitable opponent for the most virile of heroes, and a man who has never envisioned harming a woman can freely indulge in fantasies of murdering an Amazon. The conquest of an Amazon is an act of transcendence, a rejection of the ordinary, of death, of mediocrity—and a reach for immortality. If the Amazon displays military prowess, then the skill of the hero who defeats her is even more extraordinary. If she is beautiful and pledged to virginity, then the sexual power of the hero who wins her heart and her bed is without measure. If she builds powerful armies, strong cities, great stores of riches, then these serve as trophies for her male conquerors. To win an Amazon, either through arms or through love, or even better, through both, is to be certified as a hero. Thus men told of battling Amazons to enhance their sense of their own worth and historical significance." Kleinbaum, *War Against the Amazons*, 1.

14 If one were writing a veritable history of Amazons, one would have to take into account the romantic literature of the Enlightenment and Renaissance, in which the sexuality of Amazons was thematic. Since the present essay is concerned

with pictorial depiction, i.e., the comparison is between two forms of pictorial depictions of Amazons, original paintings and contemporary twentieth century comic-book renditions, this literature is not taken into account. The literature insofar as it reveals the conceptions of its various authors is nonetheless relevant. Kleinbaum writes, for example: "Although most medieval authors stripped Amazons of their physical desirability, the sexual element is clearly present, with redoubled force, in Renaissance and Elizabethan literature. Even more, the notion that Amazons are sex-starved women who diligently seek out valorous men for their own pleasure as well as for the propagation of their race was so well nurtured by the romance literature that it became the common possession of the populace, which tied Amazons to fantasies of sex as well as wealth." Ibid., 114.

[15] Other corporeal archetypes as they appear in the comics could be equally examined and analyzed along with size. In particular, *making a spectacle of oneself* is a primate archetype of power evident in descriptions of chimpanzees and gorillas as well as humans. Chimpanzees, for example, make a spectacle of themselves by leaping about, slapping the ground, brandishing tree limbs, and so on; gorillas beat their chests and vocalize (see Sheets-Johnstone, *Roots of Power*). None of their conspecifics can miss the display, and *display* it truly is. The comics exemplify this archetype of power no less than they do the archetype of size—by having things crash, detonate, explode, and so on, and by the enlarged printed words that try to capture

the horrendous force of the blast, as in "RAHRGH!" (*Visual Assault Comics*), "KRAASH!" (*Satanika*), "BLAM BLAM BLAM" (*OH*).

In choosing *size*, we are thus not ignoring those intercorporeal spatial relations itemized earlier, but allowing the subject itself to dictate the archetypal form of moment. As might be apparent, for example, the comics are actional rather than positional, actional by the very nature of their picture-by-picture presentation of a particular narrative or story line. In this respect they differ from the vase paintings, which, though they may represent a battle, do not represent it in narrative form. By and large, the only intercorporeal spatial positioning of moment that we see in the comics is the position of fornication in the broadest possible anatomical sense of the word. The analysis that follow in the text will substantiate the claim that sex, not muscularity, is the focal point of the comics.

[16] David Attenborough, *Life on Earth* (Boston: Little, Brown & Co., 1979), 140; Charles Darwin, *The Descent of Man and Selection in Relation to Sex*, vol. 2 (Princeton: Princeton University Press, 1981) 278; see also Sheets-Johnstone, *Roots of Power*, chapter 2.

[17] The lure of sexual power is not only medically tended to but commercially orchestrated through the media; *more* sexual power is a prime ingredient of big business. For the naive, and perhaps especially for young people, it is a lure that is hard to resist much less to ignore.

18 That the power of this evolutionary archetype may be and is culturally co-opted for the purpose of gaining sexual attention is readily documented by practices in other cultures, that is, by the fact that in other cultures, different body parts are inflated and in turn seen as sexually attractive—as in the practice of steatopygia, for instance, of lip and ear lobe enlargements, of cranial elongations, and so on (see Ted Polhemus, *The Body Reader: Social Aspects of the Human Body* (New York: Pantheon Books, 1978) and Bernard Rudofsky, "The Fashionable Body," *Horizon* 13, no. 4 (autumn 1971): 57–65.

19 Von Bothmer, *Amazons in Greek Art*, 14.

20 Again, attention should be called to romantic literature. See note 13 above.

21 Darwin, *Descent of Man*.

22 Willam G. Eberhard, *Sexual Selections and Animal Genitalia* (Cambridge, Mass.: Harvard University Press, 1985), 14; see also Maxine Sheets-Johnstone, "Hominid Bipedality and Sexual Selection Theory" (chapter 7), in *The Roots of Thinking* (Philadelphia: Temple University Press, 1990).

23 A comment by the creator of Quadra Blu sheds significant light on the meaning of it all, i.e., on female muscularity and the comics. Lyman Dally writes of his creation: "An object of lust for males and a role model for females, Quadra embodies bodybuilding's most positive qualities." Dally, letter to author, December 1998. It would be interesting to know in comparison how John Byrne, creator of the contemporary Wonder Woman, would describe his creation—and how other creators would describe theirs as well.

24 It is notable, of course, that male comic book heroes do not sport mega-sized penises. If the latter exist, they are not displayed as mega-sized breasts are consistently displayed, but remain (except for hard-core pornocomics) hidden from view. In effect, one must guess at what males keep under wraps, which makes (or can make) male sexuality titillating in a way that, oddly enough, mirrors the way in which sexual titillation is typically attributed by males to females in everyday Western life. (For more on these male psycho-sexual inversions, see Sheets-Johnstone, *Roots of Power*.)

It is of particular interest in this inversional context to note the reaction of some males to the sight of female hypermuscularity. In one instance, a male, seeing a hyper-muscled comic-book female, was at first shocked, then laughed, then said quite seriously before immediately walking away, "She'd pulverize me." (See Fierstein in Laurie Fierstein and Joanna Frueh, "Comments on the Comics," in this book.) The reactive comment warrants serious and extended reflection. *Size* is a marker of power, is clearly seen as such, and can just as clearly awaken fear or apprehension, or be intimidating as in this instance. But deep and honest reflection on one's own reactions to female muscularity—whatever they might be—can go even deeper than this. Reflection on one's own reactions has the possibility of leading one to reflect upon the body one is and the body—and bodies—one is not. See Sheets-Johnstone, *Roots of Power*, and Sheets-Johnstone, *The Primacy of Movement* (Amsterdam/Philadelphia: John Benjamins Publishing, 1999), 37, 49, 249, 430, 448. In this instance, for example, such reflection has the possibility of awakening *in the male himself* a sense of the kind of

threat that males, because of their generally larger size and larger muscles, can readily pose to females. One's own reaction to the bodies of others can in this way be a revelation—and a veritable learning experience. For further discussion of archetypal male and female bodies, see Elaine N. Arons, *A Cultural-Historical Exploration of the Archetypal Relationship of Delicate Small and Forceful Big*, doctoral diss. in Psychology, Pacifica Graduate Institute, Santa Barbara, Calif., 1995.

25 See, for example, the new men's magazines discussed in Richard Turner, "Finding the Inner Swine," *Time* (February 1, 1999): 52–53.

26 In a phone call in March 1999, Laurie Fierstein spoke to me of the possibility of a qualitative appreciation of female muscularity. Such an appreciation is hardly suggested by comic book female muscularity, not least because it is hardly compatible with outsized, larger-than-life breasts. From the viewpoint of the present essay, a qualitative hypermuscularity is tied to a sensual rather than sexual eroticism and as such has more to do with aesthetics than with paroxysmal orgasms. The strength indicated by a cultivated muscularity, for example, would be of aesthetic proportions rather than of objective measure and, by the same token, of possible aesthetic as against possible brute value. To begin fleshing out the qualitative dimension Fierstein has in mind would mean allowing a qualitative or sensual erotics to play out along the lines of the body unsilenced and unsubverted by typical (not universal or inevitable) male-defined sex.

27 Dolf Zillman, *Connections Between Sex and Aggression* (Hillsdale, N.J.: Lawrence Erlbaum Associates, 1984).

One might find it equally surprising that hard-core pornography is not correlated with the violence of war. Just as military training raises the threshold for violence, so also does consistent pornography viewing. Moreover, is it not telling that rape victims as well as those who have been mugged report experiences similar to those of soldiers who have been traumatized by what they have experienced? (See Sheets-Johnstone, *Roots of Power*, for references and a discussion.) No matter that post-traumatic syndrome is medically attended to and ministered to socially by "stress management teams." Even with their training, some individuals cannot stomach the violence they have lived through but find it coming up again and again, like nausea. Are these individuals wimps—or are they human? In comics that advertise themselves as being "For mean-spirited male adults only" (*Hup*), as well as in others less forthright about their audience, intentions, or appeal, the mean-spirited male adult's sexual other is not a significant other but only a thing, and protesters to his mean-spirited intercourses are indeed clearly nothing but wimps.

NEW MEN, *SECRET PLOT* NO. 3, DECEMBER 1997.

comments on the comics

Laurie Fierstein and Joanna Frueh

revolutionaries and clichés

Fierstein Unlike most of my childhood chums, I never read comics. Even as an adolescent, my heroes were the likes of Mother Bloor, Paul Robeson, and Rosa Luxemburg, real-life wonder women and super men who devoted their lives to the cause of the downtrodden. Sheena Queen of the Jungle and Captain Marvel were no match for Harriet Tubman and Emiliano Zapata, the nobility of whose words and epic struggles transported me. Considering this background, it may seem antithetical, even droll, that comics now intrigue me, and to underscore the irony, specifically comics about one of the most "ignoble-ized" of all personae: physically muscular women.

Frueh My mind reels with clichés and trite alliterations. Monster, goddess, dominatrix, fetish, phallic mother, savior. Avatar and atavistic. Homoerotic, hellcat, hex. Threat and theater. Demon, babe, and jungle queen. The animal and the primitive. Appalling and appealing. Magical, mysterious. Only the obvious appears to be available.

Fierstein Believing that females' big muscles have revolutionary implications, metaphorically and corporeally, for both gender and women's empowerment, I turn to the comics and comic book artists and writers, because

they provide some of the most richest iconographical commentary on these subjects. These representations are bizarre and fantastical, and, in many cases, vulgar and crass. When I explore them in as unbiased a way as I can muster, I have discovered that the comics confront hypermuscular female corporeality in a manner rarely found elsewhere. However, in order to appreciate this representation, we must embark from the premise that the corporeality of hypermuscular women is unique and complicated; and that this complexity is not understood if the observer uses orthodox markers and methodologies in order to culturally situate—or even resituate—the hypermuscular woman.

cosmic proportions

Fierstein Comic book art and narrative is a genre in which absolutely anything can be or can happen. No matter how phantasmagoric, unearthly, preternatural, exaggerated, or hyperbolic, it is acceptable in the comics. Thus, it's also acceptable to present hypermuscular female figures of cosmic proportions.

Frueh Here are some characteristic measurements: Quadra Blu: height, 5 feet, 9 inches; weight, 215 pounds; chest, 50 inches; arms, 19 1/4 inches; waist, 29 inches; thighs, 33 1/3 inches. Styge: height, 6 feet, 10 inches; weight, 325 pounds; chest, 68 inches; arms, 22 inches; waist, 28 inches; thighs, 44 inches; calves, 26 inches.

PAT OLLIFFE, *THE SENSATIONAL/SAVAGE SHE-HULK* VOL. 2, NO. 55, SEPTEMBER 1993.

QUADRA BLU™, APEARING IN *MAX REP*™ CARTOON SERIES BY LYMAN DALLY, REPRINTED FROM *MUSCULAR DEVELOPMENT MAGAZINE*, FEBRUARY 1993.

Fier∧tein Comics art and narrative is intended to be outrageous and entertaining, to grant popular culture a haven for the expression of imagination and fantasy without inhibitions and reality checks. This made its way into an array of subgenres ranging from main-stream comics (for both children and adults, which allowed fantasy within limits), to underground, erotic, and "fetish" comics, in which constraints disappeared altogether.

Frueh These female giants of luxuriously eerie propor-tions possess Artemisian attributes in great measure: shrewdness, stamina, endurance. They have so much and so extremely, but they also have nothing to spare. Sometimes they belong to mystic or athletic sister-hoods; nonetheless, they strike me as a melancholic crew, isolated, lonely in the ways that oddities of the human species tend to be.

Imagine your calves and waist to be roughly the same size. Imagine your biceps to be only a little smaller than you might like your waist to be. Imagine how it feels to be this body, how differently you would walk than you do now, how you would sit in the chairs you know so well in your own home, how you would fit into clothing, how you would choose it when you shop, how your flesh would glide and press against another's when you make love.

the get-up of predators

Frueh The hypermuscular female in comics frequently wears great shoes, if you like fetish gear. The heels are so high that they throw the calf into tremendous tension, exaggerating its size and shape. Cleo, the dominant bodybuilder in Diane DiMassa's all-female world of "Hothead Paisan: Homicidal Lesbian Terrorist," orders one of her bodybuilder subordinates to "get [Hothead Paisan] some **proper footwear**!!" Which, clearly, would duplicate the genre of Cleo's own platform, super-high heels with ankle straps.

Fier∧tein We naturally read armor worn by a "regular"—unmuscular—woman as fulfilling the same purpose or desire as armor worn by a man—protection and invinci-bility, for example. Jung said that armor protects the heart, which he defined as feminine. Scholar Alan Klein likens bodybuilding muscle, on men, to armor—a self-constructed fleshy defense against the feminine trait of vulnerability. The clearly masculine/phallic connotation of armor serves to hide or transform an unmuscular female's gender or gender identity. Witness Joan of Arc. In comics or action hero adventures, we almost never find a muscular male (hero) adorned in armor. He exposes his meticulously represented, engorged and rippling muscles in every frame and from every angle. Armor or an armorlike veneer is, however, a marked "costume" worn by several muscular female comic heroes. We know or assume the actual muscular-ity of these characters because we are given glimpses of their bodies from time to time or because their armor-sheath insinuates muscle beneath it. Examples include Dave Gibbon's black hero Martha Washington in *Martha Washington Goes to War* (Dark Horse Comics); Masamune Shirow's Deunan in *Appleseed* (Dark Horse Comics); Jan Duursema's Haven in *X-Factor* (Marvel Comics). In some cases, such as Nixa by Rhyan Scorpio-Rhys (Visual Assault Comics) and Calico by Hillary Chang, Randall Lavarias, and Chun Lee (Pagers Comics Anthology), it is ambiguous whether the characters "wear" flesh or armor or some alien composite of both, or none of these.

Frueh The Sphinx who terrorized and killed men out-side of Thebes asked a riddle whose answer was "Man." A predator, she is sister to the comics monsters in whose muscle animal intelligence has combined with human will. Their gender indeterminacy asks a simple question, "What is woman?" whose answer is itself the riddle.

Fier∧tein If muscle can be considered armor, then why the need to place non-fleshy protection or covering on

top of the powerful muscle of some female heroes but not on that of their male counterparts? Could it be that this covering exists precisely to obscure what we infer from the (male) heroes' massive muscle: that the women have become their own protectors? Does this message push the superheroine too far off the gender map? Does the "necessity" of armor over mighty flesh dehumanize the power of the female figures and alienate them from the very essence of their strength, thus making them more not less vulnerable? Does the armor *allow* the portrayal of a muscular female by easing a reader's/viewer's possible embarrassment brought on by having to cope with obvious female-muscle-as-flesh? Does the armor safeguard the characters' feminine normality

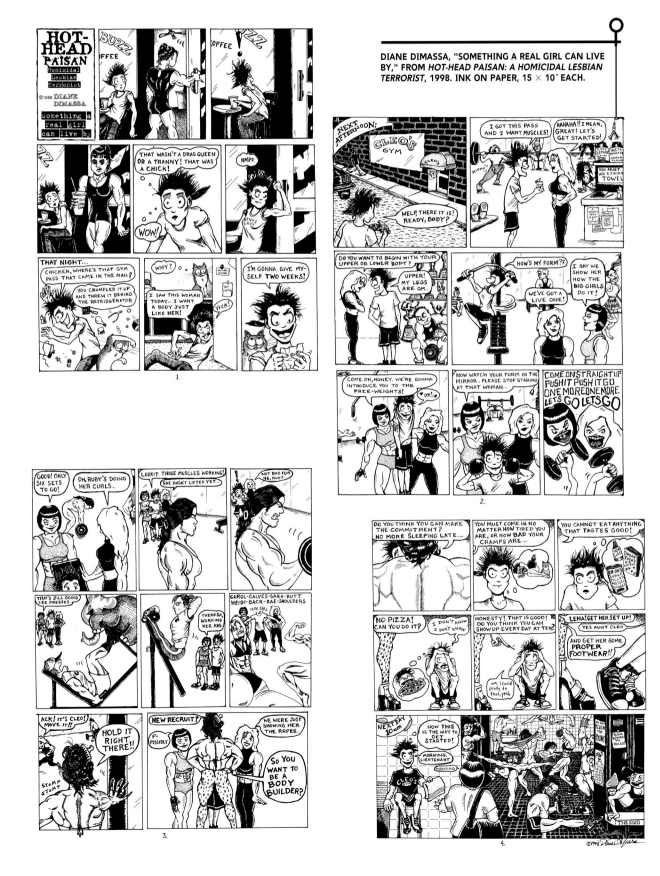

DIANE DIMASSA, "SOMETHING A REAL GIRL CAN LIVE BY," FROM *HOT-HEAD PAISAN: A HOMICIDAL LESBIAN TERRORIST*, 1998. INK ON PAPER, 15 × 10" EACH.

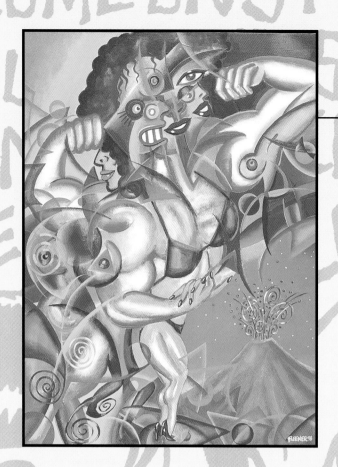

and, by extension, the "natural" sexual and gender order? (Maybe an artist just thought that a dazzling steely-blue outfit looked really cool.) But the muscular female comics figure has become her own armor, and the point remains: armor is not simply artifact, and its implications for hypermuscular and non-muscular female images are totally different.

Frueh John Howard created a character named Horny Biker Slut. She is nothing like Xena or Wonder Woman, for whom blood and cum—their own or others'—are alien bodily fluids. Xena and Wonder Woman are cuddly in comparison to many of the hypermuscular comics females, whose familiarity with blood and cum is passionate. Deer, rabbit, duck, antelope: Xena and Wonder Woman would be prey for the predator.

Our culture does not admire human predator females. In her scholarly study *Woman the Hunter*, Mary Zeiss Stange asserts, against ecofeminist arguments and general cultural belief, that women are no more nurturing or non-violent than men, and she contends that women armed with what have been designated men's tools endanger romanticized ideologies about gender and violence. In Stange's book Artemis is no forest nymph, whose hunting prowess and ability to kill, whose archetypal power as death-dealer, has been virtually removed by many contemporary feminists.

They design her instead as a figure with whom women who enjoy a tamer side of nature can identify. Stange's killer and hunter Artemis is neither lovable nor easy to identify with, for she has assumedly appropriated male cunning and weaponry. But a goddess doesn't appropriate; she uses her own tools. Like Artemis, many of the comics' hypermuscular females are ready to kill, and though they seem to have appropriated male bodies, that perception is part of the riddle of female identity.

overpowering goddesses

Frueh Gargantuan riddles, trapped in the comics, enslaved to sex and violence, to blood and cum, maybe you are more than sluts and goddesses, which is the title of a videotape by artist and ex-porn star Annie Sprinkle. In *Sluts and Goddesses* (1994), Sprinkle instructs her viewers in how to become these female archetypes, which she also very evidently treats as parodies of femininity. Her methods include being both serious and absurd in order to make her point, which is that women should take pleasure in themselves.

Hothead Paisan imagines her own pleasure if she were to look like a female bodybuilder. Paisan, our terrorist heroine, is hot for the built women in the gym, and hot for herself as she identifies with them.

Fierstein Venus Envy appears on Hothead Paisan's t-shirt only once, at the moment when she is struck by a dual realization: the hugely muscled creature she saw going into the gym was "a chick," and that is what Hothead wants to be. Created for the Amazon project, Diane DiMassa's "Something a Real Girl Can Live By" treats us to a feast of scrumptious subtleties in a hilarious narrative about the muscle-quest of the wiry, androgynous, homicidal lesbian terrorist Paisan in Cleo's Gym. When Hothead's gym mentor asks Hothead whether she would like to begin training with her upper or lower body, she answers, "Upper! My legs are OK." This reveals DiMassa's sensitivity to the clichés that "real women" only want to tone their legs and glutes and "real men" only want big arms and chests. One of my most vivid fantasies has always been to leg press an elephant—and there is Jill in Cleo's Gym, gripping and grunting and pushing out reps with Jumbo peering down from the sled as Hothead stares in disbelief. I've seen that stare, usually reflected in gym mirrors. I know it well.

R. Crumb's longstanding interest in hypermuscular goddesses and variegated depictions of them seem to have emerged from the artist's belly, his tearing it open and inviting a public inspection of his deepest, secret places. In his raw-nerve sketchbook drawing "Frightened Little Man in the Land of the Vulture Goddesses," Crumb images a small man—the artist's persona—cringing and scrunched against a wall, enveloped in helpless terror, as potent, massive female figures with vulture heads surround him in trancelike promenades. His fear and their power are absolute and irreconcilable for him. I feel an impulse to enter this chilling scene in order to rescue and comfort the stricken soul, but feel no equal compulsion to displace the goddesses, whose removal would totally destroy the eco-balance of the panorama. It is the frightened little man who is out of place.

bodies turn Crumb into both a literally fucking idiot, as we see inside *HUP* (no. 3), and a big baby, which is how he portrays himself on the cover: drooling, terrified, and sexually excited to be pushed in a buggy by a muscular and girlish Scandinavian goddess/nanny.

He can twist her this way and that as he screws her, he can smash her boot into her face and enjoy it. Her body seems so strong, yet he can toy with her. Crumb's are the only comics I looked at in which a male creator admits to his lust-near-adoration of big female muscle while also realizing that he is, in his own words, "abnormal," "boring," "annoying," a "creep." I appreciate his honesty. Crumb's fuckable, manipulatable, and degradable muscle girls and many of her kin are exactly the amazon described by Abby Wettan Kleinbaum in *The War Against the Amazons*: hugely attractive as women and hugely skilled as fighters, destined for sex and death (at the hands of a man). However, unlike Kleinbaum and Crumb's destroyable amazon, Robin Ator's Kyra, Lyman Dally's Quadra Blu, and BC Comics's Jodi the Atomic Age Amazon all defeat their opponents.

Crumb calls one of his hypermuscular goddesses Devil Girl. The devil made me do it: male comics artists celebrate female muscle and degrade it at the same time. Demonize the enemy. They are bedeviled by her, who they themselves designed.

Fierstein Surveying the breadth and content of Crumb's investment in the strong, muscular female, we experience his and our own feelings of tenderness, savagery, and lust. He gives us no determinate victim or victimizer. The stories and situations are absurd. But taken together as a statement Crumb's body of work declares not only his undeniable attraction to the "vulture goddess," but also his need for powerful women. Crumb has made this known to the world. Hurray!

Frueh Crumb makes it evident in his comics that he loves muscular women's big calves. He loves their asses, too, and describes one as "huge, yet solid and buoyant." For those physically drawn to the hypermuscular woman or her comics counterparts, Crumb's description is the crux of desire. Huge, solid, and buoyant female

 R. CRUMB, *TINA LOCKWOOD*, 1998. INK ON PAPER, 11 × 14". BASED ON A PHOTOGRAPH BY MARK SCHAEFFER.

"I WOULD LIKE TO THANK MY PARENTS FOR GIVING ME AN EXTRAORDINARY PACKAGE OF GENETICS."--TINA LOCKWOOD

"BOY, I'LL SAY!"--R. CRUMB, 1998
(DRAWN FROM A PHOTO)

ALL GROWTH!

Frueh I see a parody of a parody: the centerfold whose breasts are perilously large, too heavy for her own comfort, so hard and massive that they are more than armor; they could smother enemy flesh, crush his or her bones. This parody uses her cunt to punish men and to please herself. (The male creator pleases himself by having her do anything he pleases.) Swinging on a vine to gain momentum, Robin Ator's Kyra slams her cunt into a bad guy's face. Larry Heller's Jackie, a splendid nightmare of muscle and bosoms, "rotate[s] her hips, her inner muscles gripping and grinding [Tim] with animalistic fury," until "Tim thought her orgasms would snap off" his dick. Her vagina is a grand canyon. Her cum sprays onto his face.

Fierstein In Elie Xyr's "Skinners II" in *All Amazon*, no. 9 medieval armies assemble, readying for a crusade. Hordes of male brigands, bodies large and hard, prepare shields and spears. Their opponents, an army of women, are even larger and harder. The female warriors are so massively muscled that it is virtually impossible to comprehend their anatomy. Breasts are swollen and exaggerated. Great material for *Hooters* or *Jugs*, were it not for the equally swollen and exaggerated biceps, triceps, calves, forearms, shoulders, leg and back muscles, all bared and flexed to support battle girdles and weaponry. The nipples are armored and spiked, making them simultaneously more and less prominent amidst the exposed and mountainous female brute force. The battle itself is a pandemonium of fleshy mounds which Xyr intricately and passionately intertwines. What and where is thigh, arm, breast, buttock, fist, throat? To whom do these body parts belong? A male? A female? Are these parts making war or copulating or both? Even after carefully examining the body parts, I can't figure it out. Regardless, the women win and no one seems particularly distressed by the outcome.

WRECKSHOP. *ALL GROWTH!* NO. 1, 1996.

the strength of sex

Fierstein A diminutive and unremarkable man watches REX's Mrs. Armstrong in *All Amazon*, no. 9 as she prepares to train. He is humbled in her presence, tense with anticipation. Mrs. Armstrong's physique is scarcely covered by spandex shorts and a crop top, which reveal her every massive muscular and mammary billow. She is compassionate to her eager observer, tenderly permitting him to be close to her. With his face just inches from her chest he blurts out, "You've got a great set of PECS, oh . . . I mean breasts . . . I, I mean" Mrs. Armstrong smiles sweetly—a combination mom and the girl next door sweetness—and invites him to spot her while she bench presses—1300 pounds. He is only seconds from ejaculation.

CLAUDIO BISCA, *JODI THE ATOMIC AGE AMAZON*, 1996 AIRBRUSH ON BOARD, 15 × 10", PUBLISHED ON THE FRONT COVER OF *ATOMIC AGE AMAZON* NO. 4, PUBLISHED BY LH-ART. .

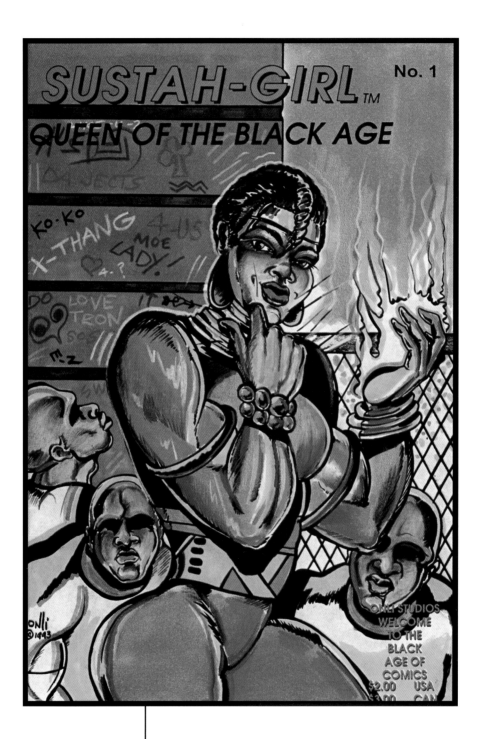

ABOVE: TURTEL ONLI, *SUSTAH-GIRL: QUEEN OF THE BLACK AGE* NO. 1, 1993.

LEFT: RHYAN SCORPIO-RHYS, *NIXA!*, 1998. PEN AND INK ON PAPER, 11 × 17".

Frueh Sometimes I wear my own mild version of the highly sexed and muscled comics goddess's dominatrix shoe—a lower heel, no pointy toes. I enjoy my own muscle, strength, and cunt, and to a degree, I feel an affinity with these highly stylized figures. Yet they and the narratives in which they act, from which they cannot be separated, nauseate as well as sexually stimulate me. My response surprises me, that I am so strongly affected. This sexual arousal, its mental and physical components, recalls to me when, as a little girl, I looked at *Playboy* nudes and masturbated afterwards.

Fierstein I show the cover of *Atomic Age Amazon* to a male co-worker in an office where I'm temping as a word processor. Claudio Bisca's Jodi glares straight at him in all her purple rage. She's of the atomic age, so it's okay that she's muscular beyond mutation and that her breasts are enormous, perfectly globular planets in quasi 3-D effect. Jodi spreads her legs and a tiny g-string cleaves her labia. My co-worker is muted for three full minutes while he regards this image. Finally the silence is broken: "She'd pulverize me."

Frueh Giants with tiny waists, these exemplars of a simultaneously feminine and masculine identity and sexuality display a magnitude of muscle as outré as this magnitude of breasts. Strenuously shapely and minimally clothed though lavishly ornamented, these fantasy fucks and sparring partners, these caricatures of gender make me think of a mutant architecture, designed perhaps by architect Philip Johnson and film-maker Cecil B. DeMille.

Blow-up doll, rubber. Statue, stone.

gravitating toward freedom

Fierstein With very few exceptions, women artists and writers did not gravitate toward expressing themselves in the comics genre until the late 1960s. They blossomed in the next two decades into a loose women's comics underground, which manifested itself in short comic strips/stories and in publications such as *Twisted Sisters* and *Wimmens Comix*. Some of the artists included in this underground are Mary Fleener, Alison Bechdel, Roberta Gregory, Joan Hilty, Kyrstine Kryttre, M. K. Brown, Diane Noomin, Jennifer Camper, Trina Robbins, Aline Kominsky-Crumb, Diane DiMassa, and Debra Rooney. Like many other women artists of that period, the women comics artists produced works reflecting self-exploration, and the comics artists' narratives were often drawn from their own experiences.

JOHN HOWARD, *HORNY BIKER SLUT*, 1998. DRAWING ON PAPER, 11 × 14".

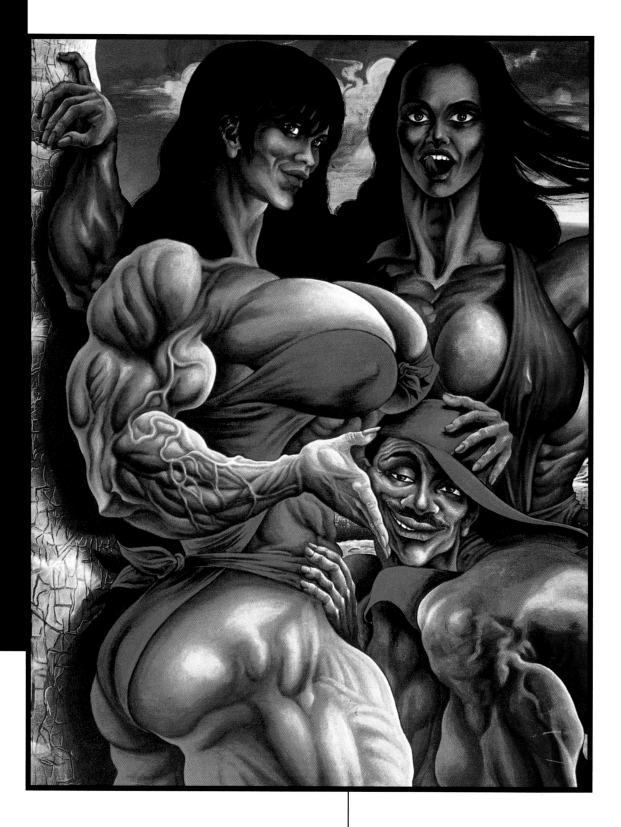

ABOVE: ELIE XYR, *BORA BORA WAHINES*, 1987.
DETAIL FROM VINYL ON WOOD PAINTING,
48³/₄ × 97¹/₂", PUBLISHED ON THE BACK COVER
ALL AMAZON NO. 9, 1996.

RIGHT: DEBBIE SCHAFER, *MIGHTY GIRL IN HER
DREAMS*, 1999. DRAWING ON PAPER, 18 × 15".

Frueh Jennifer Camper's current character Swizzle, a sweet, tank-topped, urban lesbian, doesn't understand her own strength, so she inadvertently kills people. Roberta Gregory recently drew a skinny urban woman who, as she walks the street and assesses the unfairness of women's being smaller and weaker than men, becomes angry and muscularly developed. Neither Camper's nor Gregory's muscular females are predators.

Fierstein Women artists' late entry into the comics, coupled with the roadblocks for women in this area that paralleled those in other creative and commercial fields, means, of course, that the comics genre has been largely male-created and -oriented. It is no surprise that the audience for mainstream commercial comics has been—and still is—mostly males between ten and fifteen years old. (The statistics are changing because of a growing adult audience and the development of high-tech entertainment for that adolescent age group.)

Considering comics' history, the introduction and development of muscular and physically powerful female images in comics and comic strips—and, of course, the attitudes toward this type of woman—could only reflect male responses and perceptions. This treatment of hypermuscular women has been inadequate, and in some cases objectionable. Nonetheless, male comics artists' implicit commentary has been significant because of its complexity and because few other portrayals of muscular women have existed in either art or popular culture.

Frueh As is typical of comics, the emotions expressed by the hypermuscular females in them or acted out upon them are explosive. But in the containment of such forceful anger, fear, sex, and revenge within 8" × 10" pages, a poignant desperation to contain her seeps through the blatancy of her depiction. Keep the mythic body in a mythic world, in a small part of the cultural imagination. Keep this female on a page. Try to flatten her.

Fierstein None of the female comics artists were muscular themselves, a reality ready for self-exploration and one that might have appeared in their self-expressive images. Yet their work, while very focused on women's empowerment, only rarely addressed that issue in the realm of physicality. (Examples of women who do address physicality in their comics are Camper and Hilty.) As a result, almost all of the women comics artists included in *Picturing the Modern Amazon* created works expressly for the project, some in the form of comic stories or

comic strips and some in the genre of comic-book art, which reflects the visual style of the comic-book artist with little or no narrative. Artists who chose to address female muscle in this way include Miran Kim, renowned *X-Files* comics cover artist; Debbie Schafer, prize-winning caricaturist (who bodybuilds); and Mary Fleener, whose acclaimed, graphic comics novel, *The Life of the Party*, morphs us into her experiences with sex, drugs, and rock 'n' roll through her invented "cubismo" style of comic-book art.

Frueh The poignant desperation of the comics hypermuscular female's containment came to me during a class I was teaching on nineteenth-century art in the spring of 1999. I was showing a slide of a painting by the Victorian artist Frederick Lewis, *A New Light in the Harem*, in which a Caucasian woman reclines while a black nurse plays with the former's infant. I didn't ask the class for personal interpretations, but some were offered. A woman in her late twenties said that the mother was a captive, a slave of her own sex and sexuality. Another student acknowledged the black woman's captivity—her labor exercised for the benefit of the light-skinned mother and child. Another added that both women's captivity benefited men. A man in his late thirties, formerly in the military, told us that he had been seeing the mother as comparable to United States soldiers imprisoned in tiger cages during the Vietnam War. They looked like captives from the outside, he said, but they were thinking of their freedom. Harem woman, black nurse, prisoner of war—all with immeasurable dimensions of the mind. So too is it in comics culture's pin-up harem of both dark- and light-skinned hypermuscular females, within whose epic dimensions revolution has begun.

inter-
views
inter-
views

with women bodybuilders

Joanna Frueh

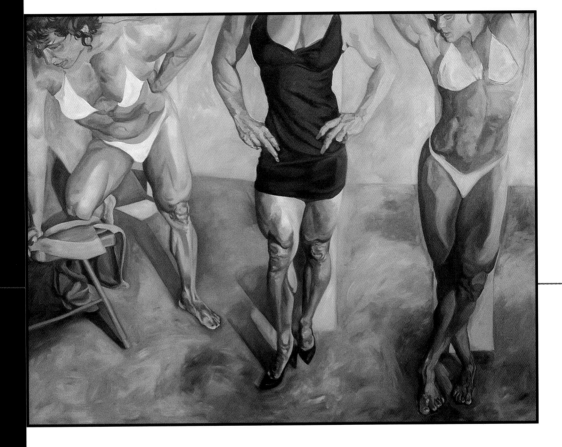

JANET COOLING, *THREE VIEWS OF FRAN*, 1998. GRISAILLE ON CANVAS, 96 × 110". PICTURING FRAN FERRARO.

pudgy Stockton

Pudgy (Abbye) Stockton is an early pioneer of women's body-building. She was born in 1917 in Santa Monica, California. In 1939 she began working out and performing balancing and strength feats at Santa Monica's Muscle Beach, often teaming with Les Stockton, whom she married in 1941. Throughout the '40s they participated in athletic shows, and from the late 1940s into the 1950s they opened gyms in the Los Angeles area. I interviewed Stockton in her and her husband's home in Santa Monica on September 25, 1998.[1]

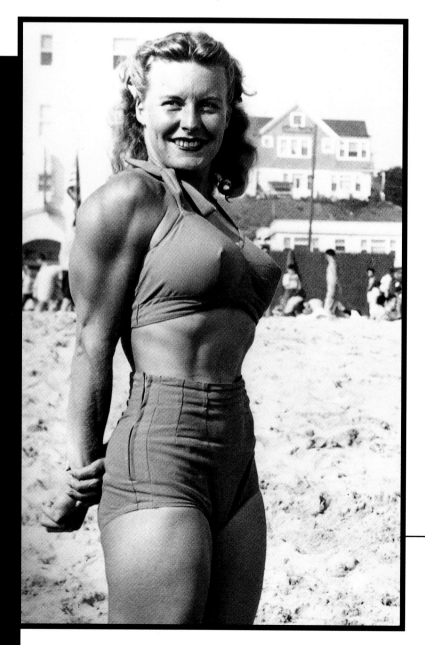

PUDGY STOCKTON ON MUSCLE BEACH, VENICE, CALIFORNIA, C. 1945–1948.

beginning with weights

i started because I was getting too heavy after I graduated from high school. I wasn't doing any exercise for about a year or two. I just lived a teenager's life and then I started working for a telephone company, so you're sitting all the time and this changes your body because you do gain weight and you get out of shape, flabby.

Les loaned me some weights and I didn't know anything about weights to speak of. I had a pair of five-pound dumbbells that I used at home, because there really weren't any gyms where anybody went to do anything like that at that particular time, and I did just arm exercises. And I noticed the change in my strength and that kind of encouraged me to do more. I was working into it slightly. It wasn't at that time a big part of what I did because a lot of it was handbalancing and because I seemed to be strong enough to do some of those support kind of things. It was just really gradual over two or three years. It wasn't until the '40s that I really started doing any kind of lifting.

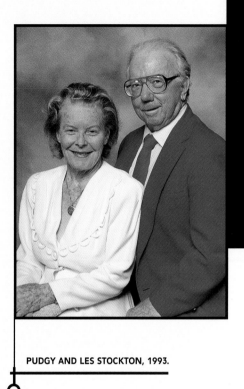

PUDGY AND LES STOCKTON, 1993.

the feminine desire The feminine desire to look good in clothes enters in—have a small waist and flat tummy and that kind of thing.

I always was pretty feminine. It was just that in anything you read it was always women shouldn't do this and women shouldn't do that, and naturally I was inoculated with those ideas to begin with. [Muscle] just makes a big change in the way you think about yourself and about what you're doing.

One of the things that bothered me—I remember walking across some place in Hollywood [in 1938 or 1939] where we used to go and do some of our balancing in a big auditorium that was open to the public, and as I walked across this room to go and change my clothes, I heard some girl say, "Wow, she looks like a man." She was looking at me from the back. I was wearing probably a two-piece bathing suit.

That was the prevailing feeling of women, I think, about anybody doing something that was more a masculine type of activity. I never felt that way [masculine] down at the beach. Because we had so much fun—to try things that were hard, that took your strength.

I think some men probably had negative feelings about it, but all those that we were around were not that way, because they all worked with us. [The negative] came from, was more apt to be women who said things like that.

I always was afraid to do too much that would develop my biceps. I had the feeling that, you know, that would be masculine.

I didn't want to [seem masculine], especially after I went into the gym business. Even though there were women getting interested in exercise, you still didn't want to—because they didn't want to come in and build up big muscles. They wanted to make their bodies look better, just physically better.[2]

beautiful legs When we went to the Olympics in 1932 I remember my mother and I and my brother— there were these men standing around where they had some tents. They were big, strong, and I'm sure they were weightlifters. That impressed me. Actually, when I stop to think about it, I did have a feeling that I liked beautiful legs. And I liked muscular legs—both men and women. This was always something that appealed to me.

an inspiration Perhaps [I was an inspiration] because gradually down there at the beach there were more girls that started to come and do these things.

I called [what I did] weight exercising. Because that's really what I gave people who came to my gyms—weight exercise for women. And it helped to keep their weight down or to gain weight.

nutrition There was not much known about some of the things that we do now in terms of what we should do and what we shouldn't do. I mean, you had people who were vegetarians. I was never a vegetarian. And of course we had our usual bacon and eggs and that kind of thing. Because that was the way people ate.

Although I was always very fond of cereals. It was easier for me to go into cereal breakfasts, which was probably a lot better for me. But, actually, the main thing was I didn't want to gain weight, suddenly blossom out to a lot of weight, because it's easy for me to gain weight if I'm not careful.

It wasn't until the 1940s I was aware of some of the nutritionists who were beginning to write books about the proper diet to follow.

At one time I followed Gaylord Hauser. Then I turned to Adele Davis. After that I worked out my own personal food program which was based on some of their theories. I began to use more natural foods—eliminating white flour and sugar—shopping for many of our foods at the health food stores, which were becoming more prevalent.

physical activity Oh, I always kept swimming. And running on the beach. The ocean is a great part of my life.

Hiking. We started in 1965, I think, doing most of our hiking with the Sierra Club. We had started jogging and we were running.

[Into the 1990s] I was running the 187 stairs in Santa Monica Canyon. Now I do home exercises—I use some light weights—and we try to do a lot of walking.

It was a very interesting thing to me when I started to be able to do handstands or [handbalancing]—it helped my self-confidence, because I needed that. And that was very, very useful to me.

I liked being strong, I liked this feeling of achieving something, which probably never was big in my life until then. I suppose that change came with doing something that very few other women were doing at the time.

bev francis

Notes:

[1] See, in this book, Jan Todd's "Bring on the Amazons: An Evolutionary History," for more information about Pudgy Stockton's accomplishments.

[2] Half a century later, Lenda Murray articulated women's same desire—or fear—in her interview with me. She said:

> People tend to be a little bit uncomfortable, especially women. If I use the word bodybuilding they almost always correct me and tell me that it's not bodybuilding they want to do, they just want to incorporate weight training into their physical fitness program. People don't understand—it's like playing basketball. When people go out into their yard to play basketball, they don't say that it's not basketball. It's basketball. When you pick up weights, it's bodybuilding. You are working on your body.
>
> When they think of bodybuilding they think of building. They think of mass, they think of—especially if it's a woman—I'm going to be too big. That's not feminine. So they don't want to call it bodybuilding.

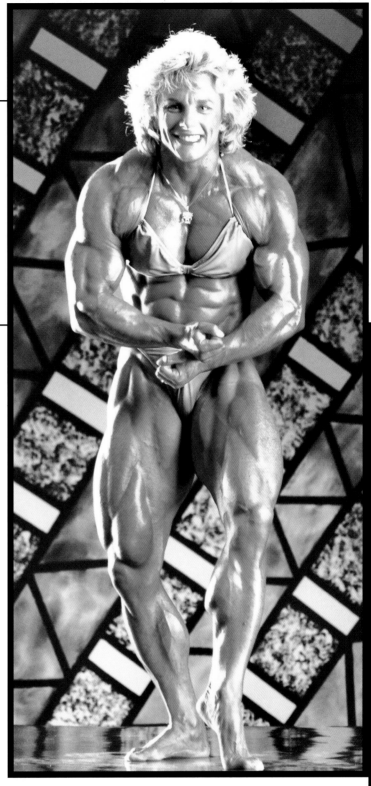

BEV FRANCIS SHORTLY
AFTER THE MS. OLYMPIA
COMPETITION, 1991, LOS
ANGELES, CALIFORNIA.

Bev Francis, born in Geelong, Australia, in 1955, became a professional bodybuilding champion in 1987 after a ten-year track and field and power-lifting career that included breaking the Australian shotput record in 1977 and reigning as world powerlifting champion from 1980 through 1985. She has broken over forty world powerlifting records, and her best lifts are 500-pound squat, 335-pound bench press, and 501-pound deadlift. With the 1985 release of the film *Pumping Iron II: The Women*, in which she was one of the three featured bodybuilders, Francis's remarkable muscularity made her an international sensation. In 1990 and 1991, she placed second in the Ms. Olympia competition, and in 1987, 1988, and 1989, she placed third. On July 3, 1998, I interviewed Francis in her gym in Syosset, New York.

BEV FRANCIS AS A POWERLIFTER AT THE WORLD POWER-LIFTING CHAMPIONSHIPS, 1983, ADELAIDE, AUSTRALIA.

changing the world

It wasn't that I decided to try and change the world. I just did it because of what was in my own heart, but I wanted to be the best.

I never won a Ms. Olympia, but I don't think there has been anyone who had more influence on women bodybuilders than me.

I made this sport more muscular, all [of the women] suddenly became more muscular. They weren't scared anymore. Because it's somebody who's going to break the barrier. I tried to play the game—I can be bigger, smaller, more feminine, less feminine, this, that. I do all the things that I think [to win] and I try to win and I can't win.

In '91 I decided it was going to be my last contest. Because I wanted to have a family, I'm getting old, so I wanted to have kids. I said, this time I don't care if I win or lose, this time I'm not going to win, this time I'm going in to show how big a woman can get, how big and muscular a woman can get. I'm going to show the world. When I walk on stage everyone would go—oh! oh! And, you know what? They did. But I nearly won. Doing this, I nearly won. I lost by a point and should have won that contest, because I was ahead, which you usually don't know. But this particular one was tele-vised, so they did it in two days. [At the end of the first day] they put the results up till now. And you were looking up before you go home—I mean, first place by four points. I said, I got it, because no one loses after being four points ahead. I don't know [what happened], I still don't know to this day. I think that all day gave the judges the time to realize what they had done. Me in first place—like, oh wow, you know, what would they have done to women's bodybuilding if Bev Francis had won?

Obviously [today women bodybuilders are] very, very masculine and huge.

I regarded myself as an equal to everyone. Either a man or a woman. I always thought I could do anything that I wanted to. So I never felt like I was a pioneer. I didn't say, oh, this hasn't been done before, let me do it.

family

No one pushed me and no one limited me. I come from a very unusual situation of a totally functional family. I mean, I had a perfect childhood. I had some rough teenage years, but who doesn't?

I was very naive as a kid, probably because of my very simple upbringing. My parents were in a way very traditional and yet in a way probably very open minded in that they always allowed me to [do anything]—if you want to do something, okay, do it as long as it wasn't against the law. Do it, but if you are going to do it, do it well. So when I was going to do lifting, okay, but, you know, do it well. Mom did the housework, Dad worked. Dad wouldn't hear of Mom taking a job. Because he was the father and breadwinner. And if he couldn't provide his family with what they needed he wasn't a man. A very traditional old way of thinking, and yet when Mom was sick [Dad and the boys] cooked, ironed a shirt. I mean, you've got to survive and you've got to know how to cook and clean and everything else, you know, women's work. You've got to be able to do it.

I grew up believing that there were physical differ-ences between men and women, obviously, but that was it. I guess that my brothers were caring, sensitive men and my sister and myself are strong capable women.

strength

I always loved strength. I loved thunder-storms, I loved wild horses, I mean any show of strength just fascinated me.

When I started to lift, I enjoyed the lifting so much. It was what I was good at, so to me the common sense is, why should I not? Because people start saying, "What are you doing? Why are you lifting?" To be strong. "Why do you want to be strong?" And that to me was such a stupid question. I mean, doesn't every-one want to be strong? Wouldn't anyone want to run fast? Wouldn't anyone want to be good?

criticism of muscular women

You've got to want to do it because, believe me, I've gotten criticized for looking muscular.

My whole life has been justification.

Acceptance of women in sport has changed a lot. But women are still having a problem with women and muscles. The women with muscles still have a problem

with women with muscles. I mean, I see the women bodybuilders with huge implants and dressing like a hooker.

If you are going to make your body muscular it doesn't go with lacy, sexy, feminine. Because muscles look silly with lace and bows and ribbons. But this is my personal opinion.

I'm not a lacy person anyway. I like playing sports, but if you play on sexy stuff because you want to look more feminine, to me you have a problem dealing with the way your body looks and you are trying to prove to everybody else in the world, look, I'm still a woman, look, I can still wear sexy dresses because I'm really a woman. If you have great big jewelry, you look like a man dressed up, you really do.[1] Tone it down rather than exaggerate, because you know you are living in a society that is not used to [muscular women]. Do what you want. That's what I did. But people don't like it. They don't have to like it, I'm not going to ask them to like it. All I ask is that people give me my room to do what I want to do.

I'm very secure in my sexuality. Even when I was a total tomboy I never wanted to be a boy. I never wanted to have a penis. It was like the last thing I wanted. I was very happy with my girl's body.

[Women would say,] "You are in the wrong room," you know, the ladies room. Some of the more polite would say, "Excuse me, you are in the wrong place." Some of these people knew who I was. Sometimes I would answer, "Oh, I'm sorry," and others would still say, "Oh, you are in the wrong place." And I could say, "You know, I am a female"—no, you are not, no, you are not—I mean, straight to me.

feminine beauty I would have loved when I was a teenager being slim and tall and elegant looking. I wasn't, and I never was going to be. I had a certain type of body, which was basically a chunky, thick sort of body. I have medium bone structure, I was always muscular. I was never skinny even as a little kid, so what am I going to do with this body? Am I going to hit my head against the wall, try to be thin, starve myself?

If you want to succeed in bodybuilding you have to bend a little bit and look a certain way.[2]

I don't wear makeup generally. I didn't even wear earrings—until I was involved in bodybuilding.

I always hated my nose. So I moved to the paradise of nose jobs, New York City. It was such a relief to me to not have to make a nose joke. I was so conscious of my nose all through my life.

I didn't even realize that you could change your appearance as such. I thought that the beautiful women in the magazines were beautiful naturally.

Someone suggested to me that I would look better as a blond, and it really went with my coloring. I liked it, and also I used to be much more blond as a child. You saw my oldest girl. She's about my coloring when

I was her age—four. I had very light brown hair with blond streaks through it and I lived in a sunny country. When I moved [to the United States] I went dark because I was inside and [there was] not much sun.

Some people say, what do you like best, bodybuilding or powerlifting? You know, it's great to look like a bodybuilder, because you look so good, especially when you are in shape and lean and so muscular, and I love that look. I've sacrificed a lot of muscle to look a certain way, so I've seen my body in all different ways and I've seen my body almost as I wanted it, sort of that slender, lean person I thought that I could never be—that elegant person. I've got to starve myself to get there. So, okay, that's how I look and it's really nice to have a photograph of that, but that's not really me.

I still like that [pretty, elegant] look. Yes, that's beautiful to me.

[Big dense muscles on women] is powerful, it's wonderful. There is a beauty in it.

Femininity is not in the way you look. Femininity is the way you present yourself, the way you carry yourself, the way you act.

the body has a purpose Your body has a purpose and I guess to me having a purpose is very important. Bodybuilding—I like how it looks, but I'm glad I was attracted to powerlifting, because my body did something. [Bodybuilding] is not as interesting as other sports. Because the end is to look good. To me the end is far less important—the training, I enjoy the training.

Notes:

[1] In part of her interview that is unpublished, René Toney described female bodybuilders with breast implants in similar language to Francis: "I go down to some bodybuilding shows and I see these women with muscles and boob jobs, in a dress or spandex pants and pumps, and they to me look like transvestite hookers."

[2] In an unpublished part of her interview, Toney, like Francis, talks about bending: "After talking to Steve [Wennerstrom] and talking to some of the other guys who are really helping me, you know, maybe it would be to my best to bend a little. It's not really going to sacrifice anything, compromise anything that I believe in. But it's just so aggravating sometimes."

BEV FRANCIS WITH HER HUSBAND, STEVE WEINBERGER, AND THEIR DAUGHTERS, TARA AND FRANCES, 1997.

lenda murray

Six-time Ms. Olympia Lenda Murray held the title from 1990 through 1995. A high school sprinter and cheerleader, she became a professional cheerleader for the USFL for two years and in 1983 was a finalist for the NFL's Dallas Cowboys cheerleaders. Her desire to maintain and develop her muscular body—too muscular for the Cowboys' cheerleading coach—led her to a professional bodybuilding career which has included her unprecedented Ms. Olympia reign; television work, such as commentating both the USA and National Bodybuilding Championships on ESPN; a photo shoot with celebrity photographer Annie Leibovitz; and appearances in fashion magazines and the *Sports Illustrated* swimsuit issue. Murray owns a gym, the Fitness Firm, in Columbus, Georgia, which is where I interviewed her on July 6, 1998.

the art of bodybuilding

[People] don't really know what they are looking at. They don't understand the art of bodybuilding.

[People] think that it's all muscle, no brain. Which is totally not true, because it takes a lot to create that physique and to have the patience and the discipline and to figure out the eating, the timing.

When I started to work on my posing routine, then I started feeling artistic. I felt very much like a work of art. When I was on stage, just showing my physique.

I just feel great. I feel very strong. My posture is just the best. I feel extremely proud, because I know I've gone through twelve or sixteen grueling weeks of very strict diet and the training, doing all the cardio, counting calories, making up the posing routine, practicing mandatory poses. I feel extremely confident, like I can do anything. I feel extremely unique, like a superhuman.

When I look at a person's physique, I look at it with a different eye than the general public would. If I see no individual abdominals—whereas most people would go, beautiful! I just want to be flat—I'm at this extreme. But it takes being extreme to be the best at something. I'm sculpting, and [being extreme] is the only way I can make a change.

I'm so involved in it. I think you have to be that way to be the best at what you do. You have to dig in so deep that you can find every new little thing and experience. Something you try that didn't work—you've got to go there to know not to go there anymore.

Someone who's extremely tall is not going to be a great bodybuilder. And usually people that are very short—they can put on muscle, but is it aesthetically gorgeous? Small waist, small joints, but having the muscle flowing and full.

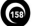

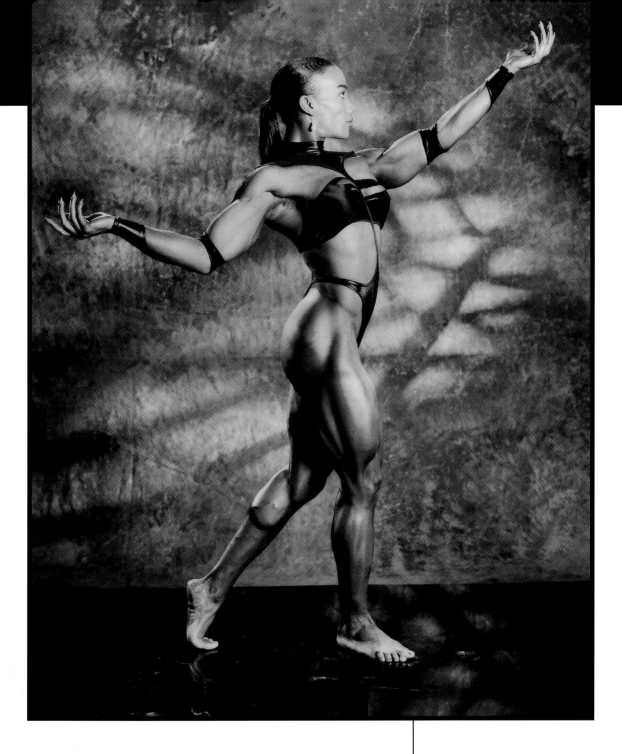

If you've done your work there's not one angle that you feel uncomfortable at. You can actually be nude and feel comfortable.

ms. olympia When I won the Olympia, I wanted to fit in.

You're put on display to be criticized. All of a sudden there were things on my body that really didn't have anything to do with muscle. The way I wore my hair. What was the best hairstyle for me. She looks good, but she just needs to get a nose job. She could be leaner off-season than she is.

BILL DOBBINS, *LENDA MURRAY*, 1994.
BLACK-AND-WHITE PHOTOGRAPH, 10 × 8".

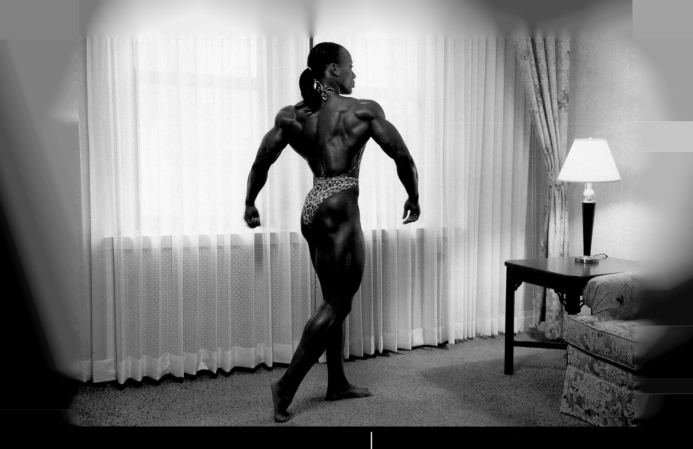

ANNIE LEIBOVITZ, *LENDA MURRAY, NEW YORK CITY*, 1997. COLOR PHOTOGRAPH, 16 × 20".

When I was little I wasn't crazy about my nose, it had nothing to do with bodybuilding. The nose was done in 1991. I was happy with it.

I did learn how to be Ms. Olympia. People don't realize that. You don't realize until you win the Ms. Olympia—the things you have to work on and make yourself more remarkable.

I had an overbite that was never a problem to me. Actually off-season I didn't have that overbite, it didn't exist. It is a look that is common among African-Americans. When you diet down it's more obvious that it is there and so I didn't even really know that it was there. Maxiofacial doctors—that's when they cut you down or push something back or pull something out. The face was suggested [to me after becoming Ms. Olympia]. I was extremely happy with the work. So the side view—my mouth wasn't as protuberant.

breast implants I've had breast implants, I'm not even ashamed to say that. I felt very comfortable with my breast size, through high school, in college. I was very happy with my breasts. I felt that they were firm. They weren't big. I started to feel I wanted more breast size trying out for the Dallas Cowboy Cheerleaders. Yes,

This is another thing that women say: I'm going to lose my breasts if I start competing and start training with weights. That's crap, because what female athlete do you know that has large breasts? Name me a gymnast, name me a track and field runner. You see a lot of female bodybuilders rushing out to get breast implants because for some reason we told ourselves that that's what's making us a woman. And that's ridiculous.

It was a sacrifice at the time that I had it done, in 1990 before I competed in my first Ms. Olympia. Probably every female bodybuilder as an amateur is looking at us and they actually feel like that's a requirement. I tell them, no, that it is not a requirement.

I have heard judges say, her boobs are too big and it throws her whole body out of proportion. I also have heard judges say someone needs breast implants.[1]

judging women People in bodybuilding or people that have some understanding of what we have to do will talk about [a woman's] face being dieted down. Even the judges. Now why is it you have two human beings, and you get a fifty-year-old guy on stage and nobody ever says anything about his face? But you get a twenty-year-old [woman] on stage and she's dieted

for a contest, you cannot say, okay, I want to lose all this weight in my thighs and my abdominals, but I don't want to lose any in my face and in my hands and in my feet. You are going to lose the weight there. But even a judge will say, oh, but did you see how she looks? she just looks so dieted down, she just looks too masculine.

[Judges] can't see the athlete for seeing that she's a female.

racism When you do win the Ms. Olympia, there's pressure on you as a woman and as an African-American. A white male [Mr. Olympia]—it's almost automatic that he is going to be on the cover [of bodybuilding magazines].

I had to demand certain things, question some things, stand up—that probably has been the most frustrating part of what I do. At the same time I can look back at it and I know that's the one thing that I'll be most proud of.

[Racism] was apparent after I won the Olympia. After the first. Because I didn't get my first cover on *Flex* magazine until 1993. Their excuse was that African-Americans don't sell magazines. And they [the Weider organization] couldn't really prove it.[2]

drugs Genetics is important because if you have the patience to train hard, learning exercises, how to connect the mind and the body, learn to diet, then there is a place for the extra support at the professional level, in order to make the physique complete.

I do wish there was more open discussion, where female bodybuilders could go to get information instead of having to depend on some guy in the gym who thinks he knows but doesn't and he's suggesting that you take something that works for him.

People that have never been competitive in any type of sport think that if you take this pill you are going to certainly become this great athlete. Nobody can win the Olympia by just taking drugs.

too big, too much In a sense they did [say I'm too muscular]. This lady was Suzanne Mitchell. I would never forget that! She was the coach of the Dallas Cowboys cheerleaders. There were four different tryouts, so by the time I got to the third she had pulled me to the side and said that I should lose some weight. Now, I was in my early twenties, I was lean, very athletic, and she said, particularly lose some weight in your thighs, tone your thighs down.

I wanted to be physically fit. I felt there was nothing wrong with my body.

So I kept trying and trying and ended up losing about ten pounds. That was hard to do because my body was very happy. I was already very low on body fat. I was asking my body to lose muscle.

I actually got through the fourth round. She wanted me to still lose some weight. I was going to have to probably weigh even less, and I wasn't feeling that good.

To have a female, that's big! [Men's] excuse is, that's too much, a woman shouldn't be this way, but the fact of it is, like all of a sudden you are looking in a mirror and—if this woman could have biceps like that or even be as strong looking as she is, if she's stronger than me, she could pick me up—that's not right. I think it's just intimidating for them.[3]

I've heard people say something like, that's too much. Or they may want to let you know, is that a woman or is that a man? Only a few times have I heard that, under their breath. They never want to let a muscular woman hear them, they are afraid of them. Under their breath, but loud enough for you to hear it.

attracting attention I wasn't afraid of being muscular, I wasn't afraid of walking through the mall with my arms out. I wanted to walk through the mall with my arms out.

When I go somewhere and I have my arms out, I attract people.

Notes:

[1] René Toney criticizes breast implants in an unpublished part of her interview:

> I don't want to conform. Maybe girls they want to make their money and conform and get the boobs and do this and that. I don't want to. At my Palm Springs show I was told by the promoter of the show and some of the judges, oh, you have a great future, a couple of things you might want to do—you get a boob job, let your hair grow.
>
> I could do the thing with the hair because I can always play with my hair, that's not a big deal. But I'm not getting the boobs. Sorry.
>
> I'm not doing that [breast implants], because that's going to stay in your body. The other things [drugs and supplements] can be in there for a temporary time and they go out. I just don't personally like boobs. Not on me.
>
> I want to look like an athlete and to me when you get your bodyfat down—I may sound really stupid, but your mammary glands, your boobs, they're fatty tissue, and I think that if women diet down and they get rid of all the fat on their body and that includes their boobs, you know, so what? You got rid of your boobs. Why do you have to put plastic boobs on? Or saline boobs in? Most women, they think that breasts are femininity. So they get the muscles: oh, my boobs are leaving, I gotta get those back, otherwise I'm not a female. But there's more to [femininity] than that.

[2] *Flex* is a hard-core bodybuilding magazine owned by Joe Weider, the prime magnate of bodybuilding.

[3] In an unpublished part of her interview Andrulla Blanchette articulates the same experience: "I'm stronger than most women and probably most men. It can only be an asset to me. Some people are intimidated by this. I have noticed this more from males. Particularly in the gym."

andrulla blanchette

Andrulla Blanchette is a current Ms. Olympia competitor, who placed sixth in the 1998 contest. She began training with weights in 1986 at age nineteen in order to improve her performance in judo. Within six months she entered a bodybuilding competition, the Miss London championships, and won. In 1995 she made her pro debut. I interviewed Blanchette, who lives in London, by e-mail and phone during December 1998.

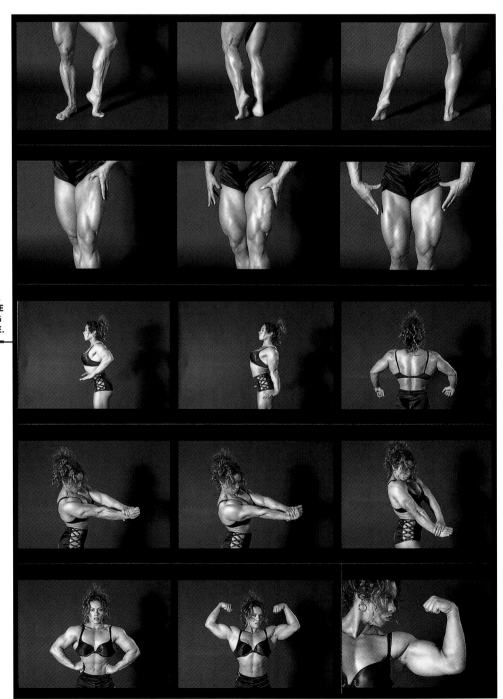

JAYNE PARKER, *RIPPED*, 1999. BLACK-AND-WHITE FILM STILLS. PICTURING ANDRULLA BLANCHETTE.

building muscle, building shape

i work out around four times per week. My sessions are usually about an hour and a half. My body has changed continuously throughout the years. I have gradually accumulated more lean muscle tissue, and my shape has become more dramatic, as well as much firmer all around.

When I first began lifting weights, I was totally unaware of the fact that I could actually tone and build muscles with this type of exercise. I would have done it long before had I known.

[When I began bodybuilding] I was hooked on how much I could lift. I got much stronger. This was a challenge and I'm very competitive.

My shape did change very quickly. I noticed my butt got firmer too. This was inspiring!

The benefits are endless. If I had not become a bodybuilder, then I may never have found a way to have a firm butt. My butt used to be something that I would be conscious of when I was a teenager, and maybe it would have still been as an adult, had I not discovered how weight training would firm it and the rest of me. God forbid but I could have ended up like one of those people that went on silly diets to lose weight off my butt. I don't have to diet at all (except for the contests, which require very dramatic levels of definition).

I have muscle-hungry fans. But I'm not doing this for other people—it's me gaining more muscle. The goal isn't to adjust my body to any beholder.

aesthetic creation I have always been artistic by nature, and very creative with my hands. I guess I could relate what I do with my body to art, since I am visualizing an idea of shape, and working to sculpt it.

Art doesn't mean beauty. Art is a creation. My idea of beautiful doesn't mean it is. This must be in the eye of the beholder.

When I look at myself it's usually to analyze my progress. I'm in the process of building and shaping my body and will check to see how it's going. This takes place mainly whilst I'm training, in the gym mirrors.

I'm creating my body as art. I don't just train in the gym; I plan, I draw sketches and plans. In 1993, looking at my business card with my picture on it, I drew around the edges of my photo, enhancing it, adding more muscle, as I saw myself in the future. I have accomplished

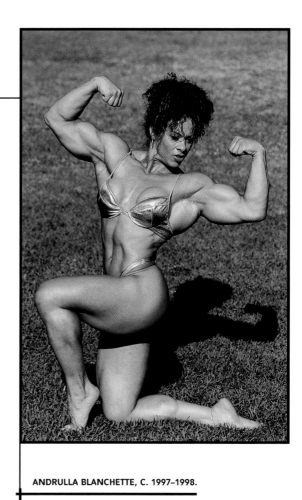

ANDRULLA BLANCHETTE, C. 1997–1998.

this now, physically, and I still do this. It's a great visualization method. My mind's eye was creating that new shape, with free weights and machines as my tools. Right now? I've always had pretty big arms, but not a high peak on my biceps. That was a flaw in my physique, especially evident when I did a double biceps pose. I wanted to bring that peak up. I've been working it for several months and it's coming up.

First, I installed the picture in my mind; I was mentally focusing on producing the peak. I build a nervous connection with the muscle I'm focusing on—the mind/muscle connection. It's a feeling in the area, and when I train I put tension in the right place. I've been training for thirteen years, and when a lot of people train for a long time, they don't get so sore because they're used to the exercise. Today I fatigued my biceps, and tonight they're sore, tingly—tight and sore. To a person who doesn't train, they'd feel bruised.

Since the Ms. Olympia contest six weeks ago, I prioritize. When I split my body into parts I work the [aesthetically] weakest at the beginning of the week. This is the first change I've made after four years of basically the same training schedule.

age I notice that all the bodybuilders that have continued training as they age don't seem to look or feel their age. And I know lots of them, so it's no coincidence.

I'm a little short of fifty yet, but if I can use a good example, my friend Laurie Fierstein, who recently turned fifty certainly looks no more than mid-thirties. Invisible—you got to be kidding!! Laurie just can't be missed. Hey! You can expect to see a whole bunch of us diehard female bodybuilders in a while, then you can judge for yourself how invisible we older women are.

My mother is sixty-eight. She recently began visiting my gym. She feels so much better all around since beginning to work out. She is attaining back some of that youthful strength of hers. A lift to her both mentally as well as physically.

genderless muscle I guess I never thought that muscle was gender bound. However, that's what the mainstream would have us believe. Don't mean it's true, though, does it? I never was a trend follower! My mother was a strong woman with big forearms. She used to dig the garden and do lots of lifting around the house. She certainly wasn't a male. My father was a strong man.

This word [femininity] really doesn't seem to have much meaning. The barriers of what is feminine and femininity have been shattered over and over. Women wear trousers, and cut off their hair—both in the past looked upon as unfeminine. Women do almost every activity that males do and vice versa. Therefore this word has got to be extinct! I mean, we don't hear of the word unmasculine being applied to men. And I could list far more unmasculine things that men do [than unfeminine things that women do].

performing I was shy as a child. If I was asked to read out in class, I was shy; I wasn't sure how I'd feel about people watching me. In sport I wasn't shy at all. I'd just run and give my all. One thing I did like was watching the school play, other people perform. I thought, I'd like to do that. Maybe I was ten years old at the time. I was involved just by watching, not feeling the slightest bit embarrassed, like when I perform now.

I perform on stage maybe once or twice per year. It's almost always during a competition. My thoughts are of winning, it's what I have worked towards. During my performance I hope that I am presenting myself well, and giving the audience an enjoyable, entertaining time.

rené toney

I interviewed René Toney September 25, 1998, at the Angel City Gym in Los Angeles. She was thirty-three and had begun body-building twelve years earlier after winning track and field awards in high school. At the time of our interview she had entered only one bodybuilding contest, the March 1998 Palm Springs Muscle Classic, and placed second. She exemplifies a small group of bodybuilders who, while they do not feel that it is always neces-sary to compete, are nonetheless acknowledged in bodybuilding culture as having world class physiques. At 5'8" tall and 207 pounds, with 11% bodyfat and 19" biceps, Toney, at the time of our interview, was widely acknowledged as having the largest biceps of any woman bodybuilder in the world.

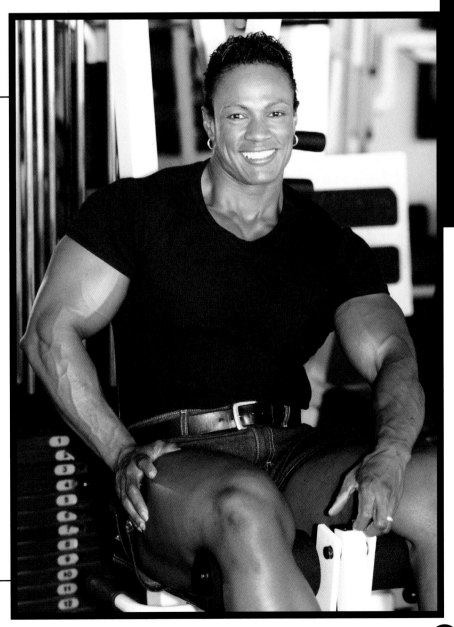

RENÉ TONEY, JULY 1998.

self-esteem and self-discipline

I'll tell you what this sport has done for me. It has really made me strong in my self-esteem. I'm very shy and it's made me a very strong person within. Spiritually it has made me very strong, it has made me a very, very disciplined person. Better than any military training. It takes a very unique individual to do what I do. Most people would think this is crazy torturing yourself in a gym for two hours a day. And all of the I can'ts that I've ever said I know I can now.

irrelevance of measurement

People always ask me, what are your arms? how much do you bench? how much do you do this? I'm like, you know, I don't know. I was trying to make a joke.

Because it doesn't really matter. You know, I really don't know, I just put the weight on; you know, next time I'll go write it down and I'll tell you.

Success is always a measurement, in the gym with numbers. If I tell them I did 325 on bench, "oh, yeah?" Especially the guys, "well I did 385." If I told them I did 405 then they're going to try and say, "well I did 5__." It's just this competitive thing, no girl's gonna beat me.

Does it bother me? No. Or, man, you lift weights? Listen I got stung by a bee and I got swollen up like this, really! You take steroids? I say, yeah. You lift weights? I say, no. Every day [I run into that kind of thing].

a masculine aesthetic

This is going to sound really bizarre, but when I visualize the kind of physique that I want for myself that I'd like to display to the world, actually it's the body of a male bodybuilder; and I'm not trying to be a man by no means by lifting weights. I'm not trying to do that at all, but aesthetically to me a muscular male's body is ideally the kind of body that I like for myself.

To be honest with you, I don't really follow the sport of women's bodybuilding. I look at the men as competitors. I look at Flex Wheeler [a Mr. Olympia contender] as, oh my god, this man is perfect. I would like to have Flex Wheeler's body on me.

a beauty show? a hair show?

Get your hair to a conventional length [the judges said].

The next show I hope they don't spend so much time looking at my hair and really appreciate my muscularity. 'Cause right now I'm going through this whole thing. That's why I'm wearing caps right now and just letting my hair grow out. You know, I'm like, this is so frickin' ridiculous, I'm spending so much time figuring out what I'm going to do to my hair what extension is going to look best, should I wear a wig or should I put color in it, should I cut it? I said, now I'm trying to get ready for a show and I'm thinking about what I have to do to my hair. I said, is this a beauty show, a hair show,

or a bodybuilding show? So I said, forget it, I'll just shave it bald.

looking androgynous

I kind of like looking androgynous. That's going to cause controversy, I know that. That's going to raise some eyebrows. I like being attractive to both sexes and transgender or whatever. It's very flattering that people can look at me—men, women, transves . . . and find something attractive. I like compliments, of course. All the usual things.

People have been very, very complimentary to me. I don't know if it's a certain mystique I have about me, but it's utter respect. And at first it's not, you look like a man. First it's, hey, sir! hey, guy! man, what do you do? I really like what you do! hey, guy, dude! you lift weights? hey, man, you look good. You get all that. Then later, you know, after they get to know and they are talking to me yeah, what are you getting ready for? you look great. And I'm like, yeah, pretty good for a woman, huh? And it just blows their mind.

Some are like, what?! I'm like, yeah, I'm a woman. Damn! or, damn! how do you do that? And they are amazed. But I've never gotten anyone to do, that's ugly, or, you shouldn't do that.

I've never really gotten anyone to disrespect me to my face. Maybe behind my back, I don't know. But you know it doesn't bother me right now. Maybe people aren't going to understand that or understand me, but I'm just not with the masses, I never wanted to put myself there.

I want to do stunt work. And I want to do male and female roles. Do body doubles for males and females. I just love being a physical being. You know, a physical man, woman, whatever you want to look at me and categorize me as. Just a physical being. Someone that should be praised for their accomplishments.

a genetic celebrity

I want to get to 225 pounds and be on the stage at 3% to 5% bodyfat. I don't know any other woman that wants to do that. That's me! Maybe people say, aw, she's just doing that to draw more attention to herself. No, no, this is honest for me. I wanna be a freak, a genetic freak. A genetic celebrity.

Freak's not bad. You gotta learn that. Freak's not bad. Freak, celebrity, genetic; like I said, this is what God gave me.

To get to the freakish level, I think that you would need to [use enhancements like drugs and supplements]. I mean, we're in a very progressive generation now with the sport. I'm going to say it, you need to.

People say, god! your arms are like this, or, your chest is different from other women. And I went through a phase where I was questioning myself and I was killing myself. I was driving myself crazy. And people called me freak or whatever or, what is that, a man? And I started feeling very bad and down on

myself. Then I just had to really gather myself within myself and have my talk with my Creator and I'm okay with me. I'm okay. I was going through this in the past four years.

There is this cartoon called the X-Men and they are mutants. And I think that's how we [bodybuilders] are. We're mutants.

being an artiѕt I'm the artist, by lifting weights in the gym. My training has got a lot smarter. I'm not just putting muscle here, putting it there. I'm putting it deliberately in special areas that suit me aesthetically. I'm definitely an artist, that's how I look at it. I'm not just slapping around the weights.

What I'm working on right now is trying to fine tune and chisel the definition in my legs more. I'm trying to bring out my back width to create the illusion of having a smaller waist. The whole hourglass thing, the "X." And that's it, constant refinement and the aesthetics are always in mind.

miѕѕionary work This is God's gift to me, I'm just taking it to another level.

I make myself this way only because the Lord tells me to. He doesn't tell me I'm going to sit on my ass on the couch all day. He tells me to go to the gym and do what he wants me to do. This is my work and this is my calling, my missionary work, if you want to call it that. This is my way of addressing the world. I'm a Christian bodybuilder and maybe this is my way of giving back.

I'm broadening minds: hey! a woman does not have to look like that. Women come in all different shapes and forms.

I think this is important for us all to just start giving back to the world.

I hope to affect [women's body-building] the way the late Kay Baxter did. She was a different type of body altogether. And she was ahead of her time. Kay Baxter came around in the '80s, and just basically her type of body had never been seen before. She was off the scale of muscularity at that time, even further than Bev Francis. There were different types of muscular women, but she was clearly twenty years ahead of bodybuilding, and so I'm pushing the envelope there now. I just really want to stand out from everyone else. And I think I'm on my way to doing that.

a loner People always asked me when I was getting ready for my show, René, do you know who you are competing against? No because I'm doing this clearly for myself.

I think maybe it has to do with the fact that I'm a loner. And even when I was a kid, I've always been a loner. And whatever I did I was doing by myself. I have a sister. But even with my sister I did my own thing. I mean, she'd be outside or be in the backyard playing with the dog or be inside playing video games or whatever. I was an island when I was a kid. I really was, I was an island. I guess I just kinda grown up not depending on anybody, not relying on anyone. In that way I'm in this world all alone. So that's what gives me that frame of mind, that state of mind.

I'm an entity within an entity.

RENÉ TONEY, MARCH 1998, PALM SPRINGS MUSCLE CLASSIC.

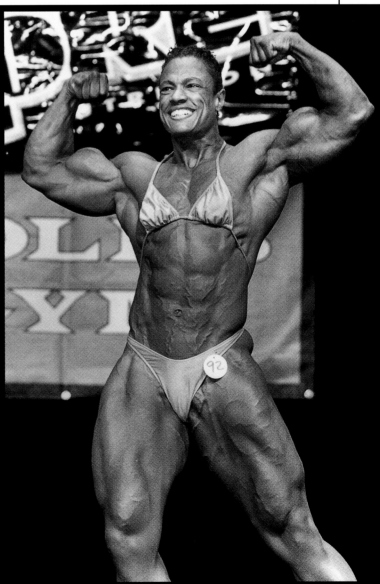

amazons in fiction
a bibliography

Pierre Samuel

I. introduction

Written fiction about Amazons—strong and generally aggressive, uninhibited women—is very extensive, even when restricted to subjects who show *physical* qualities of strength, skill, or daring. Physicality is the focus of this bibliography, and after a systematic search I have found around one thousand novels and magazine short stories, and about one thousand folktales involving such Amazons. (Psychological Amazons, remarkable for their will, ambition, and cunning, would include a myriad more sources.) Most of the modern fiction in my study is French and American.

Amazon fiction is written largely by men, and one may wonder why these writers are interested in and sometimes fascinated by Amazons. A significant possibility is given by historian Abby Wettan Kleinbaum in her 1983 book *The War Against the Amazons*:

> Like her modern day incarnation, Wonder Woman, [the Amazon's] strengths and talents have a supernatural quality. She is therefore a suitable opponent for the most virile of heroes, and a man who has never envisioned harming a woman can freely indulge in fantasies of murdering an Amazon. . . . To win an Amazon either through arms or through love, or, better through both, is to be certified as a hero. Thus men told of battling Amazons enhance their sense of their own worth and historical significance.[1]

Sex, strength, and violence—the battle and the eros between the sexes—frequently recur, together, in Amazon fiction. Often, women fight men and win, and often, women please themselves sexually with their own as well as with the opposite sex. Amazon fiction written by women offers a different perspective. Its heroines are depicted with greater sympathy, and their training is much better described. Whereas, for most male writers, one is born an Amazon, for female writers, one can become one.

Some Amazon fiction takes place in exotic settings, such as islands of women or science fiction locales. Perhaps this is the writer's way of saying "this cannot happen with the girl next door." Writers regularly use humor to introduce figures who are larger than life, and sexual encounters are both prevalent and dominant. I have used the sign (E) to signify that, in the novel, one or more of the following events, between male and female, take place: Amazon initiates sexual activity; Amazon uses her strength to initiate sex; Amazon rapes a man; sexual activity is athletic, sometimes brutal; a fight serves as a prelude to sex; Amazon's vaginal muscles milk a man dry, and though he is often exhausted, he is also usually appreciative; dominatrix/Amazon uses her strength on men, hires very strong female helpers, or uses her muscular pussy as an instrument of torture. Uniformly, Amazons are young—under thirty—white, tall, beautiful, and extremely strong and/or visibly muscular. The wealth and tone of Amazon fiction strongly depend upon the period in which it is written. In works written during the Italian Renaissance and the Second Wave of the Women's Movement, from the late 1960s through the mid-1980s, Amazon fiction is abundant and Amazons are often positive characters. The same is true in works written near the ends of wars in which women had to fight or to take male jobs.

II. background to modern fiction: settings and themes in folklore and legend

societies of amazons

In an Amazon society, women live without men and are skilled and savvy fighters. Ancient accounts, often unreliable, report fewer than ten examples of such societies. However, I believe that three such societies existed, to some extent: Asia Minor (c. 1200 B.C.), Bohemia (c. A.D. 730), and Amazonas, in Brazil,

where the Spanish explorer Orellana fought a troop of tall, strong, and fierce women on 24 June 1542. In these instances, women took arms by themselves to resist either invaders or the rise of a more patriarchal order. The actual women warriors of Scythia, who are widely agreed to have existed (c. 700 B.C.), were said, by Herodotus, to be offspring of the Amazons of Asia Minor. Many reputable ancient authors write that, in the Sarmatian tribes of Scythia, women hunted and went to war with the men and enjoyed somewhat equal status with them. Scythia was located in the south of the former USSR, and weapons have been found in or near the graves of women in this region.

land of women

Some tales about lands, or islands, of women come from historians, chroniclers, or travelers, but most of them come from folklore proper. In these isolated locales, women breed either by supernatural means or by mating once a year with neighbors: they keep the girl children, and the boys are either killed or sent to their fathers. Dozens of tales exist worldwide. The most frequently recurring features of these Amazons are strength, fighting ability, and a lasciviousness that sexually exhausts men. The women are often as friendly as they are ferocious.

women warriors

Women warriors did and do exist in many societies. Some defended their homes during sieges. Others were warrior queens or were moved by the joy of fighting, such as the ultrastrong Maria of Puteoli, described by Petrarch in 1343. Many such women fought alongside their men. Some kings in Siam and Dahomey[2] organized well-trained and fearsome all-female troops. Around 1895, French colonial troops fought the Dahomey Amazons and were impressed by their skill. Other examples include Joan of Arc; Freydis, who led a Viking

expedition to America in 1011; pirate women, such as May Reed and Ann Bonney in the eighteenth-century West Indies; female outlaws in the nineteenth-century American West; female bodyguards for VIP's; and guerrillas, such as women in contemporary terrorist groups.

Folklore about women warriors is extensive, coming from Scandinavia, Germany, Ireland, Persia, India, Arabia, and central Asia. Russian tales are especially numerous and striking, perhaps inspired by the historical women warriors of Scythia. The *bylinas*, Russian tales in verse transmitted by oral tradition, often describe formidable women warriors roaming the steppes, called *polenitsas*.

challenging the suitors

Scholars call the testing of the suitor the Brunhilde Theme, because one of the most elaborate forms of this challenge occurs in the marriage of Brunhilde in the German epic poem *Nibelungenlied* (c. 1200). The story is as follows. In a faraway land lives a beautiful and very strong princess or warrior maid. She has decided that she will marry only a man able to better her in various tests, usually athletic. If he does not, he will be killed. In simpler versions of the tale, the suitor succeeds—but barely—in winning a wrestling match. They marry and he is happy to have won such a valuable partner. In more elaborate versions, the suitor uses tricks, such as substituting for himself a disguised or magically altered, superstrong hero. Some of these versions include the substitute suitor and the Amazon fighting one another in bed on the wedding night.

Simple versions come from Persia, India, Africa, and Mongolia, and appear to have some basis in truth. Marco Polo relates that the strong Mongol Princess Angiarm, daughter of Kaidu Khan, successfully outwrestled all her suitors and remained unmarried. In fact, Kaidu Khan did exist and did have a strong-willed, warlike daughter who did not marry. In many societies, fights between bride and groom did take place either before marriage or in the wedding bed.

athletic skills

Many tales focus on some aspect of a woman's athletic skill. These range from wrestling between women and men, to other competitive and noncompetitive activities such as lifting heavy burdens, hunting, running, and, in native Hawaiian folklore, surfing. Sometimes in these tales one character suspects that a man is truly a woman, and in order to find out, organizes athletic tests such as jousting, archery, foot racing, wrestling, or swimming. The woman, who conceals

her breasts while competing, wins the tests by a wide margin. Tales about the "athletic" seduction of a man by a woman are widespread; one group that performed these include the Russian *polenitsas* mentioned earlier. One form of this seduction is the "horseback lift," in which a warrior maneuvers her horse alongside a man's, lifts him from the saddle with one arm, and places him in front of her. She then forces him to make love.

III. background to modern fiction: epic poems and romances of chivalry

Anonymous Byzantine poet, Digenis Akritas, *10th Century*
The hero fights Maximo, a beautiful offspring of the Amazons. He disarms her without doing her harm. Impressed, she disrobes and they make love with shared pleasure.

Firdausi, Shah Nama (The Epic of Kings), *Persia, c. 1020*
Two heroines, Gurdafarid and Gurdija, defeat various men in single combat and are faithful to their kings.

Various Italian poets, **Charlemagne Cycle**, *1380–1516.*
Poems describe wars between the Saracens and the knights Roland and Roger or Renaud. Many striking Amazons appear. They are rarely vanquished and undefeated in the cases of Bradamante and Marfisa. When these Amazons marry, they continue to fight afterwards. Italian poets of lesser talent than Boiardo and Ariosto wrote sequels to their epics; in addition to featuring Bradamante and Marfisa, these poets introduced other Amazons who were either Christian or Saracen.

• *Anonymous*, Aspramonte, *1380*
In a tournament a Saracen girl, Galiciella, defeats all the Christian knights except Roger, who requires three rounds in order to win. They fall in love and marry in a Christian ceremony.

• *Pulci*, Il Morgante, *1450*
Saracen queen, Antea, invades France, performs brilliantly in single combats, falls in love with Renaud, and, after inconclusive battles, returns to the East with glory and honors.

• *Anonymous*, La Regina Ancroja, *1470*
Saracen queen, Ancroja, a first-rate fighter, muscular seducer, and free-thinker, finds the Trinity and the Immaculate Conception unbelievable.

• *Francesco Bello*, Mambriano, *1478*
Features the Christian Amazon Bradamante, sister of Renaud.

• *Ludovico Ariosto*, Orlando Furioso, *1516*
This was intended as a sequel to Boiardo's *Orlando Innamorato*. Marfisa reappears. She lifts men overhead with one arm, runs for thirty days as fast as

a horse while eating only grass, and defeats countless knights, often several at once. Her limbs compare with those of Mars. The Christian Amazon Bradamante also reappears.

Torquato Tasso, Jerusalem Delivered, *1570*
This poem is in the same vein as the Charlemagne poems, but takes place later. During the Crusades the Persian Amazon Clorinda, who has been victorious in many single combats, meets the Christian knight Tancred, who falls in love with her. In a battle, however, because her face is hidden by a helmet, he does not recognize her and mortally wounds her. She dies in his arms and he deeply regrets his mistake.

French and Spanish poets, Amadis Cycle, 16th Century
The recent European discovery of unknown lands led poets to describe the extraordinary territories of the Amazons, in which lived powerful fighting queens such as Zahara, Florella, Pintiquinestra, and, above all, Califia, queen of a land called California. (Califia—ancestor of the women at Venice's Muscle Beach?) These Amazons fight the Christian knights around Amadis and, when defeated, become the Christians' allies.

CINDY SHERMAN, *UNTITLED #339*, 1999. BLACK-AND-WHITE PHOTOGRAPH, 35 × 12".

Edmund Spenser, The Faery Queene,
*Six books, 1578–96; first complete edi-
tion published in 1609*

This poem concentrates on an evil
Amazon queen, Radigund, and the virtu-
ous Amazon, Britomart, who fights for
good causes. Other characters include
the beautiful, efficient huntress Belphoebe,
and the gigantic, strong-armed rapist
Argante, who, after having clubbed her
prey, uses the horseback lift to carry him
off in order to sexually violate him.

IV. modern fiction

secret agents, spies, adventuresses: woman as main character

In contemporary fiction, knights are
replaced by secret agents and spies. As
a rule, the main character must succeed.
When it is a woman, she thus must be
an invincible Amazon.

*George Maxwell, Le Jaguar series (Paris:
Sogedide, 1953–56); eleven books*

The heroine, nicknamed Le Jaguar, is
grim and pitiless, cold-blooded, and very
quick in action. She kills, strangles, or
maims a good many people by using
knives, bludgeons, and, more often, karate,
her teeth, and her iron-hard fingers. She
never uses firearms. Climbing walls is an
easy matter with her clawlike fingers,
and single-arm pullups conclude the
ascent. She fights everywhere, from on
top of sloping roofs to in the water.
Sometimes, captured by a gang of ene-
mies, she is tortured, but her hard body
does not suffer too much—she even
enjoys it—and she soon reverses roles
and becomes a terrifying torturer. Her
toughest opponents are other Amazons.
Her limbs are long, hard, and very efficient.

*Peter O'Donnell, Modesty Blaise series
(London: Pan Books, 1965–77); four
books*

Abandoned as a girl, Modesty Blaise
had a hard childhood in the Middle East.
This toughened her body and mind. She
loves danger and is very proficient in the
martial arts, with daggers, and with
guns. Modesty loves luxury and fashion-
able clothes. An even more Amazonian
character in the series is Mrs. Fothergill,
a super muscular bodybuilder employed
by the villains. She loves to kill men by
breaking their bones with her bare
hands, and she carries tremendous bur-
dens without puffing or raising a sweat.
When sunbathing, she loves to exhibit
and flex her mighty biceps and abs and
to bounce medicine balls on her belly to
harden her muscles.

*René Charvin, La Panthère series (Paris:
L'Arabesque, 1963–74); seventeen
books (E)*

Eve Miller is perfectly trained with
daggers, guns, and karate. After victori-
ous, barehanded fights against men, her
clothes are unruffled. Jumping and
climbing walls are easy for her. She

sometimes kills enemies in her bed. The
last volumes describe her lovemaking,
in the female superior position.

*Rod Gray, Lady from L.U.S.T. series
(New York: Tower Books, 1969–79);
twenty-four books (E)*

Eve Drum is the heroine in this humor-
ous series. Enchained, she uses the
chains to beat up her kidnappers.
Attacked by a tiger, she kills it with her
dagger. She strangles men while having
sex with them, and one of her most
potent weapons is her powerfully muscu-
lar pussy. With friends, she uses it for
mutual pleasure. With enemies, she
squeezes hard, forcing men to confess;
or the pressure makes them faint, and
she then steals precious documents.

*Th. Dorval, Kali series (Paris: Eurédif,
1975–85); six books (E)*

Véronique de Saligny is a countess
who works for a French secret service.
Other Amazons who appear in this series
include Lucia, a native of Rio de Janeiro,
and Lydia, a Eurasian villain. Lucia's mus-
cles are impressive on her lean body.

secret agents, spies, adventurers: man as main character

When the main character is male, he
often wages his own war against the
Amazons, which he must win. Often he
must use firearms, helpers, or treachery
in order to kill or tame Amazons.

*Troy Conway, Coxeman series (New
York: Paperback Library, 1969–74);
seven books (E)*

In *The Blow-Your-Mind-Job*, hero Rod
Damon is investigating in a South Ameri-
can jungle when he is captured by a
tribe of Amazons. Ranging from six to
seven feet tall, each Amazon is able to
carry him like a feather, to tear a jaguar
from limb to limb, and to casually break
tall saplings in half with her bare hands.
In another book, a group of "man-eaters"
dares him to satisfy them all. He also
encounters sex-crazed mud wrestlers in
Hamburg.

*Gérard de Villiers, S.A.S. series (Paris:
Plon, 1964–93); one hundred twelve
books (E)*

The hero, Malko Linge, is an Austrian
prince who works for the CIA and is
himself a strong and cunning fighter.
Among the four hundred or so female
characters in this series, 160 are Ama-
zonian: agents in various secret services,
guerrillas, terrorists, helpers of Linge, or
freelance adventuresses. Particularly
striking are Natalya from the KGB; the
Hungarian Erain; a pair of Chinese twins;
Zamir from the MOSSAD; almost all
guerrillas; and, above all, the herculean
Obok-Hui-Kang, a Tae Kwon Do cham-
pion and barehanded killer from North
Korea. Five policemen are needed to
overcome her.

women warriors

*Paul Féval, fils, Mademoiselle de
Lagardère (Paris: Flammarion, 1885)*

The heroine is a noble royalist who,
during the French Revolution, hides
under the name of Rita Zinetti and per-
forms with swords in a circus. She beats
many adversaries in duels and other
fights. Along with a fellow circus per-
former, a gigantic strong woman who
accomplishes feats such as destroying
buildings with her bare hands, Zinetti
joins up with a royalist guerrilla.

*P.C. Wren, Sowing Glory (New York:
Avon, 1931)*

Mary Ambree, a very big and strong
tomboy, is indignant because her father
and brothers refuse to teach her how to
box. She leaves home and becomes, dur-
ing World War I, a driver of trucks and
ambulances just behind the front in
France. After the war, she enlists in the
French Foreign Legion—her sex is not
discovered because her lover, rather than
Mary, underwent the medical examina-
tion. There, she is among the best in
training, marching, brawling, and fight-
ing in North African battles. (Of note, the
circus aerialist Cara Gunther did join the
French Foreign Legion in the 1920s.)

*Madeline La Grange, Ways of A Wanton
Wench (New York: Bee-Line Books,
1970) (E)*

Knight-errant Bradamante has lost her
maidenhood to her father, a strong
knight who, finding his dull, sickly wife
undesirable, much prefers his Amazonian
daughter. She finds the sexual initiation
enjoyable. After a number of fights and
spicy adventures, she engages with a
nice young knight in long, inconclusive
fights followed by lovemaking. He asks
her to marry him, and she is reluctant at
first, wanting to keep her freedom. When
he tells her that women in his country
are free and warlike, she accepts his
proposal.

*Jean Tur, L'Archipel des Guerrières
(Paris: Robert Laffont, 1973–76); three
books (E)*

A group of young sailors explore an
ocean full of islands. Some are inhabited
by fierce women warriors. The men
have to fight for a landing, but say they
are coming as friends and allies against
common enemies. Athletic games are
organized—archery, javelin, foot races,
and more—in which the women beat the
men. The women are eager to be loved
and to become pregnant, so tournaments
alternate with lovemaking. Their muscles
are extensively described.

*Phyllis Ann Karr, Frostflower and Thorn
(New York: Berkeley Books, 1980) (E)*

The setting is a medieval society in
which warriors and bodyguards are
women who become physically superior
to men and take the initiative in love-
making. This role reversal is rendered
with wit: "fathermilker" replaces the
insult "motherfucker."

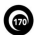

amazons at work and in everyday life

Émile Zola, Les Rougon Macquart series (Paris: Charpentier-Fasquelle, 1871–90); seventeen books

Zola describes aspects of contemporary French society, including its Amazons. In *La Fortune des Rougon* (1871), a nice peasant girl, eleven and big for her age, becomes friendly with fifteen-year-old Silvère. They climb trees, race, engage in horseplay, and when Silvère tries to throw her down, she resists and overcomes him. Lisa, a butcher, and Clara, a fishmonger, are Amazons in *Le Ventre de Paris* (1873). Their thick arms work well against men who try to rape them. The heroine of *Pour une Nuit d'Amour* (1876) wrestles with her boyfriend, beats him, hurts him. In *L'Assomoir* (1877) Gervaise forcefully wields her washerwoman's beetle and also wins a fight with another female. *Germinal* (1885) includes several women miners, one of whom, Catherine, puts back on the rails a fifteen-hundred pound corf full of coal. The peasant women in *La Terre* (1887) are Amazons whose strength prevents them from being raped. Zola's most Amazonian character is Flore in *La Bête Humaine* (1890), who reins in a wayward horse and stops a freight car from rolling down a slope. She loves to roam by herself in the country and to swim nude, and she easily repels men who think she is sexually easy.

Rachilde (A. Vallette), Monsieur Venus (Paris: Fayard, 1884)

Raoule de Vénérande is a fencer and sculptress. She hires as a model a man smaller and weaker than she and dominates him when they make love. She also engages in duels and other fights against a gentleman. Rachilde was probably herself an Amazon and wrote other novels with Amazonian characters.

Joséphin Péladan, La Gynandre (Paris: Fasquelle, 1891)

Six heroines—one is nicknamed The Bully—are all accomplished fencers. One of them organizes a Club Maupin for women interested in fencing and wrestling. These Amazons challenge men to contests; the men agree but then become afraid and back out.

Joseph Delteil, Les Cinq Sens (Paris: Grasset, 1921)

Eléonore has big biceps. She plays rugby, wrestles with men, and leads an army of women in a troubled country. Delteil's *Sur le Fleuve Amour* and *Jeanne d'Arc*, both published in 1925, also feature Amazons. Joan of Arc enjoys wrestling and fist fights with men.

T.F. Powys, A Strong Girl (London: Archer, 1931)

Polly Brine carries a 250-pound sack of grain on her back and lifts a big armchair upon which her mother is seated.

Louis-Ferdinand Céline, Mort à Credit (Paris: Gallimard, 1936)

The teenage hero is raped by a middle-aged woman who is able to crush nuts in her hand and to break planks with her fist. Sent to England, he meets Gwendoline, a muscular young woman who forcibly pulls him into a dark alley and plays roughly with his penis. Gwendoline's thighs are particularly muscular. Later he is hired to help an authoritarian woman in the fields. Because she does the greatest amount of labor, she develops huge biceps, and she terrorizes her male helpers. In other works, Céline admiringly and precisely describes the muscular, athletic physiques of various women.

Marcel Aymé, La Vouivre (Paris: Gallimard, 1943) (E)

Germaine Mindeur is gigantic in proportion and appetites. She untiringly works "as well as three men and a horse" and uses her colossal strength to rape every man she can. The title refers to a lake creature, half-woman, half-fish, who is a muscular seducer.

J.P. Donleavy, The Ginger Man and seven other novels (New York: Dell, 1958–81) (E)

In *The Ginger Man* (1958) Mary, a thickset working girl, knocks the hero down onto a mattress and makes love to him. Women's sexual force with and frequent physical violence to men recur in Donleavy's novels, in which Amazons appear in various vocations—cook, tennis player, singer, stewardess—and avocations—gymnast, horsewoman, flogger.

Robert Merle, L'Ile (Paris: Gallimard, 1962)

Mutineers of the bounty, bringing with them Polynesian men and women, take refuge on a desert island. The most impressive woman, Omaata, who is 6'5", breaks naval cordages by mistake, lifts a man with one hand, forces men to break up a fight, and performs many feats. In other novels, Merle goes beyond the theme of physical and "exotic" Amazons, for he features women who are both strong-bodied and -minded.

BILL DOBBINS, *SKYE RYLAND*, 1994. SELENIUM-TONED SILVER PRINT, 16 × 20".

171

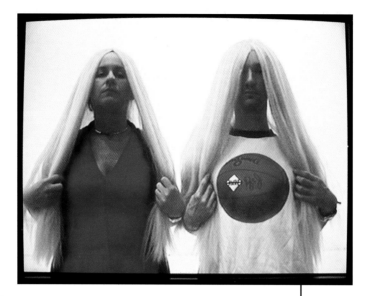

OLIVER HERRING, STILL FROM *VIDEO SKETCH #5*, 1999. DIGITAL VIDEO.

circus, nightclub, unusual feats

Georges Pioch, Les Dieux chez nous *(Paris: Ollendorff, 1908)*

Pioch fondly describes women who lift men overhead in their acts.

Damon Runyon, More than Somewhat *(New York: Albatross Books, 1947)*

Lola Sapola, who juggles four people in her act, rescues her husband from goons by using her fists. Acrobatic dancer Miss Claghorn breaks the neck of a man who tries to have sex with her.

Paul Vialar, Les Quatre Zingaris *(Paris: Grasset,1958)*

Christine Lange becomes, by willpower and hard training, an Amazonian virtuoso of the flying trapeze.

N. Jackson, The Sharpshooter *(New York: Lancer Books, 1969) (E)*

The setting is a circus. A sadistic equestrian and a sharpshooter are physical as well as sexual Amazons.

sports

Dozens of novels and short stories feature women wrestlers, and wrestling bouts between women. Boxers appear far more infrequently in fiction.

Many novels feature amateur martial artists. Some of these Amazons train in karate in order to dominate men; some practice in defense or revenge against men. An example of the latter is J. Ulm's *La Femme sans Pitié* (1978), who was the victim of a sadist and, after becoming proficient, beats up every man she meets.

Oliver Wendell Holmes, A Mortal Antipathy *(Boston: Riverside, 1885)*

Euthymia Towers, eighteen and a college student, excels in all sports, lifts barbells that her classmates are unable to move, enables her team to win a rowing race against a male team, breaks a dynamometer by exerting the full strength of her hand, and loves to climb trees, to roam in the woods, and to row alone at her leisure. During a fire, she rescues a sick young man who is unable to move, and later, they marry.

Jody Lark, Gigantic Passions *(Chicago: Novel Books, 1962)*

This is the supposed autobiography of a wrestler, 5'11" tall and 160 pounds.

Gene Cross, The Wild Mare Affair *(San Diego: Greenleaf, 1967) (E)*

Rodeo women excel in bronco busting and other events and entertainments. Linda, for example, strips and performs other acrobatics on a horse. At the novel's end, the reader discovers that Linda is the killer in a crime that nobody suspected a woman could have the strength to commit.

Tibor Tibbs, Jigai *(Paris: Premières, 1977) (E)*

Karate and other martial arts are featured, and many fights—between women and between women and men—are described. Hong Kong is the setting. The best fighter is a lascivious Chinese woman with long and very hard muscles.

Cleo Birdwell, Amazons *(London: Granada, 1980) (E)*

Cleo plays on a male ice hockey team. She is an expert in male bodies and loves to have sex in acrobatic positions.

Anonymous, Raging Hellcats *(New York: Star Distributers,1986) (E)*

Lesbian roller-derby champion Rhonda uses a baseball bat to wreck the car of a man who sleeps with the girl she is in love with, throws him to the sidewalk, and rescues her sweetie. Her matches and their aftermaths in the showers— where Rhonda crushes a soap bar in her pussy—are graphically described.

detective stories: general patterns

The Amazon generally appears in the detective story as a tangential character, such as in Dashiell Hammett's *Red Harvest* (1929) and *The Maltese Falcon* (1934), and in some novels by James Hadley Chase, Raymond Chandler, and their followers. Alternatively, Amazons appear as gangs of criminal women who use knives or karate, speed on motorbikes, steal, and torture and kill men. Occasionally, an Amazon fights against these gangs on the side of the law. Another trend is the appearance of isolated sadistic women, who rob or dominate men while making them suffer. Several men with guns are needed to overcome such women.

detective stories: departures from general patterns

A. Bastiani, Madame Lucifer Vous Fait un Bras d'Honneur *(Paris: J. Dullis, 1971) (E)*

Cigar-smoking Lucie operates on the side of the law and strangles villains between her thighs.

J.P. Manchette, Fatale *(Paris: Gallimard, 1977)*

A private eye nicknamed Fatale practices martial arts. Investigating the shady trades of a group of rich people, she is discovered by them, and during a fight on the docks she uses karate to kill one of them, strangles others with a wire, and cuts the throats of still others with a sharp shell. A woman shoots her, and, wounded and weakened, Fatale loses control of her car and dies in a crash.

science fiction and fantasy

Charlie de Kemp, Frenesie Romaine *(Paris: Editions de Paris, 1961)*

The hero is transferred by time machine to a medieval battle in which he has to fight the warrior woman Gjalog. Returning to his own time, he finds that his fiancée is a descendant of Gjalog and other women warriors, a fact of which she is very proud.

Philip Jose Farmer, Image of the Beast *and* Blown *(London: Quartet Books, 1966 and 1969)*

The Amazons are supernatural beasts—werewolf, wereboar, werepython.

Monique Wittig, Les Guérrillères *(Paris: Minuit, 1969)*

Major feminist theorist Wittig creates a poetically intellectual celebration of warrior women.

Jeffrey Lord, Blade series (New York: Macfadden, 1970–88); thirteen books (E)

The hero is a British agent sent to various planets on which he often meets Amazons. Lord depicts most of the Amazons as being intelligent as well as the usual—strong, beautiful, sexually passionate. The last volumes in this series, those written after 1987, are devoid of Amazons.

Françoise d'Eaubonne, Le Satellite de l'Amande *(Paris: Flammarion,1975)*

A space expedition headed by women overcomes obstacles on a strange planet under the leadership of herculean athletes Carlotta and Ingrid.

Marion Zimmer Bradley, Free Amazons of Darkover *(New York: Daw Books, 1985)*

This book describes the evolution of the planet Darkover toward a society of Free Amazons. The organization of guilds in which women can train in martial arts, wrestling, weightlifting, and swordswomanship is instrumental.

amazons at the core: heroines' strength is the heart of the story

Anonymous, The Life of Long Meg of Westminster *(London: Reeves and Turner, 1872)*

In this sixteenth-century tale, the gigantic heroine is the maid in charge of all heavy work at a London inn. She fights unsavory characters, dresses as a man for sword duels with men, disarms them, and forces them to wear feminine clothing.

Louis Chauvet, Furieusement Tendre *(Paris: Flammarion, 1950)*

A teenage girl shows she is physically superior to all boys her age.

Carson McCullers, Ballad of the Sad Cafe *(New York: Houghton Mifflin, 1951)*

Miss Amelia is a Jill-Of-All-Trades. She likes to feel her big, hard, arm muscles, and she is a first-rate fighter, feared by everyone. While winning a fight with her ex-husband Marvin, for which she has prepared with homemade barbells and a punching ball, the hunchback Lymon, whom Amelia has pampered, drives his fingernails into her neck, enabling Marvin to regain his footing while Amelia lies on the ground. The two men leave town, and Amelia loses her courage and becomes physically inactive.

Louis Chauvet, La Petite Acrobate de l'Helvetia *(Paris: Flammarion, 1953) (E)*

This book consists of four stories about Amazons. In the title story, Ruth lifts her 170-pound brother in a circus act. She meets a gang of petty criminals and joins in their deeds. Ending up in prison, she becomes the inmates' boss due to her strength. The most striking story, "Arènes Olympiques," features fairground wrestler Ida. When, in the sideshow, she flexes her huge biceps, the onlookers are amazed. When angry, she bends iron bars. To punish a heckler, she rapes him. At the same time, Ida is warmhearted, helping to reconcile a young man, whom she has beaten several times in the arena, with his jealous fiancée.

Tony Calvano, Lust Monsters *(Chicago: Midnight Readers,1963) (E)*

A traveling salesman is kept prisoner on a farm run by four women, one of them herculean.

Stella Gray, The Naked Archer *(New York: Vega Books, 1966) (E)*

The athlete Diana is distraught when her first love, another girl athlete, dies in a car accident. Diana has a troubled relationship with Hank, a football player who competes with her in various sports. She travels to Mexico where she performs a naked archer act in a nightclub. Using a very hard bow, she shoots arrows around a stooge's body; the last one, rubber-tipped, she shoots at his genitals. Hank substitutes himself for the stooge, making Diana so angry that she wounds him in several places; but he shows so much courage that, finally, she admires him, makes love with him, and marries him.

Kenneth Roberts, Flame *(New York: Paperback Library, 1970) (E)*

African warrior Flame is captured by slavetraders and sent to Dixie. Her size and muscles impress her wardens. Tommy, a relatively decent farmer, buys her. She forcefully makes love with him, saves him from villains, strangles would-be rapists, and, far more than Tommy, is the boss.

Kermit Klitch, Different Strokes for Different Folks *(Chicago: Midwood Books, 1970) (E)*

The hero, a bashful youngster, searches for his brother, who has disappeared and who is renowned as a great lover. He finds addresses of his sibling's former mistresses, Amazons well-versed in the arts of love. The hero ends up squeezed in their strong arms and muscular pussies. One of them, a tall and powerful stripper, impresses people by flexing her big calves; they seem able to grind a man to death.

Paul Adouy, Fantastique Brigitte *(Paris: D. Leroy, 1978)*

Brigitte effortlessly lifts her partner while dancing. She loves to fight and outboxes and outwrestles her lover, whom she easily lifts overhead and finally rapes. He is strong, but his muscles look puny in comparison with hers. With another Amazon, Diane, Brigitte opens a bawdy house specializing in the muscular domination—no whips—of male customers. "I still remember," the narrator writes, "the impression my whole body felt when I was touching the thickness of her arm, hard as steel, covered by muscles which powerfully reacted to each move I made. I felt an incredible bundle of muscles lift and stretch the fabric of her sleeve."[3]

Jérôme Fandor, Ton Corps Est Tatoué *(Paris: La Brigandine,1982) (E)*

A muscular, tattooed Amazon heads a motorcycle gang. Any strong young man would be proud to have muscles like hers.

Pierre Mertens, Perdre *(Paris: Fayard, 1984) (E)*

The author daydreams about a reconstructed Carthage in which dominant Amazons from all over the world have settled. Many mixed wrestling bouts and gladiator fights are organized.

This is only a small sample of all the Amazons I have found in written fiction. As stated, they are more numerous in periods favorable to women. But, independent of the period, some writers—male and female—seem to be fascinated by Amazons.

Notes:

[1] Abby Wettan Kleinbaum, "Introduction," *The War against the Amazons* (New York: New Press, 1983), 1.

[2] Siam is present day Thailand and Dahomey, a former French colony in West Africa, is now Benin.

[3] Paul Adouy, *Fantastique Brigitte* (Paris: D. Leroy, 1978), 3.

AMELIA LAVIN, *TIGRESS*
(DETAIL), 1999. LOOMED
DELICA BEADS, 8 × 12".

michael cunningham is the author of the novels *Flesh and Blood* (1995) and *A Home at the End of the World* (1990). Michael Cunningham's most recent work, *The Hours* (1998) was the winner of the 1999 PEN/Faulkner Award for Fiction and the Pulitzer Prize in Fiction. His work has appeared in the *New Yorker*, the *Atlantic Monthly*, and the *Paris Review*. He has received fellowships from the National Endowment for the Arts and the Guggenheim Foundation.

laurie fierstein, a bodybuilder and social activist, is a central figure in pioneering creative expression for a new discourse about muscular and physically powerful women. Fierstein produced the watershed performances of female bodybuilders and strength athletes, *Evolution F: A Surreal Spectacle of Female Muscle* (1995) and *Celebration of the Most Awesome Female Muscle in the World* (1993).

joanna frueh is an art historian, art critic, and performance artist who has written extensively on the female body and contemporary art. *Monster/Beauty: Building the Body of Love* (2000), one of whose subjects is female bodybuilding, is her most recent book. She is author of *Erotic Faculties* (1996) and *Hannah Wilke: A Retrospective* (1989) and a co-editor of *New Feminist Criticism: Art, Identity, Action* (1994) and *Feminist Art Criticism: An Anthology* (1988). She is Professor of Art History at the University of Nevada, Reno.

nathalie gassel is a Belgian writer who loves to train with weights, to display her muscles and her strength, and to wrestle men. Born in the late 1960s, she wanted to do all that boys her age were doing. At age twenty, she discovered bodybuilding, and she developed sizeable muscles, a very hard body, and a strength in which she takes great pride.

leslie heywood's most recent books are *Bodymakers: A Cultural Anatomy of Women's Bodybuilding* (1998) and *Pretty Good for a Girl: A Sports Memoir* (1998). She currently competes in powerlifting and teaches cultural studies at State University of New York, Binghamton.

irving lavin has been Professor of the History of Art at the Institute for Advanced Study, Princeton, NJ, since 1973. Best known for his many works on Gian Lorenzo Bernini, his research and publications cover a wide range of subjects from Late Antiquity to Jackson Pollock. For many years he taught at the Institute of Fine Arts, New York University, and has lectured at the Collège de France, the American Academy in Rome, the University of California, Berkeley, and Oxford University. He is a fellow of the American Academy of Arts and Sciences, a member and past President of the US National Committee for the History of Art (CIHA), and a Foreign member of the Accademia Nazionale dei Lincei, Rome, and of the Accademia Clementina, Bologna. Among his books are *Bernini and the Unity of the Visual Arts* (1980), *Past-Present: Essays on Historicism in Art from Donatello to Picasso* (1993), and *Erwin Panofsky: Three Essays on Style* (1995).

pierre samuel is a French mathematician who has written numerous books and papers in his field. He is now Professor Emeritus from the Université de Paris-Sud. He is fascinated by Amazons and female strength and muscles, and his extensive research in these areas was published in his book *Amazones, Guerrières et Gaillardes* (1975).

maxine sheets-johnstone is an independent scholar who teaches periodically in the Department of Philosophy at the University of Oregon. Her research and publications focus on the evolutionary, psychological, ontogenetical, and philosophical dimensions of the tactile-kinesthetic body and on the significance of animate form—in broad terms, on what it means to be the bodies we are. She has published six books—*The Phenomenology of Dance*, (1966; 2nd ed., 1979) *Illuminating Dance: Philosophical Investigations*, (1984) *The Roots of Thinking* (1990), *Giving the Body Its Due* (1992), *The Roots of Power: Animate Form and Gendered Bodies* (1994), and most recently, *The Primacy of Movement* (1999). She has published numerous articles as well in philosophy, art, and science journals.

judith stein is a curator and art critic. As curator of the Pennsylvania Academy of Fine Arts from 1981–1994, she organized over ninety exhibitions of contemporary art. Stein writes frequently for national art publications and was a contributor to *The Power of Feminist Art* (1994). She is president of the International Art Critics Association (AICA), American Section.

al thomas is recognized as the foremost contemporary pioneer in heavy weight training for women. His contributions are analytic and literary as well as in the field of training techniques. Thomas began writing on women and muscle in 1952 as the editor of a Navy newspaper. Since then his controversial articles on muscular women and female bodybuilders and strength athletes—as well as male strength athletes and physical culturists—have been published nationally in numerous magazines including *Ironman, Strength & Health, Muscular Development, Body and Power, Power and Fitness, The Sports Reporter, Pallas Journal, Women's Physique World*, and *Iron Game History*. Thomas co-authored, with Steve Wennerstrom, the first book on women's bodybudilding, *The Female Physique Athlete: A History to Date; 1977–1983* (1983). With a Ph.D. in American Literature, Thomas taught that subject and others for thirty-six years. At Kutztown University, from which he retired in 1992, he was also adviser to the school's powerlifting team, which won national collegiate championships in 1981 and 1982.

jan todd teaches Kinesiology, Health Education, and American Studies at the University of Texas at Austin. She is the author of *Physical Culture and the Body Beautiful: Purposive Exercise in the Lives of American Women* (1998), the founder and co-editor of *Iron Game History: the Journal of Physical Culture*, and has published numerous articles on the history of women and exercise. With her husband, Terry Todd, Jan also serves as the co-curator of the Todd-McLean Physical Culture Collection, the largest archive in the world in the field of physical fitness, strength training, and bodybuilding. Todd's interest in the academic study of strength and exercise grew from her personal involvement in the sport of powerlifting. In the 1970s and early 1980s, Todd was considered by both Sports Illustrated and the Guinness Book of Records to be the "strongest woman in the world."

steve wennerstrom is editor of *Women's Physique World* magazine and editor-at-large for *FLEX* magazine. In addition to his editorial duties, he is the official historian on women in bodybuilding for the International Federation of Bodybuilding (IFBB). Considered without rival in his area of expertise, Wennerstrom possesses an encyclopedic knowledge about the competitive years of women's bodybuilding.

carla williams is a photographer and writer. She is co-author of *The Black Female Body in Photography* (2000). Her publications include "Naked, Neuter, or Noble: Extremes of the Black Female Body and the Problem of Photographic History" in *Venus 2000* (2000).

credits

front cover, courtesy the artist; half-title page, courtesy the artist; copyright page, courtesy DC comics; page 4, from Ruth Malhotra, *Manese frei Artisten-und Circusplakate von Adolph Friedländer* (Dortmund, Germany: Harenberg Kommunikation, 1979), courtesy David Webster Collection; page 7, courtesy *Women's Physique World*; page 8, courtesy *Women's Physique World*; page 8-9, background image, courtesy Illinois State University; page 10, courtesy the artist; page 13, courtesy the artist; page 14, photo: Mark Schaeffer; page 15, left, courtesy David Webster collection; page 15, right, courtesy *Women's Physique World*; page 16 and page 17, photos: Andi Faryl Schreiber; page 18, top, courtesy Universal Studios Publishing Rights, a Division of Universal Studios Licensing, Inc., © 1999 by Universal City Studios, Inc., all rights reserved; page 18, bottom, photo: Mark Schaeffer; page 18, background image, courtesy the Trustees of the British Museum, © The British Museum; page 19, photo: Carlo Puzzilli; page 20, courtesy Yale University Art Gallery, gift of Dorothy Darrow Stravola; page 22, courtesy Sharadin Art Gallery; page 23, courtesy the artist; page 25, courtesy The Robert Mapplethorpe Foundation, © Estate of Robert Mapplethorpe, used by permission; page 26, courtesy the artist; page 27, courtesy Worcester Art Museum; page 28, courtesy the artist; page 29, courtesy the artist; page 30, Private Collection, courtesy Ronald Feldman Fine Arts, New York, Photo: Jennifer Kotter; page 31, courtesy Pamela Demme; page 32, courtesy the artist and Carl Hammer Gallery, photo: William Beng and Son; page 33, collection the Los Angeles County Museum of Art; page 35, courtesy Steinbaum-Krauss Gallery, New York; page 36, top, courtesy *Women's Physique World*; page 36, bottom, courtesy *Women's Physique World*; page 37, courtesy the artist, photo: Kevin Ryan; page 38, courtesy *Women's Physique World*; page 39, courtesy *Women's Physique World*; page 40, courtesy the artist, photo: Dennis Dal Convey; page 41, courtesy *Women's Physique World*; page 42, top, Private Collection, courtesy Barbara Gladstone Gallery, photo: Michael James; page 42, bottom, courtesy *Women's Physique World*; page 43, courtesy David Chapman Collection; page 44, courtesy *Women's Physique World*; page 45, collection of Elie and Ethel Romano, photo: John Bessler; page 46, courtesy the artist; page 49, courtesy Mary Ellen Mark; page 50, courtesy the artist, Photo: Ken Burris; page 51, top, courtesy Illinois State University; page 51, second from top, courtesy Circus World Museum; page 51, background image, from Groth Lothar, *Die Storken Manner: Eine Geschichte der Kraftakrobatik*, revised ed. (East Berlin: Henschelverlag, 1987), courtesy David Chapman Collection; page 51, third from top, courtesy David Chapman Collection; page 51, bottom, from *The Kings of Strength* by Edmond Desbonnet (Paris, 1911), courtesy David Chapman Collection; page 52, above, courtesy Circus World Museum; page 52, right, courtesy Marcia Richards; page 53, right, courtesy David Chapman Collection; page 53, below, courtesy David Webster Collection; page 54, courtesy David Webster Collection; page 55, top right, courtesy Circus World Museum; page 55, top left, courtesy Marcia Richards; page 55, bottom left, courtesy Circus World Museum; page 55, bottom right, courtesy Circus World Museum; page 56, top, courtesy Illinois State University, photo: Sveere Braathen; page 56, bottom, courtesy David Webster Collection; page 57, courtesy Orrin J. Heller Collection, photo: Cecil Charles; page 58, courtesy the artist; page 59, top, from *The Kings of Strength* by Edmund Desbonnet (Paris, 1911), courtesy David Chapman Collection; page 59, bottom, courtesy Bibliothäque nationale de France; page 60, top, collection of The John and Mable Ringling Museum of Art Archives, photo: Frederick Whitman Glasier; page 60, bottom, courtesy David Chapman Collection; page 60, background image, Courtesy Orrin J. Heller Collection, photo: Orrin J. Heller; page 61, left, courtesy The Todd-McLean Physical Culture Collection at the University of Texas at Austin; page 61, right, courtesy Orrin J. Heller Collection, photo: Orrin J. Heller; page 63, courtesy the artist and Jessica Fredericks Gallery, landscape photo: Marnie Weber; amazon women photo: *Women's Physique World*; artwork photo: Chris Warner; page 64, courtesy *Women's Physique World*; page 65, courtesy *Women's Physique World*; page 66, top, courtesy *Women's Physique World*; page 66, middle, courtesy *Women's Physique World*; page 66, bottom, courtesy *Women's Physique World*; page 67, courtesy the artist; page 68, top, courtesy Steve Wennerstrom; page 68, bottom, courtesy *Women's Physique World*; page 69, courtesy *Women's Physique World*; page 69, background image, courtesy *Women's Physique World*; page 70-71, courtesy Susan Meiselas/Magnum Photos; page 73, courtesy Bill Lowenberg; page 74, courtesy *Women's Physique World*; page 75, courtesy Bill Lowenberg; page 77, courtesy Jack Tilton Gallery and P.P.O.W., New York, photo: David Reynolds; page 78, courtesy the artist; page 79, courtesy the artist; page 80, photo by Cat Farrar; page 81, courtesy Adam Baumgold Fine Art and Cavin Morris Gallery, photo: Jean Vong; page 82, background image, courtesy David Webster Collection; page 83, courtesy the artist; page 84, courtesy the artist; page 85, courtesy Bill Lowenberg; page 87, courtesy the artist; page 88, courtesy *Women's Physique World*; page 89, courtesy Adel Rootstein; page 90, top, courtesy Illinois State University, photo: Sveere Braathen; page 90, bottom, photo: Norm and Jerry Cohen; page 91, courtesy Cheim and Read, New York, photo: Quesada/Burke, New York; page 92, courtesy the artist; page 95, photo: Mark Schaeffer; page 96, courtesy *Women's Physique World*; page 97, left, courtesy the artist, Photo: Keith Schreiber; page 97, right, courtesy *Women's Physique World*; page 98, courtesy the artist; page 101, courtesy the artist; page 103, courtesy Eros Comix; page 105, courtesy the artist; page 106, courtesy the artist; page 107, courtesy the artist; page 108, courtesy Steinbaum Krauss Gallery; page 111, courtesy the artist; page 112, courtesy the artist, © Cynthia Wiggins, 1999; page 113, courtesy the artist; page 114, courtesy the artist; page 121, courtesy DC Comics; page 122, collection of Johnny Suarez, courtesy DC Comics; page 123, courtesy the artist; page 124, courtesy the artist; page 125, courtesy the artist, photo: Jelly Bean Photography; page 126, courtesy LH-Art; page 127, courtesy the artist; page 128, courtesy Gay Comix; page 129, courtesy Dark Horse Comics; page 131, courtesy the artist; page 132; courtesy Dark Horse Comics; page 133, reprinted from OH Comics, courtesy the artist; page 134, courtesy the artist; page 135, courtesy Eros Comix; page 136, courtesy Marvel Comics; page 139, courtesy the artist; page 140, left, courtesy the artist, photo: Gary Agliata; page 140, right, photo: Mark Schaeffer; page 142, Courtesy LH-Art; page 143, courtesy the artist; page 144, courtesy the artist; page 145, ©1993 Turtel Onli, courtesy the artist, comic collection of Laurie Fierstein; page 146, courtesy the artist; page 147, courtesy the artist and Cleis Press; page 148, courtesy LH-Art; page 151, courtesy the artist; page 152, courtesy Orrin J. Heller Collection, photo: Cecil Charles; page 153, photo: Pride Pak; page 155, courtesy Bev Francis, photo: Mike Neveux; page 159, courtesy the artist; page 160, courtesy the artist; page 162, courtesy the artist; page 165, courtesy *Women's Physique World*; page 167, courtesy *Women's Physique World*; page 169, Collection of Meridian Fine Art, courtesy the artist and Metro Pictures; page 171, courtesy the artist; page 172, courtesy the artist and Max Protetch Gallery, photo: Dennis Cowley.

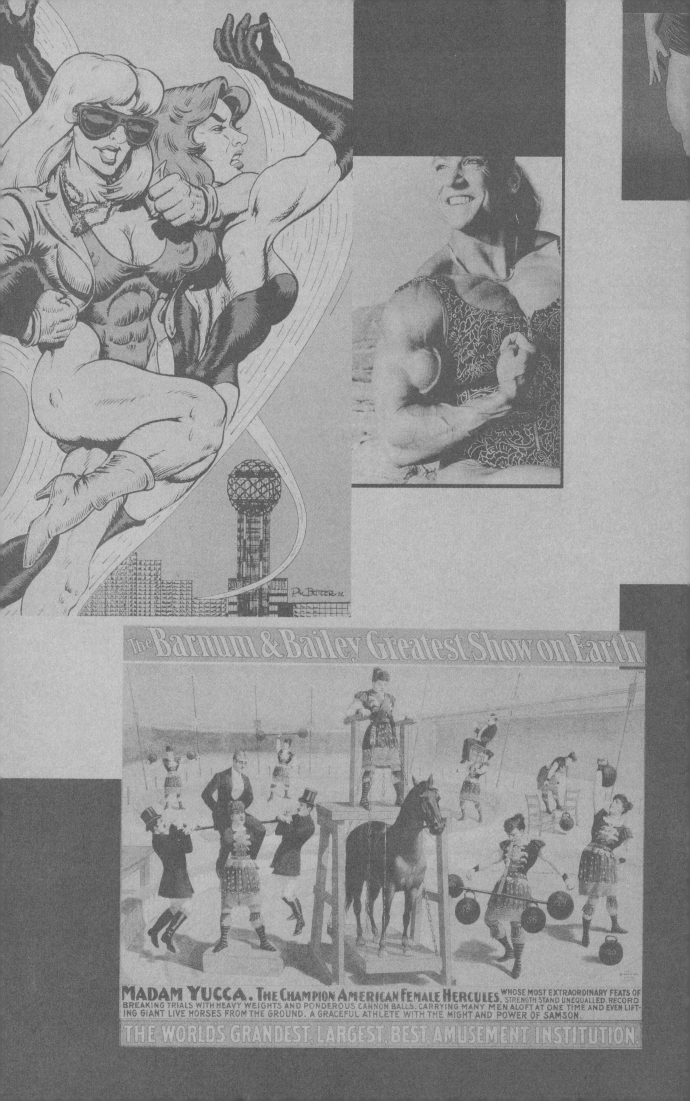

The Barnum & Bailey Greatest Show on Earth

MADAM YUCCA. The Champion American Female Hercules, WHOSE MOST EXTRAORDINARY FEATS OF STRENGTH STAND UNEQUALLED. RECORD BREAKING TRIALS WITH HEAVY WEIGHTS AND PONDEROUS CANNON BALLS. CARRYING MANY MEN ALOFT AT ONE TIME AND EVEN LIFTING GIANT LIVE HORSES FROM THE GROUND. A GRACEFUL ATHLETE WITH THE MIGHT AND POWER OF SAMSON.

THE WORLD'S GRANDEST, LARGEST, BEST, AMUSEMENT INSTITUTION.